GAUGUIN

FRANÇOISE CACHIN

GAUGUIN

Translated by Bambi Ballard

Flammarion

This text, now considerably expanded and brought up to date, was first published in May 1968 by *Le Livre de Poche illustré*, edited by the late André Fermigier. It is to his memory many years later that I dedicate this new version with unfailing gratefulness and affection.

F.C. April 1988

© Flammarion, 26, rue Racine, Paris 75006

Copyright © 1988 Flammarion for the French language edition

English language translation copyright © 1990 by Flammarion

The translation of this volume was assisted by a grant from the French Ministry of Culture and Communication.

ISBN 2-08-013501-5

Design by Jacques Maillot
Copyediting by Julie Gaskill
Composed by Nord Compo, Villeneuve-d'Ascq
Photoengraving by Bussière Arts Graphiques, Paris
Printed by CAMPIN, Tournai
Bound by Reliure Brun, Malesherbes

CONTENTS

THE PAINTER AND THE LEGEND 9

1 THE SUNDAY IMPRESSIONIST 1873-1885 13

2 THE FIRST JOURNEYS 1885-1887 33

3 BRITTANY IN THE JAPANESE STYLE
BY A 'SAVAGE FROM PERU' 1888 57

4 GAUGUIN, BAUDELAIRE AND THE EIFFEL TOWER 1889 91

5 THE 'PREY OF THE MEN OF LETTERS' 1889-1890 103

6 THE STUDIO IN THE TROPICS 1890 133

7 A SEASON IN PARADISE 1891-1893 145

8 'AT THE MYSTERIOUS HEART OF THOUGHT' 1894-1895 193

9 'NEAR GOLGOTHA' 1895-1901 215

10 'THE RIGHT TO DARE ALL' 1901-1903 247

FROM WAGNER TO MATISSE 267

BIOGRAPHY 277
NOTES 288
GAUGUIN'S PAINTINGS IN MUSEUMS 293
BIBLIOGRAPHY 298
LIST OF ILLUSTRATIONS 301
INDEX 310

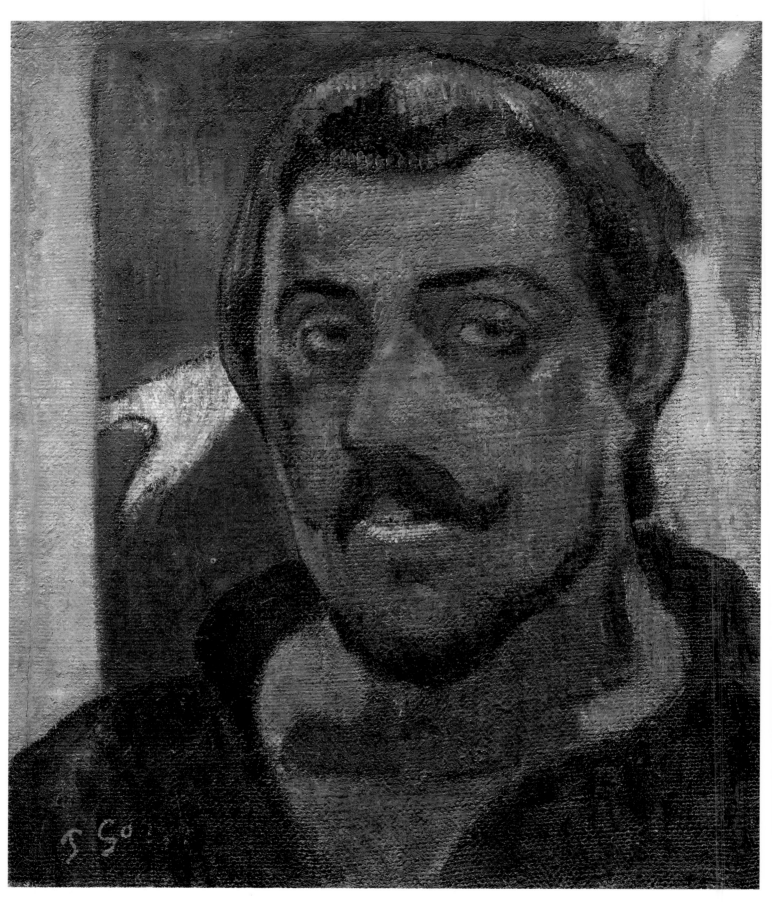

1. *Self-portrait*, 1889-1890.
Oil on canvas, 46×38 cm. Moscow, Pushkin State Museum of Fine Arts.

THE PAINTER
AND THE LEGEND

Oh! those pink horses!
Oh! those lilac peasants!
Oh! that red smoke!

Baudelaire.

A social exile, a tortured painter, a scandalous yet sublime creator, an exotic hero and a mystic lover of the primeval in an age that built the Eiffel Tower, out of all the modern artists Paul Gauguin was the first to become a legend. Indeed, even before he died legend had ordained him keeper of the inviolable, but did this not result in the sacrifice of his art?

At first glance his paintings seduce the eye, then the underlying truth in them rises to the surface. But—the Tropics? Although he never left Europe, Douanier Rousseau's *The Snake Charmer* or *The Sleeping Gypsy* convey an exotic poetry that is infinitely more telling than anything Gauguin painted in Tahiti. Daring angles and composition? Wittier and more powerful, Degas outstripped him at this. Expressive colour? Van Gogh had the greater mastery of it. Humour, power of observation, discipline? These are areas in which Toulouse-Lautrec and Seurat surpassed him. Lastly, an obsessive Symbolist imagination pervaded the works of Odilon Redon and Gustave Moreau far more than his and it was Cézanne, not Gauguin, who was the first to separate the canvas from its subject and suggest a metaphysical grandeur through technique alone. Thus Gauguin is far from emerging as the victor in this quarrel over precedence, even though some of his paintings are considered masterpieces today and his experiments with style were instrumental in giving birth to contemporary art.

The aura of literature and legend with which he so assiduously surrounded himself may have served his memory well, but it did a great disservice to his art. One could even say that it eclipsed it, for, by the turn of the century, between Impressionism and modern art, there had been a sudden acceleration in the development of artistic awareness when, as soon as Monet and Cézanne had been assimilated, Picasso, Braque and Matisse began to conjure up new 'worlds of shapes' from the void. Somehow, in passing from one to the other, the history of taste glossed over the contribution of those two great intermediaries, Georges Seurat and Paul Gauguin, so essential to the evolution and understanding of twentieth-century art. Both tried to go beyond Impressionist realism and create a major modern style, a more ambitious art-form that would express the world rather than reproduce it. Each in his own way systematized, simplified and enriched the discoveries of the Impressionists with new advances that carried them to extremes. Seurat achieved this through a sort of scientific poetry, Gauguin applied a resolute Symbolism that never strayed from the pictorial rules found in a Degas or a Pissarro. The austerity of both Seurat's personality and technique, coupled with the brevity of his production, have perhaps protected his painting from being too quickly absorbed and subjected to the kind of superficial interpretation that is the price of being fashionable.

As for the hapless Gauguin, he had already done his utmost while alive to ensure that his life would be confused with his art, his passions with his ideas and his legend with his pictorial innovations. Even today, almost a century after his death, the man is invoked before the painter and his erotico-exotic adventures are discussed more than his role in the history of Art. The fact is that Gauguin was at first solely motivated by his personal destiny—his 'ego'. Gradually he perceived the crisis that painting was undergoing and threw his romantic narcissism and that sincerity belonging to the self-taught into intellectual probings that his contemporaries were not prepared to face outside the comfortable setting of a café or studio. He was to live as an outcast, taking a purely pictorial drama increasingly to heart and, even though it was to kill him, he applied quite literally the Symbolist precepts that Mallarmé murmured from the safety of his snug home in the Rue de Rome—'To flee yonder! To flee!'

Gauguin, more than Van Gogh perhaps, was the first artist to idolize Art. Delacroix had been the last of the artists of an earlier age—a superb craftsman, but a professional who, once he had cleaned his brushes, became a diligent frequenter of dinner parties and the opera. Gauguin, on the other hand, was to go to scandalous and sometimes idiotic lengths to advertise the fact that he was a man with a glorious destiny, since Art would not only redeem the artist, but would also be the salvation of a fallen and decadent society. His life is made up of all the ingredients that fire the popular imagination. From being a typical product of nineteenth-century industrial society, a stockbroker, he went to the opposite extreme and became its dramatic antithesis, the Creator of the South Seas. From unhappy slave to outcast painter his comic strip persona has never ceased to inhabit the cautious, yearning dreams of the petty bourgeois.

He is the first artist who, like Freinhofer in Balzac's *Chef d'œuvre inconnu*, actually lived painting as an absolute search and a total commitment of the self. But to sacrifice one's life for one's art is not a guarantee of genius. Sacrifices do not necessarily produce good paintings, and those that Gauguin made so heroically may have done an injustice to the painters who followed him. The miracle, the 'Gauguin case' we could call it, is that he actually did succeed, partly through will-power—'I willed myself to will,' he once wrote—in becoming the major painter that we know. This is why Gauguin is such a disturbing artist, for we are troubled as much by the unevenness of his work as we are by the astounding course of his artistic evolution, and by his naïve but ultimately triumphant will to become a great artist.

Gauguin's real tragedy lies not so much in his life, but in his work. He left the security of a family existence to lead what he proudly called the life of 'a lean wolf'. He broke away from Pissarro's Impressionism around 1885; in 1890 he endeavoured to go beyond the discoveries of Synthetism and, towards the end of his life, he finally stripped himself bare of all Symbolism and literary allusions. Each time he abandoned painfully acquired aesthetic certainties to throw himself into an adventure that was infinitely more dangerous for his 'glory' than Bohemianism or an exotic isolation. At times it is difficult to follow the path of this stylistic adventure as it winds through the many detours, repetitions, discoveries, influences, weaknesses and flashes of brilliance in his career. It was first and foremost a dramatic adventure because it was lived as such, unlike Degas's for instance, for this artist's susceptibilities were so modern that he seems to us today to have been a completely unsentimental painter. But above all, Gauguin was a product of Impressionism, which had overthrown all the canons of academic painting, with the result that in this intellectual *fin de siècle* he found himself totally bereft of a means to forge a style that would be acceptable to the sensibilities of the day.

Before it drew on its inner resources and found its own justification in abstraction—the repercussions of which still pose fresh problems today—Symbolist painting first sought to recapture the spiritual dignity that literature and music seemed to be trying to appropriate. Gauguin felt this need confusedly but quite strongly and, although we could reproach him for having sometimes lacked intelligence in the way he dealt with the problems inherent in the painting of his time, we cannot but admire him for having faced them with courage and for having sometimes recognized them with an intuition bordering on genius.

Amongst his contemporaries, Toulouse-Lautrec, for example, quite simply never considered the problem. He never pretended to have a 'great style', hence the ironic observation that is so characteristic of his painting which, though we find it so delightful and astute today, is nevertheless superficial. When Georges Seurat wanted to go beyond Impressionism he was able to draw on a classical pictorial culture acquired from the disciplines of the École des Beaux-Arts and on an intelligence that was more reflective and assured than Gauguin's. For everything about Gauguin, despite his bombast, betrays his anxiety, his endless quest, his constant need to express himself, the attraction typical of the self-taught to the ideas of others, and also the systematic use of what belonged to him, Paul Gauguin: his childhood in the Tropics, his Peruvian ancestry, his unpolished personality, his lawless life, everything in fact that he naïvely but accurately called his wildness.

Naïve it was, for it was very much the wildness of the turn of the century and what he considered most original and interesting in his art no longer appears so today. Kandinsky could rightly say that Cézanne 'raised the still life to the noble rank of an outwardly dead and inwardly alive object', but Gauguin's approach was often unwittingly the reverse, and when he imagined he was painting the mysterious or the fabulous—'something immemorial'—he was painting merely a decorative motif, with an abstract and rhythmic inventiveness imbuing his motif with what lacked in poetico-religious meaning. On other occasions he communicated his feelings or anxieties in a purely pictorial language without even realizing it,—or at least so it appears, as we shall see—so much so that it is not a contradiction to say that the wilder he wanted to be, the more sophisticated and 'Art Nouveau' he became. What's more, after a certain stage in his development, it was when he deviated from what he considered essential that he was to achieve—in his pottery, engravings and monotypes as well as in some of his paintings—all that was best, most powerful and truly free in his art.

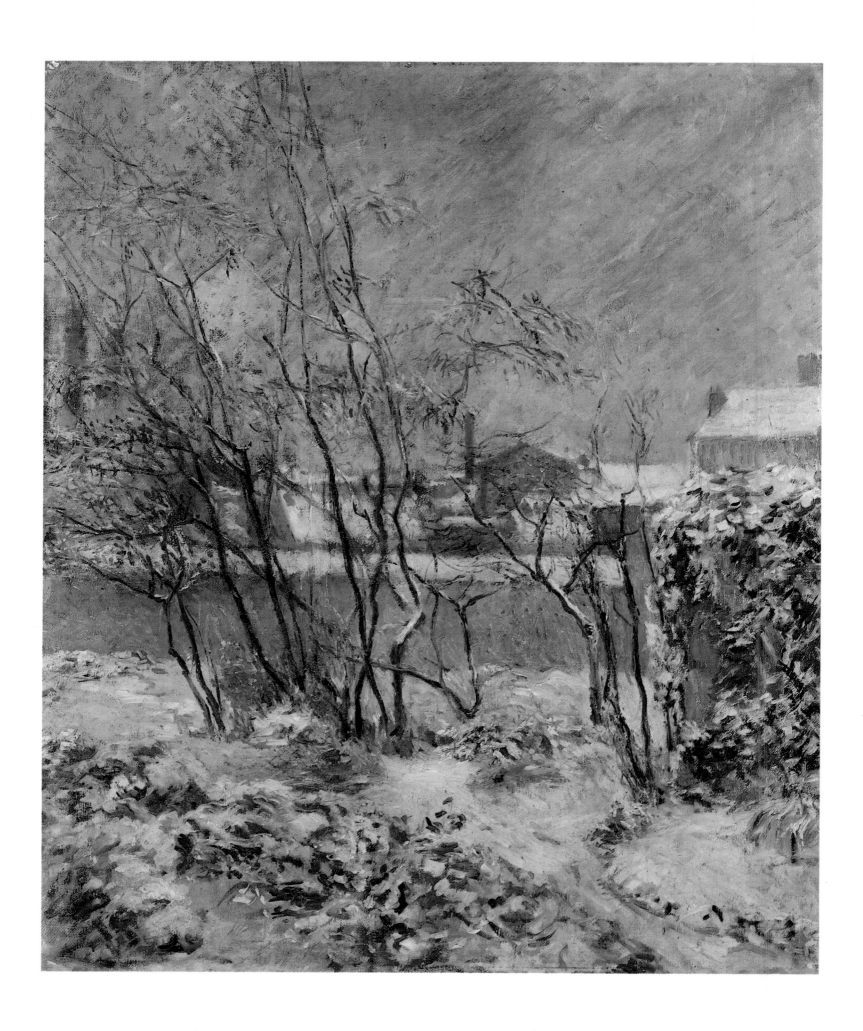

THE SUNDAY IMPRESSIONIST

1873-1885

2. *Snow Scene, Rue Carcel*, winter 1882-1883. Oil on canvas, 60×50 cm. Copenhagen, Ny Carslberg Glyptotek.

While still a zealous Impressionist, Gauguin painted many snow scenes, from *The Seine at Iena Bridge* in 1875 (fig. 7) to the mediocre *Village in the Snow* that Victor Segalen found on his easel in the Marquesas Islands after his death. In the summer of 1880 Gauguin moved into a small house with a garden at 8 Rue Carcel in the Vaugirard district, which at the time was still partly rural. He had a studio and an apartment, which enabled him to combine his roles as a broker on the Paris Stock Exchange and family man with painting. At the time he painted this canvas he wrote: 'I cannot resign myself to spending the rest of my life in finance and amateur painting, I have got it into my head that I shall become a painter' (to Pissarro, June 1882). This firm and almost too classically Impressionist painting immediately places Gauguin's work at the level of the best contemporary snow scenes by Sisley and Pissarro, but one feels that he restrained his colours and carefully designed his composition so that the horizontal lines of the walls and roofs would correctly balance the vertical branches. In it he painted a latticework of all the subtle blues and greens that he was later to abandon for colours that were muted, warm and quite soon, dazzling.

Your foot is in the stirrup.

Degas to Gauguin.

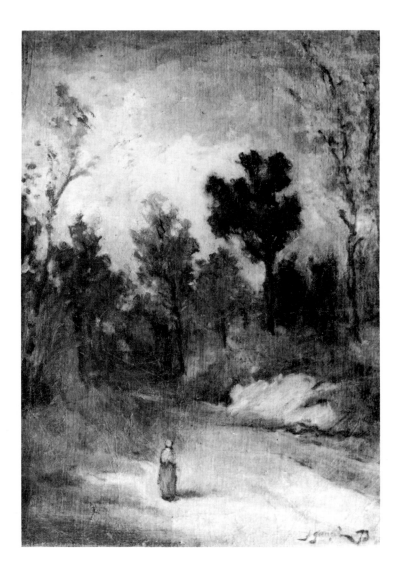

3. *Woodland Scene*, 1873? Oil on canvas, 45×31 cm. United States, Private Collection.

Gauguin's first known canvas dates from the summer of 1873.[1] It is a timid little painting in the manner of Corot of a woodland setting containing a small figure that brings to mind one of Pissarro's peasants.

These comparisons should not surprise us since, just as he was to be the painter whom society cast out, he was also the conscientious pupil of the Impressionists.

When Aline Gauguin died in 1867 while the nineteen-year-old Paul was on a ship somewhere in the Atlantic, she entrusted her children to the guardianship of her old friend, Gustave Arosa. In her will she predicted the difficult life in store for that sullen and unresponsive young man she knew so well: 'As for my dear son, he shall have to make his own way in life, for he has so signally failed to make himself loved by my friends, that he shall find himself quite abandoned.[2] Fortunately for the history of painting, Arosa's care of his ward gave the lie to this prediction. A warm and cultivated man of sure, almost daring taste and an excellent photographer, Arosa owned a collection of paintings that included works by Courbet, Delacroix, Tassaert, Corot, Jongkind and even Pissarro, at a time when Impressionism was still abhorred. Throughout Gauguin's career we will find frequent precise indications of the attention with which he must have examined these paintings, for, even in Pont-Aven and Tahiti, when he had achieved maturity as a painter, his works sometimes hinted of them. No doubt he refreshed his memory with the illustrations that he had cut out of the catalogue of the Arosa sale and taken with him to the Tropics, as can be seen when a motif of a peasant or some cows copied from Tassaert or Pissarro appear. Evidently Gauguin also owned a number of Arosa's published photographs, for a composition

by Prud'hon, reliefs from the Parthenon, and Trajan's Column inspired by his plates can also be found in his work.

What Gauguin discovered thanks to Arosa, when he returned to Paris in 1871 after having hardly set foot there for six years, must have been a tremendous revelation to him. Painting especially must have greatly stimulated the sensitivity of a young man who had so far learned more from seeing the world than from books or social contact. It must also have gone some way towards fulfilling the unsatisfied desires and dreams of someone who had already become a restless wanderer and experienced both pride and humiliation.

'Were I to tell you that on my mother's side, I am the descendant of an Aragonese Borgia Viceroy of Peru, you would say that it is a lie and that I am pretentious.'[3] This is the opening line of Gauguin's chaotic confessions, *Avant et Après*. And yet everything he wrote was true, despite the occasional exaggeration.

Gauguin was the grandson of Flora Tristan, the illegitimate daughter of a rich Peruvian, Tristan y Moscoso. This extremely beautiful, passionate and slightly mad young woman, a friend of Proudhon, George Sand and Père Enfantin, became the coquettish Egeria of the Socialists and was led by her convictions and a highly romantic temperament to become a genuine heroine: an orator in petticoats spreading the good word in defiance of danger. One of her contemporaries wrote: 'Flora became so exalted by the struggle that she saw herself as having reached mythical dimensions, and believed she was a female Messiah.'[4] Did Gauguin know of these words when he represented himself as Christ, as a latter-day martyr and the redeemer of modern painting? Flora, who published an autobiography in 1838 with the premonitory Gauguinesque title of *Pérégrinations d'une paria*, died in 1844, four years before the birth of her grandson Paul in 1848. He was the son of Aline—as beautiful as her mother but gentler and more self-effacing, according to George Sand[5]—and a journalist, Clovis Gauguin, who was quite literally to die of rage. Violence was rampant in the family: when Gauguin was born, Chazal, a lithographer and the unlucky husband of his 'red' grandmother, was serving twenty years hard labour for trying to kill his wife in an attack of jealousy. When Paul was barely a year old, the whole family made the three-month crossing to Peru to seek the protection of relatives whom they did not even know. Like his son, who wore himself out many years later in petty disputes with local authorities

4. Flora Tristan, engraving by Gerinler, 1847. Paris, Bibliothèque Nationale, Department of Prints.

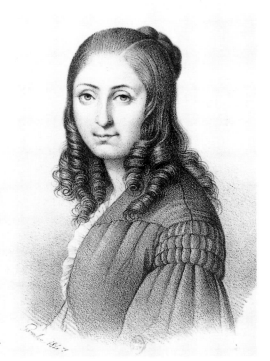

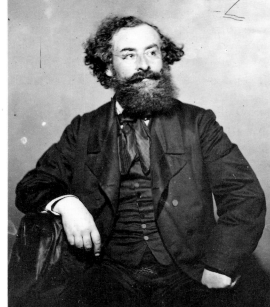

5. Gustave Arosa, photographed by Nadar.

in the Marquesas Islands, Clovis quarrelled incessantly with the ship's captain and ended up dying a short while later from a heart attack caused by a fit of rage, in a Patagonian monastery with the 'enchanting' name of *Port Famine*.

After the storms, agitation and tears of the journey, the bruised feelings of the infant were soothed by the warmth and the lazy luxury of their life in Lima, under the protective wing of the patriarch Don Pio Moscoso. For the first six years of his life, the future painter of Tahiti was pampered by exotic and adoring nannies, as was his somewhat puerile young mother—'My mother, amid all this, was a real spoiled child.' He astonished everyone with his independence and fearlessness. His child's memory became impregnated with vivid impressions of colours, odours, flavours and sounds. 'I have a remarkable visual memory and I remember those times, our house. . . . I can still see our little Negro maid, one of whose duties was to carry the little carpet on which we prayed to church' and 'our Chinese servant who ironed our linen so well.'[6] Small wonder that, once back in France, the lands across the seas would always seem a lost paradise to Gauguin. They stayed first in Orléans, then in Paris, in a cold and grey Europe where life was difficult for his mother, fallen on hard times again, and for him, brutally dragged back to the harsh realities of the French language and a school where everything was foreign to him and at which he inevitably became a bad pupil. For this aggressive, unhappy, out-of-place child, who had been a little king in Lima and was now treated as a dunce or worse, as humiliatingly mediocre in the 'humanities', there was only one recourse: to escape, if possible by sea. Lacking the qualifications for the Naval Academy, he embarked at age seventeen as a ship's apprentice aboard the *Luzitano*, bound for South America.

Apart from the occasional short stay with his mother in her villa at Saint-Cloud that abounded with reminders of Peru, he did not settle permanently in France until 1871, when he was twenty-three.

Through the good offices of Gustave Arosa's brother, a banker, and his son-in-law Calzado, a receiver on the Stock Exchange, the young man went to work the next year for Paul Bertin, a stockbroker in the Rue Lafitte. This rolling stone, who had been merely a common sailor a few months earlier, showed a surprising aptitude for the demands of the Stock Exchange. And it was a young broker full of promise that the pretty Danish girl Mette imagined she was marrying in 1873. She would reproach Gauguin for the rest of his life for having misled her as to his real identity, whereas all he had done was discover money and good manners, replace the girls in the ports with ones from good families, and begin to move in a circle which, surrounded with collections of paintings, was part bourgeois and part artistic. In any case, up to 1883 Gauguin was just an amiable Sunday painter, sufficiently gifted—though self-taught— and unsubversive enough to have a painting in the style of the Barbizon School, *Landscape at Viroflay*, accepted for the 1876 Salon, the same year, incidentally, in which Edouard Manet was refused.

Up to 1878, he painted still lifes and landscapes in the style of Corot or Jongkind, though his own distinctive style was gathering strength, as can be seen in the painting *The Seine at Iena Bridge*. A few months before he died Gauguin remembered, 'I lingered over Corot's nymphs dancing in the the sacred woods at Ville-d'Avray.'[7] But the Corot that inspired Gauguin must have been a Corot without nymphs.

In fact, the first nymph to inspire the man who was to celebrate the female body so magnificently in his paintings was a woman with tired flesh, Suzanne, a servant girl. His study of her was one of his rare naturalistic works, done at a time when literature was popularizing images of this kind.[8] The composition is rather flat and Gauguin filled the background with the paraphernalia that was to be one of the the hallmarks of the 'dauber' that he would become: the Algerian fabrics and particularly the mandolin, that traditional instrument found in studio fantasies which only the Cubists, thirty years later, would know how to use as a shape and not, as here, for its narrative content. As for the nude itself, it is powerfully painted with a naturalism that obviously pleased J. K. Huysmans, then a disciple of Zola's, when he reviewed the sixth Impressionist exhibition at which the painting was shown: 'I can safely say

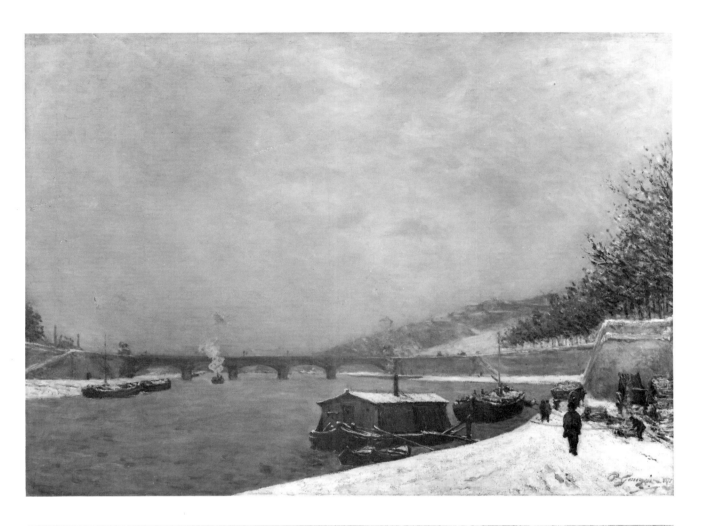

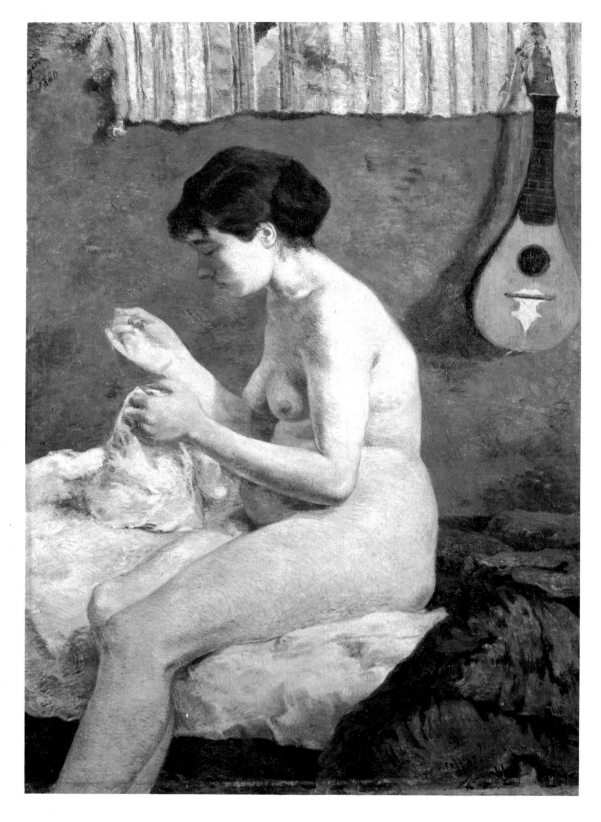

10. Camille Pissarro, *Madame Pissarro Sewing*, 1878. Oil on canvas, 16 x 11 cm. Oxford, Ashmolean Museum.

9. *Nude Study* or *Suzanne Sewing*, 1880. Oil on canvas, 115 x 80 cm. Copenhagen, Ny Carlsberg Glyptotek.

that amongst modern painters of the nude, not one has as yet struck such a realistic chord . . . she is a girl of our times, not showing off for the crowd, since she is neither wanton nor coy, but simply busy mending her togs.'[9]

A 1878 portrait of Mette, also sewing, shows the influence of Impressionism for the first time in its delicate colours, its luminosity and a grace more evocative of Berthe Morisot than Monet, though it would be another year before Paul Gauguin could be described as an 'Impressionist painter' according to the strictures laid down by Pissarro.

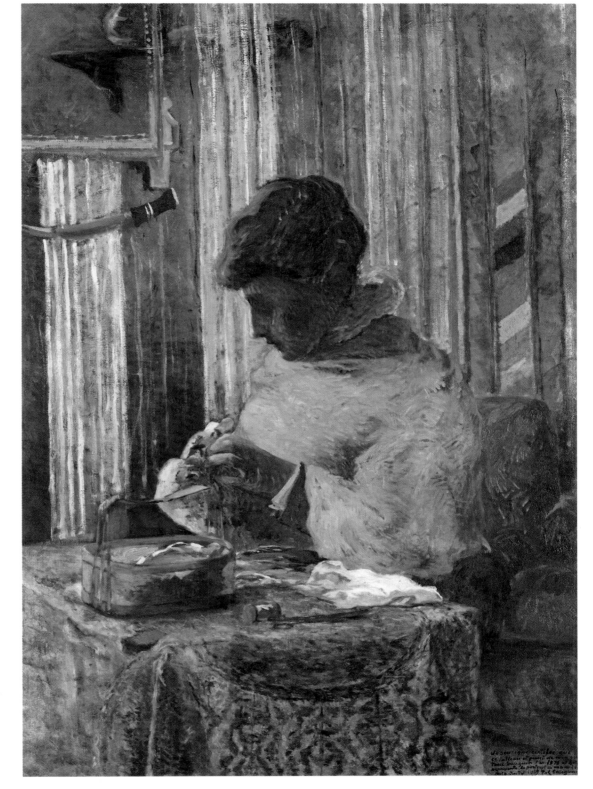

11. *Mette Sewing*, 1878? Oil on canvas, 116 x 81 cm. Zurich, Bührle Collection.

While still a beginner Gauguin set himself the perilous task of painting a figure against the light, and thus produced one of his best early works. The influences are obvious: Pissarro had painted a rather similar subject—a portrait of his wife sewing, with her head bent, beside a window (Fig. 10), and the overall atmosphere and technique are inspired by Degas. This homely scene in which Mette is still the pretty Danish girl he met and married in 1873, gave Gauguin the opportunity to make his colours shimmer in the tints of the silks in the work-box and on the table that Mette was using for her embroidery, it seems, rather than sewing, and in the wall-covering in the background, which might be wallpaper or a drawn curtain, but which already has an exotic air about it, reinforced by the scabbard—probably a Japanese sword—hanging below the painting. The mixture of opulence and Bohemianism in the setting reflects the kind of life Gauguin and Mette led at the time.

Gauguin had probably met Pissarro through Arosa as early as 1874, but he began to visit him regularly at Pontoise in 1879, to hear the wise words of a man who already cut the figure of a patriarch. He tried his hand at orchards and patches of farmland at different times of day, perhaps more in a spirit of dedication than pleasure, but his already formidable sureness of touch was no longer that of a Sunday painter.

Pissarro was quick to perceive this, and he lavished advice and encouragement on Gauguin, becoming the friend of a family that soon included one child, rapidly

12. *Gauguin by Pissarro and Pissarro by Gauguin*, 1883. Paris, Musée du Louvre, Department of Drawings.

followed by four more. During the time that Gauguin spent surrounded by the clamour of the Stock Exchange, Pissarro's patient goodwill replaced the academies and studios where he might have joined the other future stars of Post-Impressionism in their apprenticeship.[10] Much later, after many changes of style and reciprocal resentments, Gauguin rendered Pissarro the homage that was his due: 'If one looks at Pissarro's overall production, one realizes that, despite its fluctuations, it contains not only an extreme and utterly uncompromising artistic will, but an art that is essentially intuitive and highly bred. . . . He took a good look at everyone else, say you! And why not? Everyone took a good look at him too, but they refuse to admit it. He was one of my masters, and I do admit it.'[11]

Who were these other masters he was referring to? Apart from Corot and Jongkind, he obviously meant the Impressionists he discovered on his return to Paris. He began to follow their production closely, first in Arosa's collection, then in the modern art galleries which, as luck would have it, were then in Rue Lafitte, two steps away from the Stock Exchange. Not only that, but the great battles over Impressionism took place beween 1871, when he arrived in Paris, and 1879, when he first exhibited with the group, so Gauguin must have experienced these battles, either intimately or from the sidelines. At least it can be assumed that he did, since there is no certainty that he met Pissarro in 1874 through Gustave Arosa, whereas he certainly did see the celebrated first exhibition by the group that same year, held at the photographer Nadar's, a friend of Arosa's, and surely witnessed the fury that it unleashed in the press, who derisively dubbed the movement 'impressionist'.[12] The several years following the war of 1870 and the Commune were spent by these painters in making the adjective invented to ridicule them famous. They formed a group that was never again quite so united, often working together in those small towns dotting the Ile-de-France whose

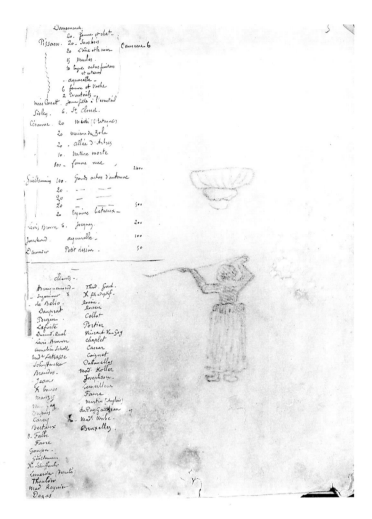

13. Photograph of Pissarro.

14. Gauguin, list of the paintings he owned, and of his own painting's admirers. Page from the *Album Briant*. Paris, Musée du Louvre, Department of Drawings.

names are now so well known— Argenteuil for Manet, Monet and Renoir, and Auvers-sur-Oise and Pontoise for Cézanne and Pissarro. It was a period that conclusively established the cohesiveness of the movement and the Impressionist style.

If, up to 1882, Gauguin was a stockbroker and speculator who 'did art' in his spare time, painting was nevertheless an indispensable part of his life, and he used his financial successes to assemble a collection that was almost exclusively Impressionist. It appears that he most admired paintings that possessed strength: sensuality such as Renoir's seems not to have attracted him while, on the other hand, he was one of the first to appreciate Cézanne. A few years later, on his return from a stay in Denmark, Gauguin made a list of his collection, which he had left behind with Mette in Copenhagen, writing in a little notebook that he owned nine Pissarros, one Mary Cassatt, a Sisley, five Guillaumins, one Jongkind, one Daumier, and five Cézannes that were, he said, 'the apple of my eye'.[13] They portrayed respectively *Zola's House at Médan*, *Mountains, L'Estaque*, *A Tree-lined Walk*, *The Harvest* and lastly a *Still-life, Fruit, Bowl, Glass, and Apples* which he was to later place in the background of one of his paintings and would often use as a source of inspiration.

As for his own painting, the ten years preceding 1884 were formative ones in which he made notable technical progress, but were relatively stagnant insofar as originality and personal discoveries were concerned, for he was fluctuating between two major influences, Pissarro and Degas.

From Pissarro, Gauguin learned a respect for nature, a sense of the humble crafts-manship required to portray the real, a distaste for the academic and the facile, and the recognition, new at the time, that the greatness of an artist is not necessarily tied to success. It is interesting that Pissarro also taught his pupil one of the principles that Gauguin was to develop later on, when he had moved into the very different field

of Symbolism: Nature should be re-created after observation, rather than simply reproduced. It is indeed a paradox that it should have been the kindly Pissarro who inculcated his student with the ideas which, taken to their extreme, would help Gauguin break free both from him and Impressionism—and yet, what advice do we find Pissarro giving his son Lucien, also a budding painter, during the period when Gauguin was most directly under his influence? 'The time will come when you will be amazed by the ease with which you remember forms and, curiously, the observations

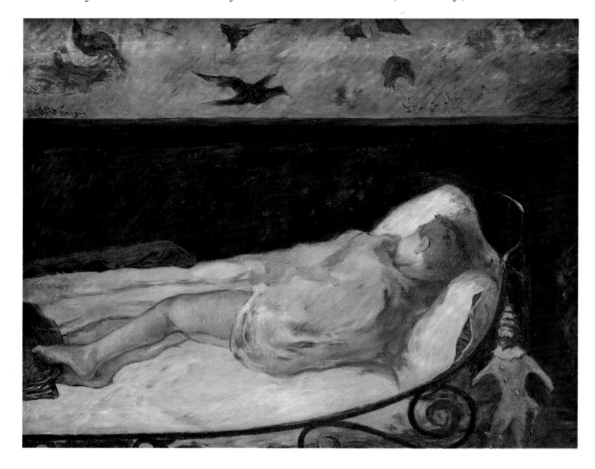

15. *Sleeping Child* (*The Little Dreamer, Study*), 1881. Oil on canvas, 54×73 cm. Copenhagen, Ordrupgaard Collection.

Interestingly, in the early years Gauguin's individuality came across far more in his paintings of interiors than in his landscapes, in which he was still very much under the influence of Pissarro's Impressionism. In this painting the composition and technique are wonderfully inventive and free.

This is probably the painting that Gauguin showed in the seventh Impressionist exhibition in 1882 under the title **The Little Dreamer, Study**. The little dreamer is his daughter Aline, aged four, his favourite, the one for whom he was to write his *Cahier pour Aline* in Tahiti, and who would die in Copenhagen before she was twenty without him having seen her again. Gauguin painted the little naked legs—holding a somewhat indeterminate object between their feet in her sleep—with great tenderness, but her almost shaven head is modelled without flattery. Because of this the subject was long thought to be one of her brothers. The red puppet hanging on the iron bed is the only detail—rare for Gauguin—that makes this almost a genre painting. And yet the dark background and the surprising horizontal band with its fantasy pictures (birds? flowers?) are perhaps the first in that long series of walls covered in enigmatic images in Gauguin's works such as his *Self-portrait* painted for Van Gogh (fig. 72), *La Belle Angèle* (fig. 115) or *Manau tupapau* (fig. 190), the Tahitian painting he would describe at length to this little girl some ten years later in **Cahier pour Aline**.

which you set down from memory will be infinitely more powerful and original than those taken directly from nature.'[14] The very day after this letter was written, Gauguin, a son by temporary adoption like so many of the apprentice-painters of the Impressionist period, visited the Pissarros at Osny. It is easy to imagine how often a concept that was to be so fundamental to the young artist's future growth might have been discussed during their interminable conversations about art.

Throughout this period Gauguin's work was oriented in two somewhat different directions, depending upon whether he was painting landscapes or still lifes. The landscapes, snow scenes and sparse copses through which the sky is visible, resemble paintings by Pissarro or occasionally Sisley in their treatment and in the immediacy of their content. His still lifes, interiors or portraits, on the other hand, are clearly influenced by Degas. Nudes like *Suzanne Sewing* and the portraits of children or women are worked in pastels in the same style that Degas was using at the time but, above all, the compositions of paintings such as *The Painter's Home, Rue Carcel, Sleeping Child* or *The Sculptor Aubé and his Son* are cropped in the abrupt and surprising way—probably borrowed from the Japanese—with which Degas had already achieved spectacular results. It was not Gauguin, incidentally, but Toulouse-Lautrec and Pierre Bonnard who would carry the plasticity and humour of this kind of composition to extremes some years later.

16. *Flowers, Still-life*, or *The Painter's Home, Rue Carcel*, 1881. Oil on canvas, 130×162 cm. Oslo, Nasjonalgalleriet.

Painted during the summer of 1881, this celebration of the conjugal life that Gauguin abandoned five years later was the most ambitious of his paintings of the period, in its format, the complexity of its composition and its subject matter.

One first sees the magnificent bunch of zinnias whose colours repeat those of the palette propped under the small wall cabinet, and which reminds one of course of Monet's bouquets, and even more of those by Degas, like *The Zinnias* in the Metropolitan Museum in New York. The rest of the composition, with its dark colours and cropped figures, appears to have been simultaneously influenced by Caillebotte and Degas. At the far end of

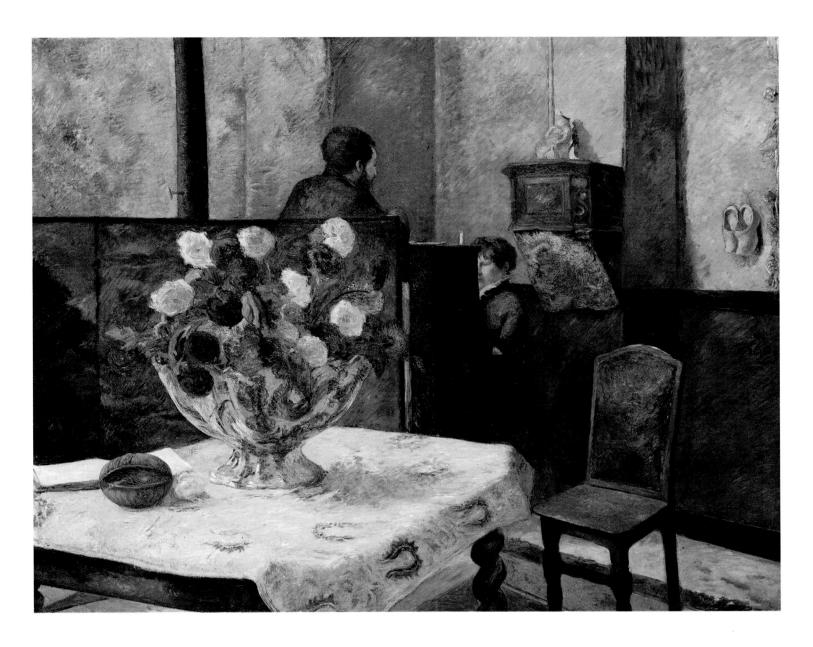

the room Mette Gauguin, glimpsed at the piano, seems to have just got up from her chair, leaving her work-basket on the table. The book or sketchbook beside it betrays Gauguin's presence and it is doubtless he who is listening to her play. Other objects in this bourgeois interior symbolize its inhabitants: the clogs on the wall and the edge of the Algerian wall-hanging next to them herald the 'primitive' and exotic aspirations of the husband, while the white porcelain figure above Mette was a popular allegory of the wife and mother.

Degas was one of the first and most loyal champions of Gauguin's painting. 'Your foot is in the stirrup,' he is reputed to have said to him at the time and, when Gauguin broke away from Pissarro, he turned towards Degas.[15]

This was not just for pictorial reasons. Degas, the member of the Impressionist group who was the most critical of authority, could not forgive Renoir, Sisley and Monet for compromising with the official Salon of 1882, which he saw as a betrayal. Always attracted to those who 'refused to get in line', Gauguin was impressed by his personality as much as by his talent, and the homage that he paid Degas in *Avant et Après* was above all for his indomitable independence.

Degas was a subtle painter of the vivacious with a reputation for 'spitefulness', but his correspondence in fact reveals tender and faithful friendships; Gauguin was a painter of the slow and immemorial who had an unerring ability to make himself hated for his brutality, clumsiness and what Jean Dolent indulgently called his 'legitimate productive egotism'. Nonetheless there was a sort of tacit understanding between these two men, coupled with a fatherly benevolence towards Gauguin on Degas's part that much amazed Pissarro and his contemporaries.

At a time when the entire artistic and literary intelligentsia of the *fin de siècle* was being politicized through its contact with anarchists and socialists, Gauguin discovered

17. *Sketch Inspired by Degas*, from *Album Briant*, Paris, Musée du Louvre, Department of Drawings.

18. *The Sculptor Aubé and his Son*, 1882, pastel on wove paper, 53×72 cm. Paris, Musée du Petit Palais.

This double portrait in pastel is very strange, for Gauguin juxtaposed the two sheets of paper in the frame while separating them with different backgrounds and false perspectives in the portraits themselves. The father and son do not really seem to be side by side, and the piece of pottery that links the two frames looks as though it had been added to make the drawing into a polite gift. Gauguin's treatment of the subject is also unusual, since the boy has been captured in a moment of intimacy as, unaware of his surroundings, he stares slightly short-sightedly at the pictures in the book, whereas the jovial-looking father has taken an 'artist's' pose for posterity. Jean-Paul Aubé (1837-1916) was an academic who achieved a degree of fame through the many monuments to illustrious men the Third Republic commissioned from him, the best known of which was one of Gambetta that used to stand in the courtyard of the Louvre (it has since been destroyed). It is doubtless his interest in the decorative arts that connected him to Gauguin. In fact at the time that this pastel was produced he furnished patterns to the Haviland Studios, and later to the ceramic artist Chaplet, with whom Gauguin would soon collaborate.

that Degas had opinions similar to his own. We find the same misanthropic traits in both of them, both hated the rise of the all-powerful nineteenth-century bourgeoisie, and they both loathed the slightly contemptuous and aristocratic scepticism of the 'right-wing anarchist' with equal passion—a fair indication of how untouched they were by the humanitarian concepts widespread among the artists of the times, whether socialist in tendency, as with Pissarro, or evangelical, as with Van Gogh. In these two divergent personalities and talents we find the same fierce individualism seemingly fueled by outside hostility, and the Gauguin to whom Strindberg said, 'Your personality delights in the antipathy it arouses',[16] resembles not a little the Degas who scolded a female friend for '. . . telling everyone that I'm not disagreeable and that they are mistaken about me! If you take that away from me, what will I have left?'[17]

Edouard Manet was another Impressionist who watched over the painter's dawning talent. His encouragement was precious to Gauguin: 'He once said to me, after having seen one of my paintings (I was just a beginner), that it was very good, to which I replied, overwhelmed with respect for the Master: Oh! But I am merely an amateur. . . . Not at all, said Manet, ". . . the only amateurs are those who paint badly." That was music to my ears. . . .'[18]

And yet Gauguin was to be an amateur for over ten years, from 1871 to 1883, at which date legend has it that he abandoned the Stock Exchange for Art under the impetus of his irresistible destiny. The truth is less clear-cut.

19. *The Painter's Family in the Garden, Rue Carcel*, 1882. Copenhagen, Ny Carlsberg Glyptotek.

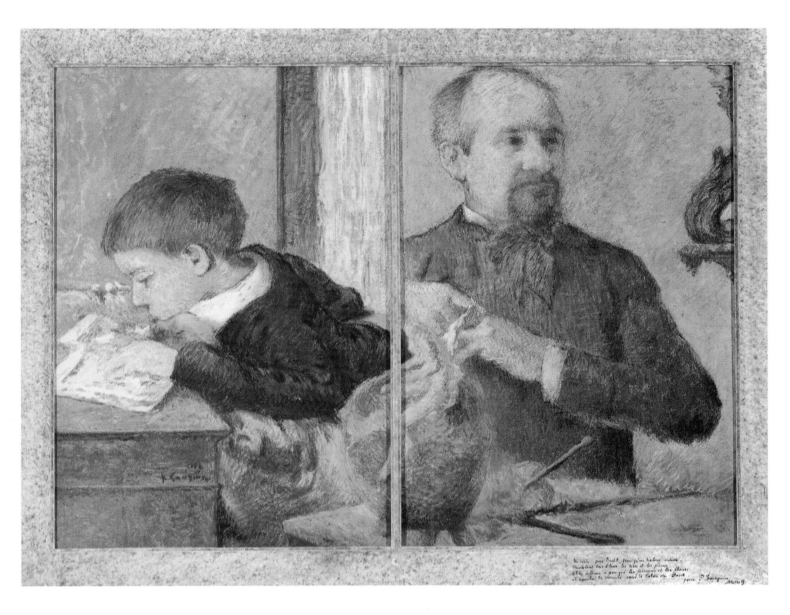

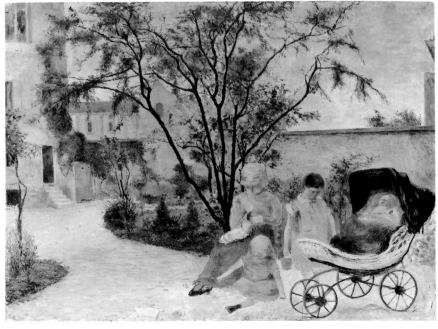

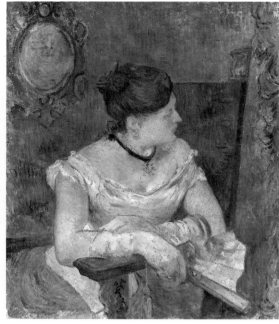

20. *Blue Roofs* (*Rouen*), 1884. Oil on canvas, 74×60 cm. Winterthur, Oskar Reinhart Collection.

21. *Mette Gauguin in Evening Dress*, 1884. Oil on canvas, 65×54 cm. Oslo, Nasjonalgalleriet.

One might wonder how a young man who was no more brilliant than any other and had no training of any kind, could find a job on the Stock Exchange in the first place. This is what happened to Gauguin, but it also happened to many other young people. Indeed not just Schuffenecker, a painter who became one of his most faithful companions, but Achille Granchi-Taylor, another artist whom Gauguin would meet at Pont-Aven, and two young writers who as yet could not live from their literature alone, Octave Mirbeau and Henry Becque, also made a living at it. How did the Stock Exchange become so privileged? Quite simply, there were no telephones before 1880, so brokers were essential, and no qualifications were required other than good manners, liveliness, a 'presentable' appearance, and the ability to recommend the more popular shares to the customers of the cafés that still surround the Paris Stock Exchange today.[19]

However, in 1880, besides the arrival of the telephone that was to do away with the most persuasive of go-betweens, the market began its vertiginous slide towards the 1882 Stock Market crash that eventually threw all these youngsters out onto the streets and eradicated any stocks or shares that Gauguin might have acquired. When Gauguin left for Rouen in 1883, he fondly imagined that painting would replace the facile deals that he had been used to. 'Decidedly, Gauguin worries me, he is too dreadful a businessman, especially at the business of worrying,' Pissarro commented in stupefaction at Gauguin's ignorance of the hard life that was indubitably in store for him. Still, what other attitude could Gauguin have taken to reassure that good little bourgeois mother of five, Mette, who was already getting hysterical about the professional developments in her husband's life?[20]

In any case, the fact that he had more time to give to his work did not immediately produce any changes in Gauguin's painting. Between Osny and Rouen, where he followed Pissarro—'That's it! He's taking Rouen by assault'—in the belief that life was cheaper and art lovers more numerous in that town, there are no obvious developments.[21] These would come later, beginning in 1885, the year of the real turning point in Gauguin's career, a turning point much greater than that of being forced to give up the security of the Stock Exchange.

22. *Mette Gauguin*, 1879. Marble. Paris, Musée d'Orsay.

Yet 1884 is a very interesting period. To begin with, Gauguin's colouring gradually became more muted, though Huysmans had already remarked with some surprise that a painting at the Impressionist exhibition of 1882 was 'dull and subdued'.[22] He also began to produce more and more sculpture, perhaps indicating a dissatisfaction, a need for something solid, something dark and mysterious even, which

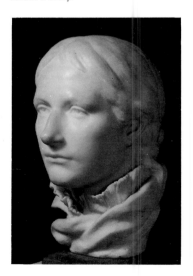

the dazzling limpidity of the Impressionists could not provide. As far back as 1879 Gauguin had produced portraits of Mette and his son, both in marble, with the help of the sculptor Brouillet, a neighbour, whose handiwork is as visible as their ostensible author's.

Gauguin demonstrated his taste for exotic art in the two Japanese netsukes he carved on a wooden box.[23] In this predilection he had been preceded by many, artists and otherwise, for Japanese art was then at the height of its popularity and a counter selling the grotesque porcelain figures produced for export alongside excellent popular prints had opened at the Bon Marché department store.[24] But his approach to Japanese art was much more original and less 'folksy' than that of most of his contemporaries. The Impressionists had admired the formalized world of the Japanese print from a distance, whereas for Gauguin there was a great lesson to be learned from the Japanese. Their tenet—which we still admire and try to follow even today—was that beauty belonged to everyday things, and not just to the *artist* whose works sneered down from their walls at the hideous domestic objects they had been dominating since the

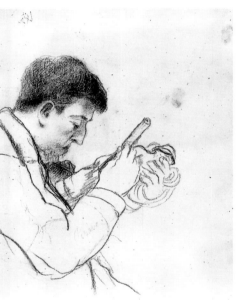

23. Camille Pissarro, *Gauguin Sculpting 'Woman on a Stroll or The Little Parisienne'.* Charcoal, 29.5×23 cm. Stockholm, Statens Kontsmuseer.

24. Decorated Wooden Box, exterior, 1884. Length 52 cm. Stockholm, Private Collection.

25. Decorated Wooden Box, interior, 1884. Length 52 cm. Stockholm, Private Collection.

Second Empire. Meanwhile there had already been attempts in England to close the gap between art and industrial production that was so glaring in Victorian art.

This kind of reaction was often the fruit of a backward-looking—even reactionary—philosophy that attempted to rediscover the fragrance of a lost 'nature', both in the art of living and in what are today called 'utilitarian objects', in the industrialized environment of Victorian England. The theoreticians who supported this move back to nature were Ruskin and the artists and craftsmen who in the second half of the nineteenth century strove to launch a new style based on anti-industrial concepts. The Pre-Raphaelites embodied this style for some, while others gathered round William Morris, and the designers at the Glasgow School, creators of the Arts and Crafts movement. Both groups contributed to what was soon called the 'Modern Style',[25] reviving ancient techniques, hand-blocking fabrics, engravings and posters and producing new designs in furniture and ornamentation.

In 1884 Gauguin was one of the first to point in the direction that Art Nouveau would follow in France. The year before he had echoed the spirit of the movement when he suggested to Pissarro that they might collaborate in producing 'Impressionist tapestries'. The project got no further but, ten years later, Aristide Maillol, an admirer of Gauguin's, took up his idea in the 'Nabi' style. If his plans to create tapestries, frescos or stained glass never came to fruition, we shall soon see Gauguin display his genius—and in the opinion of many contemporaries such as Odilon Redon, Eugène Carrière or Félix Fénéon, the very best of his genius—in another field belonging to what is called 'applied' art—ceramics.

In the meantime, Gauguin's painting revealed a new influence that was to have a profound effect on the development of his painting—that of Paul Cézanne.[26]

Three years earlier, in 1881, Gauguin had spent long periods in Pontoise with Pissarro and Cézanne during which he carefully observed Cézanne's method of painting. This was his last chance to do so, incidentally, for Cézanne retired almost definitively to Provence the following year. Cézanne was not impressed by Gauguin's admiring attentiveness, indeed he was somewhat irritated by it and later accused Gauguin of having 'nicked his little number' and 'hawked it round the Tropics.'[27] In fact Cézanne was not to play a fundamental role in Gauguin's evolution until two years later at Pont-Aven: *Still-life with an Iridescent Glass*, painted in 1884, yet so different from what he was producing at the time that one could almost believe it has been antedated, reveals all that Cézanne's painting gave Gauguin when he came to reject Pissarro's Impressionism. The composition of the jug, glass and apples is set down with a geometric solidity unknown in his previous work, and the much broader and simpler brushstrokes convey the shape of the objects rather than their lighting.

When Gauguin, in Rouen with his family, learned to his great dismay that paintings are not easy to sell, Mette decided that they should leave France and settle near her parents in Copenhagen. We know what this eight-month stay in Denmark from November 1884 meant for Gauguin through his correspondence with the tarpaulin wholesalers, Dillies & Co, whose local agent he became. As we read these sinister letters that Gauguin tried so hard to give a commercial tone,[28] we can see his anxiety

26. *Sleeping Child*, 1884. Oil on canvas, 46 × 55.5 cm. Josefowitz Collection.

The theme of the sleeping child appealed to Gauguin (see fig. 15) for it is obviously easier to paint a restless child asleep than awake, but Gauguin also displayed great tenderness in this depiction of the abandoned trustfulness of sleep. This sup-posedly 'unworthy' father was to suffer a great deal in his future wanderings because of the absence of his children. It is difficult to know which of his five offspring is portrayed here. The long blond hair leads one to think of Aline, his favourite, but in 1884 she was seven years old—and all the photographs show her with short hair. The child in this painting is nearer three or four. It is therefore either Clovis or Jean-René. The spot on which he laid his head is rather vague, but is probably a table covered with a thick cloth. The huge rustic tankard in brownish red wood, which Gauguin used in several paintings, makes the head and hands of the little boy appear even more delicate in comparison. The bright blue background, like the rest of the canvas, is painted with broken brushstrokes of pure colour in an Impressionist style, though we already see the exotic and mysterious floral motifs that Gauguin used throughout his life.

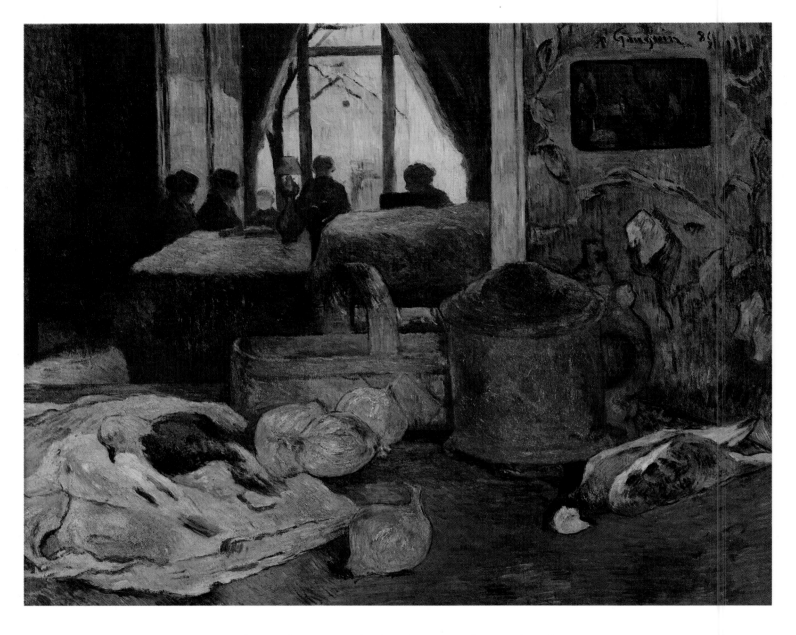

27. *Still-life in an Interior*, 1885. Oil on canvas, 60×74 cm. Switzerland, Private Collection.

and financial disaster grow on a day-to-day basis. His family-in-law despised and rejected him, Mette grew more and more bitter and the exhibition he attempted to hold at the art society in Copenhagen provoked such a scandal that it had to be hurriedly closed—though not on the very first day, as he claimed when he later exaggerated the event.[29]

Separated from Pissarro and Schuffenecker, cut off from the Parisian art circles that had been seething with excitement when he left, Gauguin clothed everything he had left behind in a kind of aura, perhaps even giving the ideas that he followed from afar when in Paris a sudden compelling reality. 'At times I feel I must be mad and yet, the more I think about it in bed at night, the more I believe myself to be right.'[30]

It could be said that this accumulation of setbacks in business and in his personal life explains Gauguin's later development at least as fully as the examination of a vocation that had so far been anything but all-consuming, and an art that as yet showed little genius. In fact he was about to enter into something resembling flight rather than a dark determination, that was to pitch him headlong into the life of an artist shunned by all. The dramatic events in his life—at least as much as any inner need—would direct his still unformed art towards an introspection and reflection that was a million miles away from the cheerful 'snapshots' of his Impressionist godparents.

28. *The Singer, Medallion*, or *Portrait of Valérie Roumi*, 1880. Mahogany with details added in plaster and touches of polychrome, diameter 54 cm. Copenhagen, Ny Carlsberg Glyptotek.

In his first relief in wood Gauguin mixed refinement, in the patinated wood modelling of the singer's face and neckline, and deliberate roughness, in the background and circular rim that show the marks of the gouge. The gold paint in the background and use of painted plaster for the bouquet of flowers is quite inventive. Both the mixture of techniques and the subject matter naturally remind one of Degas, whom Gauguin knew and greatly admired by then, but this traditional kind of medallion with a sculpted head had above all been brought back into fashion by romantic decorative and funerary sculpture.

We know that Gauguin was always interested in wood carving, though he actually started by sculpting marble—as in the portrait of his wife Mette (fig. 22). Here it is interesting to see his first attempt at a technique that he would use for his most beautiful bas-reliefs in Brittany and the South Seas, in his own interpretation of a classic subject of the 1880s, the 'Impressionist' *café-concert* scenes.

This piece was shown at the sixth Impressionist exhibition in 1881, where it attracted the attention of the naturalistic novelist J. K. Huysmans, who was unexpectedly 'reminded somewhat of the kind of woman adopted by Rops'—in other words a depraved *femme fatale*.

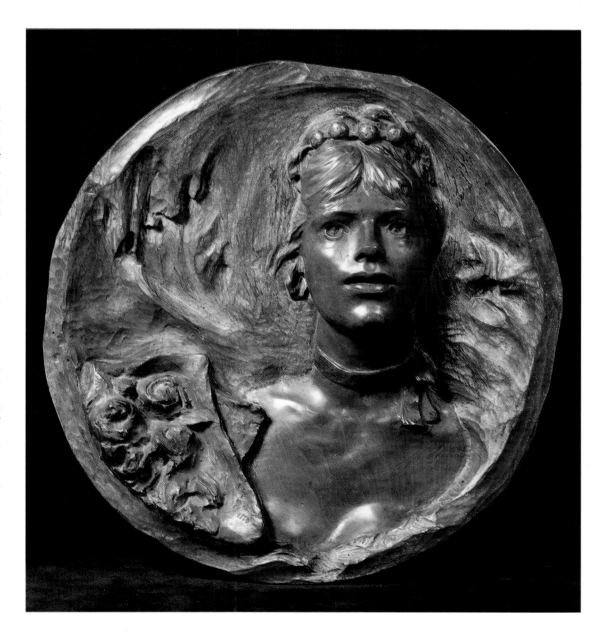

29. *In the Soup*, Drawing on Dillies & Co. letterhead, detail, 1885.

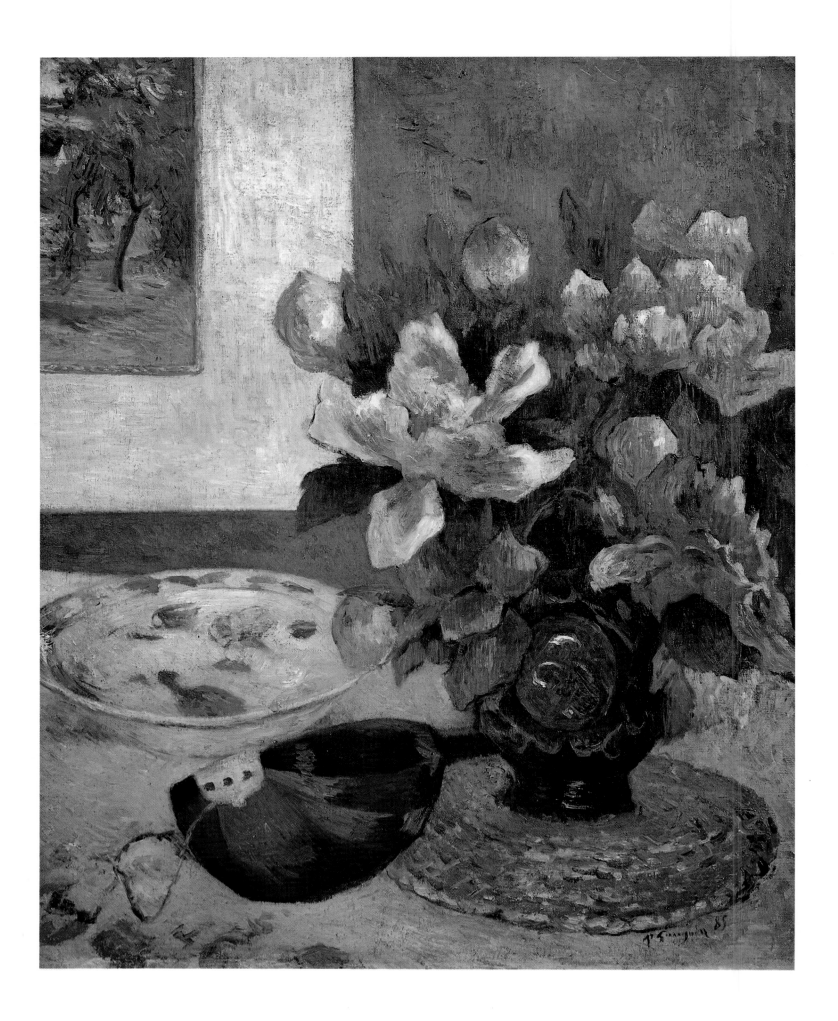

Gauguin was above all a painter of landscapes, nudes and portraits. This is perhaps the first really successful of his still lifes, which were almost always to mark a turning point in his career. It is not known exactly when or where this particular one was painted; the peonies indicate that it was June, the month in which he left Copenhagen for Paris. The broad white frame, fashionable among the 'modernistic' Impressionists of the 1880s, denotes ownership, but the 'picture within the picture' is a landscape that is difficult to identify (Pissarro? Gauguin? Guillaumin?). Whoever may have painted it, it illustrates Gauguin's tastes and is reminiscent of what he himself painted for years under the influence of Pissarro. The ceramic vase heralds his work with Chaplet the following year (figs 42-44) and the mandolin, which he actually played (and took with him to Tahiti) suggests his 'artistic' and independent nature and was his first portable bit of exoticism. It had already appeared in several paintings, in particular in *Suzanne Sewing* (fig. 9). However, what is more remarkable in the painting is his very personal, harmoniously warm and muted tones and the luxuriant opulence of the flowers against the blue background, which carry the seed of his future works.

2
THE FIRST JOURNEYS
1885-1887

The Dream! The Dream!
my friends!
let us set off
in pursuit of the Dream!

Les Déliquescences
d'Adoré Floupette,
1885.

While he was still in Copenhagen Gauguin had begun to recognize the importance of the artistic crisis that he was soon to share and live through in his own epic way. By the end of the century there was a general malaise in painting provoked by the Impressionist upheaval. Now, after their rejection of every academic value—the supremacy of the subject and its 'rendering', chiaroscuro, composition, drawing and modelling—in favour of a more original reality of feeling, Impressionism found itself at a dead end even before it was accepted by the public.

Monet, the purist, would be the only Impressionist to carry the experiment to its logical conclusion by painting visual sensations that were increasingly spare in a style that was more and more spontaneous and direct, thus giving them a new dimension that increased their meaning and 'the immediate data of consciousness'. By 1885 Renoir had already felt the need to get back to more severe delineations than those that coloured highlights alone could bring to a canvas, and adopted a style that has been called 'sharp' or 'Ingres-like'. Pissarro, still hesitant over which direction to take, became enthusiastic about the very young Seurat's technique in 1886, and turned himself into what he termed a 'scientific Impressionist', describing his former companions as 'Romantics' or 'tachists'. Only Cézanne, protected by the solid construction of his painting and by the modesty of his aims, escaped this wave of stylistic anxiety. It therefore will come as no surprise that it was to him that Gauguin turned in his disarray.

While in Copenhagen, Gauguin shared his thoughts with Schuffenecker, a friend and colleague from his earliest days with the Paul Bertin brokerage firm, who was also increasingly devoting himself to painting. A rather confused letter written in January 1885 that is essential to an understanding of the development of Gauguin's art, shows his preoccupations at the time.[1] He did not belong to the same self-confident generation as Seurat, Anquetin or Émile Bernard, who saw painting with a fresh eye and relegated the Impressionist way of seeing to the older generation. In 1885, unlike them, he was no longer under twenty-five, but older by ten years—ten long years of Impressionist experience. How was he to use his mind to go beyond impression or sensation

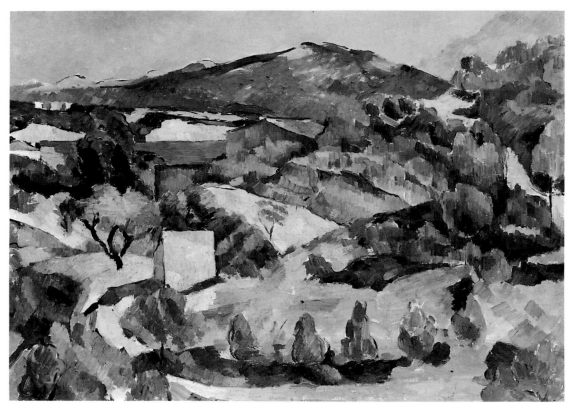

31. Paul Cézanne, *Mountains, L'Estaque*, c. 1883-1885. Cardiff, National Museum of Wales.

32. *Fan with Landscape after Cézanne*, 1885. Gouache, 28×57 cm. Copenhagen, Ny Carlsberg Glyptotek.

Like Pissarro, and Degas before him, Gauguin enjoyed painting fans—that were never used, incidentally—in gouache or watercolour. This fashion for fans shows the influence of Japanese art on French painters of the period, though there is nothing Japanese about this copy of a landscape by Cézanne (fig. 31) belonging to Gauguin, apart from its shape. He interpreted the painting freely, shamelessly adding a little house to the bottom right-hand corner to balance a composition that here spread in the shape of a fan. We know how much Gauguin admired the painter of Aix, though it was not reciprocal, and out of all the paintings in his collection he sold the Cézannes last, for they were, he said, 'the apple of my eye'. Most of Gauguin's fans were painted as gifts to artist friends or critics. The dedication on this one shows that it was given while he was in Copenhagen to the Danish painter Pietro Krohn, who had just been appointed stage director at the Royal Opera House.

without betraying the one through the other? He spoke of 'the misunderstood' Cézanne, who 'likes to give his forms mystery and the heavy repose of a man who has stretched himself out to dream' and whose 'colour is as solemn as the character of the Orientals'. He related handwriting to colour: the one reflecting the nature of its author, the other the forms in a painting. It is very moving to watch all Gauguin's future subjects—exoticism (Oriental in this case), the love of mystery, a symbolic treatment of form and colour, his admiration for Cézanne—appear chaotically throughout the letter, and to hear him speak of the 'heavy repose' that he had as yet been unable to convey in his own painting but which was to become his hallmark.

Lastly he discussed Neo-Platonic concepts such as the Golden Number or the meaning of lines and colours, which he wondered about with a vagueness that was at least equal to his passion: 'Our five senses reach our *brain directly*, bearing the imprint of an infinite number of things that no amount of education can destroy. I conclude from this that there are noble lines, deceitful lines, etc.; a narrow line leads to infinity and a curve curtails creativity, not to mention the fatality in some numbers—have the numbers 3 and 7 been sufficiently discussed?'

Indeed they had been discussed, like all the pictorial Symbolism in Paris at that time, but by a painter with an infinitely more methodic and reflective mind, Georges Seurat, and by young Symbolist writers such as Gustave Kahn and Félix Fénéon. They were also discussed by the aesthete and physiologist Charles Henry, the author of a scholarly *Introduction à une esthétique scientifique* that was published at the same time that Gauguin was musing about mathematical keys and absolute pictorial solutions in Copenhagen.

All these men searching for the means to go beyond Impressionism had a common pictorial and literary source: Eugène Delacroix, or rather, Delacroix as interpreted by Baudelaire. This Romantic painter was the ultimate master of colour for Gauguin as he was for Seurat, and as he had been for the young Cézanne. More than Monet or Renoir, he was the painter who truly understood how to use colour to express a

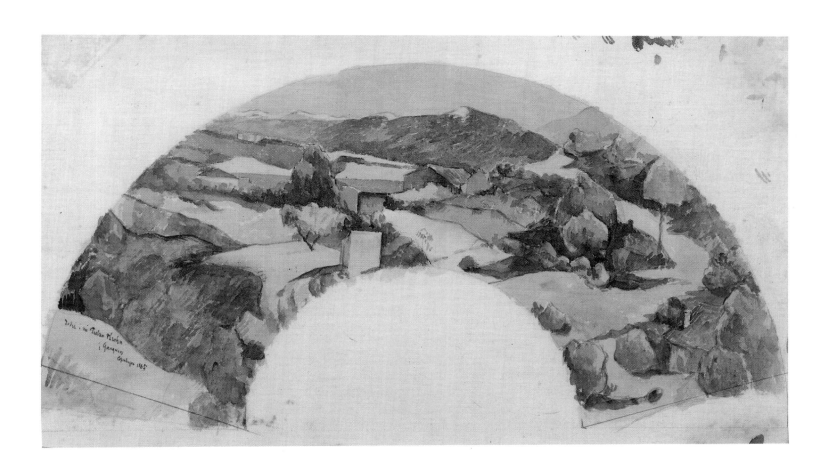

feeling or an idea rather than just the joys of a visual immediacy. Delacroix's *Journals* were not published until the end of the century, and Gauguin was still in Copenhagen at the time of the major Delacroix retrospective held at the École des Beaux-Arts, but, like everyone in the literary and artistic sphere into which Symbolism was being born, he had been an avid reader of Baudelaire, especially of the poet's quotes from Delacroix on colour. Gauguin repeated this almost word for word in his letter to Schuffenecker. 'There are devices that are noble and others that are ordinary, there are tranquil and immutable harmonies and then there are those that arouse you with their daring.' Baudelaire had written in his comments on Delacroix: 'Obviously a specific colour is placed in a particular spot in the painting to become the keynote that governs the rest. We all know that yellow, orange and red at once represent and inspire joy, richness, glory and love.'[2]

And yet, though he drew from the same sources and had similar concerns, Gauguin's position was already totally different from that of Seurat and his friends. These Neo-Impressionist painters and Symbolist poets shared a knowledge of the internal laws that governed sensations, and of the colours or shapes that symbolized them, that stemmed from their belief in science and progress. Here they were very much in tune with the materialism of the dawning century. Seurat believed that a work of art should incarnate a sort of universal harmony, just as science had done through its own means, and that, contrary to Impressionism (by then considered a rough draft of painting and an art that was subject to nature and sensation) the new painting should re-create nature. Painting should rediscover nature's style and not its appearance—a bit like classical theatre that reveals the eternal and the underlying truths in everyday life by condensing and stylizing them. Lastly, the ambition of these new painters was, in the words of Fénéon, to 'sacrifice the anecdote to the arabesque, the nomenclature to synthesis, the transient to the permanent', and to 'confer an authentic reality on Nature', for her 'precarious reality exhausts her in the end'.[3]

This definition intended to describe Seurat's painting, could, if the reference to the arabesque was not there, equally apply to Cézanne's work. Cézanne also sought the foundations of the formal structure and the internal dynamism of people and things that lay beneath their appearance, but he followed the path that led to Cubism and not, like Seurat and Signac, to Fauvism and Abstract art.

Cézanne, like Seurat, wanted to 'confer a reality on Nature' that would be stronger than the Impressionist one, which was all surface. By 1885 Gauguin also felt that his aim was not a representation of nature, however good, and he began to search for *something else, elsewhere*, without quite knowing what it might be. To begin with, Gauguin's approach was more sentimental and emotional than Cézanne's or Seurat's, and it is not surprising that harmonious relations developed between himself and the father of Expressionism, Vincent Van Gogh. But if the aesthetic ideas that Gauguin expressed with varying degrees of clarity were typical of the Symbolist beliefs of 1885-1886, he was already confusedly imbuing them with dreams that were his alone, through which he searched uncertainly for something eternal and obscure, for that very thing that, a few years later, he thought he could find more easily in distant lands. He had written to Schuffenecker that 'our five senses reach our brain directly, bearing the imprint of an infinite number of things that *no amount of education can destroy*'. To go beyond an Impressionism that he found insufficient, Seurat attempted to subordinate sensibility to an intelligence in painting that he termed scientific; Gauguin, on the other hand, once he had acquired the pictorial maturity he lacked when he wrote that sentence, set off on a quest that was as naïve as it was hopeless but, along the way, as he searched for the Rousseau-like Grail of a lost paradise of sensibility 'that no amount of education can destroy', he was to produce his most beautiful paintings.

It cannot be doubted that Baudelaire's writings were as instrumental in developing Gauguin's sensibilities during his period of gestation as they were in consolidating them later on, but what about his painting at this time? As we shall so often find with Gauguin, his production lagged behind his thinking, or rather, his intellectual pulsations. He would first choose, then half-perceive, then labour over; then, often with

33. *Two Girls Bathing*, 1887. Oil on canvas, 92×72 cm. Buenos Aires, Museo Nacional de Bellas Artes.

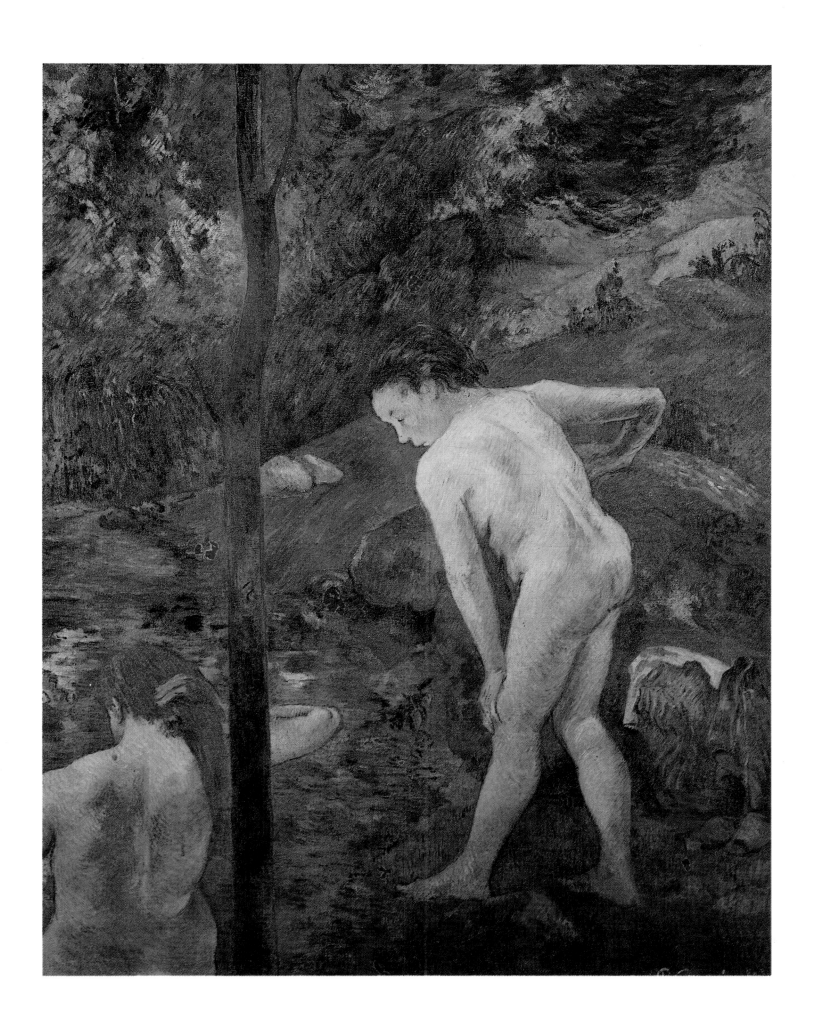

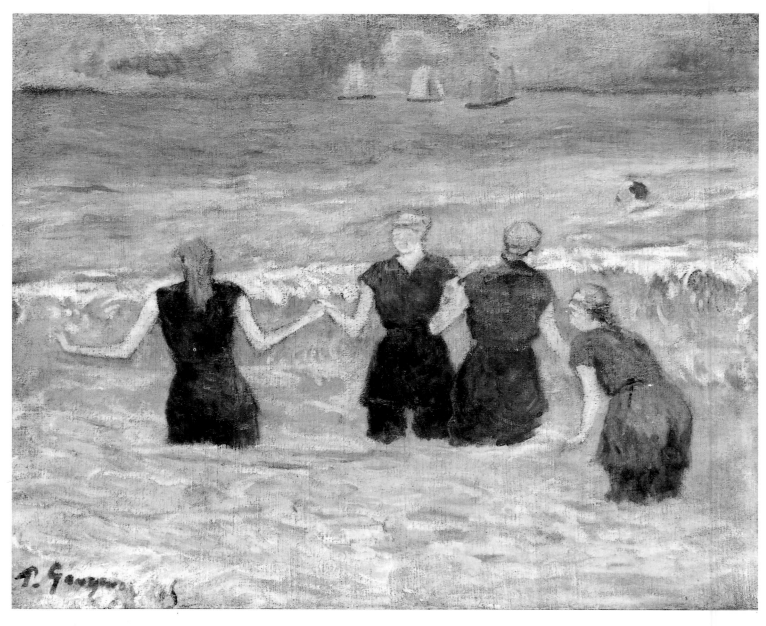

34. *Women Bathing* (Dieppe), 1885. Oil on canvas, 38×46 cm. Tokyo, National Museum of Western Art.

the help of one of his friends, he would at last find a form that was right for his idea. But this ultimate 'find' usually possessed a mastery and a power that was far superior to the paintings of those who had initially helped 'reveal' the work. When he was giving Schuffenecker the following advice, which so admirably describes what he would one day succeed in doing, 'A great emotion can be immediately transformed, dream about it, then try to find its simplest form,'[4] he was actually struggling with painful contradictions in style. He still clung to his Impressionist training, and was working slowly and painstakingly to develop it. He wrote to Pissarro from Copenhagen: 'Skies are very difficult in my new experiments. I try to keep them as simple as possible, and yet break them up with colour; I achieve this with brushstrokes that are barely crossed and end abruptly' and, a few weeks later he wrote: 'My Rouen series is a passing note rather than the foundation of what I perceived, by this I mean very matt painting, without obvious contrasts, but its drab side doesn't frighten me, for I felt I needed it.'[5]

He was not to bring to fulfilment what he had perceived either in Copenhagen—for he was soon to leave it, more or less driven out, it appears, by a family-in-law that was embarrassed by such a 'Bohemian' relative—or in Paris, where the worst period of his life, the autumn and winter of 1885-1886, awaited him.

36. *Cows at the Watering-place*, 1885. Oil on canvas, 81×65 cm. Milan, Civica Galleria d'Arte Moderna, Grassi Collection.

His letters to his wife from Paris, where he had also taken his son Clovis, show him to be both bitter and humbled, penniless, out of work and forced to survive on the sale of some paintings from his collection, among them a Renoir and a Pissarro. He had left some of these paintings in Copenhagen and he begged his wife not to sell the Cézannes—'one day they will be very valuable'[6]—or the Manet, or the Mary Cassatt. During a brief respite in Dieppe, he was commented on by the elegant painters surrounding Degas—Jacques-Émile Blanche, Albert Besnard and Paul César Helleu— who were to be immortalized by Marcel Proust in *A l'ombre des Jeunes Filles en fleurs*. The wretched Gauguin, uncouth, anxiety-ridden and an exhibitionist, was kept at a distance: 'No one with such an awkward appearance could possibly have any talent!' scoffed Helleu, while the painter Jacques-Émile Blanche, son of the well-known alienist, painted a disturbing portrait: 'His strange features, the extravagance of his attire, and a certain haggard look that my father has only too often pointed out as a sign of megalomania, led me to keep away from him.'[7]

While in Dieppe Gauguin painted a few canvases that looked like a return to Jongkind, a sort of regression from Impressionism, but he also produced an interesting painting, *Women Bathing*, in which we see a new departure—the flat treatment and the composition of the figures into a frieze of black bathing-suits and white arms, though somewhat clumsy, show a decisive decorative strength. However, it was not to be this canvas, but others of landscapes closer in style to Pissarro, that would represent Gauguin at the 1886 Impressionist exhibition in Paris.

This famous eighth—and last—exhibition by the group in May 1886 is generally considered to mark the end of Impressionism as a revolutionary movement and the beginning of what is called Post-Impressionism. Seurat exhibited *La Grande Jatte*, the painting that was his manifesto, and out of the confusion of opposing tendencies in the exhibition, two points stood out: the next step forward from Impressionism had been taken, and Gauguin, still a minor figure of the avant-garde, was working in its direction. The most brilliant and perceptive critic of the day, Félix Fénéon, immediately discerned the differences between Gauguin's work in 1886 and the Impressionist he had been up to then: 'Monsieur Gauguin's colours are very close to each other, which is what gives his paintings their muted harmony. Thick trees rise out of rich, fertile, damp soil and invade the frame, banishing the sky. The air is heavy. A glimpse of bricks suggests a house close by; some sheltering hides, some muzzles pushing the thickets aside [barely reveal] cows. The painter constantly opposes the russets of his roofs and animals to his greens.'[8] Fénéon's emphasis on Gauguin's experiments in colour was not too surprising. In the detailed reviews that he wrote of the exhibition, he also heralded the new technique of 'the scientific division of colour' that Seurat had used so masterfully in *La Grande Jatte*, and confirmed that this generation of dissident Impressionists, for whom their elders' unprecedented observation no longer sufficed, were consciously creating a new '*grand style*'.

Following his conversion to Seurat's methods, Pissarro joined the group composed of Signac, Angrand, Dubois-Pillet, etc. Gauguin was to make fun of their style much later, calling them 'these young chemists' and 'travellers in *petit point*', particularly in a still life—a caricature painted at Pont-Aven called *Ripipoint*—but at times he used their methods, even in Tahiti, to purely decorative ends.

In fact, though the pictorial methods that he eventually used were completely different from those of the Neo-Impressionists, Gauguin's technique evolved from a similar base. Fénéon noted an essential ingredient in Gauguin's colouring: the opposition of complementaries, as in the reds and greens he described. Gauguin did not achieve this complementary contrast through the multiple brushstrokes the Neo-Impressionists used, putting yellow dots next to blue ones in such a way that a spectator standing at the right distance from the painting saw a purer green than could be achieved by first mixing the two primary colours on a palette. On the contrary, he placed areas of colour side by side so that a green appeared greener beside its complementary red. Also, in remarking that 'Gauguin's colours are very close to each other,' the critic meant that the tone—or value—of each contrasting colour is the same; again contrary to the

35. Edgar Degas, *Peasant Girls Bathing*, 1875-1876. Oil on canvas, 65×81 cm. Private Collection.

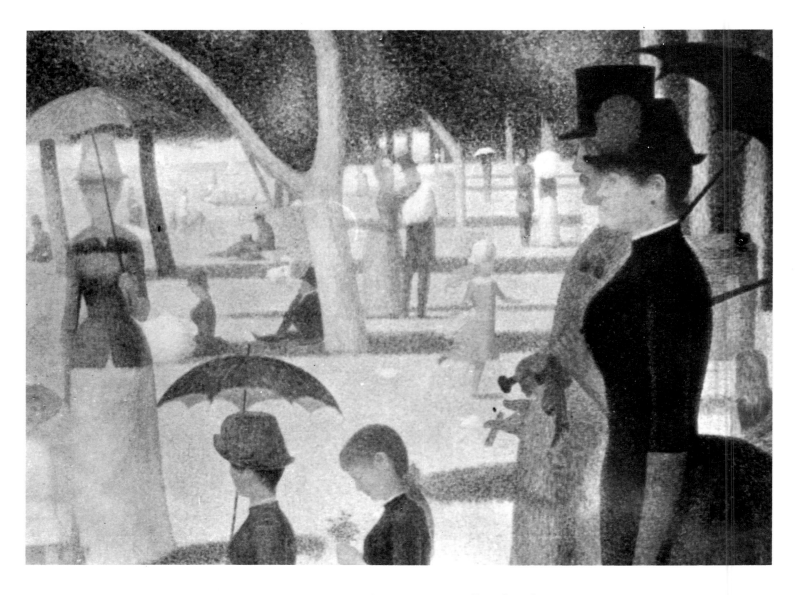

37. Georges Seurat, *A Sunday Afternoon at La Grande Jatte*, detail, 1886. Oil on canvas, 205.7×305.8 cm. Chicago, Art Institute.

Neo-Impressionists, who aimed for an unclouded and shimmering effect by alternating warm and cool colours. Gauguin kept to similar colours because he was making a still faltering attempt to express a more Symbolist unity, or 'musicality', instead of luminosity.

At maturity, therefore, Seurat's painting in 1886 and Gauguin's two years later was the result of a reaction against Impressionism which had led towards Symbolism. In Seurat, this Symbolism is rational and scientific, and reflects a reality that was intended to be eternal, hence the fixedness, the stiffness, the luminous haze and that 'immutable' aspect of his painting. Gauguin's Symbolism is infinitely more emotional and decorative, for he tried to express a kind of idealistic fervour through pattern and colour. Hence his obsession for the archaic, for periods when art was *inspired* and not produced for the sake of beauty alone, such as that of the Middle Ages or Ancient India and Egypt, or what is called 'primitive' art. Despite their dislike for each other, Seurat and Gauguin realized that they were in the same boat and Fénéon, whose tastes definitely inclined towards the austere intellectual art of the former, still objectively pointed out what the two painters had in common: 'The tachist technique, so right for painting evanescent visions, was abandoned around 1886 by a number of painters who wished to produce art that was synthesized and premeditated. While Mr Seurat, Mr Signac, Mr Pissarro and Mr Dubois-Pillet were actualizing this concept in paintings in which the episodic was abolished in favour of an orchestration that obeyed the laws of optical physics, and in which the personality of the author remained under the surface,

like Flaubert's in his books, Mr Paul Gauguin was working towards a similar end, but by different methods.'[9]

Before he cut himself off from them Gauguin saw a lot more of the Neo-Impressionists during 1886 than any of them later acknowledged. The intermediary in the friendships, especially with Seurat and Signac, was of course Pissarro, who was still very close to Gauguin. When he returned from Denmark Gauguin was in full intellectual spate and, as can be seen from his letter to Schuffenecker, eager to find the answers to all the pictorial questions he was asking, particularly how to support sensibility with a more solid structure. It was therefore quite natural, since his own art was still incomplete, to be interested in the solutions that Seurat and his friends had found, especially as they had even managed to 'convert' his master, Pissarro.

In a notebook kept sometime between 1884 and 1888, though it could probably be narrowed down to 1885-1886, he drew a wheel of complementary colours like Seurat's, below a paragraph in which he spoke of the 'infinite combinations in the play of colours when juxtaposed unmixed' and noted: 'So there is in fact a science of harmony? Yes.'[10] Meanwhile, an orientalist friend of the poet Gustave Kahn and the scholar Charles Henry, whose book on scientific aesthetics Seurat much admired, translated a Turkish text that made the rounds of artistic circles during 1886, in which Zumbul-Zadé analysed the ideas on painting of a certain 'Mani, giver of laws'. Seventeen years later Gauguin carefully copied an excerpt from it into *Avant et Après*, and a longer excerpt of the same section, copied out in his own hand, was found among Seurat's papers after his death. Who had been the first to read it and pass it on to the other? No one knows.[11] However, they were not interested in it for the same reasons. Seurat must have been particularly impressed by precepts of the following kind: 'Keep to the three colours indigo, red and yellow alone. With patience you will be able to make every colour out of them.' With patience—God knows he didn't lack that! Or again: 'Nothing is black or grey. What appears to be grey is made up of light nuances that a trained eye can distinguish.' But the next sentence applies to both the Seurat who painted *La Grande Jatte* and to the future Gauguin: 'Avoid a pose that is in movement. Every figure must be in a state of immobility.' At that time especially, Gauguin must have retained everything that presented him with an argument against Impressionist aesthetics, such as: 'It is better to paint from memory, thus your work will be your own and your sensations, your intelligence and your soul will outlive your spectator's eye,' and: 'In you, everything should breathe calm and the peace of your soul,' and above all this, which he was to quote frequently: 'Do not apply too fine a finish to your work, no first impression is lasting enough to survive the addition of minute details found afterwards, by doing so you cool the lava and turn boiling blood into a stone. Were the stone a ruby even, cast it away from yourself.'[12]

Gauguin fancied that this text dated from the age of Tamerlane, whereas in fact its author, who was better known to orientalists for his amorous writings than for his treatises on painting, did not die until 1809. But Gauguin was more than ready to find in an exotic text of this kind, one which he believed to be quite ancient, the teachings of a wisdom that he imagined was rooted in the darkness of the past.

However, it was not to be the East that provided Gauguin with the occasion for a departure that he saw more and more as a necessity. The first stop along the way to that 'authentic reality' behind the fleeting effects of the Impressionists had to be in a landscape that was less friendly and more favourable to mystery than the Ile-de-France so dear to Monet and Renoir. Where else could he find it other than in Brittany, the region of France most attached to its mythic past, the land of the last Druids, the last bastion against Rome and the French Revolution, a land that has chosen to remain archaic and whose very landscapes reflect a timeless geology with their sadness.

From the romantic era onwards Brittany had been a place of pilgrimage for writers and artists in search of inspiration, so in his desire to turn his back on a prosperous industrial society and throw off the yoke of Antiquity and Classicism imposed by the École des Beaux-Arts, Gauguin was understandably drawn to the utterly romantic land of Merlin's forest of Brocéliande and Chateaubriand's *René*. The all-powerful magnetism

38. *Seated Breton Woman*, 1886. Charcoal and pastel. Chicago, Art Institute.

of Brittany had just been celebrated by Renan, who was of Breton stock, in *Prière sur l'Acropole*, and it is no coincidence that, in the general malaise of the end of the nineteenth century, a book like Gustave Flaubert and Maxime du Camp's *Un voyage en Bretagne (Par·les champs et par les grèves)* was published in 1886, almost forty years after it was written.[13] In it they claimed to have rediscovered 'the human form in its original state of freedom, as it was when it was created on the first day of the universe', and the mournful wildness of a primitive land whose ancient Celtic past lingered in its sunken paths. In the summer of that same year Maurice Barrès sent the review *Voltaire* his impressions of a journey through Brittany where 'under a green sky of immeasurable softness one is led, in the evening, to love those nameless chapels, those melancholy grey stones'. For Barrès as for Gauguin, the grandeur of Brittany lay in that 'here, at last, the spirit of Gaul is not dulled by Latin dust'. Who knows whether he was not describing Gauguin and his friends when he wrote of those 'excellent Impressionist painters hunched over their paintings of the wild sadness of its wastes'.[14]

For Gauguin, this stay in Brittany was to be the first of the great journeys, though the reasons that led him to leave for Pont-Aven in that summer of 1886 were more prosaic—the romantic archaism that drew him to Brittany was coupled with some very practical considerations. After the miseries of his winter in Paris when, as a further disgrace, he had been forced to drag his son Clovis with him everywhere he went, he was told that he could live more cheaply in the Gloanec Inn in Pont-Aven which gave special terms to 'artists'. Pont-Aven has been immortalized by Gauguin, but at the time it was already the celebrated meeting-place for young painters from Julian and Cormon's academies and cosmopolitan artists, especially Americans, and soon became the haunt of Charles Cottet, a painter of 'genre' and Breton scenes. Thus, long

39. *The Breton Shepherdess*, 1886. Oil on canvas, 60×73 cm. Newcastle Upon Tyne, Laing Art Gallery.

From July 1886 Gauguin spent three months in Pont-Aven and, judging by the russet leaves, this bucolic scene must have been painted sometime in September. It is perhaps the best of the few landscapes that Gauguin painted during that period. Although it is still an Impressionist paint-

ing, his brushstrokes reveal more choppiness and swirls than in the past. Still, Gauguin returned to traditional techniques for its careful composition: the Breton girl, for instance, was painted from a large preparatory drawing (Paris, Musée des Arts Africains et Océaniens) in which he meticulously detailed the traditional Pont-Aven costume that he had just discovered. He also used it as a motif in his

famous *Four Breton Women* (fig. 40), in which we recognize the coif, the black bodice, and the embroidered slippers tucked into the wooden clogs like those he wore himself. His obvious enchantment by this gentle rusticity is revealed in the pose of the girl nonchalantly watching her flock, perched on the wall that separates two fields, one for the sheep on the left, the other for the cows on the right.

40. *Four Breton Women*, 1886. Oil on canvas, 72×91 cm. Munich, Bayerische Staatgemäldesammlungen.

41. *Still-life with Profile of Laval*, 1886. Oil on canvas, 46×38 cm. Josefowitz Collection.

before Gauguin's arrival, the village was populated with daubers in flowing neckties and Brittany had become a centre for the most conventional kind of 'tourist-artist', amongst whom we find Charles Laval and another escapee from the Stock Exchange, Granchi-Taylor. For all these painters, the Impressionism that Gauguin stood for still had an aura of scandal about it, and the prestige that accrued to him and his work because of it delighted him: 'I am considered the best painter in Pont-Aven.'[15]

Two canvases show the direction his painting was taking particularly well: *Four Breton Women* and *Still-life with Profile of Laval*. In the first, so similiar to what he would produce two years later that it has often been believed to be antedated, Gauguin developed the theme of the *Women Bathing* painted in Dieppe even more decoratively, confidently using the stiff collars and caps to give the painting its rhythm. Despite the light fretwork of his brushstrokes that harks back to Pissarro, his use of arabesques makes it obvious that he painted from preliminary sketches for the work, although the bulk of it was certainly done out of doors 'from life', in obedience to the precepts of his kindly ex-teacher. The composition of the still life, on the other hand, is very odd in the way the profile enters the frame of the work, and recalls Bonnard. This rather Japanese choice is all the more striking because throughout the rest of the composition, with its carefully constructed background and the apples placed so solidly on the white table-cloth, he treated space in the manner of Cézanne. There is another component that was new for Gauguin: the centre of the table is filled with a strangely shaped object, apparently made out of terracotta. It was in fact a pot made by Gauguin himself in which one can see a definite tendency towards primitive art.[16]

Gauguin was very interested in ceramics at the time. Apart from the arguments that he used with Mette, insisting that 'it could become quite lucrative',[17] there are other conceivable reasons why he chose this art-form. In his possibly still unconscious search for the means to convey a primeval feeling that was outside time or history, he drew pottery from the recesses of his mind, for it most reminded him of the

For many reasons this little painting is one of the most exceptional among Gauguin's early works. To begin with there is the surprising Japanese-style composition that crops the profile of the young painter Laval, his first companion in Pont-Aven in the summer of 1886, who was to go to Martinique with him. The little glasses and the goatee, and the way the profile enters the frame against the light, are curiously evocative of Bonnard—both of his face and his 'Nabi' paintings of the 1890s. The strange way in which the face intrudes on the still life from behind the table leads one to suspect that Gauguin added it as an afterthought a year or two later. Laval appears to be fascinated by the fruit, or perhaps is breathing in their perfume with closed eyes.

In any case, the still life itself seems to project into the future with its exotic apples that come close to being mangoes and the primitive pot—most likely one of Gauguin's own that has since disappeared—that would have been a forerunner of the ceramics he was to produce at Chaplet's studios in 1886, in its inspiration by Peruvian pottery. It presages some of his most beautiful potteries of 1887-1889.

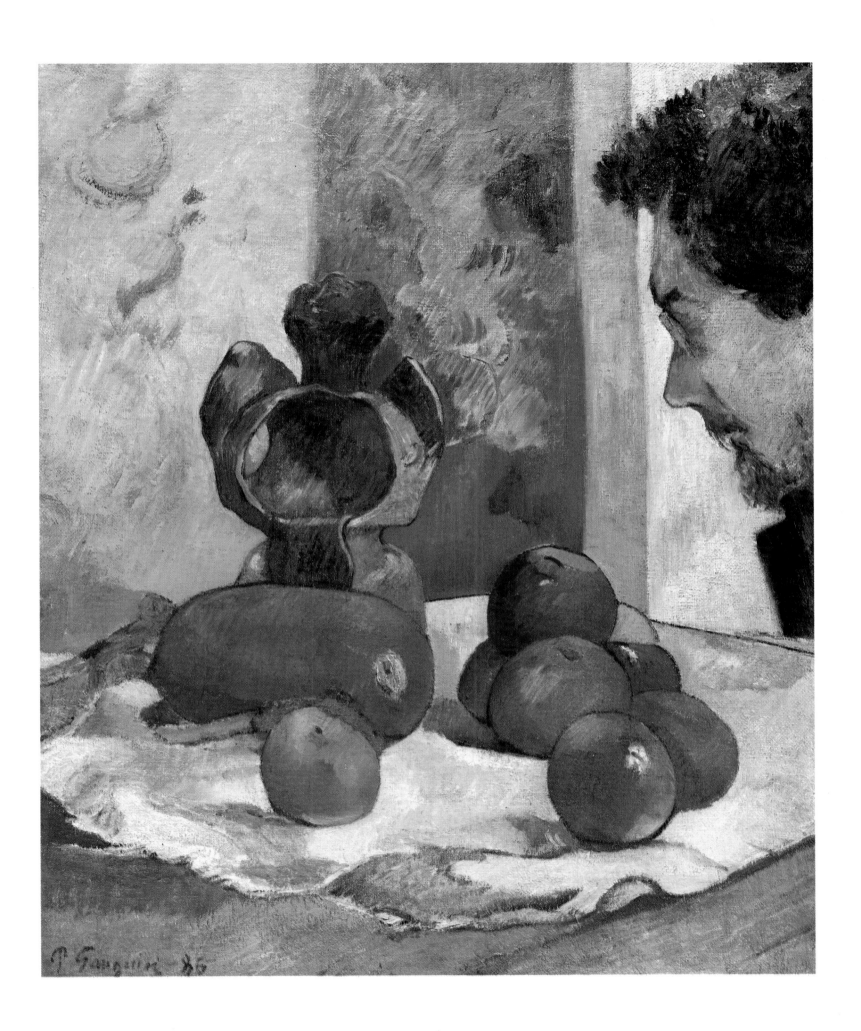

P. Gauguin 86

enchantment and exoticism of his childhood in Peru. His mother had brought back a wonderful collection from Lima that she took with her from Orléans to Saint-Cloud, and this formed part of his childhood background. It was lost when their home was burned down during the 1870 revolution. He had undoubtedly read the book that his protector, Gustave Arosa, had provided illustrations for, the great *Histoire de la céramique* by A. Demnish, published in 1865. The year before in Denmark, he might have come across some of those excellent Danish potters, like Philipsen, Bindesbøll or Skovgaard, who played such an important part in the revival of the 'applied arts'.[18]

Gauguin was one of the first painters to refuse a hierarchy of artistic values, paving the way for the Nabis and Toulouse-Lautrec in the 1890s, when they put the best of themselves into illustration, poster art, typographical experiments and theatre sets. In 1881 Gauguin carved furniture and ornaments for his home, in 1883 he wanted to make tapestries and in the winter of 1886-1887 he produced no less than fifty-five ceramic pieces.[19]

Gauguin had always been attracted by sculpture and pottery, arts in which the physical imprint of the personality is more direct and spontaneous than in painting. A childhood artistic effort had been the beginnings of a piece of scupture: '. . .Using a knife, I was carving the handles of daggers without the daggers themselves. . . . A good-natured old woman whom we knew cried admiringly: "He is going to be a great sculptor!"[20] One of Pissarro's earliest drawings of Gauguin shows him absorbed in the carving of one of his first sculptures in wood, *The Little Parisienne,* which was heavily influenced by Degas.[21]

During the winter of 1886 Ernest Chaplet let Gauguin share his studios and kiln on the recommendation of their mutual friend, the engraver Bracquemond. At the time, especially at Sèvres, the applied arts revelled in the worst kind of eighteenth-century or Chinese pastiches. Three years later Gauguin wrote amusingly: 'Sèvres of the hallowed name has killed ceramics. Nobody wants the stuff and, when a Kanaka ambassador arrives, wham! they burden him with a vase. . . . Everyone knows this, but Sèvres is untouchable, it is the glory of France.'[22] The only worthwhile ceramic artist of the

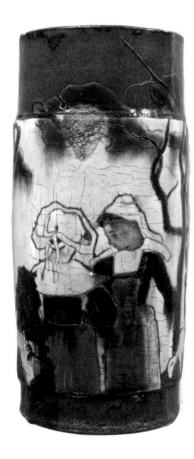 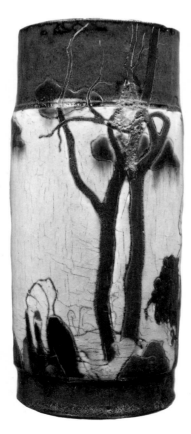 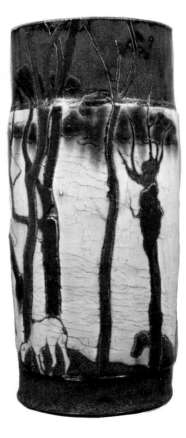

42. 43. 44. Three views of the *Vase Decorated With Breton Scenes,* by Chaplet and Gauguin, 1886-1887. Glazed stoneware, Brussels, Musées Royaux d'Art et d'Histoire.

period was Ernest Chaplet, who had achieved a very pure style by returning to the shapes of peasant stoneware, while borrowing the technical refinements of the Far East. Gauguin admired him greatly and called him 'the equal of the Chinese'.[23]

Usually, when a sculptor designed a ceramic or porcelain piece, he provided a pattern to be manufactured by a craftsman. Gauguin, in contrast, placed more importance on ceramics, bolstered by the decorative and industrial ideas then being developed in England by William Morris. 'Beauty will always find a place,' Gauguin wrote. '. . . Manufacturers, no more feeble excuses, get to work and above all employ *artists* and not workmen.' He was not carried away by a humanitarian desire to beautify everyone's lives in a time of mass-produced ugliness, but was rather trying to find employment for artists by persuading industrialists that a new kind of patronage could be profitable for them, and that it was still possible to have a collusion 'between the artist and the powerful—which nowadays means the rich. Beauty will always find a place,' he continued, 'especially today when the wealthy want to show off their fortunes. We see marvels in Cluny—who do you think they are made for if not for the privileged classes rather than the masses?'[24] One senses here everything that stood between Gauguin and a man like Pissarro, and everything that distanced him from the fervent English renovators of the Arts and Crafts movement. For them, the artist had to serve craftsmanship, whereas for Gauguin craftsmanship was another means of expressing his artistic temperament. He would certainly not have imitated William Morris and designed wallpapers for mechanical reproduction! Where could this artistic temperament find a better vehicle for expression than in the noblest and most primitive medium of them all, earth? 'Ceramics are not a waste of time. . . . As far back as man can remember, this art was favoured by the American Indians. God made man out of a little bit of clay. With a little bit of clay one can make metals and precious stones, with a little bit of clay and a little bit of genius, of course!'[25] Indeed, in 1886, at his first attempt, Gauguin produced several pieces of a ruggedness and strength that he had as yet not been able to put into his painting. His contemporaries were immediately reminded of exotic art, as Pissarro wrote to his son Lucien: '[Bracquemond] gave me

45. *Jardinière Decorated with Motifs from The Breton Shepherdess and The Toilette,* 'The Toilette', 1886-1887. Stoneware decorated with barbotine. Paris, Private Collection.

46. Ceramic Vase decorated with a Dancer by Degas, 1886-1887. Copenhagen, Museum of Decorative Art.

47. Ceramic Vase decorated with a Breton Woman, 1886-1887. Copenhagen, Museum of Decorative Art.

the impression that he was saying it was a sailor's art, picked up from all over the place.'[26]

Picked up from all over the place it was, but not as souvenirs of a world tour, as Bracquemond scornfully thought. The pots in the shape of a head, or those where the handle forms a bridge between the double lip, or those conglomerations of several vases stuck to a single handle/spout, were all derived from Peruvian pottery, but the feverishness of the modelling and their provocative, unfinished quality actually bring them closer to the suggestive aesthetics of Impressionism. Gauguin's pottery, despite his insistence that it was 'primitive'—for where in the world can one find pottery that is more lovingly polished than primitive pottery?—is more like the sculptures of contemporaries such as Medardo Rosso or perhaps Rodin, rough-hewn works marked by the inchoate imprint of their author's will. He himself described his ceramics as the 'little products of my grand delusions'.[27] Some of his pots with their swollen, budding shapes, covered in plant-like protuberances, reveal a sensitivity to nature that augurs the Art Nouveau style that Gaudi in Barcelona and Guimard in Paris were to develop some years later in their architectural ornamentation. At the same time Gauguin frequently applied motifs from the Impressionists onto shapes that recall Chinese or Peruvian pottery, such as a dancer copied from Degas, a Breton girl, a shepherd, a sheep or a gaggle of geese taken from his own or Pissarro's painting.

After his return from Denmark, Gauguin had again been confronted with the artistic effervescence of Paris, where he had lived in poverty and felt himself to be, so to speak, pictorially isolated. He had then gone to Brittany and worked in his new medium of ceramics but, despite his undeniable achievements, he was far from attaining his hoped-for maturity. In the naïve but often well-founded belief that new surroundings would foster the artistic maturity that he lacked, and well aware of both the indecisive nature of his future and of his style, 'to leave' had by now become his last resort. So 1887 was to witness his first journey to the Tropics.

Where he would actually go was not immediately clear. First of all he wanted to 'go to America' and 'flee Paris, which is a desert for the poor man'.[28] Signs of that compensatory tendency towards megalomania that Jacques-Émile Blanche had noticed are visible in the self-aggrandizement that grew embarrassingly and dangerously amid the disappointments of his life and the overall indifference to his work. 'My fame as an artist is growing every day,' he cried, and the business to which he had been rather evasively promised the directorship grew to fabulous proportions: 'Recognizing my energy and my intelligence, they desperately wanted me to go there.'[29] He finally decided to go to Panama where Juan Uribe, his sister's husband, ran some vague business concern. Gauguin's fantasies of the Tropics immediately became real, for they answered the prayers both of the man and the painter to get back to the source, regardless of whether it was his childhood or the origins of humanity. 'I am going to Panama to live *in the wild*, I know of a little island (Taboga) a league across the sea from Panama, in the Pacific, which is hardly inhabited, free and fertile. I am taking my brushes and paints with me and I shall plunge into work once more, far away from mankind.'[30]

And yet Gauguin the painter was already isolated. The evolution of his painter friends during the winter of 1886-1887 had contributed not a little to this. After Pissarro became a rabid 'scientific painter', the style of Seurat and Signac had had a fleeting influence on painters such as Anquetin, Schuffenecker, already a close friend of Gauguin's, and Émile Bernard who was to become so a year later. In addition, a quarrel had poisoned relations between Seurat, Signac and Gauguin the previous summer. Signac had gone to Les Andelys, lending Gauguin his studio in Avenue Clichy. Not realizing this, Seurat happened to be there one day and brutally stopped Gauguin from entering, which Gauguin naturally took very badly.[31]

Not much is known about his encounter that winter with a young artist who had just arrived in Paris and was dazzled by Impressionism and Neo-Impressionism, whose name was Vincent Van Gogh. Gauguin made no mention of it at the time, and probably paid him no more attention than he paid Émile Bernard, whom he had met the summer before in Pont-Aven, or any other new acquaintance. He must have been

48. *Head of a Martinique Woman*, 1887. Pastel, 36×27 cm. Amsterdam, Vincent Van Gogh Foundation, National Museum Vincent Van Gogh.

This handsome pastel is one of the rare works done on paper during his stay in Martinique (June-October 1887). The young West Indian woman coquettishly sports a Madras cotton headdress, and Gauguin emphasized the gold earring in the centre of the drawing. The fruit she is carrying reminds one of Gauguin's description: 'There is no lack of Potiphar's wives. Almost all of them range from the darkest ebony to the matt white of the Maoris, and they even go so far as to put spells on the fruit they give you in order to entrap you. The day before yesterday a young negress of 16 (goodness, she was pretty!) brought me a guava that had been cut and flattened at the end. I was about to eat it. . .' but he was told: 'the fruit is bewitched, the girl has crushed it against her bosom and you will be absolutely in her hands after eating it' (to Mette, 20 June 1887).

Theo Van Gogh bought this drawing and both brothers much appreciated his Martinique period. Theo had bought two other paintings from Martinique, both now with this one at the Van Gogh Museum. It is worth noting that Vincent Van Gogh had compared Gauguin's Martinique paintings with *La Description d'Otahiti* by Pierre Loti in a letter to his sister of 3 July 1888, and that it was he who gave Gauguin the idea of going to the South Seas: this young Martinique woman is therefore the first in the long line of exotic beauties painted by Gauguin.

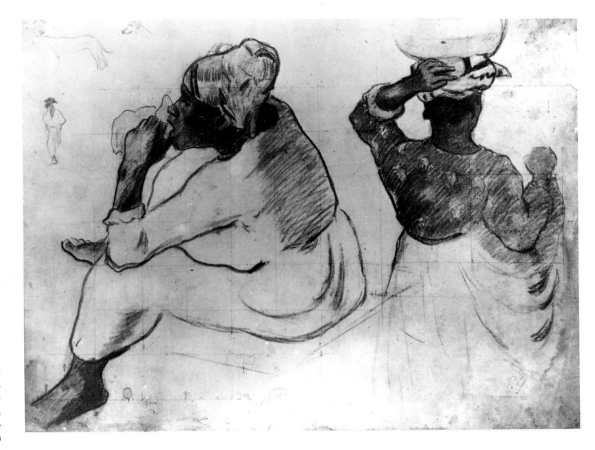

49. *Two Women from Martinique*, 1887. Drawing, Paris, Musée des Arts Africains et Océaniens.

50. *Les Cigales et les fourmis, Memories of Martinique.* Zincography. Paris, Bibliothèque d'Art et d'Archéologie.

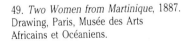

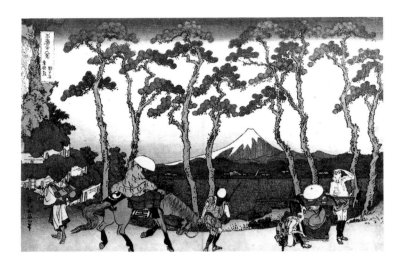

51. Hokusai, *Hodogaya on the Road to Tokaido*, 1825-1832. Print from the *Thirty-six Views of Mount Fuji.* Paris, Huguette Berès Collection.

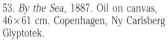

53. *By the Sea*, 1887. Oil on canvas, 46×61 cm. Copenhagen, Ny Carlsberg Glyptotek.

The composition of this landscape in Martinique is very Japanese and its similarity with one of Hiroshige's prints from the *Thirty-six Views of Mount Fuji* was noted by art historians a long time ago. In it the local volcano, Mount Pelée, is half obscured by clouds and one can just see the town of Saint-Pierre in the top right corner. The unusual brightness of the blue of the sea under a leaden sky accentuates the vivid silhouettes of the line of Martinique women: 'What I find most enchanting are the figures and every day there is a continual coming and going of negresses decked out in colourful finery with infinitely varied graceful movements. . . carrying heavy loads on their heads, they chatter endlessly' (to Schuffenecker).

Gauguin was to keep his sense of wonder at this scene, for he later produced a superb zincography, *Les Cigales et les fourmis* (fig. 50) on the same subject, in which he concentrated on the women. The cicadas here are the two women squatting in the foreground gossiping, and the ants are the ones carrying their loads on their heads whose 'gestures are very characteristic, and their hands play a large role in harmony with the swaying of their hips' (to Schuffenecker, July 1887).

52. *Conversation in the Tropics*, 1887. Oil on canvas, 61×76 cm. Private Collection.

aware, however, of Van Gogh's instant passionate admiration for him, and he is doubtless one of those Gauguin was referring to when he wrote to Mette: 'Ask Schuffenecker what the other painters think of my work.'[32]

Finally, after Mette made a short stay in Paris where she had come to collect their son and choose paintings that might be saleable in Denmark from amongst her husband's works, Gauguin left for Panama, taking with him his faithful friend from Pont-Aven, Charles Laval. The Island of Taboga and the South American brother-in-law were equally disappointing, so they decided to leave for Martinique and, to earn the money for the passage and their stay, they both worked on the building of the canal. It was a disastrous experience in which the fevers were higher than the pay, though they did end up with just enough to make their way to Martinique. It was here, for the first time, that Gauguin set up his studio in a native hut, amid the kind of mythic surroundings that he was to immortalize a few years later.

During their stay, Laval and Gauguin's paintings became so similar that many of Laval's canvases have been attributed to the greater of the two with the injustice of posthumous celebrity. Partly because of the doubt into which this threw collectors, Gauguin's work of this period was unjustly deprecated for quite some time. Compared to what he was to produce later, the paintings from Martinique are almost rough drafts for the Tahitian ones. And yet, though they have neither the brilliance nor the force of the later work, these landscapes of aubergine-coloured soil spotted with light blue and damp shady undergrowth in which one half-perceives a black face or some red fruit, have a lightness of touch and a sense of poetry that disappeared in the self-confident strength of his later paintings. The violence of his attacks on Pointillism is belied by the presence of details that are treated with dots of complementary colours and by his systematic use of the red-green contrast even in larger spreads of colour.

In Paris, among the painters like Van Gogh who admired what Gauguin had brought back with him, there was one whose style was perhaps fundamentally altered by it, though, interestingly, not in the ensuing ten years, but in the works of his maturity. This was Pierre Bonnard. Gauguin's range of colours, the lightness of his contours, hesitant, even soft; the sweetness and sensuality inherited from Impressionist sensibility in these paintings from Martinique recall some of the landscapes of the Ile-de-France or the Mediterranean that Bonnard painted between the wars.

By the time of the famous exhibition at the Café Volpini in 1889, the sensitive and silent twenty-two-year-old Bonnard was already more drawn to Gauguin's painterly side than to the 'novelties' of Sythetism and Symbolism that were nonetheless to be major factors in his Nabi style of the 1890s. Indeed, the pictorial formulas that Gauguin would soon work out with Émile Bernard in Pont-Aven were to be as essential for Bonnard as they were for Vuillard, Maurice Denis or Maillol and, more generally, for all painting by the end of the century.

55. *Tropical Vegetation*, 1887. Oil on canvas, 116×89 cm. Edinburgh, National Galleries of Scotland.

Laval (figs 41 & 54) accompanied Gauguin on his first painting journey to the Tropics. The rare works from this period, which lasted from June to October 1897, are all marked by his rapture at the splendours of nature. 'We have been in Martinique, the land of the Creole Gods, for three weeks. To tell you the truth, we are staying two kilometres from the town in a negro hut on a large plantation. Below us the sea. . . and on either side of us there are coconut trees and other fruit trees that are perfect for the landscape artist' (to Schuffenecker, July 1887). This view of the Bay of Saint-Pierre with the volcano of Mount Pelée on the horizon—which would erupt fifteen years later and destroy the island—is the most dazzling of the series. His personal Impressionism which had always led him to paint the more exuberant and overgrown landscapes in the Ile-de-France blossomed on this island. But he treated its exoticism without clichés, depicting a sky that was more overcast than blue and earth and vegetation that were imbued with dampness and heat. Martinique was to be a decisive stage in his search for the primitive and the lost paradise prior to the stylistic revolutions of 1888 in Brittany.

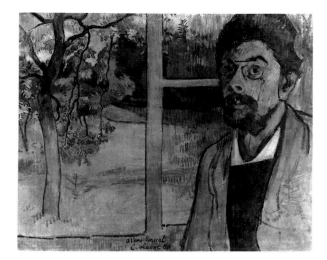

54. Charles Laval, *Self-portrait 'for Vincent'*, 1888. Amsterdam, Vincent Van Gogh Foundation, National Museum Vincent Van Gogh.

BRITTANY IN THE JAPANESE STYLE BY A 'SAVAGE FROM PERU'

1888

56. *Children Wrestling*, 1888. Oil on canvas, 93×73 cm. Josefowitz Collection.

Up to 1888 Gauguin painted few nudes, partly because he could not pay for models. Some little Breton boys swimming in the river at Pont-Aven gave him a chance to paint a nude that was not of the usual academic kind. Its style was new and consciously 'primitive': 'I have just finished some nudes that you will like,' he wrote to Schuffenecker, 'and they are not at all like Degas's. The latest is a wrestling match between two children by a river, very Japanese as seen by a savage from Peru. It is very lightly worked with green grass and a white upper section.' The group in the centre may in fact have been taken from a Hokusai drawing, and yet this surprising painting was inspired as much by Degas as by Japan. A great green empty space surrounds each component: the mill's cascade at the top, the boy clambering onto the bank, the two boys at the left immobilized in a struggle that doesn't appear to interest them much, and the pile of clothes at the bottom that includes the Breton hat and blue smock of real peasant children. If Gauguin wouldn't admit to painting 'a Degas', it was because two years earlier, in the summer of 1886, he had painted a similar scene that Schuffenecker must have quite justifiably thought was inspired by Degas's *Young Spartans* (Musée d'Orsay). This time Gauguin has indeed gone beyond this influence, and the theme of the struggle and the dislocated composition of this painting heralds the celebrated *Vision after the Sermon* (fig. 65) that he was to paint two months later.

Art is an abstraction.

Paul Gauguin,
1888.

Going to the Tropics to paint, then running out of money and having to work his passage home on a sailing ship must have reminded Gauguin of his adolescence as a ship's apprentice, whereas in the year that followed he was to embark on an entirely new stylistic adventure. By the end of of 1888, after another stay in Pont-Aven and the famous tragic episode with Van Gogh in Arles, his painting entered a new phase and Gauguin reached maturity both in his work and personally.

Since he was penniless when he finally got back to Paris in the autumn of 1887, he was housed by the faithful Schuffenecker. The ungrateful Gauguin repaid the man's patient generosity with indifference to his painting and an affectionate condescendence for his person that appeared even cruel in the portrait of his family he painted a year later, for Schuffenecker is depicted as a tiny, timid figure standing before his easel in the background of a composition dominated by his overbearing wife, whose favours Gauguin was rumoured to have enjoyed. During the year he made a few contacts with dealers such as Theo Van Gogh and Portier, which brought him a few sales, and there was the occasional real satisfaction, like the admiration of the dealer's brother Vincent for his Martinique landscapes, as well as a number of disappointments, such as Chaplet's retirement just as Gauguin was hoping to get back to ceramics—'another lost opportunity',[1] he lamented, for they would have been more remunerative than painting. All in all, Paris had turned out to be unsatisfactory, so in February 1888 he decided to settle in Pont-Aven once more.

Although Gauguin's painting over the previous two years remained far below the ambitions expressed in his letters, his belief in himself, in his genius and his vocation as the misunderstood artist had grown apace, and the admiration of men who were less energetic and self-assertive than himself, like Schuffenecker, Laval or even up to a point Vincent Van Gogh and the very young Émile Bernard, served to strengthen his resolve and calm his anxieties.

But his commitment to painting had cost him Mette and brought about his social 'downfall', forcing him to abandon his family. The experience of having been literally thrown out of Copenhagen by the Gad family had inspired him with a horror of the

57. The Gloanec Inn in Pont-Aven in Gauguin's time.

58. *Young Bretons Bathing*, 1888. Oil on canvas, 92×73 cm. Hamburg, Kunsthalle.

bourgeoisie in general and of the Danish bourgeoisie in particular. We still find him saying 'I utterly loathe Denmark'[2] twenty years later, and in a letter to Mette in February 1888, he commented on bourgeois ethics and worship of money in a way that was both aggressive and naïvely anarchistic: 'There are two classes in society, the one has a private income or a partnership or directorship of some business, the other class has no capital, and what does it live on? the fruits of its labours. . . . Which is the best part of a living nation, the productive part that brings progress and enriches the country? It is the artist. You don't like art . . . what do you like then? Money.'[3]

This notion of the privileged position of the artist in society had existed throughout the nineteenth century. For Gauguin, whose brilliance as a gambler on the Stock Exchange had been admired not long before by the same society that now ignored his painting, this belief became an indispensable salve for his ego. His romantic persuasion that he had a mission to accomplish was now reinforced by an inner conviction of his originality as a painter. In July 1888 he wrote to Shuffenecker about a series of nudes painted after several months' worth of rather indeterminate Breton landscapes: 'They are not at all like Degas's [nudes]', which proves that he was aware of the latter's influence, and then he clearly defined his pictorial intentions in the description of *Children Wrestling* that followed: 'The latest is a wrestling match between two children by a river, very Japanese as seen by a savage from Peru.'[4]

This was when the stories of 'Gauguin's childhoods' began to assume legendary proportions as much for the teller as for the listener. He already sensed that his own 'little number', as Cézanne had called it, his uniqueness as a painter, had its source in the uniqueness of his life.

His wife's short stay in Paris at the end of 1887 had marked the final separation that he had not really believed would happen. In the solitude of Brittany he persuaded himself that the last ten years of a bourgeois existence as a father and husband in the world of money had only been an interlude, and that he was now somehow connecting with a past that was further away, more uncertain and more epic. His letters betray that he loved the inflexible Mette more than is generally thought, and a part of himself saw their break as a failure. He compensated for it by a return to his roots and the consolation of his ancestry, assuming the supreme and precious dignity of the 'noble savage' lost in a petty, mechanical, ugly world given over to the worship of gold. Later, in his touching *Cahier pour Aline* (1893) written as a sort of self-justification to his favourite daughter, he carefully copied out these lines from Verlaine and made them his own:

Je suis venu Calme orphelin	A quiet orphan I came
Riche de mes seuls yeux tranquilles	With only my soft eyes for riches
Vers les hommes des grandes villes	Towards the men of the great cities
Qui ne m'ont pas trouvé malin[5]	Who did not find me clever

Another letter to Mette shows that he was quite aware—even complacently so—of what was happening to him: 'It would be dangerous to keep my children by me only to abandon them once more. You must remember that I have two personalities, the Indian one and the sentimental one—the sentimental one has gone, thus permitting the Indian to walk straight and true.'[6] Pont-Aven had helped Gauguin find his true persona; his handsome face whose lines were deepening with the passing of time, his heavy eyelids and his hooked nose were indeed those of an Indian, and he now had the experience, the past and the authority of a forty-year-old; everything, in fact, he needed to fascinate the younger generation.

Also, besides the presence of Laval, who had followed him back from Martinique by then, Émile Bernard's arrival in Pont-Aven during the summer of 1888 led to one of the most fruitful encounters in the history of art.

It was not the first time that Bernard had come across Gauguin. He had met him two years earlier but had merely admired his vigorous Impressionism and left it at that. For his part Gauguin had not even noticed the eighteen-year-old. During the intervening two years, Bernard had frequented the young avant-garde that included Seurat, Signac, Van Gogh and Anquetin, and after trying his hand at Pointillism in 1886, he

59. *Portrait of Madeleine Bernard*, 1888. Oil on canvas, 72×58 cm. Grenoble, Musée de Peinture et de Sculpture.

elaborated a diametrically opposed technique with Lautrec's friend Anquetin in 1887. Their use of large flat areas of colour stemmed from their admiration for Japanese prints: 'The study of Japanese prints,' Émile Bernard said later, 'led us towards simplicity,'[7] and Vincent Van Gogh, who had organized an exhibition of Japanese prints in 1887, confirmed this: 'The exhibition of prints that I put on at the Tambourin influenced Bernard and Anquetin nicely.'[8] Lastly, all of them—except for Gauguin in Pont-Aven and Van Gogh in Arles—had gone to see the first major exhibition of Japanese prints at Bing's in the spring of 1888 and could have bought the first issue of *Le Japon Artistique* that came out in May that year.

Bernard and Anquetin's colours, surrounded by a darker line like the leading in stained glass or the copper round a bright piece of enamel, led to their style being christened Cloisonnism by the critic and Symbolist poet Edouard Dujardin: 'These works give an impression of purely decorative painting, with the strong outline and violent and decided colouring that inevitably recall illuminations or Japanese art. Then, un-

60. *Breton Peasant with Pigs,* 1888. Oil on canvas, 73×93 cm. United States, Private Collection.

derneath the overall hieratic style of the drawing and colour, one perceives a reality of feeling that reflects the romanticism of its spirit.'[9]

The young Émile Bernard was a talented painter, but he was above all connected to the most spiritualistic and intellectual kind of Parisian Symbolism; he was exalted, always ready to theorize or generalize, and full of confidence. His presence in Pont-Aven brought more to Gauguin than the older artist ever admitted or even perhaps realized. Of course his *Children Wrestling,* like his *Still-life with Profile of Laval* or his *Four Breton Women* of 1886 showed a tendency towards flat colouring, Japanese composition and a decorative simplification that were not unlike Cloisonnism. But, as he himself admitted later (unfortunately with much bitterness), Bernard's arrival, accompanied by his paintings of the previous winter, and the impassioned discussions

61. *Woman with a Pitcher* or *Landscape at Pont-Aven*, 1888. Oil on canvas, 92×72 cm. London, Private Collection.

born of his youth and enthusiasm that took place at the Gloanec Inn, were the stimulus that Gauguin needed to clarify his thinking. At long last he had found the companion he had lacked since he distanced himself from Pissarro, someone whose admiration, enthusiasm and speculative mind could satisfy Gauguin's undefined but sincere intellectual needs. The letters he wrote to his confidant 'Schuff' throughout that summer are full of his erstwhile preoccupations and echo the tone of the letter from Copenhagen of 1885: 'A word of advice: don't paint too much from nature. Art is an abstraction, draw this abstraction forth from nature by dreaming before it and thinking about the work that will result from it; the only way to climb up to God is to imitate our Divine Master—and create.'[10] The extent of Bernard's influence can be seen in this last line, for he was a fervent Catholic and proselyte, whereas it is unlikely that

62. Émile Bernard, *Breton Women in the Fields*, 1888. Private Collection.

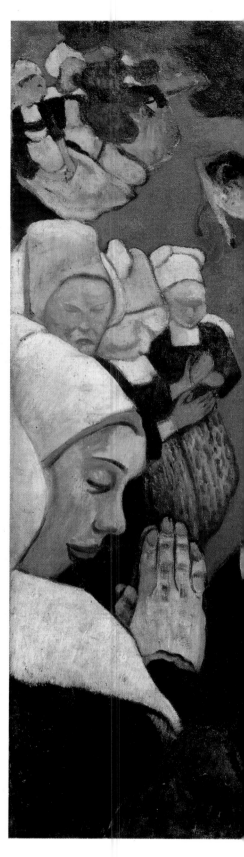

'I have just painted a religious picture that is quite badly executed but which I enjoyed painting and which I like. I tried to give it to the Church in Pont-Aven. Naturally they didn't want it. . . . A group of Breton women are praying. Intensely black costumes. The yellowish blue bonnets very luminous and severe. The cow under the tree is unnaturally tiny and is rearing up. To my mind, in this painting the landscape and the struggle exist only in the minds of the people praying after a sermon. That is why there is such a contrast between the real people and the unreal and disproportionate struggle in the landscape' (to Van Gogh, end of September 1888).

The sermon that these parishioners had just heard described the struggle between Jacob and the Angel, a popular subject for Gauguin's generation of painters. Like himself, they admired Delacroix's celebrated fresco of the same subject in the church of Saint-Sulpice in Paris. The actual fight is taken directly from a drawing of wrestlers by Hokusai, and the great flat area of red and the slanting branch were also inspired by Japanese prints. As soon as it was exhibited in Paris and Brussels in 1889 it was seen as a sort of manifesto of Symbolism in painting because of its visionary, religious subject and its use of opposite versus real colours (for example the green of the field becomes its opposite red). Gauguin was highly praised for this painting, especially by the critic Albert Aurier, though there were a number of reservations, like those of his erstwhile teacher Pissarro who said: 'I reproach him for having stolen from the Japanese, from Byzantine painters . . . for not applying his synthesis to our present social philosophies, which are both anti-authoritarian and anti-mystical' (to his son Lucien, 20 April 1891).

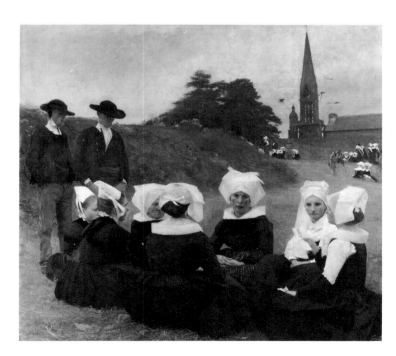

63. Pascal Dagnan-Bouveret, *The 'Pardon'*, 1887. Oil on canvas, 125×141 cm. Lisbon, Caloustian Gulbenkian Foundation.

64. Hokusai, *Assaults*, detail, extract from *Mangwa*. Paris, Bibliothèque Nationale, Department of Prints.

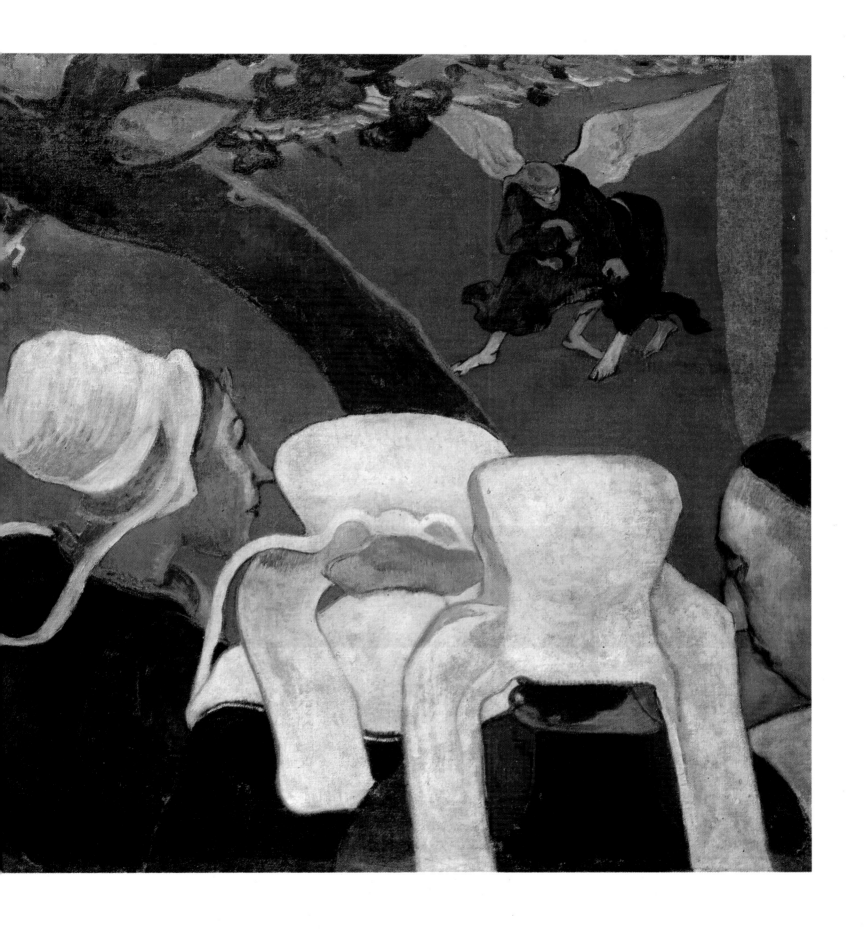

Gauguin had much religious feeling, though he was always attracted by anything that could prove that the artist had a mythic and demiurgical nature. 'My latest paintings are well under way and I think you will find a special quality, or rather the confirmation of my previous experiments in sythesizing a form and a colour by taking [only?] the dominant one into account.' This new pictorial language is affirmed by the fact that 'the little Bernard is here . . . he really is someone who will stop at nothing.'

The half-hidden autodidactic side of Gauguin gleaned a wonderful, childish reassurance from these meetings. The man who had been a convinced painter long before convincing us of this, felt the rise of a new vitality and assuredness inside himself: 'The self-esteem that one acquires and the feeling of a strength that is deserved are our only consolation in this world.'[11]

There is an odd similarity between what Gauguin said to Shuffenecker and the contents of a letter that preceded his by only a few months, which Gauguin may have read. It was from Vincent Van Gogh to Émile Bernard, who admired him greatly and generally followed his counsel. The advice in this particular letter reveals a far more solid and pictorially direct thinking than that of either Bernard or Gauguin: 'The imagination is something we should develop, for it alone can help us create a more exalting and consoling nature than a mere glance at truth—that we see as changing and passing by in a flash—can make us perceive'[12]—a profession of faith that could be said to sum up all of Gauguin's future concepts.

The letters that Vincent received in Arles from his two friends during that celebrated month of August made him realize that something important was going on in Pont-Aven. 'Gauguin is full of praise for Bernard's work, and Bernard is full of praise for Gauguin's,' he wrote to Theo. Then, full of curiosity: 'Gauguin and Bernard are now saying that they are doing "children's painting". I like the idea of that better than decadent painting.'[13]

However chaotic the discussions between a rhapsodic young man 'who will stop at nothing' and a man of forty who was already enough of a professional to have become weighed down by it, they resulted in some masterful canvases from Gauguin, the most famous of which is *Vision after the Sermon*. The decorative use of the white Breton coifs seen from the back and the treatment of the colour in outlined blocks recall the canvas Émile Bernard painted a short while before, *Breton Women in the Fields*, which Gauguin had considered very good. Even if the Cloisonnism and the flatness of the colour in *Vision after the Sermon* came from Bernard's and Anquetin's influence, in reality Gauguin was applying a method to painting that he had previously, it might seem, used in his ceramics: *Vase Decorated with Breton Scenes* variously dated 1886 or 1887,[14] shows that Gauguin had already found a style that was close to *cloisonné* enamel work, and here, too, the subject was Breton women in coifs seen from the back in a landscape. The religious theme that appears for the first time in *Vision after the Sermon* is probably due to the younger man, as is the obviously Japanese style of the composition—the slanting tree in the centre and the motif of Jacob and the angels that look as if they had been copied from a group of wrestlers by Hokusai[15] —even the muscles on the angel's legs rise from the ankle, like those of sumo wrestlers. Gauguin had already tested the theme of the echoing white curves of Breton headdresses in *Breton Women*. The real novelty in this canvas lies in his adaptation of a familiar theme to an imaginary event and in the tremendous directness with which the Breton scene is linked to the visionary one through purely plastic means.

And yet in this painting Gauguin was expressing some very literary concepts that the critic Albert Aurier would soon praise, for it was because of this painting that he called Gauguin a Symbolist painter *par excellence*. At the time he was working on it, the author of this first major work of religious Symbolism wrote to Van Gogh: 'I think I have achieved a really rustic simplicity and superstition in the figures. . . . To my mind, in this painting the landscape and the struggle exist only in the minds of the people praying after a sermon. That is why there is such a contrast between the real people and the unnatural and disproportionate struggle in the landscape.'[16] The major pictorial innovation lies in the startling red meadow ('I would like there to be

66. Hiroshige, *The Whirlpool*, detail, 1857. Document belonging to Huguette Berès.

67. *The Wave*, 1888. Oil on canvas, 49×58 cm. New York, Private Collection.

Like *Seascape with Cow on the Edge of a Cliff* (fig. 69), Gauguin painted an overhead view from the top of a cliff at Le Pouldu. The location is easy to identify, for he depicted these two rocks several times, in *Life and Death* (fig. 118) and in an engraving called *The Black Rocks*. Although the landscape is realistic, in it Gauguin turned the rocks into two formidable natural towers and above all reinterpreted them by stylizing them in the Japanese manner. Indeed, this painting has often been compared to a famous print by Hiroshige, *The Whirlpool*, which it resembles in the circular treatment of the waves, the plunging, horizonless perspective and the arbitrary colours. The beach which is in fact a greyish pink, is painted bright red, the colour which, as in *Vision after the Sermon* (fig. 65) and the table in *Still-life: Fête Gloanec* (fig. 68), represents the visionary and the right to a poetic interpretation and constitutes the painting's 'Symbolism'. The tiny bathers caught by the unfurling wave have been reduced to absurd comic insects.

meadows coloured red!' Baudelaire once cried) behind the peasant coifs and the wings in the vision, and in the arabesques running from the kneeling women at the top left to the inexpressive profile in the bottom right corner, that set off the little biblico-Japanese group above it. Painting had come a long way since Delacroix's great fresco of the same subject in the church of Saint-Sulpice: from a painting so close to Impressionism that it foreshadowed it, to a canvas by a defector from that same Impressionism that in turn presaged the Modern Style with its utter modernity!

This work represented Gauguin's complete and final break with Impressionist realism. When he saw it, Pissarro immediately sensed this break, as he sensed the spiritualism in the painting's conception. According to him—and he was not completely unjustified—Gauguin had taken a stand in this painting that was close to the English Pre-Raphaelites, as much in his archaic subject matter as in his 'poetic' flight from reality. Pissarro found his attitude reactionary: 'I am not reproaching Gauguin for having painted a vermilion background, or the two struggling warriors, or the Breton women in the foreground. I reproach him for having stolen from the Japanese, from Byzantine painters and the rest, I reproach him for not applying his synthesis to our

69. *Seascape with Cow on the Edge of a Cliff*, 1888. Oil on canvas, 73×60 cm. Paris, Musée des Arts Décoratifs.

This painting from the summer of 1888 is one of Gauguin's most 'Cloisonnist' and audaciously composed paintings. It is possible that this was the picture the critic Félix Fénéon was referring to in his highly 'aesthetic' language when he reviewed the exhibition by Gauguin and his friends at the Café Volpini during the Universal Exposition of 1889: '[He] disdains the *trompe l'œil*, even the *trompe l'œil* of atmosphere. He emphasizes his lines, keeping them to a minimum and hierarchizing them; and in each of the spacious cantons that interlace them, an opulent and heavy colour mournfully enriches them without touching the neighbouring ones.' This sort of colour puzzle augurs the sinuous lines of Art Nouveau and the flat colour areas of the Nabis and the Fauves. Yet Gauguin stayed close to reality: the coastline of Brittany often astounds one with this kind of field on the edge of a cliff with cows silhouetted against a restless sea. It is two different worlds, and Gauguin probably appreciated the irony in the contrast between the cow placidly turning its back on the abyss and the boat scudding under a stiff breeze in the upper part of the picture.

68. *Still-life: Fête Gloanec*, 1889. Oil on canvas, 38×53 cm. Orléans, Musée des Beaux-Arts.

Marie-Jeanne Gloanec was the proprietor of the inn of the same name in Pont-Aven where Gauguin and his friends stayed. Gauguin painted this picture for her birthday, signing it 'Madeleine Bernard' (fig. 59) on the assumption that its apparent naïveté would be better received if it were the work of a young girl. The painting is an overhead view of a pedestal table onto which he put all the necessary accoutrements—the birthday bouquet in its white frill, the cake and some fruit. The black-bordered vermilion table top on a single plane and the warm and subtle combination of similar colours—reds, oranges, etc.—transform this modest still life into a rare and precious, almost lacquered gift. The consciously Japanese influence lies in the absence of volume and resolutely anti-naturalistic treatment of space.
For a long time this painting belonged to Maurice Denis, who, less than two years after Gauguin painted it, became the theoretician behind the new colourful 'Synthetist' painting of the Nabis which derived from Gauguin's pictorial principles. When we look at this painting it is impossible not to remember Denis's famous definition in 1891 of what painting should be: '. . . essentially a flat surface with colours assembled in a certain order.'

present social philosophies, which are both anti-authoritarian and anti-mystical. That is the crux of the problem. It is a return to the past. Gauguin is not a seer, he is a clever fellow who has sensed this return to the past in the bourgeoisie, the consequence of the grand concepts of solidarity that are fermenting among the people—an unconscious concept, albeit the only right one—the Symbolists are going through the same thing.'[17] Pissarro was obviously being unjust; it had escaped him that the novelty in this painting was not its subject but its pictorial advances, and here the Impressionist painter could see only the borrowings and not the intentions behind them.

If we look at other paintings from the same period, that have no metaphysical or narrative ambitions to disrupt their pictorial style, like *Seascape with Cow on the Edge of a Cliff* or *Still-life: Fête Gloanec*, we can better appreciate the mastery that Gauguin attained in such a short time. The first of these paintings is a stunning, abstract study of the equilibrium of masses and relationships between colours. The curves fit into one another with an intentional mannerism; the rocks and the wave that they are supposed to portray are merely a pretext. This painting is a good illustration of what Gauguin, who knew perfectly well what he was trying to achieve, wrote at the time: 'This year I have sacrificed everything—brushwork, colour—for style, because I wanted to make myself go beyond what I already know how to do. I think it is a change that has not as yet borne fruit, but it will eventually.'[18] *Fête Gloanec*, which

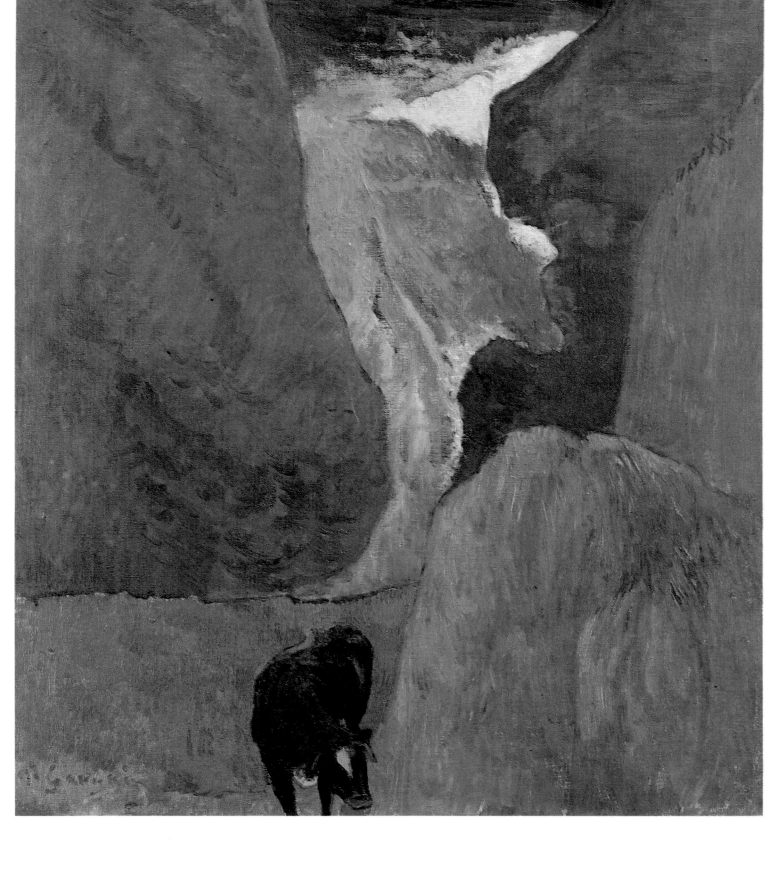

70. *Still-life with Three Puppies*, 1888.
Oil on wood, 92×62.6 cm. New York,
Museum of Modern Art.

71. Kuniyoshi, *Japanese Proverbs* from
the *Tatoye Zukuski* series. Document
belonging to Huguette Berès.

is perhaps the first really good 'very Gauguin' Gauguin, is especially striking because of the strange way in which he arranged its components, massing them on the left and slicing them off with the edge of the frame, and his use of exclusively warm and spicy colours. The three fruits on the right are no longer the sober apples anchoring a Cézanne-like cloth that appear in so many of Gauguin's paintings; instead they have become exotic fruits negligently thrown down in a gesture that is more Creole than Breton. The composition makes one think of Degas, but what transpires most from it is a search for the unexpected and a deliberate graciousness.

The painting *Still-life with Three Puppies* was probably painted soon after *Fête Gloanec*, and looks as though it was inspired by a print by Kuniyoshi.[19] In it we find the same round table edge at the bottom of the picture, the same apparent ingenuousness, though here it is much more self-conscious and organized. Curiously, as if he were excusing himself for the audacity of the rest of the painting, the right-hand corner is carefully modelled. The rest of the painting is flat and works upward on the same plane as the canvas, with neither volume nor perspective, on an almost unbroken white ground, reminding one of Matisse, or of Bonnard at the time of *La Revue Blanche*. The three somewhat shapeless puppies resemble piglets, and the handle of the saucepan is deliberately crooked while the three blue goblets repeat a feigned clumsiness next to three identical pink eggs. The subject may indeed have come from a Japanese print, but the purposeful naïveté and the lines around the little dogs clearly belong to the 'children's painting' that Émile Bernard and Gauguin had mentioned to Van Gogh.

During the previous months Gauguin had written Van Gogh a stream of self-pitying letters complaining about the poverty and the physical and moral misery that the artist's condition imposed on even the greatest amongst them. That this kind of statement might have been a stratagem to soften Theo Van Gogh, the buyer of modern painting at the Boussod and Valadon gallery, through his brother is conceivable—especially if one takes Gauguin's subsequent behaviour towards the recluse in Arles into account. But this is beside the point, for it was then that Gauguin's personality crystallized: in his own eyes he was the incarnation of the 'doomed' painter, more bitter, unhappy and satanic than truly uneasy about his genius. This is how he wanted to be seen, admired and feared. Van Gogh, a little jealous of an artistic friendship that appeared so fruitful, wrote to Gauguin and Bernard from his solitude in Arles to ask each to paint the portrait of the other in exchange for his own self-portrait. They tried but, oddly enough, Gauguin did not 'feel' the portrait of the younger man who in turn pretended to be so crushed by the talent and personality of the artist that he dared not set about Gauguin's. Finally, they decided that they would also paint self-portraits.

Van Gogh found the results very interesting, although in truth it was Bernard's that he liked the most. Nevertheless, Gauguin's letter describing himself further with words that accompanied the portrait moved Van Gogh 'to the very depths of [his] soul'.[20] Perhaps Gauguin's showing-off—though it contained a measure of genuine sadness—escaped Van Gogh's notice: 'My first impression is definitely that of seeing a prisoner. It is worlds away from real flesh, but boldly speaking, we can put that down to his wish to produce something melancholy,' he wrote. Gauguin had explained his intentions to Schuffenecker and to Van Gogh at great length, decribing them slightly differently to each of his correspondents. With the first, the tone is didactic: 'I believe this to be one of my best things, it is so abstract that it is absolutely incomprehensible (for example). The face of an outlaw first of all, a Jean Valjean who also personifies a disdained Impressionist painter . . . the eyes, mouth and nose are like flowers on a Persian carpet and also represent the symbolic side. The colour is very far removed from natural colour. . . .'[21] His relationship with Van Gogh was more emotional, and Gauguin wished to move as well as impress him: '[It is] the face of an outlaw, ill-clad and powerful like Jean Valjean, who also has an inner nobility and gentleness. The lusty blood spreads over the face, and the hues of a furnace around the eyes indicate the fiery lava that engulfs our painters' souls.' And to involve Van Gogh personally in this portrait of an outcast: '. . . I have given you my own likeness as well as the portrait of us all—pitiful victims of society that we are—avenging him [Valjean] and

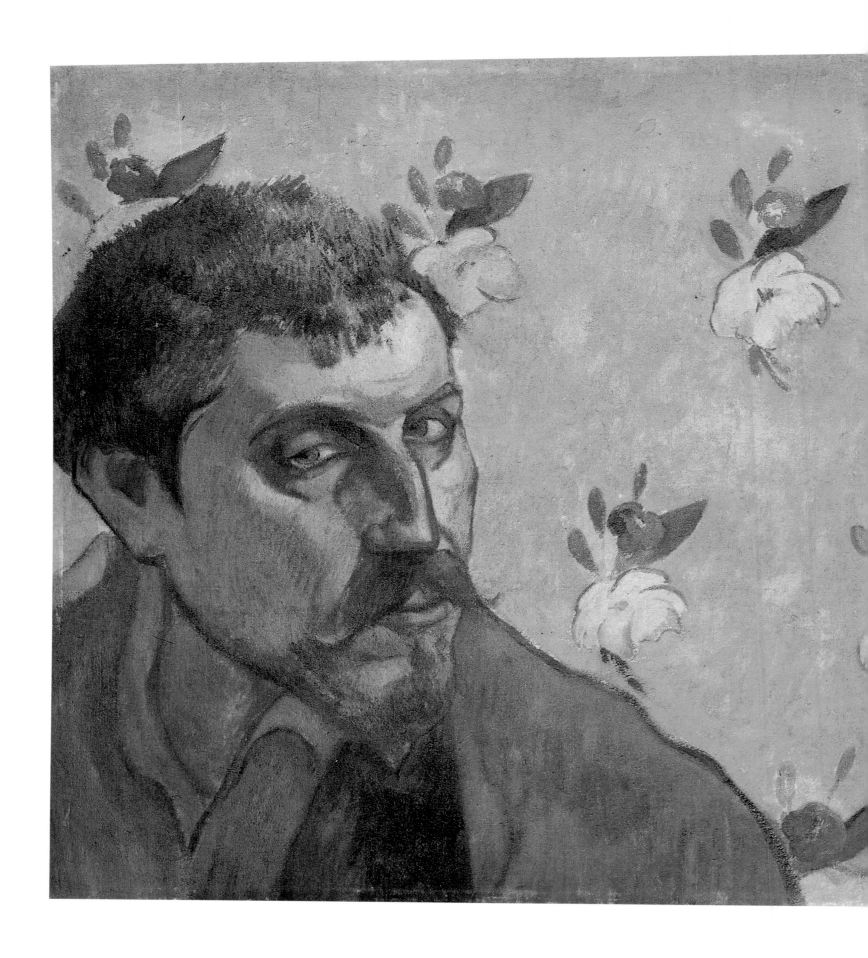

72. *Self-portrait, 'Les Misérables'*, 1888. Oil on canvas, 45×55 cm. Amsterdam, Vincent Van Gogh Foundation, National Museum Vincent Van Gogh.

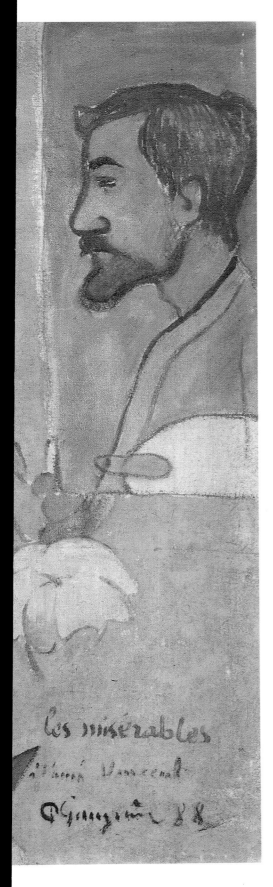

73. Émile Bernard, *Self-portrait*, 1888. Amsterdam, Vincent Van Gogh Foundation, National Museum Vincent Van Gogh.

We know that Vincent Van Gogh had asked for the portraits of his friends while in Arles. He was sent three self-portraits, one by Émile Bernard incorporating a sketch of Gauguin, one by Laval and one by Gauguin dedicated 'to my friend Vincent' with a line drawing of Bernard's profile on the wall behind himself. With it he sent a letter: 'I feel I need to explain what I wanted to achieve,' he wrote. '[It is] the face of an outlaw, ill-clad and powerful like Jean Valjean, who also has an inner nobility and gentleness. The lusty blood spreads over the face, and the hues of a furnace fire around the eyes indicate the fiery lava that engulfs our painters' souls. Drawing the eyes and nose like the flowers on a Persian carpet summarizes an abstract and Symbolist art. The charming girlish background with its childlike flowers is there to bear witness to our artistic virginity. As for this Jean Valjean, whom society oppresses, cast out for all his love and vigour, is he not the image of an Impressionist today? By giving him my features I have given you my own likeness as well as the portrait of us all—pitiful victims of society that we are—avenging [Valjean] and doing good' (to Van Gogh, early October 1888). When Van Gogh received a painting partly intended to impress him—the choice of Jean Valjean, a favourite hero of his, indicates this—his reaction was mitigated: 'Gauguin is the first person one sees. . . . My first impression is definitely that of seeing a prisoner. . . . Gauguin looks ill and tortured in his portrait! . . .we can put that down to his wish to produce something melancholy, the shadows on the flesh are lugubriously bluish.' 'I do not like to see "art" taken to such extremes of atrocity except where they show us the way' (to Theo, 7 October 1888) and 'too gloomy, too sad. . . all in all painted in a hurry' (to Theo). In the final analysis Van Gogh, the father of the Expressionist movement of the beginning of the twentieth century, disapproved of Gauguin's exhibitionism, despite Gauguin's successful rendering of his cantankerous distress through his daring composition, colour and contrast.

Also, the portrait must have been accurate, for when he arrived at the café near Van Gogh's house in Arles early one morning, the owner to whom Van Gogh had shown the painting 'looked at me and exclaimed: you must be his mate, I recognize you' (*Avant et Après*).

74. Vincent Van Gogh, *Self-portrait*, 1888. Oil on canvas, 60.5×49.4 cm. Cambridge (Mass.), Fogg Art Museum.

le tout sur un fond chrome par
passemé de bouquets enfantins !!
Chambre de jeune fille pure,
L'impressionnité est un pur non
souillé encore par le baiser putride
des beaux arts (école) — Je vous envoie
une lettre de Vincent
pour vous faire voir
où j'en suis
avec lui et
tout ce qu'il se
projète en ce
moment. Montrez
lui à Mad⁰ Poujin
pour lui faire voir
que vous n'êtes pas
le seul à m'estimer.
Cela lui fera voir aussi
que les artistes sont
des êtres à part qui ne
peuvent avoir les idées pratiques de
commerce entrevues par elle —

Jacob was a captain in the customs service responsible for preventing the smuggling of salt by sea between Pont-Aven and Quimperlé. He was happy to lighten this monotonous job by fraternizing with the painters in the area, becoming friendly with Gauguin and often taking him for trips outside Pont-Aven—which is upstream—to the coast, especially to Le Pouldu. 'We embarked on the customs rat's boat to transport our bits of luggage from Pont-Aven to Le Pouldu,' Sérusier, a faithful pupil of Gauguin's (fig. 103), recalled, adding: 'I still remember the ruddy face Gauguin gave him when he painted him in his bathing suit.' Indeed, despite the intellectual-looking little pince-nez, he looks as though he is about to enter the water. The unusual format of the canvas leads one to believe that Gauguin cut it in half and kept only the upper part, unintentionally creating the amusing layout that the Nabis—especially Bonnard—would use in the 1890s. Gauguin had fun emphasizing the plump white back of this *bon vivant* who accompanied his painter friends on trips that were often as gastronomic as they were artistic. And, since his job entailed coast-guarding in the open air, only his face was tanned, or rather, reddened.

doing good.'[22] What an incredible technical and spiritual transformation since the timid self-portrait painted in Copenhagen only three years earlier!

The last Gauguins that Van Gogh had seen before leaving for Arles were the paintings from Martinique. Of all of his friend's work, they were the ones he had most admired so far: 'Those negresses of his are highly poetic, everything done by his hand is gentle, woebegone and stunning.'[23] Coincidentally, Van Gogh had been enthusiastically reading one of the most popular books of the period, *Rarehu, ou le mariage de Loti* by Pierre Loti. The haughty and sugary descriptions by the most graceful naval officer in French literature enchanted Van Gogh, for the enlightened traveller in search of the 'authentic' made remarks like: 'civilization has been here too often—our stupid colonial civilization', and gave long descriptions of exotic landscapes that the artist immediately visually associated with Gauguin's Martinique paintings. He wrote to his sister in April 1888: 'I can easily imagine that a modern painter could paint the kind of thing we find depicted in Loti's book describing the countryside of Otaeite. I strongly recommend the book to you.'[24]

In response to Gauguin's long unhappy letters, so distressing that Van Gogh feared, as he confided to Theo, that Gauguin might commit suicide, Vincent must have recommended this dream-provoking book, and he tried to convince Gauguin to join him and other artists in setting up a 'Studio in the Tropics'. Doubtless the evangelizing Van Gogh combined his technical encouragements with humanitarian digressions on the grandeur of primitive man as opposed to Western degeneracy, themes that Gauguin would have instantly responded to. Gauguin brought up the subject with Émile Bernard in May that year: 'The dreadful white man with his hypocrisy, avarice and

77. Émile Bernard, *The Artist's Grandmother*, 1887. Amsterdam, Vincent Van Gogh Foundation, National Museum Vincent Van Gogh.

sterility. [Whereas] those savages were so sweet, so loving!'[25] and had surely read the letters from Arles with the greatest attention, for he again wrote to Bernard, who was back in Paris by then: 'I am somewhat of Vincent's opinion, the future belongs to the painters of the as yet unpainted Tropics.'[26]

But these projects still lay in the future. For the moment, before pushing him towards the islands, the Van Gogh brothers were more concerned with getting him to Arles where, to relieve the poverty in which he had been living at Pont-Aven, Theo would support him in exchange for a painting a month. In his letters to Theo during the six months between the invitation and Gauguin's arrival, Vincent began by showing moderate enthusiasm for the visit, having suggested it only to help the penniless Gauguin. Little by little, however, he became really pleased with the idea, putting himself out of pocket to furnish Gauguin's room, finally becoming quite worried when the summer came and Gauguin, surrounded by admirers in Pont-Aven, showed less and less inclination to leave. Van Gogh realized this at once and said sadly: 'Gauguin prefers to manage through his friends in the North,'[27] in other words, through Laval, Bernard, Chamaillard and a newcomer called Sérusier.

Sérusier reached Pont-Aven at the end of the summer holidays, when Bernard and the other painters of the group had already formed a tight circle round Gauguin. A pupil and bursar at the small Académie Julian, he began by going around with the 'people from the School', but it was not long before he approached Gauguin and his friends. He was fascinated by their noisy metaphysical discussions and soon followed their precepts. We shall let Maurice Denis describe how Gauguin, through Sérusier, had a decisive influence on the young future Nabis Bonnard, Ibels, Ranson, Roussel, Vuillard and himself:

'It was after his return from Pont-Aven at the end of the summer of 1888 that Sérusier first revealed Gauguin's name to us. With an air of mystery he unveiled a cigar-box lid on which there was a landscape that had been rendered formless through its synthesized transformation into areas of purple, vermilion, Veronese green and other pure colours taken straight from the tube, with barely a touch of white mixed in. "How do you see this tree?" Gauguin had asked in a corner of the Bois d'Amour. "Is it really green? Paint it green, then, the most beautiful green on your palette; and this shadow, rather blue? Do not hesitate to paint it as blue as possible." It was in this paradoxical, unforgettable way that we were first presented with the fertile concept of "a flat surface covered in colours assembled in a certain order". It was thus that we learned that all works of art are a transposition, a caricature and the passionate translation of a received sensation.'[28]

Besides being a living example of every kind of daring, Gauguin was the initiator—directly or indirectly—of a series of discoveries that led these young painters hardly aware of Impressionist art, from the Boussod and Valadon gallery, where Theo Van Gogh exhibited works by Monet or Degas alongside Gauguin's Martinique paintings, to Père Tanguy's celebrated shop in Montmartre stacked with unsold canvases signed Van Gogh and Cézanne. Gauguin's enthusiam for Cézanne, coupled with his own style of painting, formed a sort of entry into the work of the Master of Aix for these young painters. Incidentally, when Gauguin at last went to Arles on the proceeds of Theo's sale of some of his pottery after his new 'pupils' had returned to Paris, his rendition of the Provençal countryside would clearly display his veneration for this artist.

The little we know about his ill-fated two months in Arles comes from the two friends' letters to Paris. Gauguin's version in *Diverses Choses* (notes added to his personal copy of *Noa Noa*) and *Avant et Après* are highly suspect, for he obviously wanted to justify his 'semi-flight' after the event, and above all it was not until after Van Gogh's death that he fully recognized the greatness of his friend's painting.

We could question whether this friendship was so strong in the first place. No sooner had his guest arrived than Van Gogh was morbidly overcome by a nervous joy, while Gauguin boasted to Schuffenecker: 'Don't worry, however much Van Gogh may be in love with me, he wouldn't have decided to house me in the Midi just for the sake of my pretty blue eyes. He has surveyed the field, cool Dutchman that he is, and fully intends to get his own thing going as far as possible, to the exclusion of everyone else.'[29] This comes across as unpleasantly spiteful in the light of what we now know about Vincent's solicitude for Gauguin, thanks to the published correspondence between the Van Goghs, and about the sacrifices that Theo made for his brother and, in this case due to his brother's wishes, for Gauguin as well. From Gauguin's point of view, however, embittered and suspicious as he had become, a dealer was a dealer, even if his name was Theo. And his recent experiences with Mette and her family who were friendly only, he wrote, 'when the money was there', had not favourably disposed this simple and genuine man towards those 'cold and calculating' Northerners.

Gauguin's behaviour, ranging from indifferent to irritated, towards the tender and ecstatic Van Gogh who was already totally given over to his love for him, was more fraught with consequences. After nine months of solitude Van Gogh longed so much for human warmth and intellectual exchange that he had taken great pains to prepare Gauguin's studio, decorating it with his paintings *A Garden* and *Sunflowers* with which, he declared, he wished to invoke both the ancient poet of the area, Petrarch, and 'the new poet here—Paul Gauguin'.

As soon as he arrived, the 'poet' was disappointed. He felt out of place and found everything 'small and mean, both the landscape and the people'.[30] Above all, whereas they had communicated perfectly on the subjects of aesthetic principles and a common destiny by letter, their physical encounter pointed up the differences in their characters. Although Gauguin was extremely flattered by Van Gogh's passionate admiration of him, he was exasperated by his physique, his demands and his reactions. It would indeed be difficult to imagine two more dissimilar personalities: in one, a painter by vocation, everything was fire and emotion, in the other, a painter by determination,

78. *The Alyscamps*, 1888. Oil on canvas, 92×73 cm. Paris, Musée d'Orsay.

79. *Farm at Arles*, 1888. Oil on canvas, 91.4×71.7 cm. Indianapolis, Museum of Art.

everthing was slow and thoughtful. Van Gogh, a character from Dostoyevsky, had nothing in common with the reader of Balzac, who in turn considered 'his brain disordered'. In painting too their tastes took them in radically opposite directions. Gauguin loathed the 'impasto' work that Van Gogh admired in painters like Ziem or Monticelli and failed to convert him to his own appreciation of Ingres, Degas or Cézanne: 'He is a Romantic, whereas I am more drawn towards the primitive,' Gauguin perceptively observed and, elsewhere, he commented in amazement: 'How strange, Vincent sees a Daumier to be painted where on the contrary I see a coloured Puvis mixed with Japan.'[31] This remark is incredibly premonitory about their objectives in the light of the Expressionism that grew from Van Gogh's work, and the non-figurative paintings that had their source in Gauguin's decorative abstraction. Gauguin's real teachers were Pissarro followed by Degas and then Cézanne—for he owed the first a 'mastery' of Impressionist techniques, the second an inventiveness of composition and to Cézanne he owed the technique of construction through colour and a taste for balance. At this time Puvis de Chavannes was the only other artist who had taken this road along which Gauguin was moving with an increasingly firm step, a road leading to decorative simplicity and what Gauguin called 'the primitive'. In the meantime, despite his intentions, his paintings were above all informed by Cézanne, as can be seen in the farmhouses and trees in *Farm at Arles*, though the haystack painted with long cross-hatched brushstrokes the colour of fire evokes the presence of Van Gogh.

Did these two great painters who worked side by side for two months actually manage, despite their aesthetic and personal disagreements, to enrich each other's work? Gauguin admitted fifteen years later that 'two men achieved a colossal work there that was useful to both of them.' But, according to him, the influence was unilateral, and so were the benefits. When he got there, Van Gogh was 'floundering considerably' and 'despite all his yellows and purples, all the efforts with complementaries, efforts that were disorganized in any case, he achieved only soft harmonies that were

81. Vincent Van Gogh, *Women of Arles*, 1888. Oil on canvas, 73.5×92.5 cm. Leningrad, Hermitage Museum.

incomplete and monotonous; the clarion call was missing.'[32] He claimed he set about enlightening Van Gogh and helped him exceedingly for 'like all unusual natures marked with the stamp of personality, Vincent had no fear of criticism and no stubbornness', and subsequently had him painting away at his famous sunflowers, those studies in yellows and ochres on yellows; in other words, neighbouring rather than complementary colours. Unfortunately, the evidence proves that the *Sunflowers* series was painted *before* Gauguin reached Arles, for Van Gogh wrote to his brother almost every day keeping him abreast with his progress. However, rather than judging Gauguin as dishonest, one must look upon his conviction that he had helped Van Gogh as the expression of a candid complacency and proof that he did not really pay close attention his friend's work. It would have been difficult indeed for Gauguin to have thought otherwise about the humble, nervous man who admired him so intensely that he copied his subjects, copied the painting by Bernard he had brought from Pont-Aven, and insisted on how much he owed him with such heartfelt sincerity. It would be unimaginable for Gauguin to have believed for a moment that out of the two, it was the other who had at last found his style, and that this style had hardly been affected by his own presence, and that to the extent that it had been so at all, the effect was short-lived. Van Gogh took Gauguin's advice for a while, and painted from memory as opposed to life. He tried this in *Women of Arles,* based on Gauguin's *Old Women at Arles*, but the resulting painting underlines the differences between them rather than the similarities, for Van Gogh's version is as substantial and thickly painted as his friend's is decorative and rhythmically flat. In Gauguin's painting strange triangular shapes stand out against a *cloisonné* garden that already resembles Maurice Denis's Symbolist woodlands, and the focal point of the painting is the somewhat theatrical group of Arlesian women wrapped in their shawls.

Van Gogh soon abandoned his efforts to paint from memory, describing the experience with the far-sightedness that was one of the paradoxes of this extremely sick

80. *Old Women at Arles*, 1888. Oil on canvas, 73×92 cm. Chicago, Art Institute.

'How strange, Vincent sees a Daumier to be painted where on the contrary I see a coloured Puvis mixed with Japan. The women here are—with their elegant headdresses, their Greek beauty and their shawls forming primitive folds—are, I say, a Greek chorus. . . . Lastly they are the epitomy of a handsome modern style,' Gauguin wrote to Bernard from Arles late October or early November 1888. How could one not recall these words? The enigmatic procession of the four Arlesian women whose shawls cover them up to their coifs is indeed full of dignity as it passes behind a bush in the shape of a monster. It ignores the strange objects behind it: the vermilion fence, the yellow cones of straw protecting the young trees from the sparkling cold reflected in the women's gestures and the blue-tinged water behind the grass. If the processional calm of these women evokes Puvis de Chavannes and ancient Greece, Japan can be seen in the bright, prominent colours and the vertical perspective—so vertical that the green bench at the top left of the path resembles an insect crawling up a wall!

man: 'Abstraction appeared to me a delightful path to follow. But the ground is bewitched . . . and one is quickly faced with a blank wall.'[33] It is worth noting, by the way, that the word *abstraction* was interpreted differently by each painter. Van Gogh saw it as the product of the imagination; for Gauguin the meaning was richer in that it was opposed to *naturalism*, especially in the use of colour. *The Laundresses* shows to what extent Gauguin perceived humanity in decorative terms compared to Van Gogh. Where Van Gogh or Pissarro would have painted a woman bent over her washboard, Gauguin created sharp silhouettes over reflections that are more strongly defined than they: more than a mere expression of the scene, Gauguin was looking for its *motif*, its underlying rhythm.

For his part, Van Gogh also played an important role in Gauguin's development, and not just because it was he and not, as is commonly supposed, Bernard who prompted Gauguin's departure for Tahiti. Having seen Gauguin's impending direction in his Martinique paintings, he encouraged him to read Loti, or perhaps even recited his books out loud to him during their evenings of 'work and conversation' that alternated with their nocturnal walks 'for reasons of hygiene' among the regulars in the town. Two of Gauguin's canvases painted in Arles show that he was more or less obscurely

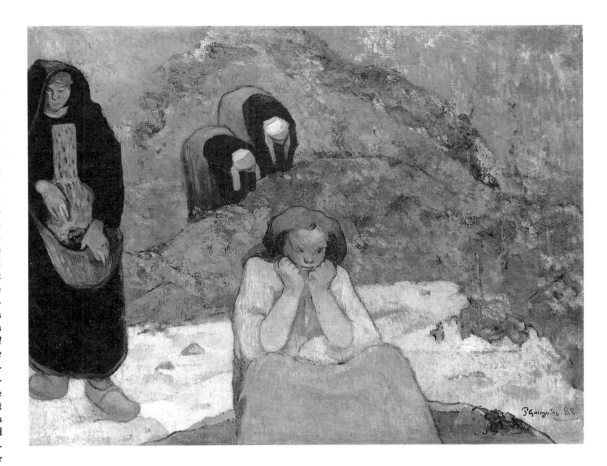

82. *The Laundresses* (Arles), 1888. Oil on canvas, 73×92 cm. Bilbao, Museo de Bellas Artes.

Daniel de Monfreid once wrote that Gauguin's art was not 'a photograph of nature' but the image of his 'rebellious, fiery and terrible' soul, and gave this painting as an example: 'The colours are as powerful as a clarion call and the highly simplified drawing of the figures make them so unlike human beings that they appear to have come from another mysterious and awful world.' Without going as far as this uncritical friend, it is true that this familiar scene is treated with exceptional strangeness, fervour and individuality. The waters of the Rhône boil and seem to redden on the top right; it may be russet grasses on the bank, but they appear to flame around the figure wrapped in shawls observing the washerwoman. Gauguin often added animals cropped by the edge of the frame to his compositions—the horse in *The Seaweed Gatherers* (fig. 126), the pig in *In the Hay* (fig. 91)—investing them with a mystery and responsibility that the protagonists lack: the pig wandering past the naked peasant girl tells us something that she does not yet know, the horse adds its implacability to the scene of the seaweed gatherers, and is the goat here just peacefully grazing near an old shepherdess or is it a witch's consort? We cannot tell, for often Gauguin's most superficially prosaic paintings are charged with this kind of ambiguity and hidden meaning.

84. *Human Misery* or *Grape Harvest*, (Arles), 1888. Oil on canvas, 73×92 cm. Copenhagen, Ordrupgaard Collection.

83. Vincent Van Gogh, *Gauguin's Chair*, 1888. Oil on canvas. Amsterdam, Vincent Van Gogh Foundation, National Museum Vincent Van Gogh.

influenced by Van Gogh. In the first of these, *The Grape Harvest*, better known as *Human Misery*, it is evident in the paint thickly applied with a palette knife and in the Expressionist spirit of the portrait of poverty squatting in the foreground.

The other painting—*Madame Ginoux at the Café*—could even be considered an unconscious homage to Van Gogh, for three of the latter's most famous models appear in it. First, in the foreground is Madame Ginoux whose portrait, known as *L'Arlésienne*, Van Gogh painted from life in the café on the very same day that Gauguin painted his own in the studio from a series of drawings also done while his friend painted. Seated in the background are the models for *The Zouave* and *The Portrait of Joseph Roulin, Postmaster*. Also, the whole of the foreground—the table, the bottle of seltzer water, the billiard table and the cigarette smoke that zig-zags diagonally across the painting—reminds one of the spatial and descriptive conception and even the atmosphere of a Van Gogh. Gauguin recognized this: 'I have also painted a café scene that Vincent likes a lot and I like somewhat less. Basically speaking, it is not my kind of thing and the cheap 'local colour' doesn't appeal to me. I like it well enough in other people's work, but I am always apprehensive about it.'[34]

Van Gogh's other contribution to Gauguin's development was surely the reinforcement of the image of himself that Gauguin had already begun to impress upon his friends at Pont-Aven. He listened with fascination to Gauguin's stories of his childhood in Peru, his 'Inca ancestors', his life as a sailor and his sexual prowess: 'There can be no doubt that we have here a virgin being with primitive instincts. Gauguin's race and sexuality are stronger than his ambition.'[35] Two months earlier Van Gogh was clearly less overcome by him—he found Gauguin so formidable that it was said that he could paint his chair only, and not his portrait—for he had written a much colder analysis of his friend: 'I instinctively feel that Gauguin is a calculating person who, finding himself at the bottom of the social ladder, will use means that are of course honest, but also very shrewd, to reach the top.'[36] Admittedly this was written at a time when Gauguin, heavily in debt after having sold nothing, was in Pont-Aven hoping

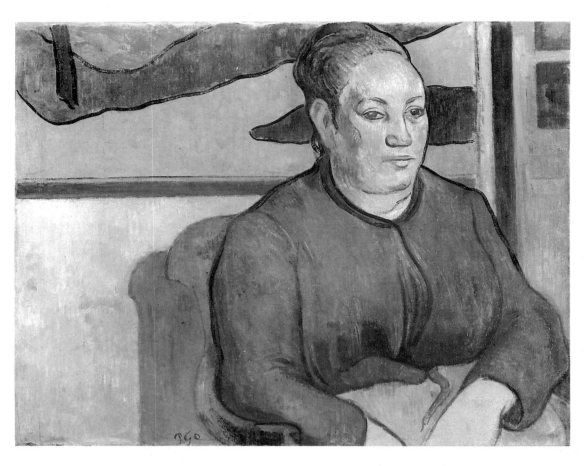

85. *Madame Roulin*, (Arles) 1888. Oil on canvas, 49×62 cm. Saint Louis, Art Museum.

86. Vincent Van Gogh, *Madame Roulin*, 1888. Oil on canvas, 54×65 cm. Winterthur, Oskar Reinhart Collection.

87. Vincent Van Gogh, *L'Arlésienne* (*Madame Ginoux*), 1888. Oil on canvas, 93×74 cm. Paris, Musée d'Orsay.

88. *Madame Ginoux at the Café*, 1888. Oil on canvas, 73×92 cm. Moscow, Pushkin State Museum of Fine Arts.

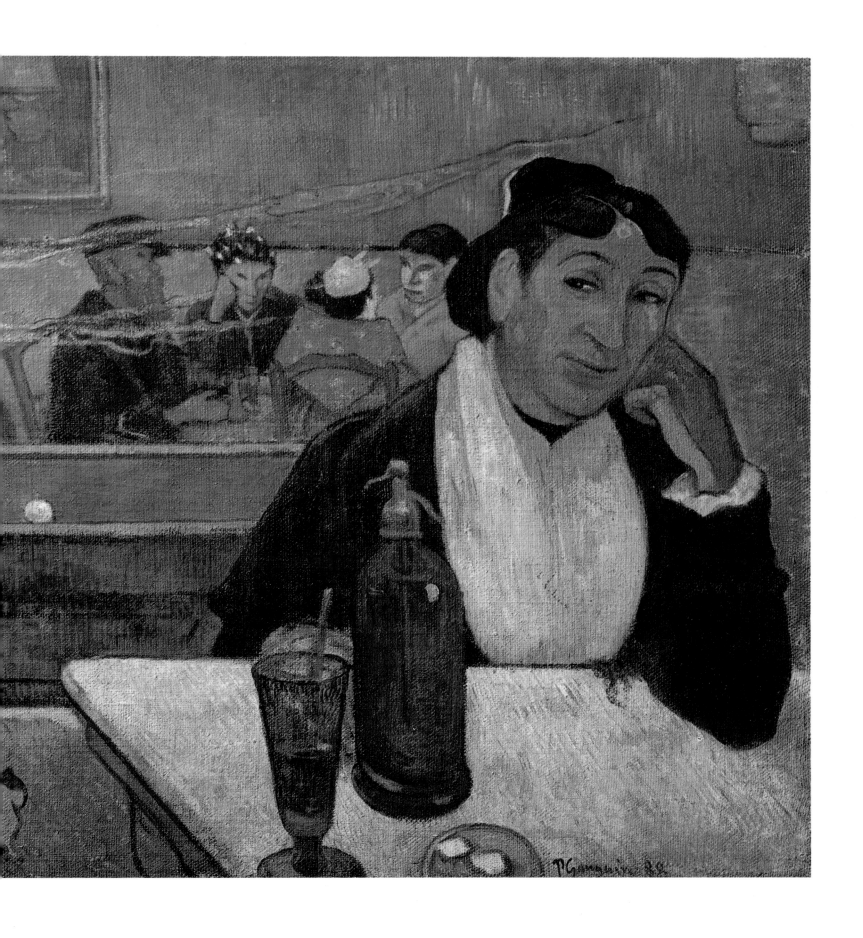

to hear from his wife and, remembering his earlier gift for making money on the Stock Exchange, had begun to build commercial castles in the air.

This ambivalent attitude, admiring and dependent but also suspicious and severe, was shared by everyone who knew Gauguin. Even his most 'uncritical' admirers recognized that there was something disturbing about a personality that was so strong—or rather, so determined to be strong—that friendship and even humanity was sacrificed to it. An independence of spirit that was all the more sensitive for being hard-won and fragile led him to invest all his energy in the glorification of his destiny, and resulted in what Jean Dolent referred to in Gauguin as the 'legitimate ferocity of a productive egotism.'[37]

We know the rest of the story. Van Gogh grew increasingly agitated and morbidly aggressive as he sensed Gauguin's need to leave Arles and escape an 'atmosphere charged with electricity'. He ended up checking on Gauguin as he slept in case he attempted to run away from the 'little yellow house' in the night, and watched the rise of an overpowering tension in himself with trepidation; as much as two months before Gauguin came to Arles his letters to Theo had drawn attention to a coming crisis. When he saw the portrait of himself painting sunflowers that Gauguin had made, a portrait that gave a potent impression of instability and unease, accentuated by the overhead angle that appears to thrust a blank-looking Van Gogh into some indeterminate place below ground, he exclaimed: 'It's definitely me, but me gone mad.'[38]

An excursion to the museum in Montpellier to see an exhibition of the Courbets and Delacroix from the Bruyas collection provided only a temporary respite, for each painting provoked heated arguments. Finally, on 23 December 1888, came the tragic conclusion to an alliance that Van Gogh had dreamed so much about. After a demented rage in the course of which Gauguin, fearing his friend would become dangerous, went to stay at the local hotel, Van Gogh turned his violence against himself and cut off a part of his ear. Perhaps secretly hoping to find Gauguin, he presented this macabre trophy to a prostitute at the house they had frequented. This incident resulted in Van Gogh's first internment in the hospital at Arles and Gauguin's immediate departure for Paris. Strangely enough, Gauguin is often condemned for having run away from the situation, but we should remember that he had come close to being murdered. Van Gogh never bore him a grudge, accepting his 'abandonment' with a humility that betrays a kind of satisfaction or perhaps even consolation. In fact, during this internment, one of the most painful in his life, he nevertheless painted the most serene and happy landscapes of his career. As for Gauguin, the least that he owed him was the idea of leaving for that island that had yet to be immortalized by anyone other than Pierre Loti, on which he would set up his 'Studio in the Tropics'.

89. *Vincent Van Gogh Painting Sunflowers*, 1888. Oil on canvas, 73×92 cm. Amsterdam, Vincent Van Gogh Foundation, National Museum Vincent Van Gogh.

In his journal written in the South Seas thirteen years later, *Avant et Après*, Gauguin tells how he came to paint this portrait just before the famous events of Van Gogh's madness and self-mutilation that provoked his own departure from Arles: 'I had the idea of portraying him painting the still life of sunflowers that he loved so much. Once the portrait was finished, he said "It's definitely me, but me gone mad." A year later Van Gogh wrote to his brother about this portrait: "My complexion has . . . become much clearer since then, but it's definitely me, utterly exhausted and charged with electricity, as I was then." ' (10 September 1889).

The angle at which it is painted is interesting and new. Gauguin looks down on a scene whose centre is the hand holding a brush. This is surrounded by empty space with the copper vase full of sunflowers on a rush-bottom chair on the left under the easel, and on the right is Van Gogh, the incarnation of defeat and anguish, looking as though he is about to faint. Gauguin gave this painting to Theo Van Gogh: 'From the geographical [*sic*] point of view it's perhaps not really like him, but I do think it has something that is very much a part of him, and you may keep it if you wish, unless you don't like it' (late December 1888). The painting does indeed suggest an arresting psychological truth, with something rather like a dominant relationship on Gauguin's side. But Van Gogh's agitation must have demanded enormous patience from a man that generally had little: 'My position here is very uncomfortable. . . I owe [Theo] Van Gogh and Vincent a great deal and, despite the occasional disagreement, I cannot resent such a kind heart while it is ill, suffering and in need of me' (to Schuffenecker, around 20 December 1888).

90. Eugène Delacroix, *Death of Sardanapale*, detail, 1827. Oil on canvas, 392×496 cm. Paris, Musée du Louvre.

91. *In the Hay*, 1888. Oil on canvas, 73×92 cm. London, Private Collection.

Diverses
Choses

1896. 97.

Notes éparses, sans suite comme les Rêves,
comme la vie toute faite de morceaux.

Et de ce fait que plusieurs y
collaborent ; l'amour des belles choses aperçue
dans la maison du prochain.

This landscape in Arles—the woman in the strolling couple is wearing traditional Arlesian costume—at sunset was painted on a winter's day in the light peculiar to the Mistral (which can be deduced by the fish-like elongation of the clouds). 'The weather here is cold but there are some beautiful things to see. Like a sunset the colour of a sick lemon yesterday evening—mysterious with extraordinary beauty,' wrote Van Gogh to Theo at the end of November 1888.

This remarkable painting, with its slender bright blue tree-trunks linking the yellow-ochre ground to the acid-yellow sky, is the precursor of all those sacred woods with stylized tree-trunks cut off by the top of the canvas favoured by the Nabis in the 1890s and that give their rhythm to many of Maurice Denis's paintings—especially the celebrated *Muses* in the Musée d'Orsay.

Gauguin used this painting in the background of his portrait of *Madame Roulin* (fig. 85); one can easily recognize the bottom half of it, for he simply left out the three trees on the right to simplify the background for the face of a woman immortalized by both himself and Van Gogh.

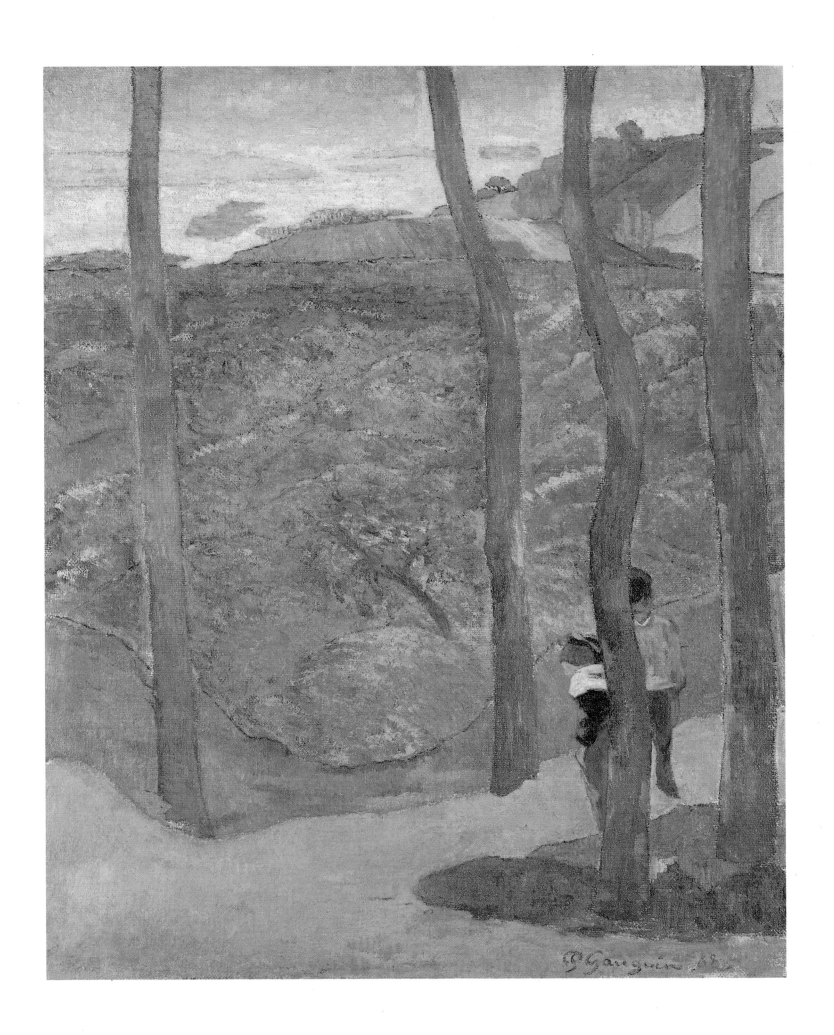

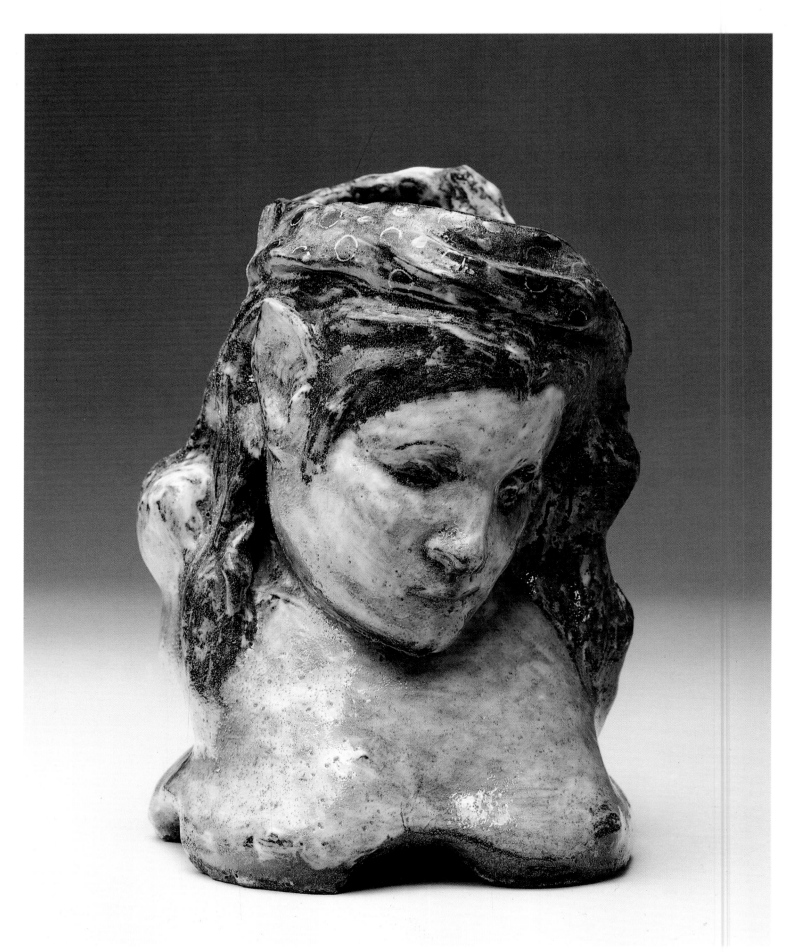

95. *Vase in the Form of a Woman's Head, Madame Schuffenecker*, 1889. Glazed stoneware with gold highlights, 24.2×16.8×17.8 cm. Dallas, Museum of Art.

4

GAUGUIN,
BAUDELAIRE
AND THE EIFFEL TOWER

1889

The transposition of daily life into legend.

Baudelaire.

The 1889 Universal Exposition applauded the bourgeois, industrialized and Republican society of the *fin de siècle* in the very year in which, paradoxically, all the rebellions—regardless of whether they were Anarchist or Symbolist, since most of the young artists and writers of the time supported both—against the official powers characterized by this triumphant positivism, came to the boil.

While Gauguin was in Brittany and Provence developing his style in a direction that was increasingly idealistic and esoteric, *Les Données immédiates de la conscience* by Bergson, *L'Art symboliste* by Georges Vanor and *Les Grands Initiés* by Edouard Schuré were published in the space of a few months, and Charles Morice suddenly became 'the soul and conscience of the movement' after the publication of *Demain, question d'esthétique* (1888) and *La Littérature de tout à l'heure* (1889).[1] His success among the younger Symbolist poets was a measure of the hopes of their generation and the ideas that were in vogue at the time.

He preached a return to nature, to man's origins, to the great forgotten traditions, legends and myths as a way of escaping the artificial and adulterated modern world; in other words, a return to the common sources of humanity whose primitive symbolism alone could re-establish a connection with 'the absolute'. The prime example of these beliefs was the work of Wagner.

So it is easy to see how the Symbolist Paris that Gauguin rediscovered early in 1889 after his long absence might have reflected the image of his growing prestige. As a rebel, an outcast artist already surrounded by an aura of exoticism and determined as a painter to go beyond the frivolity of Impressionist naturalism in quest of a timeless art, Gauguin was on the way to becoming the Wagner of painting and the painter of poetry.

Apart from the painter Daniel de Monfreid, Gauguin's new friends were all young poets and critics like Albert Aurier and Charles Morice and, from then on, his friendships and support came mainly from literary circles. Hence a surfeit of discussions and reading can explain why, apart from a short stay in Pont-Aven, Gauguin worked so little in the few months that followed the conflicts in Arles. The only major painting from this Paris period is the sarcastic portrait of the Schuffenecker family with whom he was staying. With a great simplicity of touch he used the principle that he later claimed to have taught Van Gogh, that of the juxtaposition of non-complementary colours, for the first time. The red of the children's clothes surrounded by a variety of yellows diametrically and straightforwardly opposes the upper part of the composition ('Schuff', the wall, the window) painted in a harmony of blues and greens. Making use of only the top half of the woman's yellow coat, he skilfully opened a channel between the patches of warm colours below it and the cold colours above.

Although he hardly painted, he did spend several weeks at the newly opened Universal Exposition taking in essential visual information for his future work. He was not the only one to go gleaning in this lavish self-glorification of triumphant European industry and colonialism. All the painters went there to stock up on ideas: the lacework of the Eiffel Tower honeycombing a luminous sky was the main attraction for a Pointillist like Seurat, and Buffalo Bill's fabulous cavalcades—the Far West, horses and a circus—had everything required to enchant Toulouse-Lautrec. Gauguin was fascinated by the model of Angkor, the Javanese dances and the reproductions of Indian temples of which he already had some photographs, having first discovered them in the recently opened Musée Guimet.[2]

He also carefully surveyed the architecture of the exhibition pavilions and, no doubt impressed by the unadorned framework of the Hall of Machines compared to the ugliness of some of the iron constructions camouflaged by academic decoration, he wrote a text of remarkable modernity and accuracy in a year in which—unknown to him—the first skyscrapers were being built in Chicago. He wrote intelligently about the Eiffel Tower that the Symbolists found so hideous—'ironmongery painted in veal juice'[3]—praising functional beauty in the tradition of Viollet-le-Duc's *Entretiens* by insisting that 'stone should look like stone, iron like iron and wood like wood'. In light of the later decorative use of iron in Art Nouveau by such people as Gaudi, Horta and

96. Photograph of the Schuffenecker family.

97. *Schuffenecker's Family*, 1889. Oil on canvas, 73×92 cm. Paris, Musée d'Orsay.

This canvas was painted at 29 Rue Boulard, in the studio belonging to Schuffenecker, Gauguin's faithful friend who regularly put him up. Despite the affectionate dedication, 'best wishes to my good Schuffenecker', it is a strange family portrait.

The two children united in the same red in the centre are painted with a certain tenderness, but Gauguin treated the parents without tact, just as he did in life. The wife, whom it is said Gauguin closely courted, looks tense and embittered and her clenched hand reminds one that Gauguin once called her a harpy in a letter to Mette. In a later letter (to Monfried, 1893), Gauguin judged his old friend—to whom he had nevertheless written some of his best letters about painting—as 'born to be a simple workman,

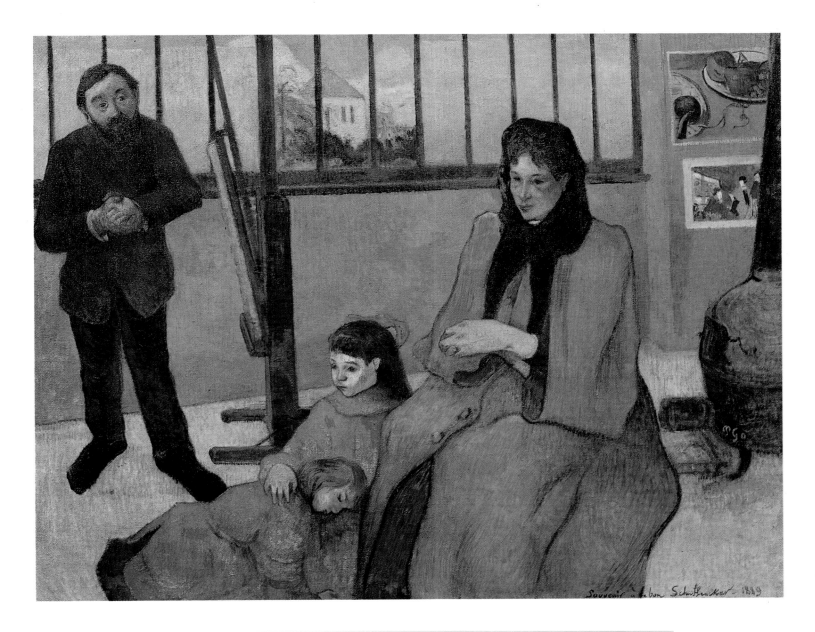

concierge or small shopkeeper', in other words, anything but an artist. Although he placed him before his easel, he is not painting, but standing there in his slippers in obsequious contemplation of his wife and perhaps Gauguin himself.

Gauguin built his painting on the contrast between the two large areas of complementary colours, the yellow and the blue, and conspiratorially gave away one of the keys to his composition in the Japanese print of a group of three people in an interior visible behind the stove on the right.

98. Poster for the exhibition at the Café Volpini, 1889.

GROUPE IMPRESSIONNISTE ET SYNTHÉTISTE

CAFÉ DES ARTS
VOLPINI, Directeur

EXPOSITION UNIVERSELLE
Champ-de-Mars, en face le Pavillon de la Presse

EXPOSITION DE PEINTURES
DE

Paul Gauguin	Émile Schuffenecker	Émile Bernard
Charles Laval	Louis Anquetin	Louis Roy
Léon Fauché	Daniel	Nemo

Paris. Imp. E. WATELET, 55, Boulevard Edgar Quinet.

Affiche pour l'intérieur

N° 81

99. Universal Exposition, Paris 1889. Entrance to the Javanese Kampong. Published in *L'Illustration*, 1889.

Guimard, Gauguin's article today seems like an exhortation: 'Architecture is only at its beginnings in the sense that it has not yet been given a decoration that is in *harmony with its nature*. Why put soft materials next to iron which is so rough and stark? Why add all the old stocks of antique ornaments modernized by naturalism to those fresh geometrical lines? Engineers and architects have a new form of decoration at their disposal, such as ornamental rivets or iron corner-pieces that stick out from the main structure like a sort of Gothic iron lace-work. A little of this can be seen in the Eiffel Tower.

'Imitation bronze statues clash with iron. Endless imitations! It would be better to have monsters, as long as they are made of nuts and bolts.

'Also, why paint iron the colour of butter, why gild it like the [Paris] Opera? No, it is not good taste. *We need iron! iron and yet more iron!*'[4]

The colonial pavilions and the problems posed by metal architecture were more attractive to Gauguin, as one can imagine, than the artistic section of the Exhibition, which was almost entirely devoted to official art despite the critic Roger Marx's attempt to include some Impressionist paintings. As for Post-Impressionism, that was out of the question, which is why Gauguin and some of his friends decided to take advantage of the crowds at the Universal Exposition to display their paintings on the fringe of the official show, at the Café Volpini on the grounds of the exhibition itself.

In his letter of agreement to Schuffenecker, who found the location, Gauguin listed those whom he wanted to be part of it. Guillaumin, Bernard, Van Gogh and a few others were named, but there was no chance of inviting Pissarro, Seurat, Signac, etc. 'This is *our* group!'[5] he exclaimed. The split between the two greatest Post-Impressionists, himself and Seurat, was now out in the open and final. As for Theo Van Gogh, he refused to let his brother take part because it would make him look as if he had 'gone to the Universal Exposition up the back stairs'.[6] Gauguin returned briefly to Paris to look after 'his group', giving Émile Bernard the lion's share of the show with twenty canvases, while he himself showed only seventeen, including works from Arles, Martinique and Brittany.

The problem came up of how to label themselves. This exhibition raised a question that was not merely a matter of language. When Gauguin or Van Gogh spoke of themselves, they always referred to themselves as 'Impressionists', not out of solidarity with Monet, Renoir and their group—who in any event were no longer particularly united, since their last exhibition took place in 1886—but simply to distance themselves from official art. In those days the designation 'Impressionist painter' covered

100. Universal Exposition, Paris 1889.
The Eiffel Tower. Photograph.

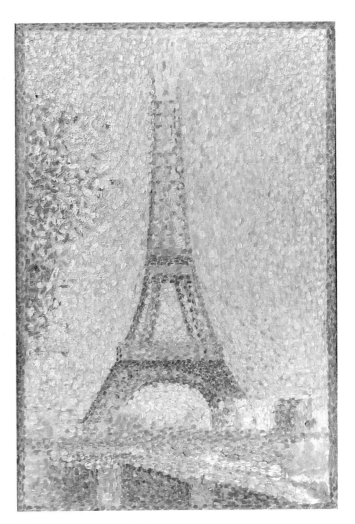

101. Georges Seurat, *The Eiffel Tower*,
1888-1889. Oil on canvas, 24×15 cm.
San Francisco, Fine Arts Museum.

102. Universal Exposition, Paris 1889.
The Hall of Machines. Photograph.

any nonconformist or colourist who did not belong to a school or the Salon circuit. Since 'Impressionist' on its own did not describe their painting, they opted for 'Impressionist and Synthetist Group', though Guillaumin, who had been included more out of camaraderie that for his stylistic affinities, was at the time a pure Impressionist in the full meaning of the term as it is used today.

The exhibition was a failure. Not a single painting was sold and little was written about it. Angry and depressed, Gauguin returned to Brittany without realizing that the exhibition had revealed his work at last to all those young painters who were already so interested in his ideas.

As a matter of fact, in the village of Le Pouldu, where Gauguin moved in the summer of 1889 because it was less overrun by trend-setters from Montparnasse or Montmartre than Pont-Aven, he figured as the leader of a new school, which far from displeased him. Toulouse-Lautrec, who had no liking for his solemn and peremptory behaviour, nicknamed him 'the professor',[7] and indeed he lived up to the name because of his need to talk about his ideas at great length as if to clarify them to himself, and the rather authoritarian fascination that he exercised over the younger generation. Sérusier had passed on Gauguin's aesthetic principles, no doubt much reinterpreted, to those friends who were dissatisfied both with official teaching and Impressionism on his return to the 'little studio' of the Académie Julien the previous autumn. This young group of painters for whom Sérusier acted as go-between with Gauguin included Pierre Bonnard, Edouard Vuillard, Maurice Denis, Ker-Xavier Roussel, Félix Vallotton and Aristide Maillol, and, half in jest and half seriously, they had dubbed themselves the 'Nabis', which means 'prophets' in Hebrew. As soon as the spring of 1889 arrived, Sérusier rejoined Gauguin in Pont-Aven. It was not long before he discovered that he had gone much further towards a systematic abstraction than the Master had ordered, and that, at least in his intentions, he had come closer than Gauguin to the modern meaning of the word: 'I discovered a number of points in his thinking on which we disagree.'[8] Nevertheless, the conversations between Sérusier and Gauguin revolved around a detachment from the real, as can be seen in the letters from Sérusier to Maurice

103. Paul Sérusier, *The Talisman*, 1888. Oil on wood, 27×22 cm. Paris, Musée d'Orsay.

The young students at the Académie Julien including Bonnard, Ibels, Ranson and Maurice Denis shared Sérusier's services as bursar of their studio. 'It was after his return from Pont-Aven at the end of the summer of 1888 that Sérusier first revealed Gauguin's name to us. With an air of mystery he unveiled a cigar-box lid on which there was a landscape that had been rendered formless through its synthesized transformation into areas of purple, vermilion, Veronese green and other pure colours taken straight from the tube, with barely a touch of white mixed in.—"How do you see this tree?" Gauguin had asked in a corner of the Bois d'Amour. "Is it really green? Paint it green then, the most beautiful green on your palette; and this shadow, rather blue? Do not hesitate to paint it as blue as possible." It was in this paradoxical, unforgettable way that we were first presented with the fertile concept of "a flat surface covered with colours assembled in a certain order". It was thus that we learned that all works of art are a transposition, a caricature and a passionate translation of a received sensation.' The present 'historic' painting on the back of which Sérusier had carefully noted 'painted 11 October 1888 under the supervision of Gauguin' demonstrates the major influence that Gauguin had on the development of the young Nabis Denis, Bonnard and Vuillard.

Denis, which may have laid the ground for their recipient's celebrated manifestos. In any case, the young Nabis rushed to the Café Volpini, and what they saw there was to be extremely useful in the formation of their style, especially for Bonnard, Denis and Maillol.

Félix Fénéon, whose absolute devotion to Seurat and the Neo-Impressionist cause never stood in the way of his judgement, summarized his impressions as a 'connoisseur' in his delightful *fin de siècle* style, managing to distance himself enough to make what he said quite historically accurate. By 1889 he was already perfectly aware that the apparent conflict in style between Seurat and Gauguin arose from shared pictorial problems born of the need to go beyond Impressionism. He acknowledged the same effort to achieve 'an art of synthesis and premeditation' in the work of each. A new art was being born in which, even more for Gauguin than for Seurat, reality had become no more than 'a pretext for creations that are far removed from it; [Gauguin] reorganizes the components it provides him with and disdains the *trompe l'œil*, even the *trompe l'œil* of atmosphere. He emphasizes his lines, keeping them to a minimum and hierarchizing them; and in each of the spacious cantons that interlace them, an opulent and heavy colour mournfully enriches them without touching the neighbouring ones, and while remaining unchanged itself.'[9]

1889-1890, the period of Cézanne's first *Card-Players*, Seurat's *Le Chahut* and Gauguin's *La Belle Angèle*, was a turning point in the history of painting. The entire traditional concept of art that had been consecrated by the Renaissance was abruptly overturned. Painting had always been an expression of reality, whether religious, ideal, epic or sensory as, for example, in the paintings of Raphael, Poussin, Delacroix or the Impressionists. Until then painting had subordinated form to intent and the pictorial to the real. One single painter had worshipped the work of art as divine, and this was Freinhofer, the fictional hero of *Le Chef d'œuvre inconnu*, Gauguin's favourite short story by Balzac. Through Seurat, Gauguin and Cézanne—who, though a contemporary of the Impressionists, was forcing modern painting to take great strides because of his personal style—the overall Post-Impressionist movement began giving form a primary role and making the painting itself its own reality and ultimate goal.

At this stage in his progress we can at last seriously discuss Gauguin's ideas, even his aesthetic theories. We have reached Synthetism, though of course the word existed during the search for unity among all the arts that the Symbolists attempted during this period. By the summer of 1888 Charles Morice could write that 'the most important aesthetic development at present is the obvious effort to synthesize all the arts into each individual art [form].'[10] The essence of what Gauguin, more than anyone, had tried to formulate into an absolute in painting, bearing in mind the confusion that such an ambition implied, was Synthetism; but Synthetism was also and above all a technical term, which initially borrowed some of the ideas of Bernard's and Anquetin's Cloisonnism. Here, in any case, is the interpretation shared by all the Pont-Aven painters at the time of the Café Volpini exhibit: the artist synthesized his impression of a real object by extracting its significant components from it; he was helped in this by his choice of an unadulterated colour that he simplified, giving it neither tonal values nor modelling, and of a line that united the whole and balanced the composition decoratively; lastly he ignored depth and space in favour of *style*. The aim, therefore, was not to reproduce an object, but to create something new from it. Thus painting was given a life of its own and was in some way sanctified; its values came from its internal harmony and everything in it referred back to itself. This was the last theoretical analysis prior to Cubism and Abstract Art. However, the man who formulated the principles that were to usher in a new age in painting was not Gauguin, though he was the first to establish its aims, but a young painter who was not yet twenty in that summer of 1890, Maurice Denis. His manifesto began with the now famous statement: 'Remember that a painting, before being a battle-horse, a nude woman or some anecdote, is essentially a flat surface covered with colours assembled in a certain order.'[11]

Who was the first of these painters to use the word 'synthetism' and what meaning did each of them attach to a concept that in the final analysis is rather vague? According to a painter who met Gauguin in Pont-Aven, Gauguin was already calling his painting 'synthetist' in 1886.[12] Whether it was he or Sérusier, or Émile Bernard, so drawn to abstractions, who first voiced an idea already latent in Symbolist concepts to describe painting is not very important, but there is one source, a literary source, that could be said to be common to all the elaborations of these aesthetic ideas. The part played by Charles Baudelaire in the birth and growth of Symbolist poetry is well known, but his importance in the history of the painting of the period has perhaps been underestimated.

The painters reaching beyond Impressionism, which they considered 'too close to the eye', evolved in a cultural context that was divided between a scientific materialism and an idealistic, even mystical rejuvenation that was most visible in Symbolist poetry. Some, like Seurat, thought that they could find truth through science; others, like Gauguin, sought it through poetry. But for all of them Baudelaire was the 'master to follow' and the ultimate example, though often for different reasons. For preaching the 'painting of modern life' and writing axioms such as 'in some areas the colourist's

104. *Portrait of Two Children*, 1890. Oil on canvas, 46×61 cm. Copenhagen, Ny Carlsberg Glyptotek.

This painting is generally dated 1894-1895 but is much more likely to have been painted at Le Pouldu in 1890. The age of the two little girls is close to that of the daughters of Marie Henry, in whose house Gauguin lived, the second of whom, then aged one, was the daughter of Meyer de Haan. The abrupt opposition of pink and yellow, red and blue is reminiscent of Gauguin's daring use of colour in 1889-1890, which we saw in *Vision after the Sermon* (fig. 65), *Schuffenecker's Family* (fig. 97.) and in *Still-life with Japanese Print* (fig. 119), and which would later be characteristic of his painting in Tahiti.

We are instantly reminded, of course, of

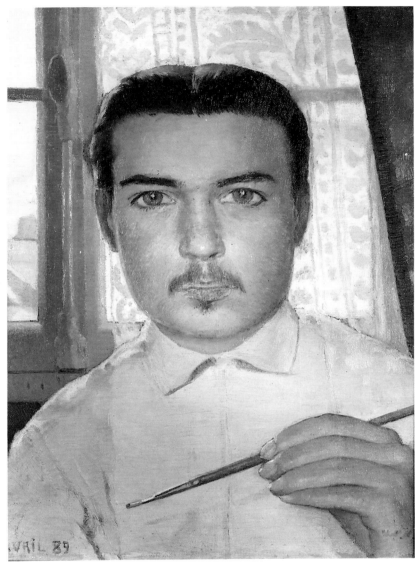

106. Maurice Denis, *Self-portrait*, 1889. Oil on canvas. Private Collection.

105. Maurice Denis, *La Tache rouge*. Oil on cardboard, 20×20 cm. Paris, Musée d'Orsay.

those rather monstrous babies painted by Van Gogh in 1888 that Gauguin saw in Arles. Like Van Gogh's *Bébés Roulin*, these children are not at all complaisant or insipid. If the baby in the background, in spite of a possible club-foot, is charming with her blue eyes, bib and coquettish Breton doll outfit, the little girl in the foreground, conversely, is somewhat terrifying: she is staring with concentrated hostility and malice, wearing an ill-natured expression that probably rather attracted the painter, or at least he had fun showing it in this unusual painting.

art is obviously drawn from mathematics and music',[13] he was adopted as the godfather of Neo-Impressionism. Like the Neo-Impressionists, Gauguin enthusiastically read Baudelaire's *Les Curiosités esthétiques* and *L'Art romantique*, probably as soon as they appeared in 1885, certainly, at least, in 1888, when the first complete edition came out. 1888-1889 was assuredly Gauguin's most productive period for aesthetic discoveries of all kinds, as well as for Bernard, for, during the time they spent together in Pont-Aven they endlessly discussed Baudelaire's theories. They gave most of their attention to what he said about Constantin Guys, for interestingly enough there is a passage in *Le Peintre de la vie moderne* that already expressed all the themes that concerned Gauguin.

For example, Baudelaire clarified his use of the word 'primitive'—a word that had already fascinated Gauguin at Pont-Aven. He did not intend to describe a crude or formless art, but 'an unavoidable primitiveness, that is to say a synthesized and childlike quality often found in art that is in fact perfect (Mexican, Egyptian or Assyrian), and that comes from the desire to see things with grandeur, and above all to grasp their effect as a whole', and he commented as far as back as 1863 that many people 'have called any painter whose eye synthesized and abbreviated a subject a barbarian, like

Mr Corot for instance, who first and foremost traces the main outline, the flesh and bones of a landscape'.[14] This naturally brings to mind Gauguin's and Bernard's plan to produce 'children's painting' in Pont-Aven in 1888, not to deliberately create something naïve, but to develop Baudelaire's ideas about an art that 'synthesized and abbreviated'. One painter who did carry out Baudelaire's ideas and who could not have existed without Gauguin, but who was much better at seeing things 'as a whole', and who reached the state of grace and the fresh vision of a child through an abbreviation that was intensely sophisticated, was Henri Matisse.

If the Café Volpini exhibition took 'Impressionist and Synthetist Group' as a title, the second word must be interpreted literally in its full Baudelairian sense. It is interesting to see Egypt associated with Synthetist art in Baudelaire's work, for by then Gauguin had long believed that its symbolic and hierachical art possessed an exemplary nobleness. And yet it was his rival brother-in-art Seurat who was criticized in 1886 for his 'Egyptian archaism' when, under the Neo-Impressionist 'confetti' of *La Grande Jatte,* a number of critics perceived an Egyptian composition. As we shall see, Pharaonic art would have an even more direct impact on Gauguin's work once he

reached Tahiti. When Henri Matisse bought the first specimen of that African art which, through Picasso and Braque, was to play such a major role in the development of Cubism, at first he thought it was an Egyptian piece, so strong was the nineteenth-century tendency to trace any art that was both archaic and formally constructed back to the Nile.

From 1884 to 1886, at the time of his friendship with Pissarro and his brief encounter with Seurat, Gauguin, like them, paid particular attention to what Baudelaire had said about colour when describing Delacroix. In other words, Gauguin had read Baudelaire as a painter; but in 1888-1889, when he was searching for a definition for his art, he referred to the writer as a writer for, now that he was the painter of the poets, he needed more than information on Delacroix. Literature rather than Art became the origin of the new formal system that he was confusedly developing in fits and starts at Le Pouldu. The period from the Universal Exposition of the spring of 1889 to his departure for Tahiti would be one of the most fulfilling and inventive of Gauguin's career, the one in which, for the first time perhaps, his achievements reached the heights he had wished for.

107. Émile Bernard, *Caricature*. Paris, Musée du Louvre, Department of Drawings.

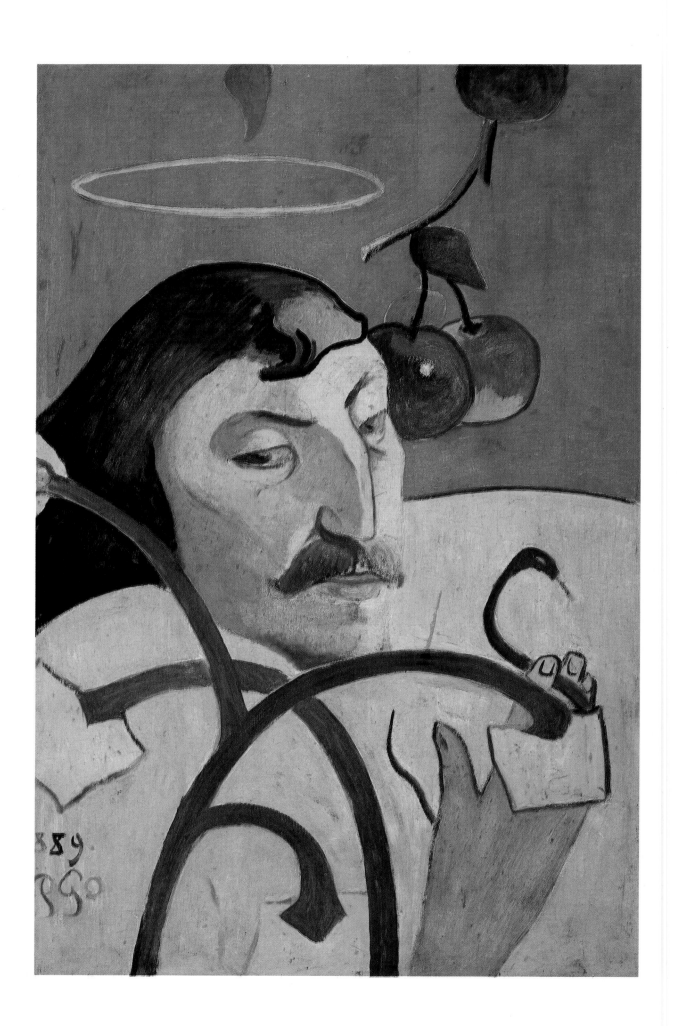

THE 'PREY OF THE MEN OF LETTERS'
1889-1890

108. *Self-portrait with Halo*, 1889. Oil on wood, 80×52 cm. Washington, National Gallery of Art.

This amazing portrait is indicative of Gauguin's state of mind and of the ambivalent and provocative image of himself that he projected at that period. It is first of all a caricature, a *'portrait-charge'* to complement his painting of his friend Meyer de Haan (fig. 109). Both the portraits, like a bizarre pair of saints on a new kind of tabernacle, were applied on the doors of a little cupboard in Marie Henry's dining room in Le Pouldu. However, despite its irony, the painting overflows with allusions: the halo denotes the hero-saint of art, the fallen angel; the apples stand for a lost paradise (the books on the table in front of Meyer de Haan in the adjoining portrait are Carlyle's *Sartor Resartus* and Milton's *Paradise Lost*) and mean that Gauguin had 'fallen' because he wanted to possess knowledge. The snake between his fingers, a reptile that has been associated with soothsayers since time immemorial, confirms that Gauguin had pictorial 'Knowledge' and that he was the 'Master' of the little community of Le Pouldu. The affirmation of his *self*, his humour and mischievousness are all transcribed with an exceptional eloquence that is reinforced by the violent association of red and yellow.

The Primitives did all that much better.

Van Gogh, 1889.

During the two years preceding Gauguin's departure for Tahiti, his art had evolved in two apparently opposite directions: on the one hand was the increasingly direct influence of the Symbolism of his contemporaries, and on the other was a definite movement towards a simplified, rhythmic and decorative style that ignored literary allusions and the descriptive; in other words, towards painting that was self-sufficient. The atmosphere and the subjects of some of his paintings enable someone aware of what was then fashionable in literature to date them exactly, and yet their technique places them far in advance of their time. In fact, despite his occasionally literary intentions, Gauguin was moving in the direction of 'pure painting', though the intellectual content of those in which he thought he was being metaphysical often obscured what he was actually contributing to modern art. Thus, though the lime and flame colouring of his famous *Yellow Christ*, rendered even more strident and acid by the Breton woman's pink bonnet, is almost brutally Fauvist, his contemporaries were more impressed by the deliberate archaism of the composition, taken from the painting of Christ

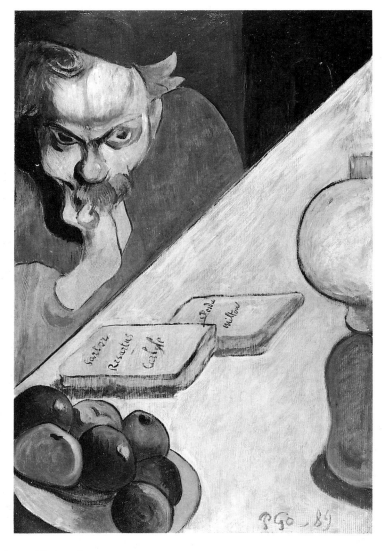

110. *Bonjour Monsieur Gauguin*, 1889. Oil on canvas, 113×92 cm. Prague, Národní Gallery.

109. *Meyer de Haan*, 1889. Oil on wood, 79.6×51.7 cm. New York, Private Collection.

in the church in Trémalo near Le Pouldu. Another detail that probably clouded his pictorial innovations for his contemporaries was that he had even 'synthesized' his signature, contracting it to *P. Go*, in his increasingly methodic use of primitive mannerisms and borrowings from other cultures. At the time Symbolist critics were attracted solely by the emotional aspects of this 'piteous and primitive Christ' set in an 'agonizing'[1] yellow landscape, in spite of its remarkably audacious formalism, and their approval encouraged Gauguin to carry his extra-pictorial ideas even further.

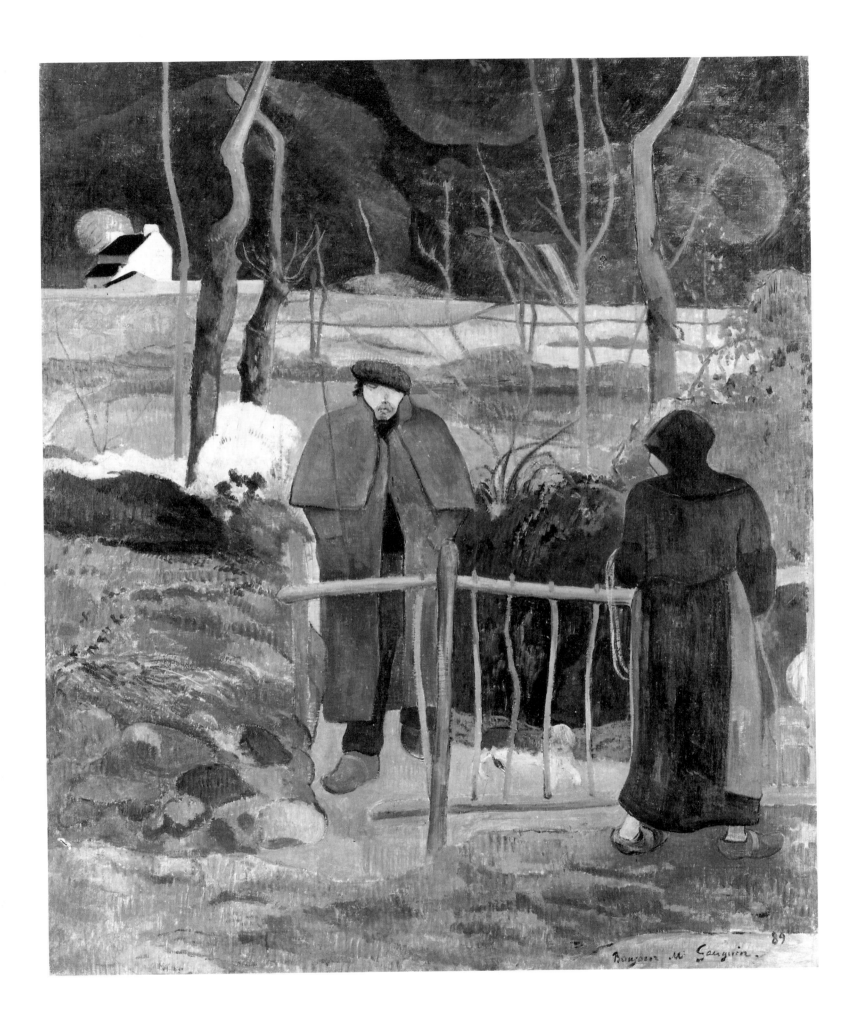

Bonjour M. Gauguin.

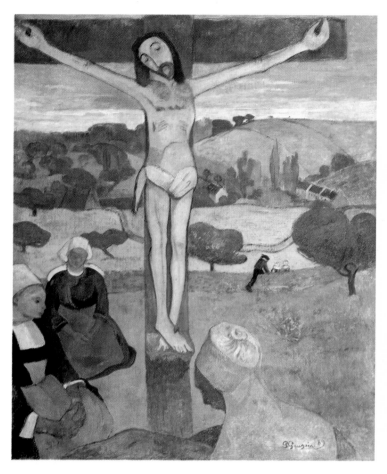

111. *Yellow Christ*, 1889. Oil on canvas,
92×73 cm. Buffalo, Albright-Knox Art
Gallery.

112. *The Green Christ*, 1889. Oil on
canvas, 92×73 cm. Brussels, Musées
Royaux d'Art de d'Histoire.

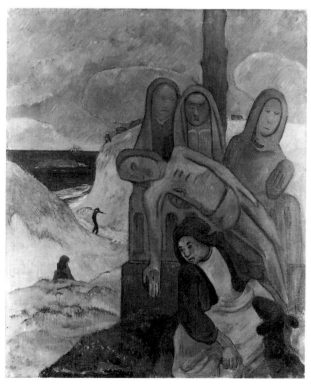

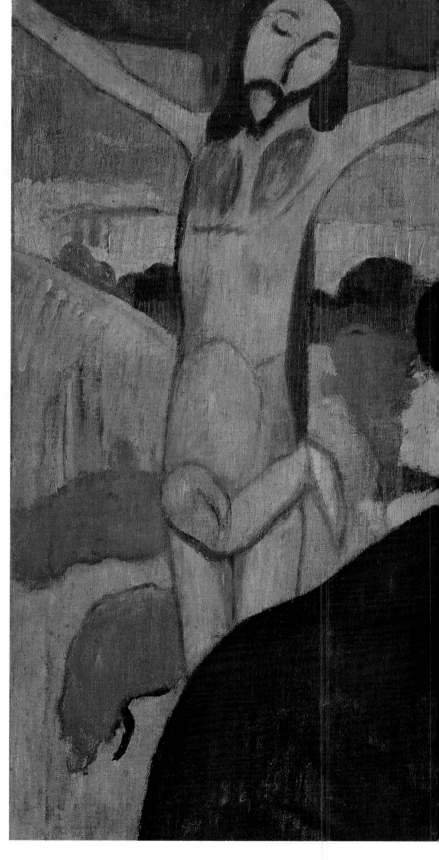

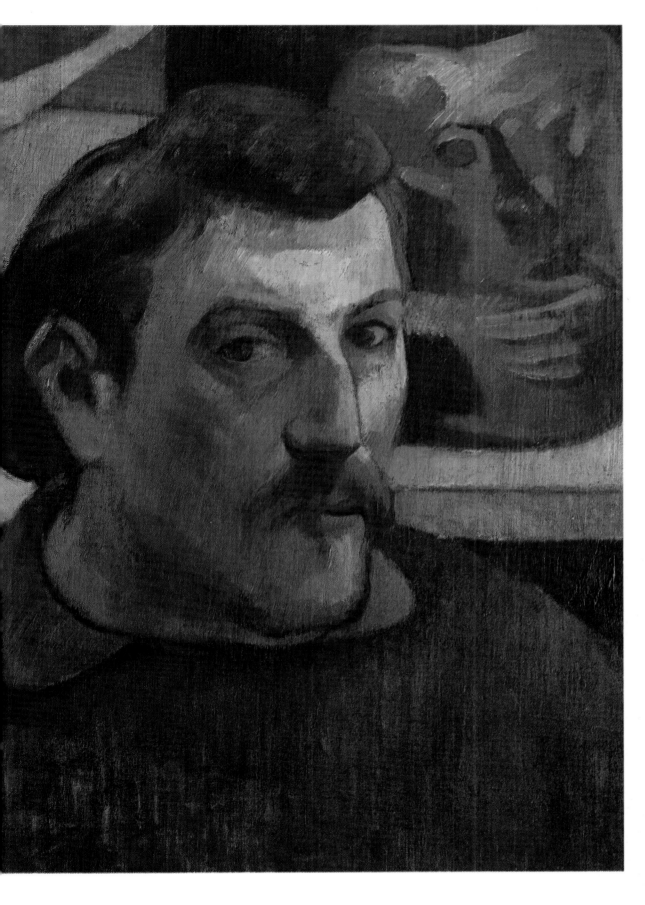

113. *Self-portrait with Yellow Christ*, 1889-1890. Oil on canvas, 36×46 cm. France, Private Collection.

Gauguin gives us a self-portrait of outstanding truthfulness in this painting from the winter of 1889-1890 spent at Le Pouldu. He is in front of two recent works that inspired pride in him: the *Yellow Christ* (reversed because he painted himself in front of a mirror) and a glazed earthenware tobacco jar made in the image of his own face. The whole is a sort of symbolic triptych; here he is facing us, painted without compromise or pathos, wearing his everyday Breton seaman's jersey and an expression both reserved and bitter. The two other images also portray him—the yellow Christ who appears to stretch his arm protectively over his head is the martyred hero with whom Gauguin identified in a self-portrait of the same period, *Christ in the Garden of Olives* (fig. 122), and the pot on the right is one that he himself described as 'a vague representation of Gauguin the savage' in a letter to Madeleine Bernard. It represents his yearning to return to primitive sources both in its style and in its expression, like that of a monstrous child anxiously sucking its thumb. In short, on the left he painted his sublimated and sacrificial 'self', and on the right his hidden childlike 'self'; both frame one of the most realistic of his many self-portraits.

This painting was bought by Maurice Denis the year Gauguin died; he hung it in his dining-room opposite a self-portrait by Van Gogh, thus reuniting those whom his young painter-guests of the beginning of the next century would see as the two undisputed heroes of modernism.

It must be said that that his Symbolist tendencies were not always in the best of taste. With a sort of brave candour, Gauguin felt it necessary to litter his paintings with literary references, as in one of his portraits of Meyer de Haan, his friend in Le Pouldu. De Haan was a Dutch mystic who led Gauguin to that path without really keeping him on it; Gauguin portrayed him as a Satanic figure with Carlyle's *Sartor Resartus*, which was probably one of the subjects of their discussions together, placed next to him as an emblem. It is easy to understand what they must have seen in this Romantic idealist who had made war on the industrial rationalism of the Victorian era almost fifty years before.

La Belle Angèle, painted in the same period, is a simpler recapitulation of his pictorial concerns. The young Breton woman in regional costume whom Theo Van Gogh aptly described in a letter to Vincent as 'a pretty young cow', is placed in a circle in the manner of some Japanese prints. The emphasis on the descriptive title of the painting, written in large letters at the bottom left, is another feature of Far Eastern art. Cézanne in fact had used this device twenty years earlier in his *Portrait of Achille Empéraire*. As he had done in *Self-portrait with Yellow Christ*, Gauguin placed a piece of his own pottery in the painting's background as if to give it a second signature and an air of oddity and coarseness. The pot is in the form of a seated 'primitive idol', and no doubt Gauguin meant it to indicate the sombre primeval aspects of the Breton character. The same thing could be said about the shy young woman, who is framed between the heraldic arms of Anne of Brittany and a piece of pottery as though she were caught between two playing-card images, proving that Gauguin's Symbolism was often no more than an allegory.

The conception of the Breton *Eves* and *Ondines* painted at Le Pouldu was also literary, but their vigour and the pronounced style of their curling lines make them among the earliest examples of Art Nouveau in painting. The two paintings reproduced here were exhibited at the Volpini Café, and their influence on the Nabis, especially Valloton and Bonnard, is obvious. These Breton nude bathers, reduced to essentials in an indeterminate and timeless landscape, are the first explicit expression of

115. *La Belle Angèle*, 1889. Oil on canvas, 92×73 cm. Paris, Musée d'Orsay.

When the art dealer Theo Van Gogh received the canvases that Gauguin sent from Brittany in the autumn of 1889, he immediately chose this one: 'There is a canvas that is once again a really handsome Gauguin. He calls it "La Belle Angèle". It is a painting laid out like the large heads in Japanese prints. . . . The woman somewhat resembles a pretty young cow, but there is something so fresh and yet so countrified about her, that it is a pleasure to look at' (to Vincent Van Gogh, September 1889). He was very observant, for this portrayal of a bust in a circle and the inscription of the model's name comes straight from Hokusai's and Hiroshige's portraits of actors. The model, Angèle Satre, was considered the prettiest woman in Pont-Aven, so she was naturally not flattered by the portrait, and refused it as a gift. 'Gauguin was very upset,' she told Charles Chassé. 'He said disappointedly that he had never painted such a good likeness.' Gauguin must indeed have felt that he had conveyed the 'primitive' splendour of Breton culture through the costume, the bonnet, the cross and the animal naïveté of the young woman's face, and he accentuated it by juxtaposing the beautiful Angèle with the piece of 'barbarian' pottery, inspired by Peru, that looks like an enigmatic little duplicate of her.

114. *Eve*, 1889. Pastel and watercolour. San Antonio, McNay Art Institute.

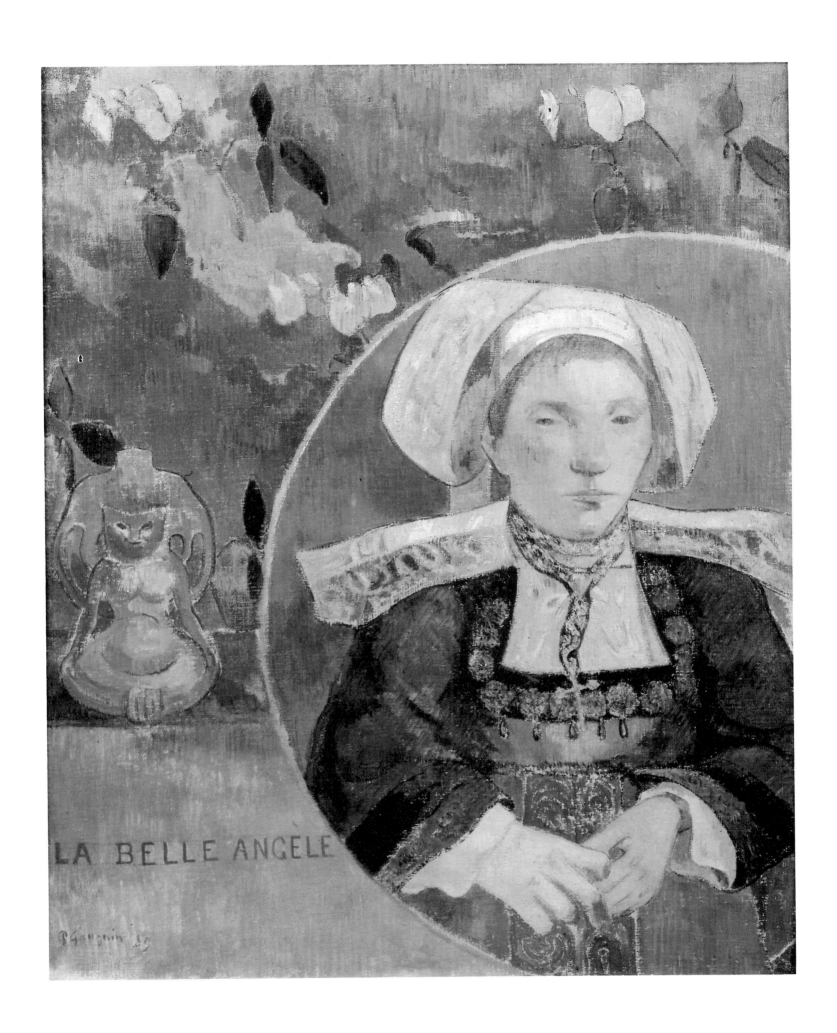

LA BELLE ANGÈLE

P Gauguin 89

117. *Bathers in Brittany*, 1889. Zincography. Paris, Bibliothèque d'Art et d'Archéologie.

116. *In the Waves* (*Ondine*), 1889. Oil on canvas, 92×71.5 cm. Cleveland Museum of Art.

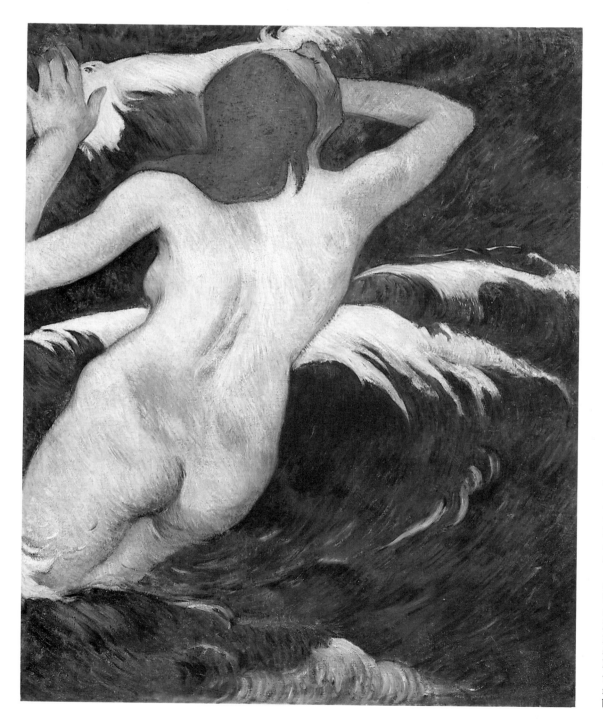

118. *Life and Death*, 1889. Oil on canvas, 92×73 cm. Cairo, Mahmoud Khalil Museum.

This painting was rather vaguely called *Women Bathing* until Merete Bodelsen correctly identified it as the one Gauguin exhibited in Copenhagen in 1893 under the title *Life and Death*. The two nudes in front of the black rocks on the beach at Le Pouldu explicitly convey Gauguin's Symbolist concepts. The woman on the left, in the blue of a drowned body, holds the crouching pose that Gauguin was to use throughout his career—right up to *Where Do We Come From? What Are We? Where Are We Going?* (fig. 245), a pose directly inspired by a Peruvian mummy that he had seen shortly before in the Musée de l'Homme; she represents, of course, *Death*. The red-headed figure, who modelled for *In the Waves* (*Ondine*) (fig. 116), a painting that he conceived at the same time, and *Be Mysterious* (fig. 137), is, certainly, *Life*. The composition and the colours underline the symbolism of the subject: like two interlocking triangles, the upper figure's blue, black and green suggest sadness and the final withdrawal, while the lower one is its antithesis, possessing the vivid tones of a living and joyously relaxed body and flaming hair against a bright pink background.

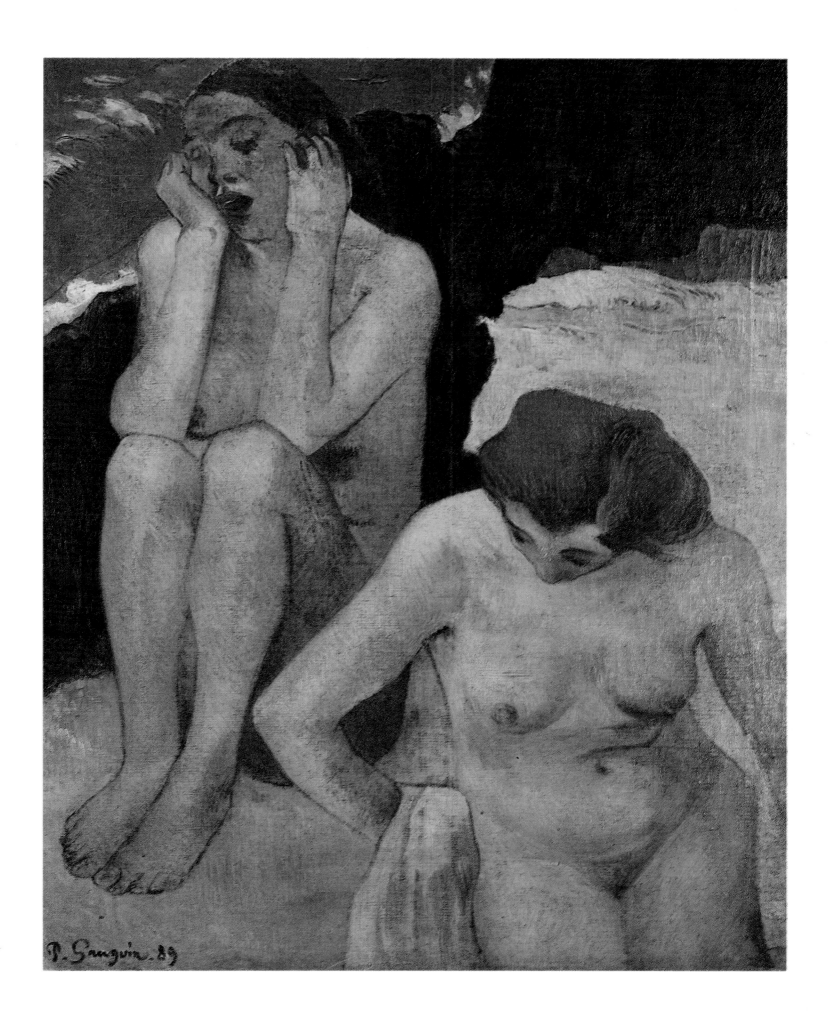

Gauguin's exotic daydreams—an incarnation of a lost paradise. Nevertheless, despite their remoteness from his awkward farmyard haymakers, these naked peasants in abstract surroundings still convey a feeling of shame and oppression: the mythic and artless nudes he would paint in Tahiti still lay in the future.

In fact the most arrestingly strange paintings from 1889 are perhaps *The Ham* and *Still-life with Japanese Print*. In both of them the composition is extremely simple, in the first painting centring on the vertical lines of the yellow ochre wallpaper broken up with blue, in front of which is placed the rounded forms of the table, the ham and the onions, and in *Still-life* on the horizontal line that cuts the jug in two. The warm and vivid chord in both paintings is struck by the technically difficult harmonization

This superb still life is undated, but one can assume that it was painted either in Paris or Le Pouldu in 1889. It is one of Gauguin's most conscientiously constructed paintings, held together by the vertical bands of wallpaper in the warm, spicy, exotic yellow that he liked so much at the time, and against which he was to place a number of his self-portraits. The intensely structured nature of this canvas—the concentric circles of the ham, plate and table against the stripes on the wallpaper—and the modulation of the colour show Cézanne's influence over him, especially in the domain of the still life. The mundane subject is not just a 'sublime' prosaic subject as with Cézanne, for it is full of allusions: the misanthropic Degas who nevertheless occasionally opened the doors of his studio to Gauguin, had bought Manet's famous *Ham*, now in Glasgow, at the Pertuiset sale of the summer of 1888. The composition of this one is very similar and was probably intended as a homage to the painter of *Olympia*.

119. *Still-life with Japanese Print*, or *Still-life with Vase in the Shape of a Head*, 1889. Oil on canvas, 73×92 cm. Teheran, Museum of Modern Art.

of yellow and pink that is found in Gauguin's best works. Rarely does a painter evoke such a feeling of warm light, spicy aromas, indulgence and restfulness soldered together through colour alone. These paintings possessed the vibrancy of the Tropics even before Gauguin went to Tahiti.

The satisfaction he might derive from this kind of instinctive achievement was not enough for Gauguin, however, even though it best displayed his gifts as a painter. His self-portraits of 1889-1890, alternately dramatized and humorous, reveal his preoccupations and torments and his anxious self-obsession. More and more we see him making his inner and outer selves serve the 'painterly' persona of that '*artiste maudit*' whose literary production Verlaine had introduced during his association with Rimbaud a few years earlier. When he sent his self-portrait to Arles, he had wanted to please Van Gogh, whose favourite hero was Victor Hugo's Valjean in *Les Misérables*. This time he chose to appear as *Christ in the Garden of Olives* because he was more or less under the influence of Émile Bernard, Albert Aurier and Meyer de Haan, who all shared a vaguely Schopenhauer-like mysticism. He depicted himself as a grieving

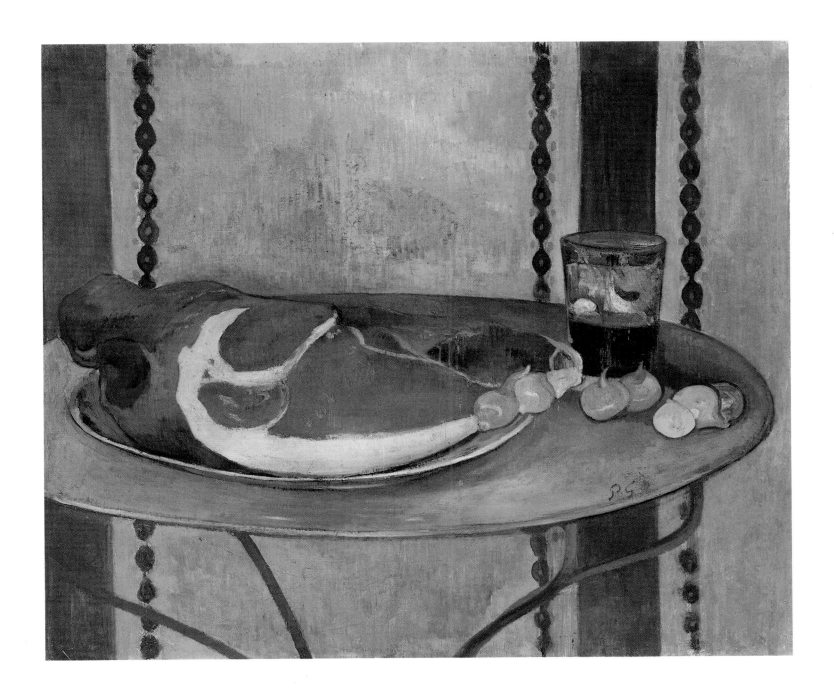

Christ-the-painter and misunderstood Messiah on the point of being betrayed—in fact as well as fiction—since Gauguin's own little Judas was to be Émile Bernard and his ascension to his Tahitian Paradise was not to take place until after a famous Symbolist banquet given in his honour, a kind of 'Left-Bank' Last Supper.

The painting, with its truncated central tree and the austerity of its technique, is interesting for more than just biographical reasons, though the crushed expression of the red-haired Christ certainly corresponds to Gauguin's descriptions of his own mood. His letters of the period show that he felt guilty and bitter because of his wife's contempt, the absence of his children and his lack of commercial success. He trumpeted his solitude and despair to anyone who would listen: 'I am in the throes of a terrible depression.'[2] 'Those times when one doubts, those results that always fall short of one's hopes; the lack of encouragement, all scourge one with thorns'[3]—a transparent allusion to the crown of thorns that is not very surprising in view of the mythic stature he gave himself. He complained to Bernard and Schuffenecker that he was too discouraged to work: 'The future is on a downward spiral,'[4] and he could think only of

verdâtres - Car malgré l'inscription les personnes ont l'air triste en contradiction avec le titre. Sur ce bois ciré il y a des reflets que donne la lumière sur les parties bosses qui donne de la richesse -

Je vais l'envoyer à Paris dans quelques jours. Peut être celui plaira plus que mes peintures. de Haann vous dit bien des choses.

 Cordialement à vous

 P. Gauguin

P.S. Je sais que vous fatiguez quand vous écrivez aussi je ne demande pas de lettre (malgré tout le plaisir que j'ai à vous lire -

 Le service militaire de Bernard a été remis à un an pour (Santé) -

au Pouldu près Quimper (finistère)

flight; for a time he even considered going to Indo-China where life was cheaper and he could perhaps 'paint in peace'.

And yet he worked a lot during this period, and his style took an intensely personal direction, becoming more and more graphic and decorative, inspired as much by caricature as by Symbolism. Another self-portrait of the time, *Self-portrait with Halo*, shows him as a saint—but a mocking saint, with two apples that went beyond the token of original sin to become an obvious sexual allusion—and holding a strange '1900-style' black tracery between his fingers that ends in a serpent according to some, a swan according to others.[5] He painted his friend in *Nirvana, Portrait of Meyer de Haan* holding the same object in a purposely naïve and stiff way, with his tragic *Eve* on her heap of seaweed next to the head of *Ondine* in the background. Probably in the same month, he painted a strange *Joan of Arc* on the wall of his inn at Le Pouldu. She is a skinny little Breton girl with big feet twirling her distaff in front of a pile of kelp and some thistles drawn like playing-card symbols. In the background one can

122. *Christ in the Garden of Olives (Self-portrait)*, 1889. Oil on canvas, 73×92 cm. West Palm Beach, Norton Gallery and School of Art.

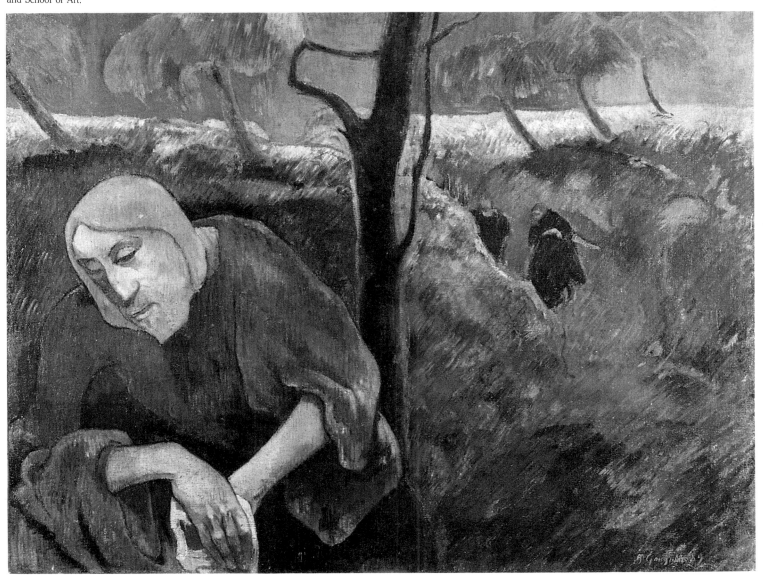

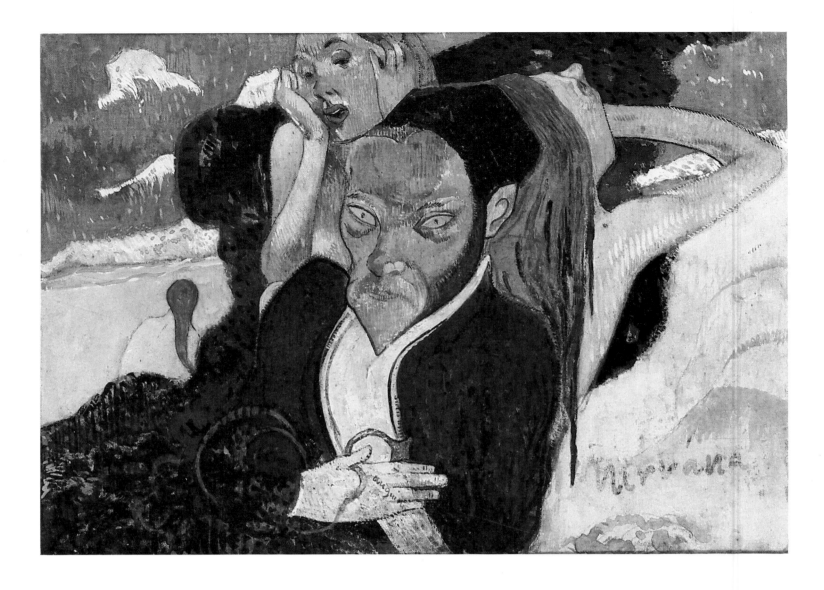

see the returning tuna boats whose Japanese-style treatment recalls the junks in a Pointillist version of a similar subject painted by Signac at Concarneau a few months later; though in fact the religious theme and the simplified depiction of this poor little spinner invested with the Holy Ghost reminds one much more of Puvis de Chavannes.

Gauguin's state of mind at the time was disclosed when the panel was taken off the wall in 1924, uncovering this emphatic declaration in his own hand: 'I believe in a last judgement in which there will be a terrible punishment for those who, while in this world, dared profit from sublime and chaste art, soiling and degrading it with their contemptible attitude.' A posthumous accusation whose timely discovery would have pleased its author, since the panel was about to be sold for what was even then a high price. Of course this remark was not his own, but a quotation from Wagner whom Gauguin apparently knew mainly through Baudelaire.[6]

It was not long before Gauguin's mystic Symbolism led him beyond finding his subjects in popular faith and translating them into a peasant imagery. If one compares the consciously ingenuous *Joan of Arc* to its contemporary *Caribbean Woman*, one can see many similarities between two so geographically divided subjects. The naked idol has almost the same pose as the saint: they share the same rather mannered gesture of the right arm, the same position of the head and the same overall form. The hand movements are those of the supple-wristed Javanese dancers with whom Gauguin made assignations after their performances at the Universal Exposition a few months earlier. While in Le Pouldu he produced two statuettes, one in wood and one in terracotta,

123. *'Nirvana', Portrait of Jacob Meyer de Haan*, c. 1890. Essence on silk, 20×29.2 cm. Hartford, Wadsworth Atheneum.

that are quite like this painting.[7] They appear to have been copied from a piece of a frieze taken from the Javanese pavilion at the Exposition which, it is said, Gauguin had lovingly borne away to Le Pouldu.

Caribbean Woman is an extremely interesting painting despite its stiffness and the literal rendition of Javanese iconography. It is the first example of a figure from Gauguin's mythic Eden, for which Tahiti would soon be providing the models, even if the idealized image would almost always come from Java. The sunflowers, epitomizing light and warmth, and the spirals in the background remind one of Van Gogh and perhaps signify a subconscious association of his dreams of the Tropics with the friend who had contributed towards their crystallization. The decidedly decorative background leads one to conjecture that it might have been a design for a fabric or a pattern for a tapestry like the ones he had thought of producing in 1883. Gauguin's exoticism is still very much on the surface here, and appears more like an intellectual and pseudo-religious theme than the true imaginings of a visionary for, in reality, there is not much difference between the Le Pouldu shepherdess and this antiquarian idol.

Gauguin's new pictorial concepts were much more self-assured when he used them without Symbolist meanings or the device of a more or less literary 'subject'. His land-scapes in Brittany are among his best. *Girl Tending Pigs*, *Farm at Le Pouldu* or *The Potato Field*, for example, are assembled like puzzles from coloured areas that lock together with great delicacy, and the relationships between them have a smoothness that only Gauguin's strength saved from being insipidly pretty. Some of the details clearly prefigure the work of the Nabis, especially Bonnard in the choice of colours: in *Farm at Le Pouldu* the pink farmyard separated from the green field by a low wall and the cow painted with large patches of light blue and muted brick-red, recall the landscapes that came after the 'Japonisme' of Bonnard's Nabi period. It is not surpris-ing that these landscapes were so admired by the group and made such an impression on Bonnard and Vuillard, and though the more mediocre painters like Sérusier, Ranson, Verkade and even Maurice Denis, were more impressed by the literary and transient

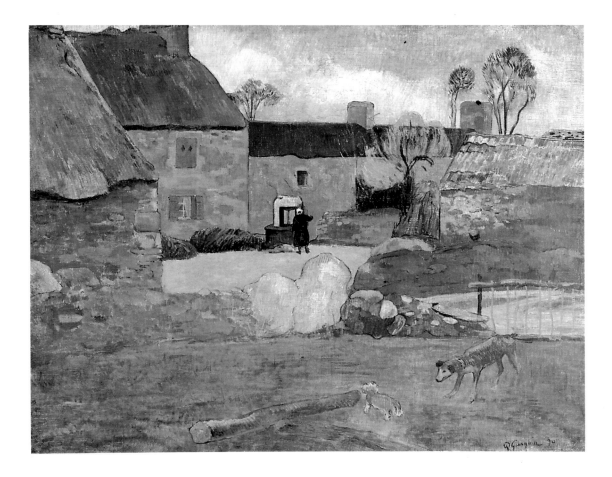

124. *Farm at Le Pouldu*, 1890. Oil on canvas, 71×88 cm. Dallas, Museum of Art.

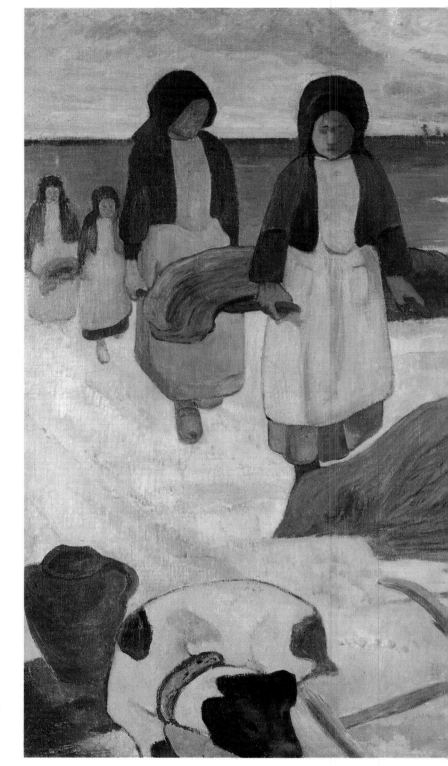

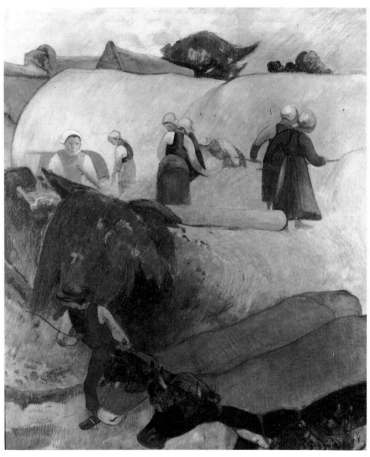

125. *Harvest in Brittany*, 1889. Oil on canvas, 92×73 cm. London, Courtauld Institute Galleries.

aspects of his art, the future great painters Vuillard and Bonnard recognized the great painter in Gauguin. The hedges, furrowed fields, white patches of potato-flowers, spotted cows with the myriad walls surrounding the tiny plots of that impoverished land, break the countryside of Brittany into decorative patterns that are much more obvious than those of the Ile-de-France or the Mediterranean coast, whose subtly brilliant light only the Impressionists knew how to paint. The natural Cloisonnism of the Breton landscape produced a very different reverberation in Gauguin's paintings than the 'muted matte and powerful tone' he had gone to Pont-Aven to find.[8] No, by this time he was

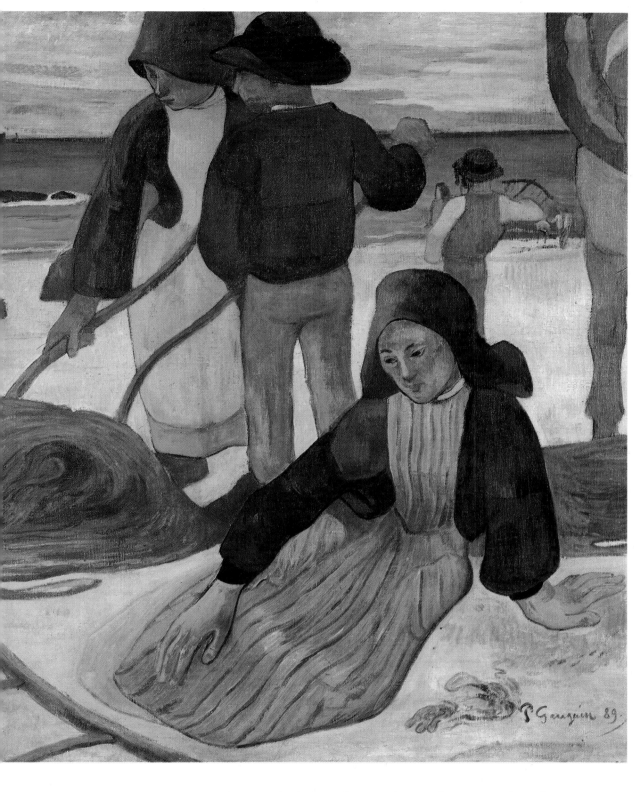

126. *The Seaweed Gatherers*, 1889. Oil on canvas, 87×123 cm. Essen, Folkwang Museum.

This large canvas is one of the most spectacular and least well-known from Gauguin's Brittany period. He already realized its importance when he wrote to Van Gogh in 1889: 'At the moment I am painting a size 50 canvas of women gathering wrack on the seashore. They are like boxes graded across the distance, blue clothes and black bonnets, despite the intense cold. The manure that they gather to fertilize their land is coloured ochre... with tawny highlights. The sands are *pink*, not yellow, probably because of the dampness—a sombre sea. Looking at this every day I get something like a gust of the struggle for life, of sadness and an obedience to unhappy laws. I am trying to put this gust onto the canvas, not haphazardly, but by reasoning it through and perhaps exaggerating the rigidity of certain poses, certain dark colours, etc.'
This letter shows how consciously Gauguin worked at his mixture of observing nature and his desire to give a natural scene a mythic content. In this painting he deliberately stressed the energy and melancholy that were as typical of the land he was painting as they were of his own state of mind.

painting an ingenuous and pretty rather than an awesome Brittany, in patchworks of warm, sweet colours that already had a consciously tropical atmosphere.

And yet it was during this period that Gauguin would drag his disciples out to paint each morning saying: 'Let's go and do a Cézanne,' and, despite his extreme poverty in that winter of 1889-1890, he clung to a Cézanne that he had managed to rescue from his collection and refused to sell it for as long as he could, exclaiming: 'It is the apple of my eye and short of absolute necessity, I shall not part with it until after my very last shirt.'[9] However, apart from Gauguin's paintings of the Arles countryside,

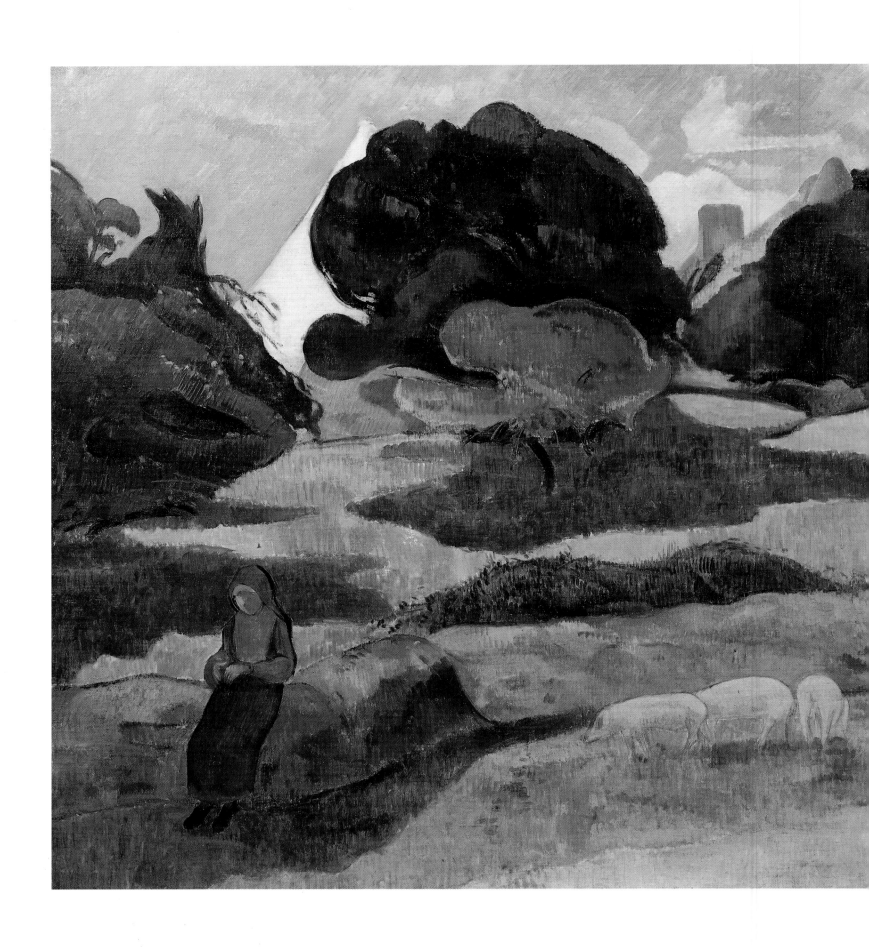

127. *Breton Girls by the Sea*, 1889. Oil on canvas, 92×73 cm. Tokyo, National Museum of Western Art.

129. *Girl Tending Pigs*, 1889. Oil on canvas, 73×92 cm. New York, Private Collection.

Gauguin wrote to Van Gogh in the autumn of 1889, when he painted this canvas: 'Most of what I've done this year is simple peasant children walking indifferently along the seashore with their cows. Except that since I don't like the deceptiveness of the open air or anything else, I try to imbue these lonely figures with the wildness that I both see and carry inside myself.' A little Breton girl is knitting, already wearing a winter wind-breaking bonnet against the cold weather. One merely has to compare this painting to one on a similar subject painted three years earlier (**The Breton Shepherdess**, fig. 39), to see how far his art had developed. His touch is smoother and the colours are spread in rhythmic outlined patches, its overall decorative and 'Synthetist' appearance has replaced the sentimentality and Impressionism of the earlier painting. The trees and their shadows are treated as abstract silhouettes, as is the strange white triangle behind them, so difficult to decipher. Their menacing shapes stress the innocence of the shepherdess and the three little pigs—Gauguin's favourite animals— which he painted with much affection (see **The Follies of Love**, fig. 132).

128. *Nude Breton Boy*, 1889. Oil on canvas, 93×74 cm. Cologne, Wallraf-Richartz-Museum.

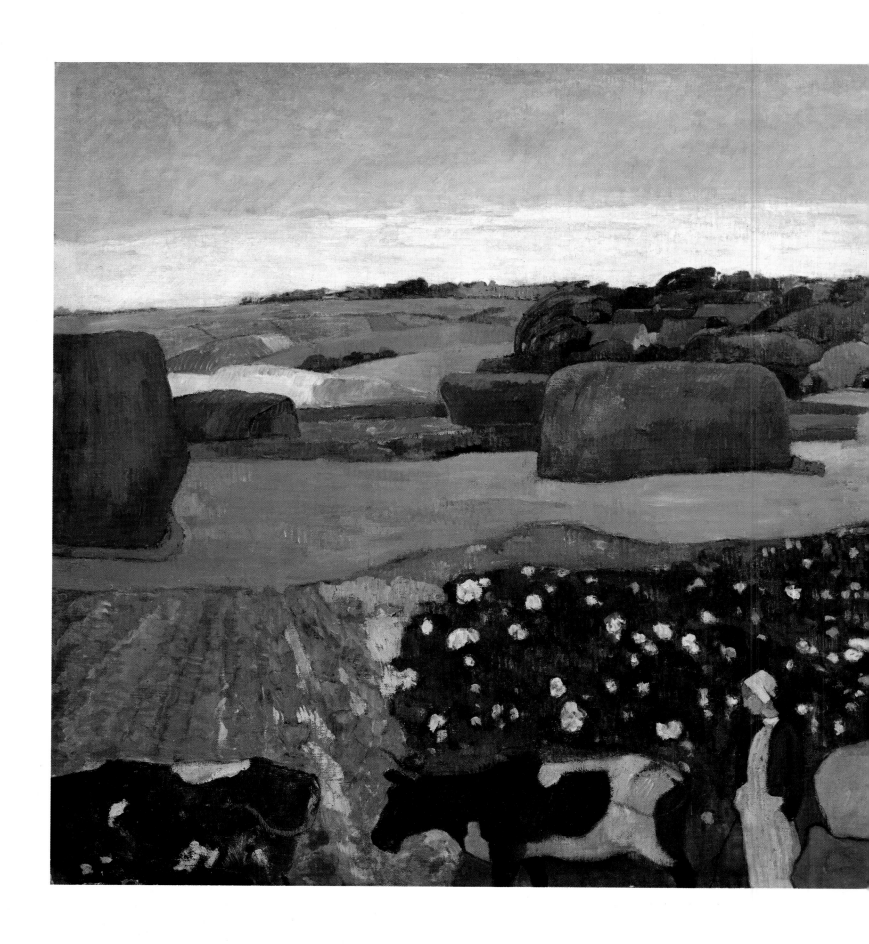

130. *The Haystacks* or *The Potato Field*, 1890. Oil on canvas, 74×93 cm. Washington, National Gallery of Art.

Armand Seguin, one of Gauguin's companions at Le Pouldu, where this canvas was painted, made this apt comment about the place: 'The landscape that lay before him each day was very conducive to the advances in "Synthesis" and fundamental characteristics that he wanted to make. . . . The dry stone walls outline the fragmented fields and form red, yellow or purple *cloisonnés* according to the season.' Gauguin decoratively used the spots of white potato flowers and the pink and green stripes of what looks like a cabbage patch on the right, and contrasted the volume of the haystacks on the fields greening under the benevolent 'Breton drizzle' with their linearity. He wittily lined up the three cows in the foreground, emphasizing the curves of the black and white patches on their hides. This painting is a perfect compromise between realistic observation and deliberate stylization.

Cézanne's influence appears mainly in his still lifes and portraits. We know that Cézanne often complained later that Gauguin had plagiarized him. His influence is in fact visible in Gauguin's more unusual paintings, as in the blue, lilac and pink wallpaper of *La Belle Angèle*. It was probably during the winter of 1890 that Gauguin painted what could be termed a 'homage to Cézanne' in *Portrait of a Woman, with Still-life by Cézanne*. The homage is twofold, for in the background he copied the still life in his possession with hardly an alteration, and the woman in dark blue and purple-violet sitting uncomfortably in her armchair is herself typical of Cézanne even in the modelling of the face, which is much less simplified than usual for Gauguin, and in the drawing of the eyes in which the colour of the pupil covers the whole orb, in imitation of a technique favoured by Cézanne and later by Modigliani.

Gauguin's own style is much more obvious, natural and free in his sculpture. In the inn at Le Pouldu kept by Marie Henry—known as '*Marie poupée*'—where the young painters flocked round Gauguin, he sculpted in wood. The most famous of his sophist-

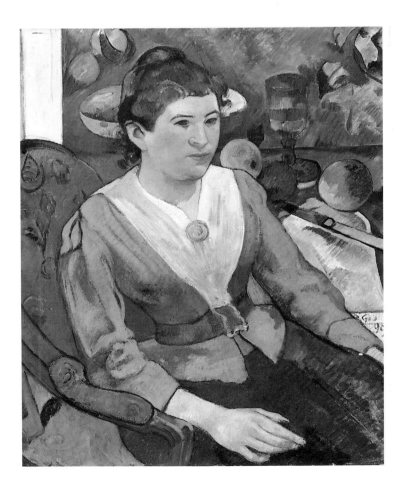

131. *Portrait of a Woman, with Still-life by Cézanne*, 1890. Oil on canvas, 65×55 cm. Chicago, Art Institute.

icatedly rustic polychrome bas-reliefs of the period has its title carved on it: *Be in Love and You Will Be Happy*. Referring to this piece, he told Émile Bernard that 'As far as sculpture is concerned, it is my best and strangest piece; Gauguin (as a monster) taking the hand of a woman who resists.'[10] He pointed out that the fox seen from the front that would often appear in his later paintings was 'the Indian symbol of perversity'. Below his own face, his Breton *Eve* appears yet again, as she did in *Nirvana*. The overall feeling is one of wilful anguish and sad, tired flesh that completely contradicts Gauguin's title. It may be that he wanted to illustrate his view of love in this work, for he had just experienced the torment of unrequited love for Madeleine, Émile Bernard's attractive, intelligent and somewhat highly-strung young sister, that must have made him feel his age and his condition as a social pariah. The easy local conquests did not help him forget this loving friendship, and it was for Madeleine that he produced one of his best pieces of pottery, in the shape of a head, which he told her was 'a vague representation of Gauguin the savage'.[11] One senses in him a search for a timeless 'self', a desire to unveil the mysteries of his own unconscious that he imbued with a primitive sensibility: 'I feel it but I cannot yet express it: I am sure of getting there, but so slowly, despite my impatience. . . . What I want is that still unknown corner of myself,'[12] and he took his 'terrible itch for the unknown' that 'led him to do crazy things' very seriously, leaving Le Pouldu for Paris to plan for journeys that had more glorious ends than Finistère. He started to negotiate emigrating to Indo-China,

133. *Be in Love and You Will Be Happy*, 1890. Carved and painted lindenwood, 119×97 cm. Boston, Museum of Fine Arts.

132. *The Follies of Love*, 1889. Gouache on millboard, diameter 26.7 cm. Westgrove, Private Collection.

During the winter of 1889-1890 spent at Le Pouldu, Gauguin decorated and sculpted a number of utilitarian objects such as clogs and a wine or cider cask. He also planned to produce some plates that never materialized, of which this amusing gouache is an example. It is full of his personal folklore: the flowers in the popular vases with Anne of Brittany's Fleur-de-Lys, the peasant woman in her Le Pouldu costume, two exotic faces that herald the Tahitian Eves whispering their secrets, and above all the pig of gluttony that represents the 'follies of love'. Gauguin loved pigs and was delighted to find ones of a different colour in Tahiti: 'These adorable little black pigs snuffle for good things for us to eat and demonstrate their longing for them with their laughing tails' (*Diverses Choses*).

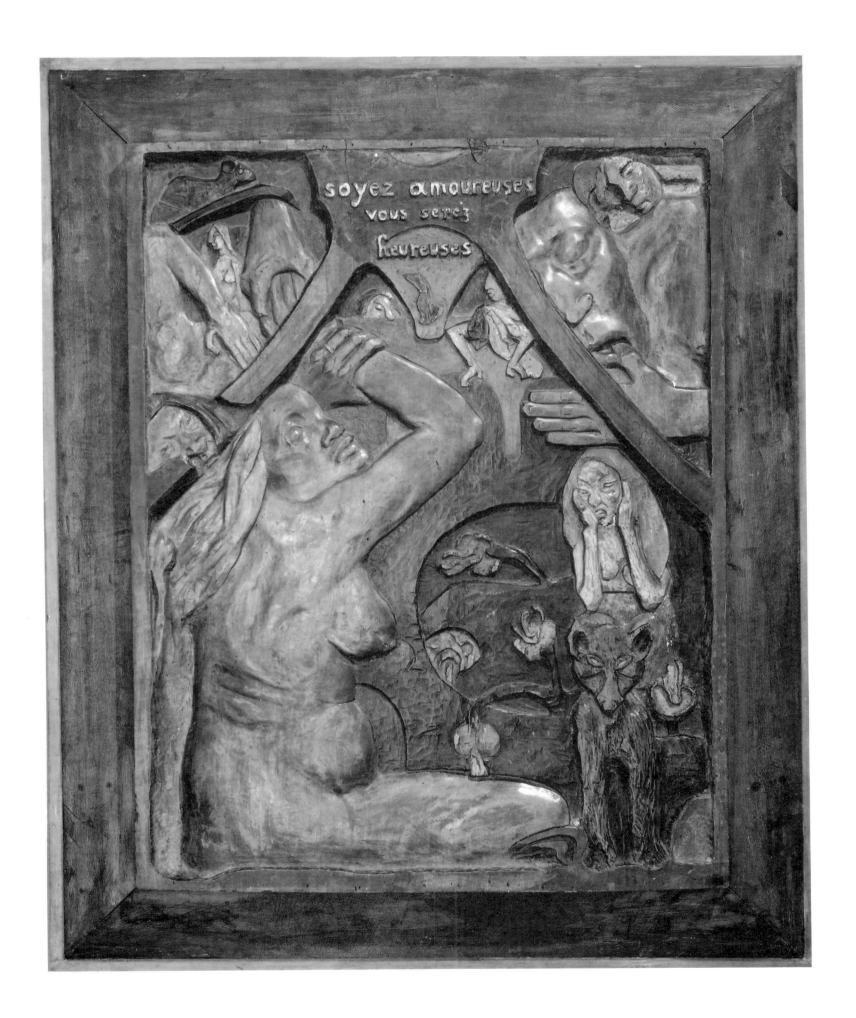

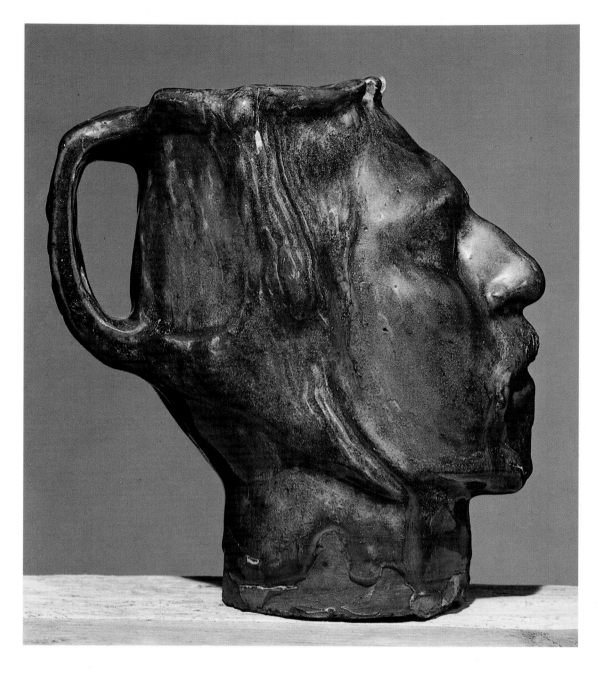

134. *Jug in the Form of a Head, Self-portrait*, 1889. Glazed stoneware, height 19.3 cm. Copenhagen, Kunstindusttrimuseet.

Gauguin portrayed his own face on this ceramic jug produced at the very beginning of 1889. The concept of a pot in the shape of a head came from popular art, but above all from the Peruvian pottery that his mother had collected and that must have fascinated him as a little boy. Also, he liked to remind people of his 'Indian origins' and, though the modelling of this pot did this in any case, he nevertheless accentuated his 'Inca' features. The actual technique of this extraordinary object in glazed stoneware with dribbled slip comes from the Far East, from those Japanese artists-craftsmen that he and Chaplet—who fired this pot—admired so enormously. The colours were not applied randomly: the blood on the neck and face evoke his own severed head and refer to Symbolist iconography representing the heads of Saint John the Baptist and Orpheus, both martyred for their belief in God or poetry. Gauguin here depicted himself as the martyr of art, as he would a few months later when he painted himself as Christ (fig. 122). Moreover, he had recently been shocked by two blood-stained events a few days away from each other: in Arles on 22 December he saw Van Gogh minus a segment of his ear and covered in blood—note that he shows himself without any ears here—and, less than a week later, he had the macabre idea of going to watch a murderer guillotined. These events surely affected him and left their traces on this tragic self-portrait.

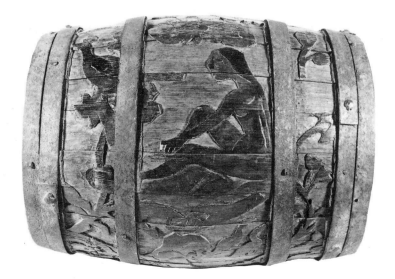

135. *Decorated Cask*, 1889-1890. Carved and painted wood. Private Collection.

for he despaired of ever living from his painting. The state of his finances was so bad in January 1890 that Schuffenecker had to lend him the money to get back from Brittany.

At the time of his return to Paris, Gauguin was a man who posed as an outcast, but he was also deeply and sincerely obsessed with a need to make his 'primitive' self correspond to a faraway unspoiled nature that would give it a structure and a setting.

By then he regularly frequented that effervescent world of the small, ephemeral and occasionally brilliant literary periodicals, and the cafés in which painters and writers spent hours in discussions that communicated a poetic exaltation more often than any precise aesthetic belief.

Consequently Albert Aurier, writing during Gauguin's lifetime, and Charles Morice—in a biography published after Gauguin's death[13]—made Gauguin's statements on art coincide with their own opinions of his painting. Unfortunately, Gauguin was not being praised by exactly the leading lights of Symbolist literature, though he could legitimately have believed so at the time. In 1890 Charles Morice was considered a rising star in the movement and Albert Aurier, then twenty-five, passed as a writer full of promise. It was Aurier who had the singular honour of being the first to write about Van Gogh, in an article in the *Mercure de France* in January 1890. A year later, in the same review, he anointed Gauguin 'the painter of Symbolism', which, though it only partially described him, undoubtedly helped to make him known to the educated public. Lastly, he was the only critic of the *fin de siècle* who honestly attempted to define the pictorial revolutions that had overwhelmed the world of art in the previous few years. At the time Félix Fénéon was the greater connoisseur and a more intelligent writer; he distilled the essence of each artist's work in a language that was perhaps 'decadent', but was also very evocative. Mallarmé, whose opinions Gauguin respected, said that Fénéon was 'the best critic that we have', and yet he never went as far as developing a real theory about contemporary art, or even attempting a general analysis of the painting of his time. Aurier, on the contrary, would have been one of the many completely forgotten '*fin de siècle*' poets had he not first enthusiastically tried to set down the principles of Symbolist painting, and then realized that the person most capable of leading such a movement, or even of becoming its figurehead, was Paul Gauguin.

Fénéon, a friend of Seurat, a cultivated and intellectual painter if ever there was one, made a scornful remark about this sudden union between literature and the man whom he had so far seen only as Pissarro's pupil. He wrote in the Montmartre weekly, *Le Chat Noir*, that after having found his direction—with the help of Bernard—in Pont-Aven, Gauguin came back to Paris 'full of literary fervour whereas, up to then, he had sedulously ignored bookshops and more generally, ideas, with a most paradoxical obstinacy. . . . He brought back paintings of a malevolent luxuriousness from the West Indies. It was then that he became the prey of the men of letters. They assured him that he had been given a divine mission. A similar misadventure befell that grand old man Courbet.'[14] Needless to say, the men of letters he was referring to were Morice and Aurier and more generally, everyone at the *Mercure de France*, which championed an idealistic and conservative Symbolism. Fénéon stood for the other Symbolist trend of the period, which was more anarchistic, rational and eclectic and would soon be represented by *La Revue Blanche*.

To call Gauguin the 'prey of the men of letters' is perhaps a little hard, but it is justifiable if one looks at some of his paintings from 1889 to 1891, for paintings such as *The Loss of Virginity* are literally swamped with extra-pictorial references. Gauguin described bitter nightmares of this kind on occasion, and expressed similar aesthetic concepts in his conversations with his friends. The *Les Misérables* portrait that he sent to Van Gogh was contemporary with *L'Œuvre Maudite*, a rather mediocre poem that Aurier had dedicated to Caravaggio:

We are the damned, the excommunicated

Dragging our rejected masterpieces like a ball and chain,[15]

and the 1889 *Christ in the Garden of Olives* corresponded to another poem by Aurier from October 1889 called *La Montagne du doute* on the same biblical subject. We often find this tone of acrimonious grandiloquence in Gauguin's letters of the period: 'Me,

136. Félix Vallotton, *Fénéon at La Revue Blanche*, 1896. Oil on cardboard, 52.5×65 cm. Josefowitz Collection.

an Impressionist painter, in other words, a rebel'[16] or, comparing himself to his terracotta portrait, '[I am] like the Gauguin of the pot, whose hand stifles the cry that struggles to escape from the furnace.' Aurier's categorical idealism in declaring that real art was 'the art of ideas embodied in living symbols, the art of Giotto, Fra Angelico, Mantegna and Da Vinci'[17] coincided with the concepts Gauguin expressed to Émile Bernard in the autumn of 1889: '. . .you believe at the moment that this art is inseparable from technique. . . . If, later on, you become as sceptical as I am in this respect, you will do something different. I must admit that I personally sense more than just words, however harmonious, in this language. Corot and Giotto seduce me with much more than just the solid aspects of their painting.'[18] This letter, written shortly before Albert Aurier, an intimate friend of Bernard's, discussed Gauguin and Symbolism in painting,[19] suggests that the painter's letters were circulated among his young friends and admirers.

The idea that painting is a 'language' and that its emotional means, its formal solutions and its 'solid aspects' are simply 'letters', took root with Gauguin, albeit in a Symbolist context. After Pissarro and Impressionism, Gauguin now wanted to surpass Cézanne and Degas. 'You know how much I admire what Degas paints, and yet I sometimes feel that he lacks a further dimension, a heart that beats.'[20]

We often find traces of this naïve need to reduce a painting whose aims were initially pictorial to its emotional content alone—but a conscious return to the simple masses of Giotto will not bring the medieval fervour of the Trecento back to life. It is obvious that, compared to a landscape by Cézanne, Gauguin's painting, despite the deliberately metaphysical eloquence of his subjects, is more decorative than charged with 'a further dimension'. So Fénéon was justified after all in saying that Gauguin had become the prey of the men of letters, for the painter became increasingly persuaded of the ascendance of the artist's idealism over his sensibility, and of the purity of his intentions over his mastery of technique. During this period he was in constant peril of slipping into the style of the Rosicrucian painters, for whom pictorial Symbolism was a mystique, an initiation into the hereafter, a work of piety, and even the best of whom now look like rather pallid imitations of the English Pre-Raphaelites. Gauguin never joined the group, unlike one of his close friends in Le Pouldu, Filiger. But even in Tahiti he was a faithful albeit ironic reader of Joséphin Péladan, the Rosicrucians' pope and theoretician.

Van Gogh was too intelligent not to see the danger that all this represented for Gauguin, and he wrote to his brother in the same month that Gauguin wrote the letter quoted earlier: 'There is erudition there, one can see that he is someone who is mad about the primitives, though, quite frankly, the primitives did all that much better, but then are Puvis and Delacroix any healthier than the Pre-Raphaelites?'[21]

One thing is certain: between 1885 and 1900 all the Post-Impressionists wanted to join in the goals of writers and musicians, in Baudelaire's sense of a correspondence and equivalence between the arts, with their own medium. For a writer like Aurier, author of *Le Symbolisme en peinture*, only the realm of ideas could hope to elevate an art that Impressionism had so intimately linked to the most sensual and ephemeral kind of reality, and that had fallen into 'the abominable error of naturalism'. And it was with Paul Gauguin in mind that Aurier proceeded to 'establish the bases of Symbolism in painting'. The work of art ought to be:

1. *Ideational*, since its only ideal will be the expression of an Idea;

2. *Symbolist*, since it will express this idea through form;

3. *Synthetist*, since it will inscribe these forms and symbols according to generally understood rules;

4. *Subjective*, since the object will never be conceived as such, but as a symbol of the idea perceived by the subject;

5. *Decorative*, for decorative painting in the true sense of the word, as conceived by the Egyptians and probably the Greeks and the Primitives, is nothing other than the manifestation of an art that is at once subjective, synthetist, symbolist and ideational. . . .'

137. *Be Mysterious*, 1890. Carved polychrome limewood, 73×95 cm. Paris, Musée d'Orsay.

Designed as a pendant to the woodcarving of the previous year, *Be in Love and You Will Be Happy* (fig. 133), this was 'more handsome than the first', according to Gauguin in a letter to Theo Van Gogh. The nude is certainly more attractive; Gauguin transferred the bather from *In the Waves* (*Ondine*) (fig. 116) into a relief, highlighting the amber patinated wood of the body. By 'exoticizing' the face he transformed the red-headed Breton girl of the painting into a girl from the South Seas. This relief denotes, prior to Tahiti, the dreams of the reader of *Rarehu, ou le Mariage de Loti*, in which 'those careless and laughing little creatures. . . lived almost entirely in the water. . . where they leaped and splashed like flying fish'.

The relief was also inspired by a colour reproduction of a Japanese polychrome woodcarving in the review *Le Japon Artistique*, from which Gauguin took the stylized waves.

The Symbolism of its other components is somewhat enigmatic. The face on the right must be the moon, but is the sour little person on the left warning the girl, who is plunging into the water as if into life? Is she protecting her? We do not know. But the injunction *Be Mysterious* doubtlessly means: stay close to the great secrets of Nature, do not become too civilized!

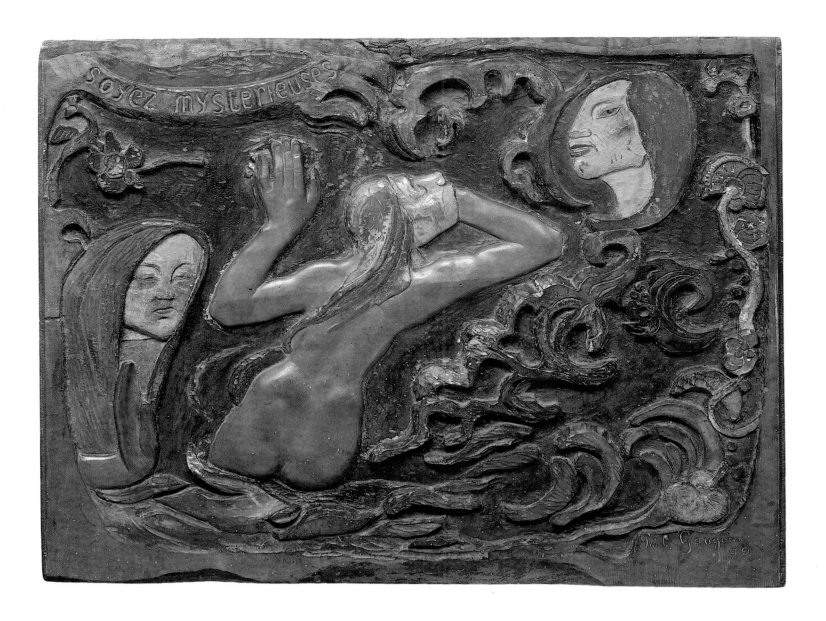

But the artist endowed with all these talents would be only a scholar if he lacked 'the gift of *emotional expression.* . . that transcendental quality that is so great and precious that its undulating drama of abstractions brings a shiver to the soul.'[22]

Gauguin, of course, was far from being displeased at 'being elected a man of genius' as Pissarro put it,[23] or at having at long last found a circle of friends that admired and understood him. But there was a distinct misapprehension between Gauguin and the literary Symbolists.

Aurier had constructed his entire article around *Vision after the Sermon* and was obviously more interested in talking of its Symbolist content, as Mirbeau would soon do, than about Gauguin's pictorial achievements, whereas it cannot be said that Gauguin was only a painter of the imaginary or the metaphysical. The illuminations and quicksands of the unconscious were more the domain of contemporaries like Gustave Moreau and Odilon Redon. As we know, Pissarro once said that 'Gauguin is not a seer, he is a clever fellow. . .'[24] and he was right, for Gauguin was in no way the visionary that poets from Charles Morice to André Breton insisted upon seeing in him.[25] On the contrary, he continually depended on other cultures or existing subjects and forms that he merely placed in a different context, and only his gifts as a painter show that he had an instinctive inventiveness. There is something laborious about the way he used a motif from a painting ten times over, applying it to a pot

here, a woodcarving there, or else putting it into the background of one painting after another. The same subjects or motifs frequently appear several years apart: his *Ondine*, for example, whose hair and uptilted nose we find on a terracotta, on a fan, on a piece of pottery, in a monotype, then behind the portrait of Meyer de Haan, and finally sculpted on the polychrome relief *Be Mysterious*. His Breton *Eve* reappeared almost ten years later in his Tahitian masterpiece *Where Do We Come From? What Are We? Where Are We Going?* Once seduced by a motif or a form, whether it was original or not, Gauguin tried to find as many uses for it as possible with an industriousness that was far from the inspiration of a visionary. For someone who had made distance from nature into an article of faith and, like his master Baudelaire, considered the imagination the queen of man's faculties, he was tightly bound indeed by observation. There are many occasions in Gauguin's life and work when one senses a suffocating anxiety as soon as he ran out of 'new subjects'. Hence the interpretation by his one-time companions the Impressionists—who knew him well—of his escapes to 'somewhere else' as a sign of helplessness. According to them he followed the fashion for literary references out of weakness and insecurity, comforting himself with dreams that had nothing to do with painting. Pissarro even accused him of quite simply having detected that there was 'a position to be gained' in Symbolism and pictorial exoticism. Renoir mocked his escapism: why travel so far to find what any painter worth his salt can find anywhere—'We paint so well in Batignolles!'

He must have recognized the limitations of aesthetic Symbolism, and his work betrays a sense of this danger, for each time he inclined towards a literary or extra-pictorial concern in a painting, he followed it by more instinctive and 'painterly' canvases whose true subjects were the arrangements of colours and forms. It was after painting *Yellow Christ* that he produced his least literary Breton landscapes and his least mystical peasant figures. It was while drunk on the heady theoretico-poetical discussions that Charles Morice has handed down to us that that he drew a caricature of Jean Moréas called *Be a Symbolist*, and, at the very time that his letters to Bernard and Schuffenecker were at their most convincing on Synthetist art, he produced a pot on which he wrote '*Vive le Sintaise*'. This humorous spelling of '*Synthèse*' corroborates the accounts of his companions in Pont-Aven which relate how he liked to invent limericks that rhymed the word describing his style of the period with the slang 'foutaise', which is, to say the least, disparaging. 'Deep down inside we all have an anti-Symbolist squib,'[26]

Maurice Barrès, whose ideology was not far removed from Gauguin's, once quipped. The tomfoolery of the dauber often tempered his impulses towards ideas, and painting itself saved him from metaphysics that he could not control. Because of this ambivalence between his destiny, his goals and his prodigious gifts as a painter, he swung back and forth between Morice and Cézanne; however, luckily for us, the brush proved mightier than the pen.

140. Caricature of Jean Moréas, *Be a Symbolist*, 1891.

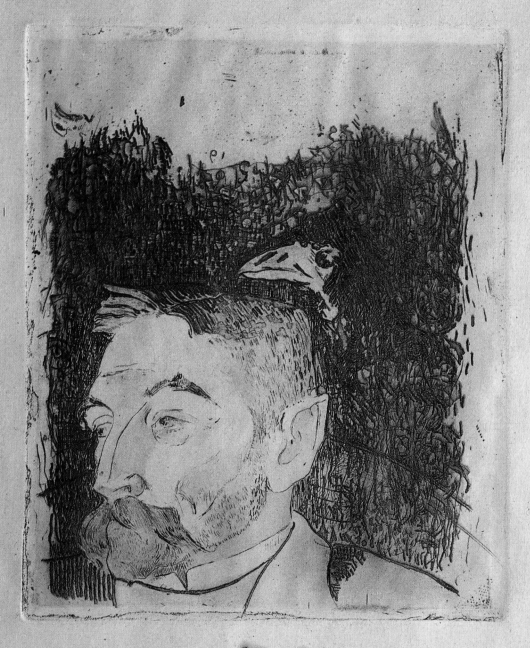

au poëte Mallarmé
Témoignage d'une très grande admiration
Paul Gauguin
J^{er} 1891

THE STUDIO
IN THE TROPICS
1890

141. Dedicated *Portrait of Stéphane Mallarmé*, 1891. Etching on vellum, 18×14 cm. Paris, Private Collection.

Throughout his career Gauguin produced a great number of lithographs, monotypes and wood engravings, but only one etching. Of this only a few prints were pulled, and were given mainly to friends such as Filiger, Monfreid and Charles Morice. Gauguin must have chosen this particular one with great care, for he gave it to the model himself, inscribed 'to the poet Mallarmé with great admiration'.

Gauguin met Mallarmé the year before his first trip to Tahiti. We know that the two men felt a mutual respect for each other and that Mallarmé was supportive of Gauguin, even though he never wrote about him directly. Gauguin proudly reported to Fontainas what Mallarmé had said about his painting: 'It is incredible that so much mystery can be put into so much brilliance'—a fine description of his art. He was terribly affected by the news of Mallarmé's death which he heard while in Tahiti: 'I am very distressed. He is another of those who have died a martyr to their art, his life was as beautiful as his works' (to Monfreid, December 1898). In this faithful portrait, off-centre like all his portraits and self-portraits of the period, he suggests the author of *L'Après-midi d'un Faune* by exaggerating the pointedness of the ear, and the translator of Poe by the raven that seems to emerge from the gloom to protect the poet, its beak echoing Mallarmé's bony nose, which Gauguin perhaps modelled to resemble his own as well.

My day is done,
I am leaving Europe.
Rimbaud.

'I believe and always will believe that there is art to be created in the Tropics' and 'I think it would be wonderful', Van Gogh wrote. 'However, I feel I am already too old. . . and too jerry-built to go. Will Gauguin do it?'[1]

During the spring of 1890 while Van Gogh was fighting despair and madness in the Saint-Rémy hospice, Gauguin was endlessly dreaming of his departure, putting it off, discussing it, abandoning the idea of Indo-China—after a year spent in vain negotiations in the hopes of a government mission—for the Ile Bourbon (Réunion) which Odilon Redon's wife, who had been born there, had told him about at length. Was he held back by lack of money, since everything hinged upon a 'little inventor' with the very Céline-like name of Charlopin who hoped to buy his paintings with the revenue from a problematical patent? Or was it a lack of the necessary energy to put a plan into action that was at once so literary and so deeply embedded that it would transform his personality 'into his real self at last. . .'? In Auvers-sur-Oise a few weeks before he died, Van Gogh still judged his friend with lucidity: 'A rather sad letter from Gauguin, he says that he has finally decided to go to Madagascar, but he is so vague about it that it is obvious that he is thinking of it only because he doesn't really know what else to think about.'[2] Almost nine months later, Jules Renard humorously wrote in his journal: 'Daudet spoke very funnily about Gauguin who wants to go and live in Tahiti so as not to see anybody, but never actually leaves. It is so bad that even his best friends have ended up saying: "You must leave, dear friend, you must leave." '[3]

He hardly painted at all between his return to Paris and his departure for Tahiti in April 1891. Interspersed with his meetings in cafés with Charles Morice and Jean Moréas, his painting stagnated in a minor Symbolism. He produced a lithograph in imitation of Redon, whom he much admired,[4] to illustrate the programme for a play by Rachilde, the wife of Valette (founder of the *Mercure de France*); he experimented with a painting, *The Loss of Virginity*, that was heavily influenced by his literary frequentations, placing an awkwardly archaic nude in an already much painted

142. *Madame Death*, 1891. Paris, Musée du Louvre, Department of Drawings.

landscape at Le Pouldu. The fox, that 'symbol of perversity' he was so fond of, contributes less to the primeval strangeness and mystery of the canvas than the composition and colour of the successive planes of the countryside. A purely personal and unconscious Symbolism turned this reclining nude thought to be Juliette Huet, his mistress during the winter of 1890-1891, into a pendant of the clothed *Madeleine in the Bois d'Amour*, painted by Émile Bernard, the Madeleine for whom the summer before Gauguin had felt a passion that was as violent as it was platonic. During this same period he copied Manet's *Olympia*.[5] This painting clearly fascinated Gauguin because of its flat, simple brushwork, the Baudelairian aspect of its subject and its allusion to the Renaissance, for *Olympia* is a sort of modern version of Titian's *Venus of Urbino*. The somewhat loose but powerful copy that Gauguin made of it belies the legend that he propagated that he was incapable of copying anything whatsoever. None of these attempts can have satisfied Gauguin, who felt by then that the only solution was to finally leave France. Leave, but for where?

He decided against the Ile Bourbon: 'It's definite, I am going to Madagascar. I shall buy a house in the countryside that I shall enlarge myself, and some land that I shall plant, and on which I shall live simply. A model and everything I need for study. Thus I shall found a Studio in the Tropics. He who wishes may come and visit'[6]—in other words, Bernard, to whom he wrote this, and Schuffenecker, whom he urged to sell a piece of land to finance the journey. Bernard replied that he preferred Tahiti, for Van Gogh had praised Loti's island to him, too. Gauguin in turn asked him to enquire about the cost of the passage there and possible sailing dates.

In Le Pouldu, where he spent the summer of 1890, the plan took on substance, and the proposed Eden became a land of milk and honey that his previous difficulties in Martinique somehow did not help make more realistic: '. . . a cow, chickens and fruit, these will be our staple diet, and we will end up living for nothing, free at last. . . .'[7]

Gauguin had picked up one of the seminal ideas of the nineteenth century, that of the social community, and transposed it into the realm of art. To the great dream of the journey, of the flight 'yonder' that was a return to the source, he now added a thirst for communal creativity. He attempted to get an energetic team dedicated to 'beauty and art' to follow him, like the brotherhoods the Pre-Raphaelites and William Morris had formed in Britain, and the groups surrounding the Nabis in Paris and the Impressionists in the Mediterranean. To amplify the concept of a brotherhood of painters delivered from material constraints and cleansed of the sins of the modern world, Gauguin wrote poetically: 'A terrible age is preparing for the coming generation in Europe: the kingdom of gold. Everything is rotten, both men and art. Down there at least, under winterless skies, on a magnificently fertile soil, the Tahitian merely has to raise his arm to pick his food; thus he never works. . . . For them, living is to sing and love.'[8] The studio in the Tropics was also intended to materialize one of Van Gogh's theories: 'I believe more and more that the paintings that need to be done so that modern painting can belong to itself and rise to the serene heights reached by Greek sculptors, German musicians and French writers are beyond the capacities of a single individual; they will probably be painted by groups of men joining together to paint a subject in common.'[9] When Gauguin finally took his decision, he still thought this possible, but when he left, no one followed him.

During this period of Tropical dreams, Gauguin was attracted mainly by the Far East. In a spirit of confusion that was to be very good for his painting, he hoped to find something of Asia in the South Seas, hence his obstination in proving that the Kanakas and Maoris originated from the West—that is to say Southeast Asia—in *Noa Noa* and later writings; a theory that modern ethnographers tend to confirm. When he planned to go to Indo-China, he seems to have acquired an indistinct and somewhat fanciful idea of the East from Javanese art and Japanese prints—which don't really have much in common—or again from what Aurier and Morice had told him about Buddhist wisdom as interpreted by Schopenhauer's aristocratic pessimism. Gauguin was counting on this imaginary Asia to heal the wounds that he liked to think were

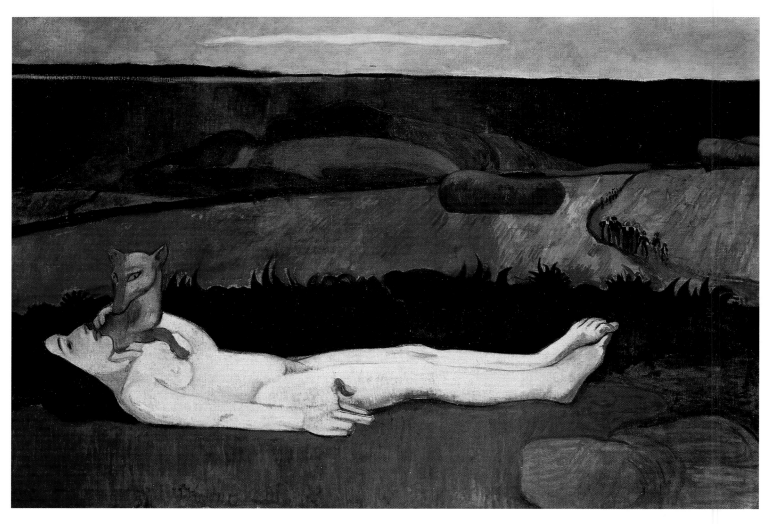

143. *The Loss of Virginity*, 1891. Oil on canvas, 90×130 cm. Norfolk, Virginia, Chrysler Art Museum.

144. Émile Bernard, *Madeleine in the Bois d'Amour*, 1888. Oil on canvas, Paris, Musée d'Orsay.

Gauguin probably did this painting in his studio in Paris during the winter of 1891, from a model said to be Juliette Huet (a young seamstress by whom he may have had a child), with a landscape painted from memory. This last is certainly fields at Le Pouldu overhanging the sea, and on the right one can distinguish a procession—or wedding—of Bretons in local costume. Gauguin attempted a Symbolist painting here: the red of the field—and of the ground on which the nude is lying—could signify the model's imagination (as in *Vision after the Sermon*, fig. 65) or passion, or blood from the 'loss of virginity'. For Gauguin the fox was a 'symbol of perversity' and yet the way its paw rests on the sickly breast of the least attractive nude he ever painted seems protective. Did he intend to be ironic and mock the pure Madeleine by using the same composition as Émile Bernard's *Madeleine in the Bois d'Amour?* Or was he inspired by Manet's *Olympia*, which had just created a sensation on its acquisition by the Musée Luxembourg and

which he copied during the same period (fig. 145)? He may have wanted to paint a primitive and Breton variation of it, replacing the black cat with the yellow fox, the bouquet with the cyclamen the model is holding and Victorine's provocative pose with Juliette's sad puppet's body.

145. *Copy of Manet's Olympia*, 1891. Oil on canvas, 89×130 cm. London, Private Collection.

Gauguin revered Manet; he had met him several times and said that Manet had encouraged him as a beginner. He had of course seen *Olympia* in 1889 at the centennial of French art at the Universal Ex-

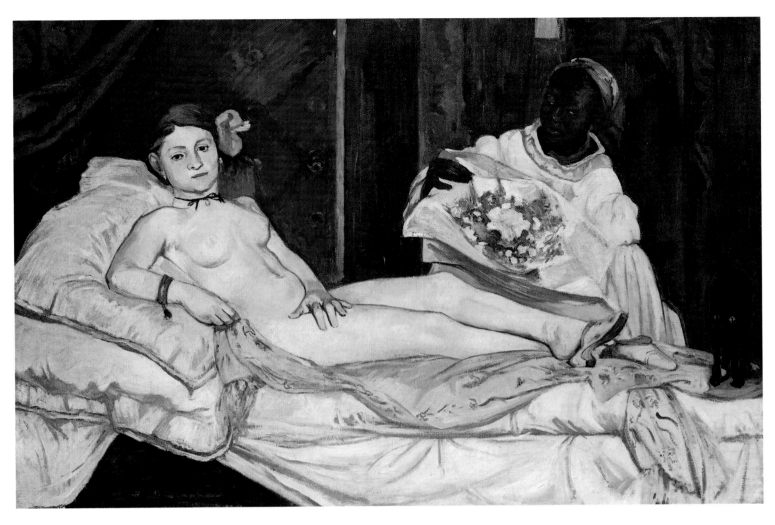

position, but this copy commemorates the furore at the induction of this scandalous painting into the Musée du Luxembourg in February 1890, when it was bought by a subscription organized by Monet, a remarkable event that Gauguin learned of in Brittany. He returned to Paris as soon as he could, in February 1891, and 'took the necessary steps to get permission to work in the Luxembourg galleries', his friend Morice reported. The copy is reasonably faithful, though he exaggerated the brutality and angularity of Victorine's face.

Gauguin wrote with flattered amusement in *Noa Noa* that when he pinned a reproduction of Olympia on the wall of his *fare* in Tahiti, one of his models asked him whether it was his wife: 'Yes! I lied—me! Olympia's man!'

It is worth mentioning that Degas bought the painting and that it hung alongside the masterpieces by the artists Gauguin most admired—Ingres, Manet and Delacroix—until Degas's death.

those of a 'barbarian' in Europe. In a traditional pre-industrial society in which art and religion were such a part of daily life, he would perhaps find a life that suited him: 'All of the East, that great concept written in gold letters in all their arts—all of that is worth studying, and I believe that I shall gain new strength over there. The West is rotten and every Hercules, like Antus, can gather fresh strength by touching that soil.'[10] This is one of the first traces of the generic theme of a decadent West that so many European intellectuals of the following generation brought up on Symbolism such as Spengler, Segalen or D. H. Lawrence would adopt. And it was definitely a native culture that Gauguin hoped to find by leaving Europe: if he tried to persuade Bernard to go to Madagascar rather than Tahiti it was because the larger island 'offers a greater variety of types, religion, mysticism and symbolism. You will find Indians from Calcutta, black tribes, Arabs and Polynesian Havas there.'[11]

Gauguin was already 'elsewhere', feeling detatched and confident in a spiritualistic and supremely nourishing Orient, when he learned of Van Gogh's suicide in August 1890—or at least one could think so in the light of his dry and sententious reaction: 'However saddening this news may be, it does not shock me, for I foresaw it, and I recognized the suffering of that poor boy struggling against madness. To die now is the best thing for him, for it means the end of all this suffering, and if he returns in another life he will bring with him the fruits of his exemplary behaviour in this world (according to Buddhist ideals).'[12] This strange funeral oration was slipped in between recriminations against Schuffenecker and details of the progress of his work, and indicates not so much reserve or heartlessness as the absolute hold that current literature and a Schopenhauer-like mysticism had over his mind at the time.

146. Émile Bernard, *Van Gogh's Funeral*, 1891. Location unknown.

Besides, Gauguin was at the end of his resources and was thinking of using the interest he aroused in Parisian literary circles to organize an auction of his paintings. Charles Morice, whom Jules Renard called 'the caretaker of Symbolism', took charge of the operation. He went to see Mallarmé who excused himself from writing about it but recommended Octave Mirbeau, who was then a popular novelist and the most influential critic in the leading newspapers. The writer was captivated by Gauguin, though more by the man than his painting; Gauguin's picturesqueness, his mixture of vital energy and anxiety, made Mirbeau feel he was in the presence of a 'natural'. It goes without saying that Mirbeau's article communicated what Gauguin had to say and the image of himself that he wanted the public to receive: 'He intends to live there alone for several years, build his own hut and work from scratch on the things that haunt him'; Mirbeau seemed convinced of the singular grandeur of 'a man fleeing civilization and looking for forgetfulness and silence in order to sense himself more clearly and listen to those innner voices that are usually stifled by the noise of our passions and arguments. . . .'[13]

147. Engraving of Octave Mirbeau. Paris, Bibliothèque Nationale.

Most of the buyers came from the eminent Parisian literary and artistic society of the period and, apart from friends of Gauguin such as Schuffenecker and Daniel de Monfreid, his chief admirers were Degas, who acquired *La Belle Angèle* and the copy of *Olympia*, Méry Laurent, Mallarmé's 'Muse', the Natanson brothers, one of whom was the editor of *La Revue Blanche*, who bought five canvases, and so forth. The Nabis—Denis, Vuillard, Bonnard and Ranson—clubbed together to buy a canvas that they took turns hanging in their homes. The fuss that was made of the painter, plus the fact that in talking to Mirbeau he made no mention of his young companion from the Pont-Aven days, led to a final quarrel between Gauguin and Émile Bernard. Each felt betrayed and from then on both would continually diminish the role of the other in the discovery of Synthetism: a precursor of art historians' squabbles that was entirely new in the history of painting. Bernard might have discovered some formulas with

Anquetin that contributed to the development of Gauguin's style, but the older man's painting was infinitely stronger and more sensitive than Émile Bernard's didactically Cloisonnist canvases. Although this quarrel was to have no effect on the man who was about to become the painter of Tahiti, for Bernard, who had been a promising painter, it resulted in his speedy evolution towards the worst kind of academic art—almost as though through spite. His conversion was as profound and definitive as the modernism of his twenties had been inventive. It was as if the benefits Gauguin had extracted from it had sullied any new attempt for ever in his eyes, and that only painting that was consecrated by the past could wipe out the burdensome memory of his former friend. Bernard retreated towards Raphael and Michelangelo—and what turned out to be an obscure career—in his flight from the man whom he would accuse for the rest of his life of having stolen his fire, while Gauguin himself, in going to Tahiti, fled an industrial century that Symbolism had not helped him to overcome.

In choosing to leave Europe, Gauguin obeyed more than external or literary urges. He had a sure instinctive perception of the need to renew his art and of where he could find the means to do so. At a time when he had just produced the paintings of 1888-1889, whose importance is clear to us now, and when his ascendency over a whole generation of painters was well-known, he behaved as though he felt his creative energy was running out, and was prey to doubts that only a 'headlong flight' could dissipate. 'In art one's state of mind is responsible for three-quarters of the results: one must therefore take care of oneself if one wants to produce something great and lasting.'[14] The Tropics were the cure for a wounded soul, and a source of new subjects and landscapes 'that have never been painted, and one needs new subjects to arouse the public,'[15] or again, 'touching that soil'[16] would bring spiritual renewal. Therefore 'that soil' had to be as far away as possible to make the new forces that much more powerful and pure: 'Madagascar is still too close to civilization,' he wrote to Odilon Redon, 'I shall go to Tahiti. I believe that what you like in my art is merely the seed, and I hope to plant it over there and make it grow to be primitive and wild.'[17]

Evidently Gauguin was thinking mainly of his painting when he undertook what he believed to be a return to the sources of creation. Even in the laziness of his departure one can sense that he already felt himself to be there: the little cardboard panel, most probably painted in Paris in the winter of 1890, representing Eve in a tropical setting is the first in Gauguin's Eden[18] if we except his Breton Eve, that image of despair set in limbo. It is a blend of Gauguin's dreams and preoccupations of the time, full of barely altered components taken from a number of sources: the figure is borrowed from a freize in the Javanese temple at Borobudur, the coconut trees come straight from his Martinique paintings and the tiny cypresses are taken from Persian rugs and miniatures. What is more interesting is the subject's face for, as many of his biographers have pointed out, this Eve resembles the portrait of his mother he painted at around the same time from a photograph of her as a young girl. Gauguin's memory of his mother was that of a wondering child-woman, whose 'sweet, imperious, pure and caressing'[19] eyes were always associated in his mind with a life of peaceful luxury in an exotic Peru, and in his subconscious with the dazzling image of a lost paradise.

Thus, in a letter to Mette in February 1890 full of reproaches such as 'your silence has made me unhappier than my financial set-backs' and, complaining of his solitude: '[I am] isolated, motherless and without a family. Rejected by all', the images of his future happiness gradually take over: 'In Tahiti, in the silence of the soft tropical nights, I shall be able to listen to the sweetly murmuring music of the beating of my heart in amorous harmony with the mysterious beings around me.'[20]

Although Gauguin hesitated over his departure, it was nevertheless a real spiritual necessity and, despite being so exteriorized and strongly marked by the times, it was deep-seated and very personal. The journeys of Romantic painters such as Delacroix or Decamps usually went no further than the anecdotal Orientalism of inquisitive travellers determined to fill their notebooks with sketches, whereas for Gauguin it meant a total renewal, a metaphysical regeneration and an open defiance of a world that

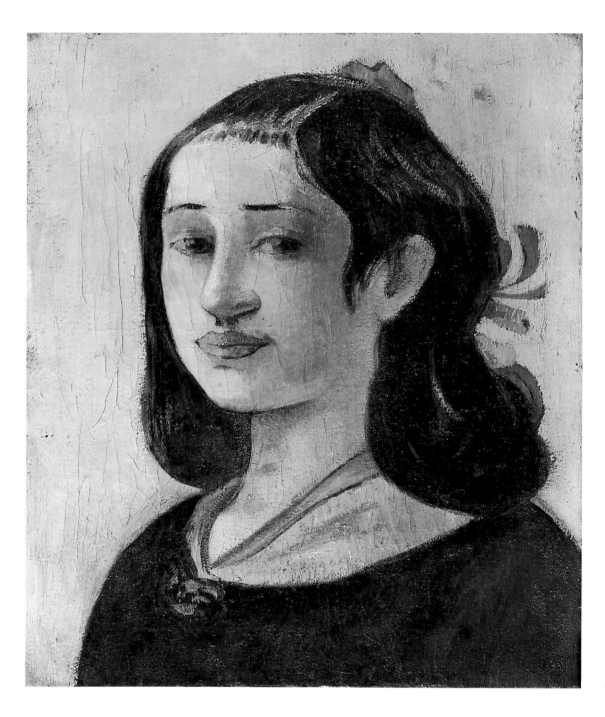

148. *Portrait of the Artist's Mother*,
1890. Oil on canvas, 41×33 cm.
Stuttgart, Staatsgalerie.

150. *Eve Exotique*, 1890. Oil on cardboard, 43×25 cm. Paris, Private Collection.

Before at last discovering his Tahitian Eden the following year, Gauguin had already invented and painted his 'exotic Eve'. The composite image is an amalgamation of memories and day-dreams whose interpretation belongs to psychology as much as to the history of art. In fact the head is that of his mother Aline Chazal, whose portrait he painted from a photograph during the same period (fig. 148). Eve's body and the surrounding trees are taken from a sculpture in Borobudur of which Gauguin possessed many photographs; and the coconut trees in the background come from his stay in Martinique. Gauguin linked the image of Eve to the original myth and associated his return to his pictorial roots with the grace of this seminal subject from the Bible. When he was interviewed on 13 May 1895 by *L'Echo de Paris* before going to Tahiti for the last time, he said he 'had been seduced by that virgin soil and by its ingenuous and primitive peoples. . . one must go back to one's beginnings, to the childhood of humanity, if one wishes to produce anything new. My favourite Eve is practically an animal, that is why she is chaste despite her nudity. All those Venuses shown at the Salon are indecent and unpleasantly lascivious. . . .'

149. Detail of a frieze on a Javanese temple in Borobudur; the photograph once belonged to Gauguin. Private Collection.

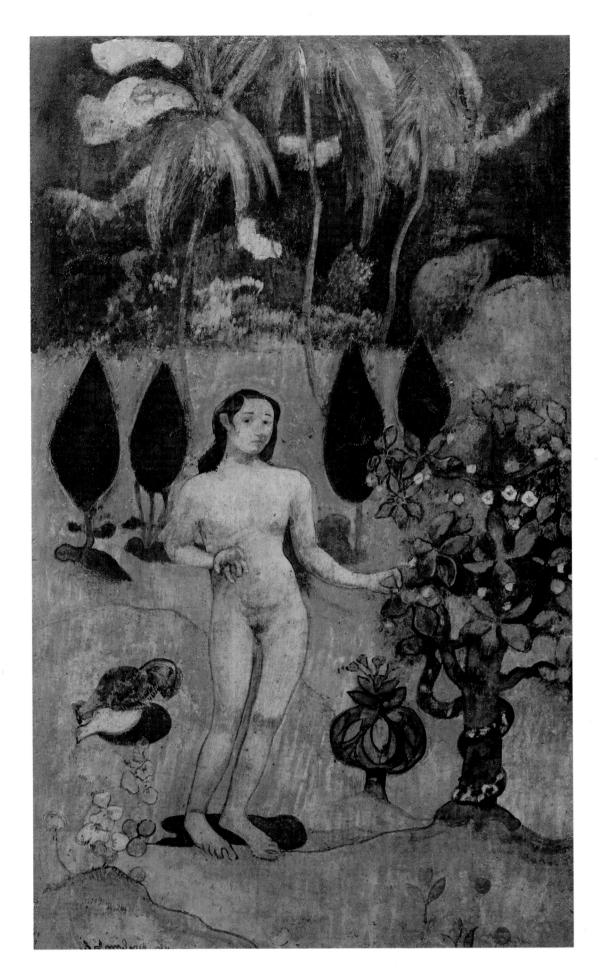

rejected him: 'I am a stranger here, an exiled Indian.' This break with civilization that, after Rimbaud, only Gauguin was to have the sublime naïveté to consummate, went far beyond the literary excesses of the *fin de siècle* Symbolism that had been his inspiration in the beginning. In this sense his departure was a symbolic act in itself. He was imprinted with the stamp of the 1885 generation that suffered the 'crisis of the soul' that Paul Bourget had branded 'the mortal weariness of life'[21] a few years earlier, that nostalgia for an earthly paradise and light and that horror of a 'crepuscular, autumnal' future. All these themes, even in their most debased, insignificant and clumsy form, exerted an obscure but potent influence over Gauguin and played on the most sensitive area of his narcissism; nonetheless, his tenacious and forceful personality gave these hazy theories a rich artistic transposition.

Gauguin could have justifiably identified his departure with those in Rimbaud's *Season in Hell* published in 1886 that his Symbolist friends had doubtless given him to read: 'Here I am on the Breton shore—how the towns light up in the evenings. My day is done; I am leaving Europe. The sea air will sting my lungs; lost climates will tan my skin.'[22] The act of leaving took on an epic aura and material considerations like the ease of island life gave way to poetic ones. The Tahiti he hoped to find had already been brought to life by Pierre Loti's descriptions of lush landscapes and golden beaches, and by the eighteenth-century and Romantic explorers whom he told Odilon Redon he was reading.[23] Above all it existed in some of his Breton still lifes, which already shone with the damp brilliance of the Tropics, such as *Fête Gloanec* or the marvellously prosaic *The Ham*.

Gauguin finally sailed for Tahiti in April 1891, from Marseilles. The painter could not know that it was to the Hospital of the Conception in that same town one month later that Rimbaud would return from the East to die. For each of them, the myth was about to begin.

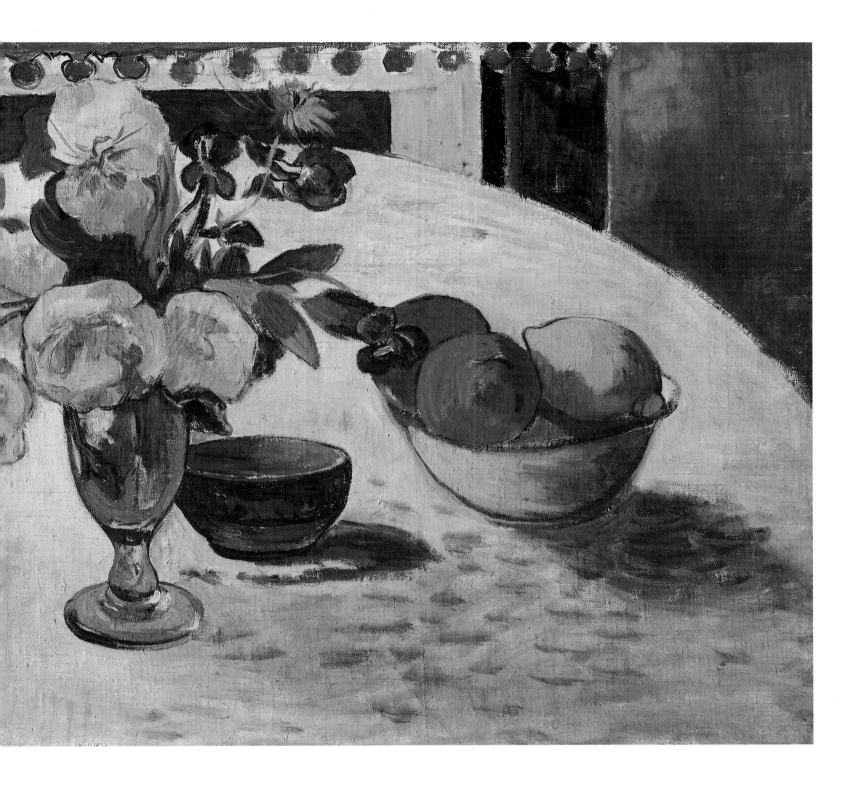

151. *Still-life with Flowers and Fruit*, 1890. Oil on canvas, 43×63 cm. Boston, Museum of Fine Arts.

This unpretentious painting, undated, may belong to a series of still lifes that Gauguin painted in the summer of 1890, all seen from a slightly plunging perspective in which the objects are placed on a table or a chair with a wilful clumsiness and naïveté. He enjoyed painting compositions in which the table forms a large arc—as in *Still-life: Fête Gloanec* (fig. 68)—a formula that Bonnard and Matisse frequently used later on. In this painting Gauguin gave his painterly abilities a free rein in the tender pink of the roses and the blue of the iris which he placed against an orange background. The blue and yellow bowl decorated with a somewhat primitively drawn animal is probably from Brittany. But the charm and spice of the painting come from the fringe of red bobbles along the mantlepiece that typifies a quality in his art that is often forgotten: his humour.

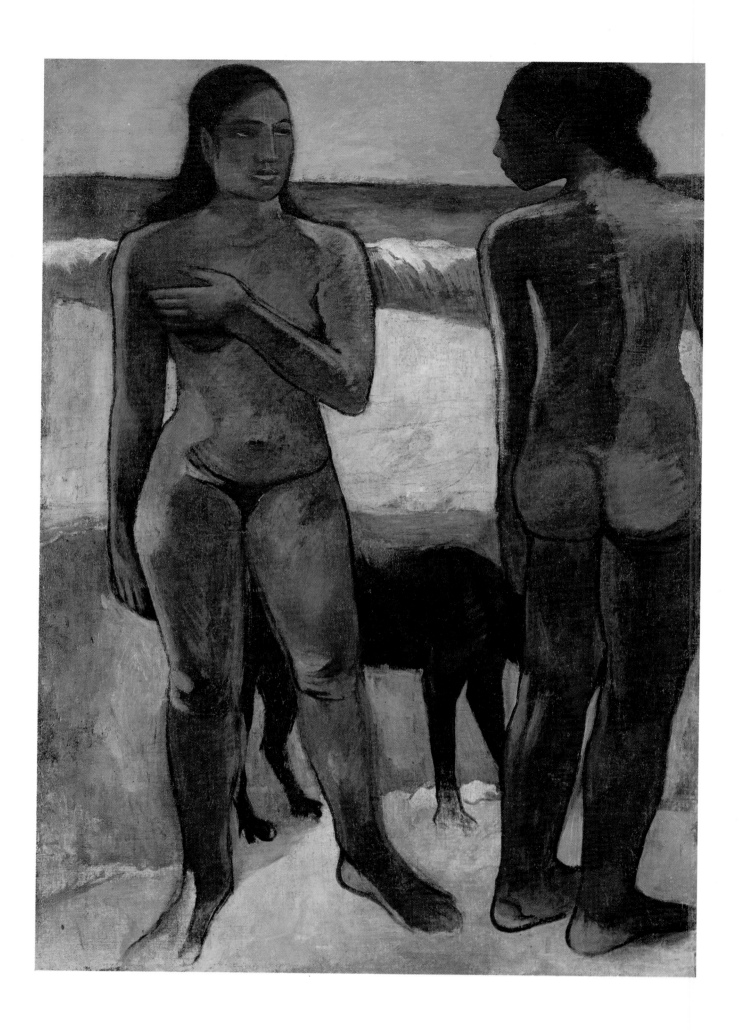

A SEASON IN PARADISE

1891-1893

152. *Two Tahitian Women on the Beach*, 1892. Oil on canvas, 91×64 cm. Hawaii, Honolulu Academy of Arts.

This may have been the painting that Gauguin described in a letter to Monfreid in August 1892: 'My latest work is a nude painted *de chic* [from memory] of two women by the sea, and I think it is actually the best thing I have produced so far,' although he could also have been talking about *Aha oe Feii?* (fig. 204). The painting is unfinished, as can be seen in a number of details (legs, faces), and unsigned. Gauguin did not include it among the paintings for sale on his return to Europe, and later gave it to his friend the painter Roderick O'Connor in exchange for the use of his Paris studio in 1894.

And yet it is a powerful work; a strong image made up of large simple strokes. The composition is monumental, though somewhat strange due to the dog behind the two women. The uprights of their combined legs form eight parallel lines that contribute to the overall impression of animal innocence.

It is interesting to note that this depiction of a beach on the Pacific, one of the most authentic of all Gauguin's Tahitian scenes, is now in a museum in Hawaii, the only one of his paintings to be exhibited in the world that saw their creation.

The Tahitian is reaching the beginning of his World, as the European reaches his old age.

Diderot.

When Gauguin landed in Tahiti he found a world that was as rich as Gustave Moreau's, as strange as Odilon Redon's and as balanced as Puvis de Chavannes's. 'I began to work, producing sketches and notes of all sorts. Everything about the place blinded and dazzled me.'[1] Almost at once, however, he turned his poetic gaze on the Tahitian women and, at his very first attempt, fixed their style of beauty for all eternity. Let the Tonkinese and Malagachian women eat their hearts out! It could so easily have been their charm that Gauguin celebrated, and their features that he made into the most famous pictorial incarnation of the sweetness and strangeness of exotic loves. . . . Who knows whether the former might not have been more delicate or the latter more vivacious and glowing than Gauguin's indolent faces.

However, from the first portraits it is precisely their placid strength and almost sad heaviness that give them their beauty, and Gauguin drew on all his taste for fable and mystery to make them enigmatic.

In talking about one of the earliest of these, Gauguin described his first meeting with a Tahitian woman: 'In order to properly initiate myself into the features of the

154. *Tahitian Woman.* Crayon and pastel, 39×30 cm. New York, Metropolitan Museum of Art.

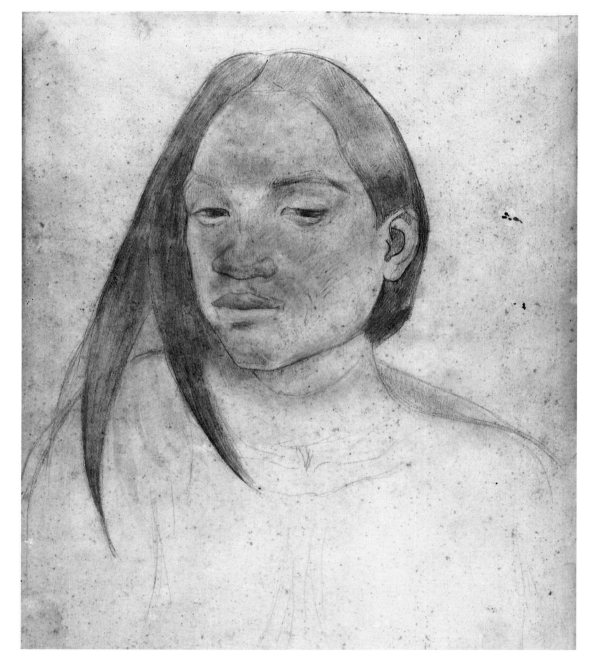

153. *Head of a Tahitian woman*, c. 1891. Graphite on vellum, 30.5×24.5 cm. Cleveland Museum of Art.

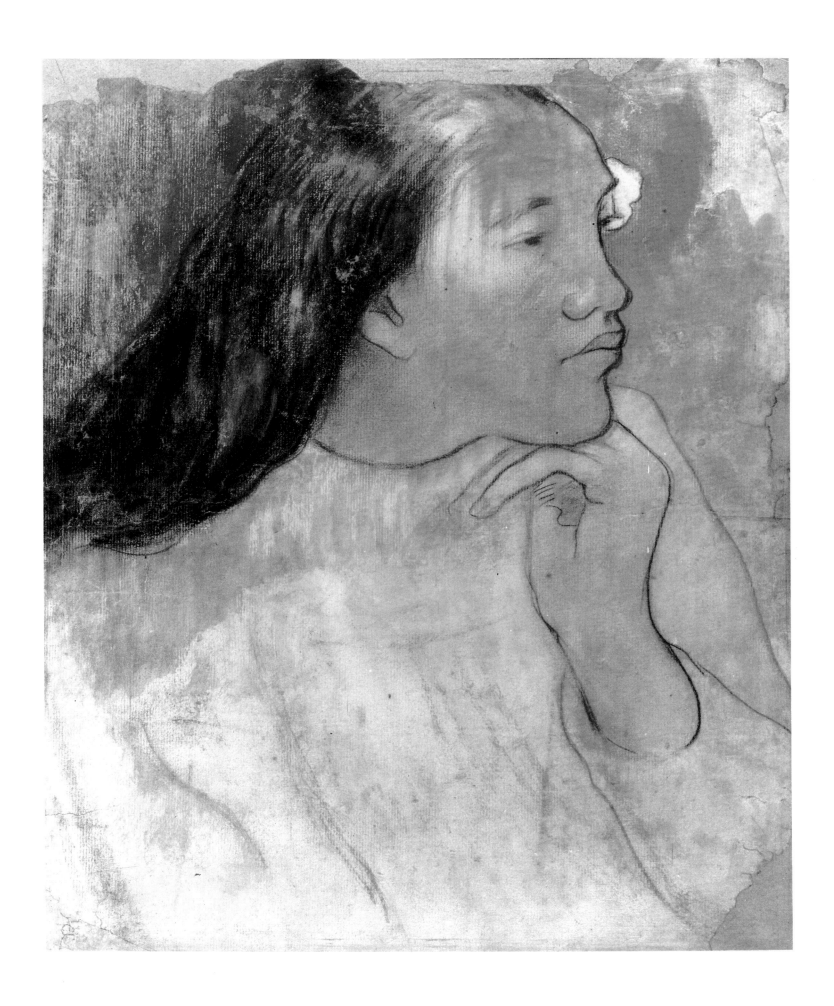

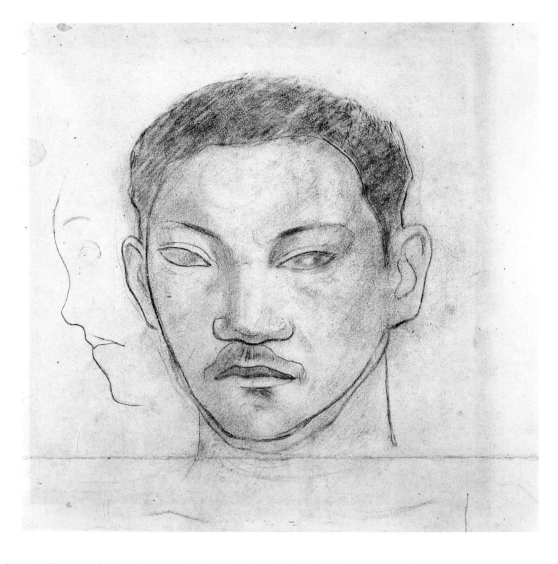

155. *Head of a Tahitian* (with Profile of Second Head to His Right), 1891-1893. Crayon and pastel, 35×37 cm. Chicago, Art Institute.

157. *Young Man with Flower*, 1891? Oil on canvas, 46×33 cm. United States, Private Collection.

This portrait of a young Tahitian is undated, but its traditional composition and the three-quarters pose similar to many of his portraits and self-portraits—a style that Gauguin abandoned in Tahiti—leads one to assume that it was painted at the beginning of his stay in Papeete. Gauguin painted few men in the South Seas; this is the only existing portrait of one. It looks as though he had been almost intimidated by the classic and exotic beauty of the adolescent's face. The boy was probably a town dweller and schoolboy, though he wore a perfumed flower behind his ear in the Tahitian manner in spite of his proper pink shirt and western tie. Gauguin brought out the soft sad green of his eyes with a dark green background. This little portrait must have delighted Henri Matisse, who bought it at the turn of the century for his personal collection.

156. *Crouching Tahitian Woman*, 1891-1892. Charcoal and pastel, 55.3×47.8 cm. Chicago, Art Institute.

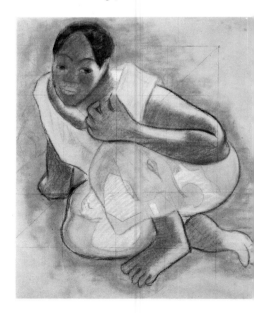

Tahitian face and the charm of the Maori smile, I had long wanted to paint the portrait of a neighbour who was of the pure Tahitian race. I asked her one day, when she had gathered up enough courage to come and examine the reproductions of paintings I had pinned to the wall of my hut. . . . I tried to sketch some of her features and above all her enigmatic smile. I asked if I could paint her portrait. She pouted disagreeably . . . then fled. . . . An hour later she came back wearing a pretty dress. Was it a struggle with herself, or capriciousness (very Maori) or again the reaction of a coquette who will surrender herself only after resisting? I became aware that in my examination of her as a painter there was a kind of tacit request that she surrender herself, surrender herself for ever with no going back, a probing for a glimpse of what lay inside. Not a pretty woman by European standards, and yet she was beautiful; all her features had a Raphael-like harmony in the way the curves met, with a sculpted mouth made to speak all the languages of words and kissing, joy and suffering: a melancholy bitterness mixed with pleasure and the passiveness found in strength. A real fear of the unknown.

'I worked feverishly. It is a good likeness that my eyes perceived *through the filter of my heart.* I think it is most like her on the inside, with a healthy glow of contained strength. She wore a flower behind her ear that appeared to listen to her perfume. And the majesty of her forehead drawn in upward strokes reminds me of this line from Poe: "There is no exquisite beauty without some *strangeness* in the proportion." '[2] The painting that resulted from this visit is the gorgeous *Vahine no te Tiare.*

Even if, as he said, Gauguin wished to capture the intimidated expression on her beautiful ponderous face, this painting is nonetheless merely a Maori version of

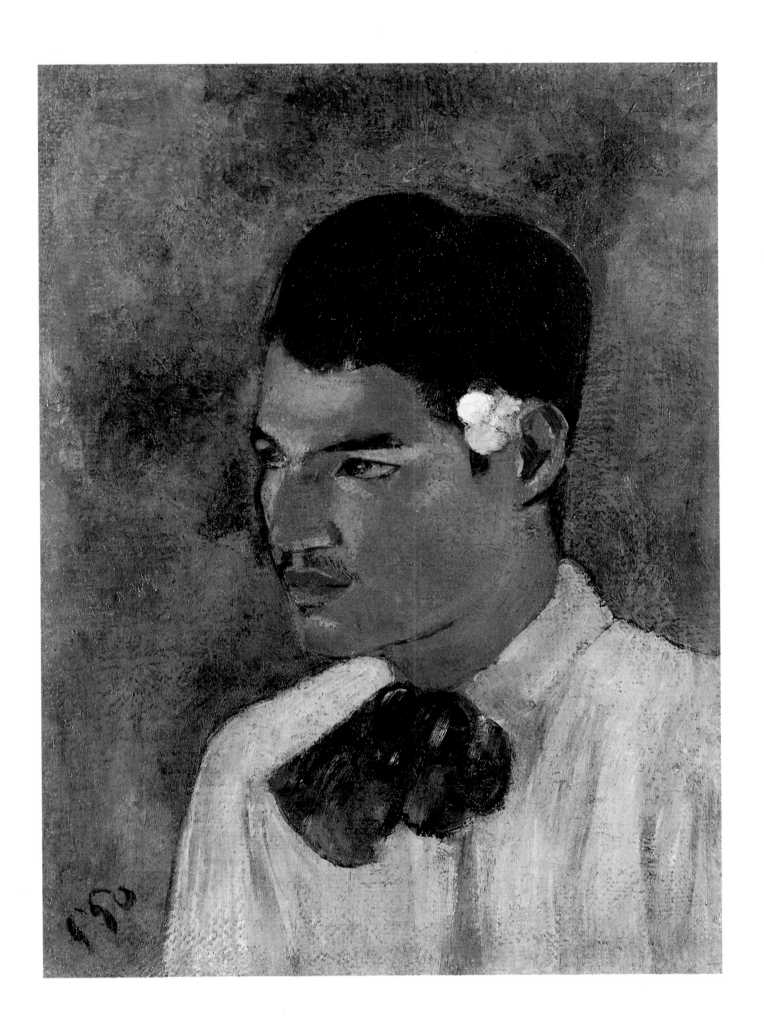

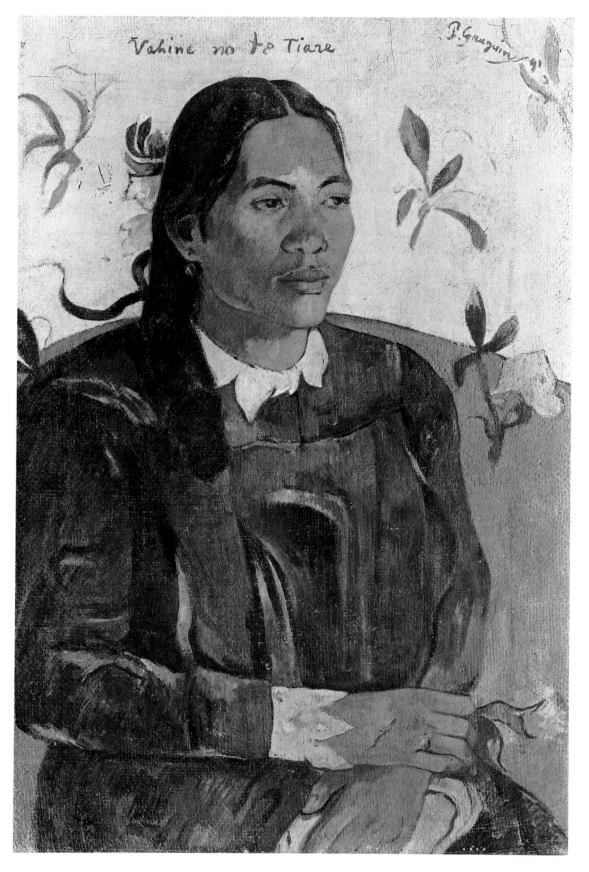

Vahine no te Tiare

158. *Vahine no te Tiare* (*Girl with a Flower*), 1891. Oil on canvas, 70×46 cm. Copenhagen, Ny Carlsberg Glyptotek.

159. *Te faaturuma* (*Silence*), 1891. Oil on canvas, 91×68 cm. Worcester, United States, Art Museum.

In the list of paintings sent for an exhibition in Copenhagen in 1893 that Gauguin annotated for his wife, he gave the Tahitian title of this painting with the translation: 'Silence, or to be sad' after explaining that the local language was strange in that one word had 'several meanings' (8 December 1892); the exact meaning according to the specialists is 'preoccupied'. In his first impressions of Tahiti that Gauguin sent to his wife: 'I am writing this in the evening. The silence of the Tahitian night is even stranger than everything else . . . I see how these people can spend hours or even days just sitting silently. . . . I feel as though the turmoil of life in Europe no longer exists and that tomorrow it will be the same and so on until the end of time' (July 1891), he brilliantly describes the torpor and dejection that resembles *fiu*, the Tahitian word for 'feeling blue'.

The simplicity of this painting makes it more obscure than the consciously enigmatic ones he painted in the years that followed. What is this woman thinking as she sits with her thick legs crossed on a pink mat on which is lying a hat and what looks like a large lighted cigar? Behind the veranda a horseman appears to wait for something, as does the dog. The potent images and the strength of the brushwork pleased Degas so much that he bought it for his collection.

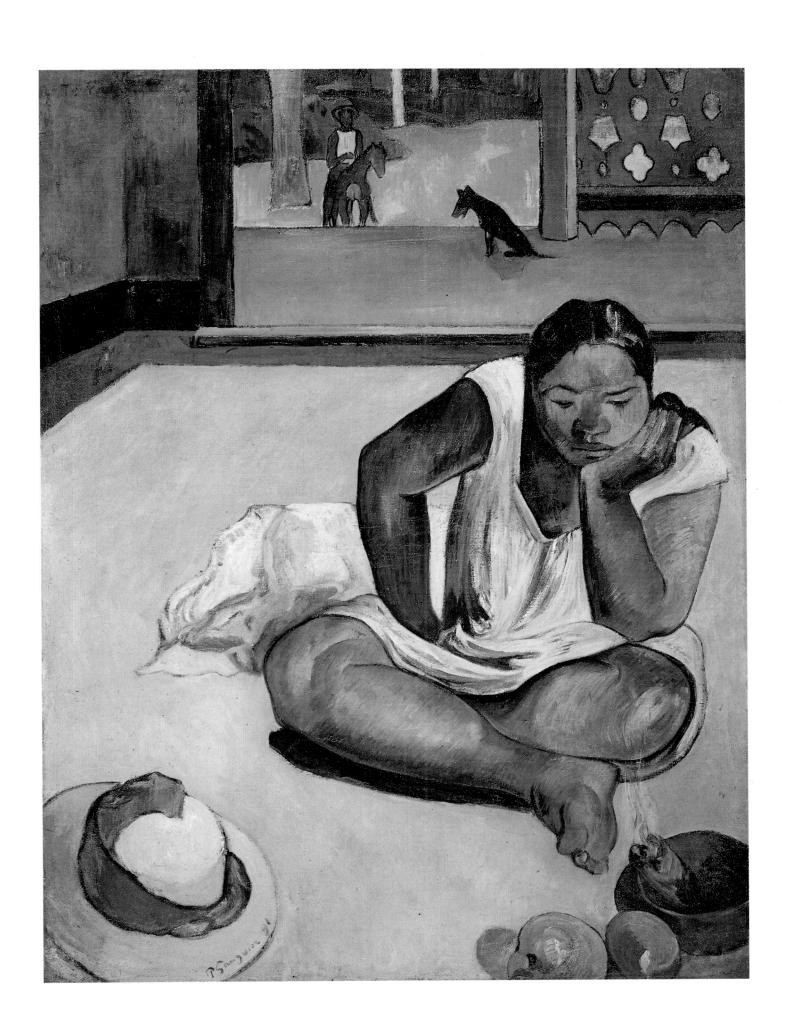

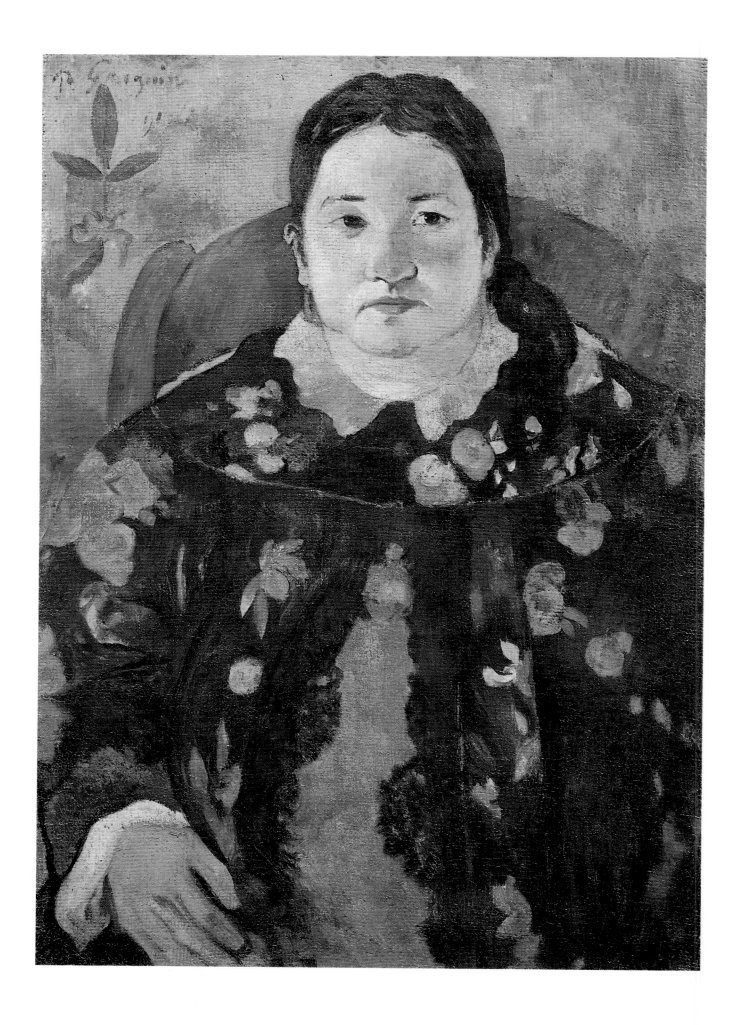

Shortly after his arrival in Papeete Gauguin tried to get commissions for portraits. The only one he received, in the summer of 1891, was from a rather plump Englishwoman with an unusual destiny, for it is said she married Taaoroa, one of the Tahitian chiefs of the windward islands and, under her Maori name of Tutana, played an important role in the court of the last Maori king, Pomare V, who died a few days after Gauguin's arrival. Speaking English, French and Tahitian, she was the ideal go-between for all kinds of negotiations. According to Bengt Danielsson, Tutana's adventurous spirit did not go so far as an unconditional liking for this portrait, especially for the red nose that leads to some unflattering conclusions about good old colonial traditions.

And yet it is a frank, handsome portrait and, though it did not flatter the sitter, Gauguin neither caricaturized nor 'sythesized' her as he had a number of his earlier portraits. He captured the intelligence of her sleepy look, and the sober eccentricity of her garb—doubtless a Chinese robe, for Tahiti already had a large Chinese merchant community—is delicately painted.

Under his signature above right, a floral motif on the wallpaper recalls some of his earlier paintings, like *La Belle Angèle* (fig. 115), or the later *Vahine no te Tiare* (fig. 158). Gauguin is of course suggesting the Tahitians' much favoured *tiare* flower, but it is also a reminder of the paintings of his Parisian seniors: Whistler's emblematic signature and the wallpaper motifs used by Cézanne. This portrait can be seen as a homage to both artists.

Portrait of a Woman, with Still Life by Cézanne. Its source is clearly Cézanne in the treatment of the dress as a simplified mass, the same flat background resembling wallpaper and the same three-quarters pose. For the time being Gauguin had simply transposed Cézanne and the fruits of all he had read to the South Seas, and his approach to the 'Maori soul' resembles Pierre Loti's fifteen years earlier. Gauguin went no more deeply into pictorial psychology than the author did in *Rarehu. . .*, when describing what was in reality a boy of fourteen: 'She was a singular little girl, and her penetrating and wild charm stood outside all the conventional rules of beauty allowed by the peoples of Europe,' and one could believe that it was the painter speaking when Loti declared indignantly that 'civilization has been here too often—our stupid colonial civilization. . . .'[3] It seems that Gauguin was disappointed at the beginning of his stay, first by Noumea, his last port of call, then by Tahiti's port, Papeete, and its inhabitants. Shortly after he reached the island its king, Pomare V, died. 'With him the last vestiges of Maori customs disappeared. It was really over: none left but the Civilized. I felt sad at having come so far. . . . Will I succeed in finding the traces of this mysterious and distant past? The present doesn't have anything worthwhile to say to me.'[4]

Nevertheless, at first Gauguin tried to associate with the 'Civilized' in Papeete in the hopes of obtaining commissions for portraits. But a colonial society whose only weapon against indolence and alcoholism was to exaggerate the conventional side of life was not the sort to please a man who believed he was 'casting off' from the West, nor was he likely to attract it, either. Also, Gauguin's somewhat caricatural 'artistic look', that Paul César Helleu had found so ridiculous in Dieppe, provoked the 'amazement and cat-calls'[5] of the Tahitians, and his long hair—which he promptly cut—led them to nickname him *taata-vahine* (Man-woman).

Too strange and poverty-stricken for the one and not yet adopted by the other, Gauguin soon left Papeete for Mataeia, some forty-five kilometres to the South, where he rented an isolated hut by the sea. He believed that he had at last reached the wilderness, but in fact he was close to a village on the bus route that served the main points of the island; even Robert Louis Stevenson, who had visited Tahiti three years earlier, had been better advised and had gone to the one really wild spot, accessible only by sea or on foot: Tahiti-iti.[6] Gauguin was nevertheless isolated enough for his first *vahine*, a half-caste called Titi, to miss Papeete and abandon him in Mataeia. It wasn't until the arrival of the young Tehamana, a pure Polynesian whom he called Tehura in his writings, that he would at last taste the simple joys he had dreamed of in Europe. Living in a peaceful paradise with this adolescent, whom he would love above all his other *vahines* and models, he began a period of intensive work lasting almost a year, the results of which justified all the hopes that he had pinned on 'new subjects'— at long last the reality of the South Seas matched the South Seas of his dreams.

Another early painting, *Faaturuma*, the portrait of a woman in a red dress seated in a rocking chair whose decorative curves he drew with obvious pleasure, was undoubtedly painted before he met Tehamana, but it anticipates how he would soon paint her, describing her as 'not very talkative, melancholy and mocking'[7]—melancholy, especially, for he already sensed the dejection of this new-found paradise and its inhabitants. The Peruvian tropics of his childhood were tempered by the dryness of the plains and mountains, and this made its people more lively, industrious and gay. Here the heat was steamy and overpowering and consequently gestures were slow, the faces were masked by something sweet and languid. He described his first impressions of Mataeia, impressions that were so strong that they would mark his vision of the islands for ever, in a letter to Mette: 'The silence of the Tahitian night is even stranger than everything else, it exists only here, not a single birdcall to disturb one's rest. Here and there a large dry leaf falls to the ground, but it does not give the impression of having made a sound. It is more like the rustle of a spirit passing. The natives often wander during the night, but they are barefoot and noiseless. Nothing but silence. I see how these people can spend hours or even days just sitting silently, sadly staring at the sky. I feel all this will overwhelm me. . . .'[8]

Gauguin immediately found the pictorial means to express this mixture of inertia

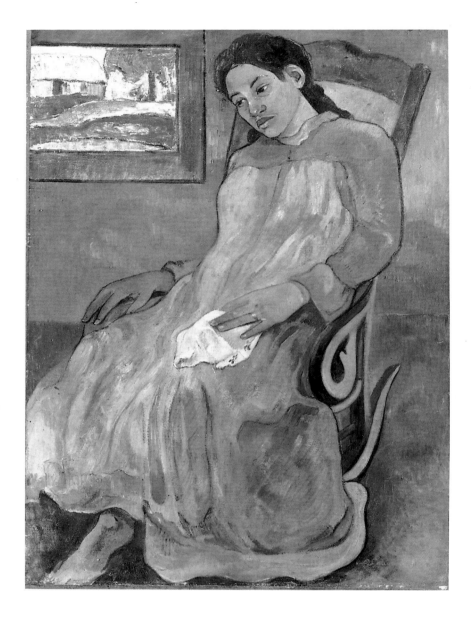

161. *Faaturuma* (*Reverie or Woman in a Red Dress*), 1891. Oil on canvas, 94.6 × 68.6 cm. Kansas City, Nelson Atkins Museum of Art.

162. *Te tiare Farani* (*The Flowers of France*), 1891. Oil on canvas, 72 × 92 cm. Moscow, Pushkin State Museum of Fine Arts.

and radiance that belonged as much to the Tropical night as to the inhabitants, in two paintings that must be counted amongst his finest. In *Te tiare Farani* and *The Meal* the painter communicated the soft poetic charm of these interiors by contrasting the smooth, indifferent faces of the children with an explosion of pink oleanders in the first and a brilliant bunch of bananas in the second, as if nature was taking its sap and exuberance from people—leaving them mere images of themselves—and giving it to flowers and fruit. In *The Meal*, in which three children are solemnly lined up behind a table, Gauguin applied the principle of a frieze composition that he would soon use for his large groups of figures. This synthesizing of a subject uncomplicated by literary references resulted in paintings that were robust and direct, including *Tahitian Women* and *The Siesta*—which, though undated, almost certainly belongs to the same period. In the first painting there is the difficult association of pink and yellow that Gauguin had mastered in Pont-Aven but that became a chromatic leitmotiv once he got to Tahiti. The woman's loose blouse in *Tahitian Women* was one of his first opportunities to use it. Before he left France Gauguin had developed a number of natural, clear and decorative compositions that he hardly stylized when transposing them to his canvases, like the Breton coifs against a field or the black and white puzzle of spotted cows, or again the striped wallpaper in *The Ham* (a ready-made decorative motif) that Bonnard and Vuillard would soon make such great use of. In Tahiti,

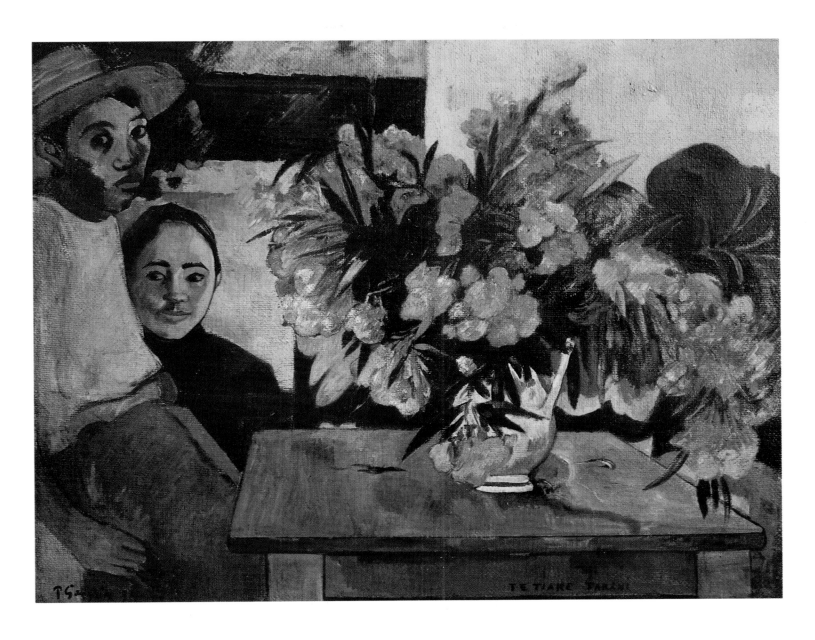

the simple pareus with their large white flowers on a red, yellow or blue ground, en-chanted Gauguin, and he used them to give a decorative liveliness to the equilibrium of his masses before Matisse did, as can be seen in the pareu worn by the woman on the left leaning on a hand and arm that are reduced to their most elementary form.

However, when Gauguin depicted Tahiti as sophisticated and tried to fit it into Émile Bernard's mystic Symbolism, he disserved his truer impressions. This is why one feels embarrassed by a painting that is nevertheless famous— *Ia orana Maria*, though Gauguin himself liked it very much, as can be seen from his letters to Monfreid and the fact that in 1893 he gave it to the Musée du Luxembourg, then the Paris museum of modern art.[9]

It summarizes Gauguin's main qualities and defects, and there is something almost irritating about its many references to other paintings of his, and to other cultures. He introduces his two latest local finds: the pareu and the bunch of bananas. The one satisfied his taste for the arabesque and flat areas of paint and the other permitted a play of volumes achieved through colour relationships alone, in the manner of Cézanne. Whereas in *Tahitian Women* these motifs are pictorially necessary to give the painting its balance and atmosphere, and bring a strength and poetry to *The Meal* whose strange power de Chirico later used in his own work, here the Virgin Mary's pareu is folklore and the still life in the foreground seems to be simply filling an empty

163. *The Meal* or *The Bananas*, 1891.
Oil on paper mounted on canvas,
73×92 cm. Paris, Musée d'Orsay.

The frontal view of the children and the
strict horizontal slicing of the composition
are rare for Gauguin, and recall Manet
rather than Cézanne or Degas, as does
the angled knife on the white cloth that
Manet took from Dutch still lifes.

There is nothing Nordic, however, about
the objects on this tropical table, whether
it is the limes, the open pomegranate, the
gourd-calabash, or the local wood goblet
that Gauguin ornamented with 'Maori'
drawings. Of course the emphasis is on
the sumptuous *fei*: those red bananas in
serried lines that he also used in the fore-
ground of *Ia orana Maria* (*Hail Mary*)
(fig. 167).

The three little Tahitians were painted
from preparatory sketches now in the
Department of Drawings at the Louvre.
One feels them posing timidly, with a
touch of melancholy. The scene has some-
thing grave and inexplicably religious
about it; the knife and the boys' eyes
direct our attention towards the little girl
with the more carefully modelled face.
One is led to think that these figures are
bringers of offerings before an altar
rather than schoolchildren at their tea.
This was another of the paintings that
Degas advised his young friend Alexis
Rouart to buy at a benefit sale for the
widow of Père Tanguy in 1894. Gauguin
donated the painting in grateful memory
of the man who had bought the most-
loved items in his collection: his Cézannes.

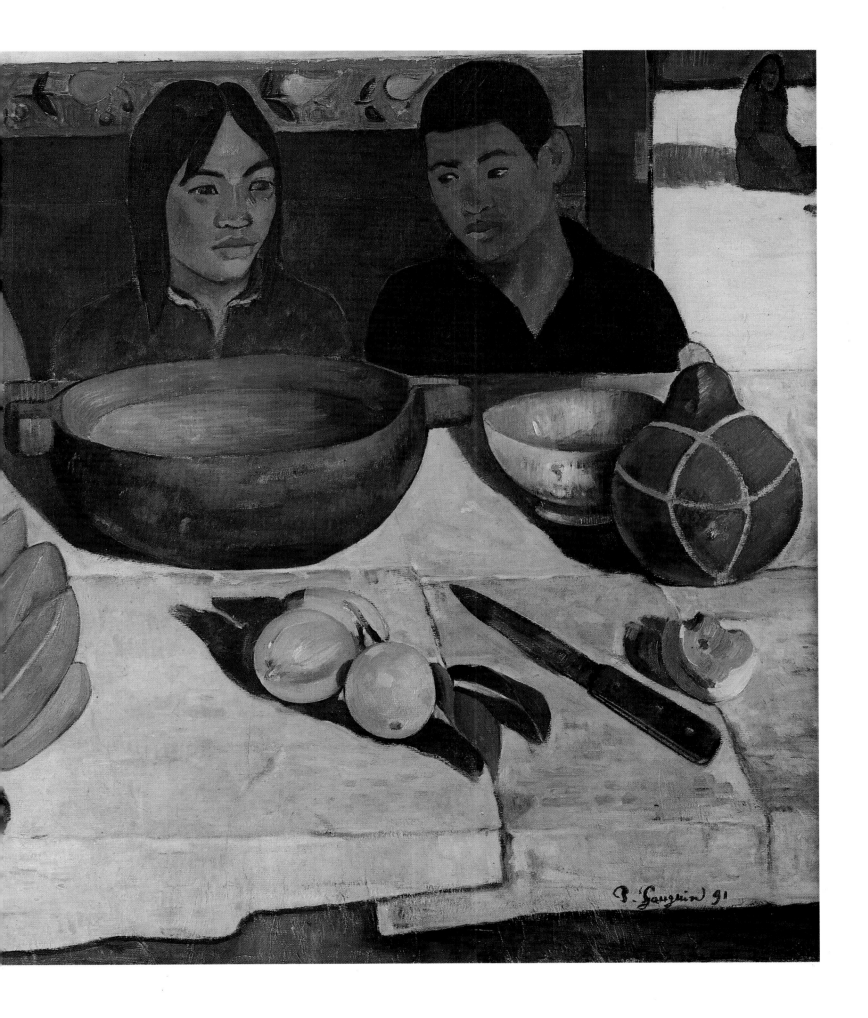

164. *The Siesta*, 1892? Oil on canvas,
87×116 cm. Palm Springs, Mr and Mrs
Walter H. Annenberg Collection.

This is not a siesta, but a South Seas
'female' gathering on the veranda of a
fare where much of Tahitian life went on.
In the background a woman is ironing on
the ground—Gauguin would use her again
in a superb monotype (fig. 263). It is a hot
afternoon and the spreading shade is
staining the grass a darker green. A
woman on the left with a *tiare* flower
behind her ear is musing or listening, like
the woman lying on her stomach whose
red dress makes the mauve pink of the
floor sing slightly discordantly.

But the main personality is the myster-
ious visitor seated with her back to us.
The lovingly detailed costume—a fine
flowered shirt worn over a traditional
pareu, and a straw hat—and the little bag
full of objects on the floor show that she
has probably just returned from the mar-
ket or vespers in town. She has brought
the latest news—*Parau Api* (as a
Gauguin painting in the Dresden
Museum from the same year is called in
which there are women seated on a sim-
ilar veranda, and of which *Tahitian
Women* or *On the Beach* (fig. 165) is
another variation).

All this painting's magic and beauty lies
in this faceless silhouette painted as
Matisse might have painted her twenty-
five years later; her hair, hand and foot
show a 'primitive' sensuality that the
rather innocent respectability of her cloth-
ing merely serves to underline.

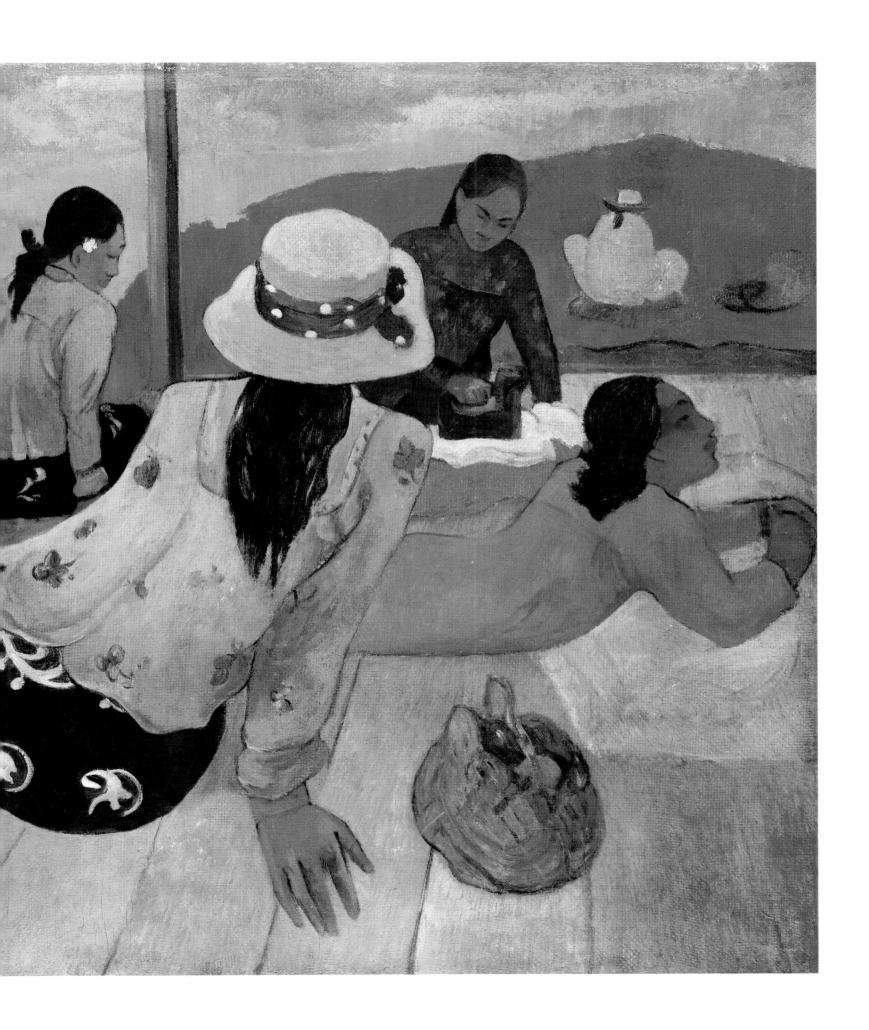

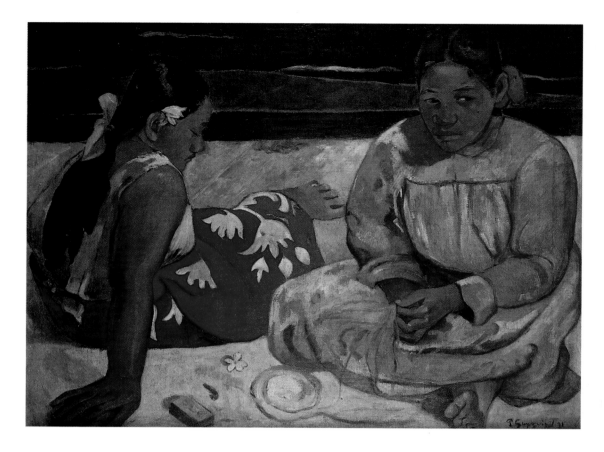

165. *Tahitian Women* or *On the Beach*, 1891. Oil on canvas, 69×91 cm. Paris, Musée d'Orsay.

167. *Ia orana Maria* (*Hail Mary*), 1891. Oil on canvas, 113.7×87.7 cm. New York, Metropolitan Museum of Art.

space. Moreover, the opposition of the decorative motifs treated as areas of flat colour to the section painted in volume, that could have resulted in an interesting contrast, is merely awkward.

The angel is borrowed from Botticelli—as are the very Florentine branches of the trees—and the two Tahitian women walking along the path praying come from a relief in Borobudur in which the joined hands did not mean prayer, but an Oriental greeting.

Everything about the painting was guaranteed to please Gauguin's literary friends; when he took the painting back to France Charles Morice wrote long lyrical descriptions of it and a little later Alfred Jarry wrote the following mediocre poem about it in the visitor's book at the Gloanec Inn:

166. Detail of a frieze on a Javanese temple in Borobudur, the photograph once belonged to Gauguin. Private Collection.

Ia Orana Maria	Ia Orana Maria
And the savage Virgin	Et la vierge fauve
And Jesus as well	et Jésus aussi
Look, here is	Regardez, voici
Alba the bat	Qu'Albe souris chauve
An angel in a green hell who flies before it	Vole un ange dont l'enfer vert se sauve
To the savage Virgin	Vers la vierge fauve...

Luckily Gauguin was too much of a painter to limit himself to the allegorical, and in this Tahitian Virgin and Child he achieved a real feeling of peace and calm despite the many clashing components, by balancing his composition with a grid of horizontal lines such as the path, the foreground, the horizon and the arms and shoulders of the three women, and vertical ones such as the bodies and the trees.

During the same period Gauguin appears to have looked for similarities to Eastern art in the Tahitian landscape once more, but this time he went beyond solely external features. The year before in Paris he was inspired by the convoluted forms of Javanese reliefs for his woodcarving *Be Mysterious*. Here were are more distantly reminded of certain Japanese prints by Gauguin's emphasis of the swirling lines of the long leaves

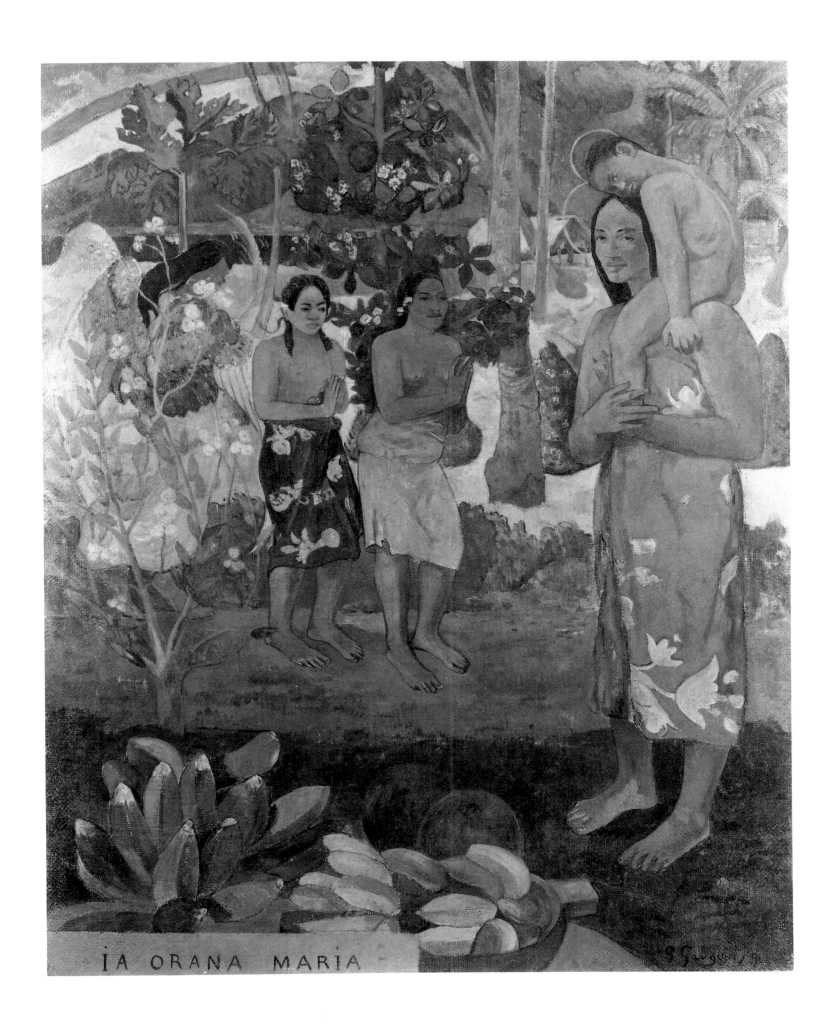

iA ORANA MARIA

168. *Te fare (The House)*, 1892. Oil on canvas, 73×92 cm. Paris, Private Collection.

Long before he left France, Gauguin dreamed of a place like the one he painted here: 'What I shall do is create a **Studio in the Tropics.** With the money I'll get I shall be able to buy a peasant hut like the ones you saw at the Universal Exposition. In wood and wattle and daub, roofed in straw, near a town but in the country nevertheless. . . . I shall enlarge it by cutting down some trees and turn it into a suitable home for us; a cow, chickens and fruit, these will be our staple diet, and we will end up living for nothing, free at last. . . .' (to Émile Bernard). The reality was different: he was alone in the **Thebais** to which he had hoped to bring his friends, and the facilities were not those he had described, though the beauty of his surroundings exceeded his hopes. Here is the 'peasant hut' that was perhaps the one he inhabited: a *fare,* the light local construction in wood, open at the front and roofed in palm fronds. A woman is seated on the veranda, which is similar to the one in *The Siesta* (fig. 164) and *Te faaturuma (Silence)* (fig. 159). Another woman in a *pareu* is walking towards her, almost as though overcome by the damp heat that bathes the landscape under a lowering sky. But the most important element appears to be the tree, the *purau,* that giant hibiscus of the island's primitive forests, mainly found in the mountains, though a few still grew on the coast in Gauguin's day.

His straightforward portrayal of nature, to which he applied neither style nor a deliberate primitivism, reminds one of his Martinique paintings and makes one think of Bonnard's later landscapes. One of the few paintings to be sold at the disastrous auction of 1895, it was acquired by the writer Ludovic Halévy, almost certainly on the advice of Degas.

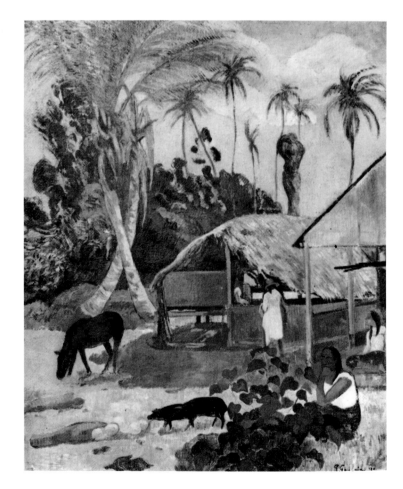

169. *The Little Black Pigs*, 1891. Oil on canvas, 91×72 cm. Budapest, Museum of Fine Arts.

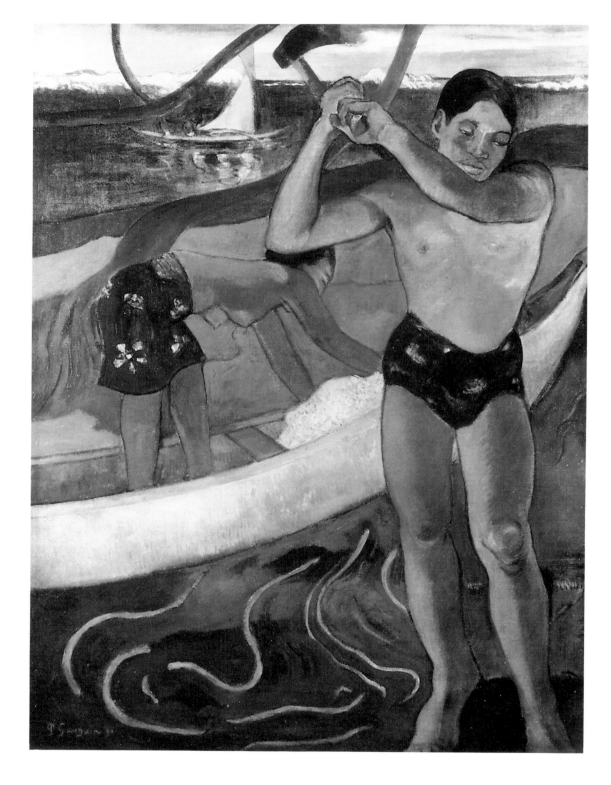

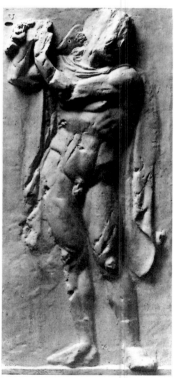

lying on the ground in *The Man with an Axe*, or the roots in *I raro te oviri*. The
description he wrote of *The Man with an Axe* in *Noa Noa* shows that he knew this:
'The almost naked man uses both hands to lift a heavy axe that leaves its blue imprint
on the silver sky; . . . on the purple ground are some long snake-like metallic yellow
leaves, in short a complete oriental vocabulary—the alphabet (to my mind) of a
cryptic unknown language. . . . In the canoe the woman is tidying some nets and the
horizon of the blue sea is frequently broken up by the green crests of the waves crash-
ing against the coral reefs.'[10] For the first time in the history of Western art, a painter
was not just giving his attention to the pictorial modelling of Far Eastern art, but

confusedly, yet already conscientiously, to its graphic qualities that would play such an important role in painting fifty years later.

Gauguin had taken all his cultural paraphernalia to Tahiti with him: 'I am taking a whole little world of friends, in the form of photographs and drawings, who will talk to me about you every day'[11] he wrote to Redon before he left. The inventories done of the contents of his hut, the papers he sent back to Monfreid or those that Segalen removed after his death and, of course, his paintings, tell us what this 'little world' consisted of. Cut off from museums, exhibitions and the nourishing discussions in Pont-Aven and Paris, Gauguin almost certainly filled his portable museum with many Japanese prints, maybe even with the first issues of Bing's *Japon Artistique*. The Japanese influence in Gauguin's Tahitian paintings is not as clear as it was in Brittany where, lacking models, he used the ones he found in the albums of Japanese art, as with *Vision after the Sermon*. In Tahiti there were plenty of willing models and, when he wanted an Eastern inspiration, he turned more towards Egypt or Java. Nonetheless, some of his canvases show a sharp Japanese influence in the decorative handling and style of their composition for, as yet unable to assimilate the primitive art that so fascinated him, he instinctively lent it the mould of the most exotic art that he knew.

The most amazing of these is *Parahi te marae*, painted in 1892. A strange slanting black fence cuts the landscape in two, its geometric lines boldly slicing the background

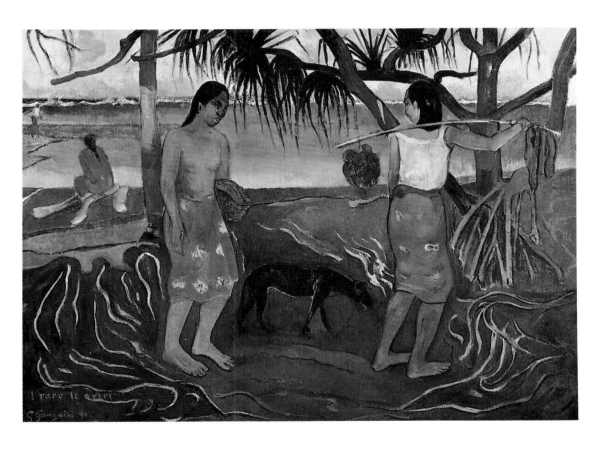

172. *I raro te oviri* (*Under the Pandanus*), 1891. Oil on canvas, 67×90 cm. Dallas, Museum of Art.

of a bright yellow hill. A bush of pink and red flowers clusters in the foreground, a sort of frozen flame or branch of coral like the ones that the fishermen must have presented to Gauguin to his great delight.

Gauguin placed a purely imaginary shrine—for the statue on the hill exists nowhere in Tahiti—behind this somewhat Asiatic fence. Consciously desiring to reconstitute the mythical, he theatrically magnified the decorative Polynesian components that he knew mainly through photographs. The impressive god is a Marquesan *Tiki*, and the fence is taken from the design of an ear-ornament.[12] Thus altered in scale and transposed into a painting meant to evoke Tahiti in the days before it was cor-

173. *Two Marquesan Women and Design of an Ear-ornament*, detail. Pen and graphite. Chicago, Art Institute.

174. *Parahi te marae (There Stands the Shrine)*, 1892. Oil on canvas, 68×91 cm. Philadelphia, Museum of Art.

rupted by white decadence, they take on an unmistakable Japanese look that conveys Gauguin's sensibilities at that time.

The reproduction of an Eighteenth Dynasty Theban painting in the British Museum provided Gauguin with a subject that he transferred almost unaltered to a bench in *Ta Matete*.[13] The stylized alignment of the front-facing torsos onto the profiled lower limbs of the five women, in a landscape that is still recognizably Tahitian despite the blue tree trunks and puzzle shapes in the foreground, provokes a sense of uneasy artificiality.

Gauguin's borrowings from Java were much better assimilated. The scene copied from the banquet in the Theban tomb has a stark sophisticated arrangement that is very foreign to a Tropical atmosphere. The Indo-Javanese friezes in the temple at Borobudur that majestically depicted sacred events of the Buddhist legend such as *The Tathagat Meets an Ajiwaka Monk on the Benares Road, Maitrakanyaka, Arrival at Nadana* or *Scenes from the Bahllatilia* have a dignity suffused with sensuality. In Indian art the sacred is not cut off from reality, but is in harmony with the grace and tropical lushness that brought it forth. It came as no surprise to Gauguin to find trees

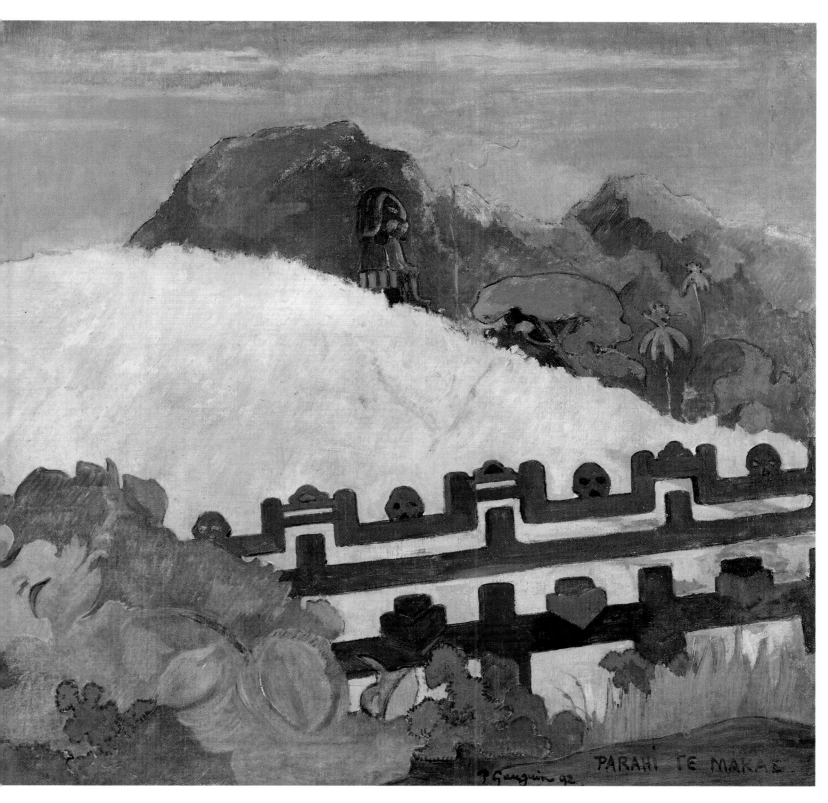

Gauguin described this painting in the list of those he exhibited in Paris in 1893: 'There stands the *marae*, the shrine—a place belonging to the cult of the gods and human sacrifice.' These *marae*, sacred places for human sacrifices—and even cannibalism—had indeed existed less than a century before. And yet he did not learn this from the oral traditions of the country, but from ethnographic literature (see caption to fig. 200). Besides, he was painting a Maori image in the imaginary wooden fence, an enlargement of a Marquesan ear-ornament drawn either from a real object or from a photograph (fig. 173). The *Tiki*, a Marquesan idol in profile on the hill, makes its first appearance in Gauguin's painting. It too is taken either from a photograph or from objects he had seen in the Musée du Trocadero in Paris before his departure.

However, the real magnificence of this painting lies in the characteristic relationship of colours, the red of the hibiscus bush in the foreground against the bright yellow of the hill. Few of Gauguin's works announced modern art so comprehensively—the art of the young Nabis Bonnard, Vuillard and Denis, who saw this painting at Durand-Ruel's gallery in 1893—and the formulas of Fauvism ten years later. This was one of the few canvases that were appreciated at the catastrophic auction of his work that Gauguin held before his second and last departure for the Tropics in February 1895. The purchaser was none other than his old friend, admirer and dogsbody Schuffenecker (figs 96 and 97).

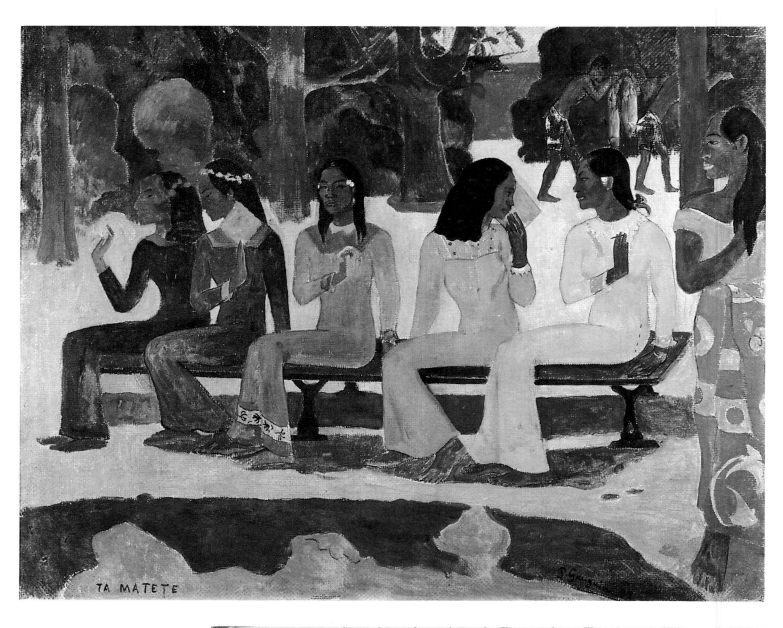

in Tahiti that he recognized from these reliefs, and it was much easier for him to give the ardent performers of *tamoure* the slow grace of the sacred Javanese dancers than the stiff courtliness of the Theban princesses.

The nude in *Te nave nave fenua* strikes the pose taken from Borobudur that Gauguin used in France for his *Eve Exotique*, but here he gave it a Tahitian guise. There is no reference to the Biblical Eden: the hand that reached for the apple now plucks a curious plant that is actually a peacock's feather, a bird that was commonly found on the island. Soon the desire to paint a Tahiti before original sin—that is to say before the arrival of the colonials—permeated all his works. *Ia Oriana Maria* was the last painting inspired by Christianity during that first stay. From then on Gauguin, always fascinated by the sacred, concentrated on Maori myths and legends. Although he liked to attribute Tehamana's silence to a kind of timeless wisdom, she was actually of little help to him in his research into her ancestral religion. In the first place she was only fourteen, in the second place women were not initiated into the tribal religions and, in any event, these had not been practised in Tahiti for several generations. A few inhabitants still remembered them, but so faintly that Gauguin despaired of ever reaching the sources of the 'primitive' that he had been trying to find as far back as Brittany. The only people who might have helped him distrusted him, whereas they had gladly shared their knowledge with Robert Louis Stevenson just three years earlier.[14] Fortunately, a Frenchman in Papeete lent Gauguin a book from which he was to draw many of his pictorial and literary subjects, for it was written around 1830 by a witness of those Maori religious practices that had virtually disappeared by 1891; it was *Voyage aux îles du Grand Océan* by J.A. Moerenhout. The two texts that Gauguin wrote and illustrated, *Noa Noa* and *Ancien Culte Mahorie* stemmed, according to him, from what his young wife told him: 'thus spake Tehura'. But however much he insisted that 'through her I at last unveiled many mysteries that had been closed to me' and 'the gods of yesteryear have been given asylum in woman's memory', the real source of his knowledge was Moerenhout's book. It was there, and not, as he had hoped, from the mouths of their descendants that he found the superb legends of the *Atua*, the *Roua Hatu*, *Fatu* and *The Birth of the Stars* which he transcribed in both Maori and French.[15] The oppressive silence of the Tahitian nights was at last peopled with memories of the gods, and he copied out long sacred texts with an inspired hand into a school exercise book. The geneology and attributes of the spirits and gods delighted him, and inspired cosmic reflections that mirrored the cultural eclecticism of his artistic tastes: 'In short, [the Maoris] had an inkling of Indian metempsychosis'[16] and he underlined the fact that the traditional lore had been handed down orally 'like Homer's poetry'. Elsewhere he compared the legend of the 'twins of Bora Bora' to that of Castor and Pollux.

The contents of the illustrations of Moerenhout's work, done in watercolour occasionally highlighted with black bamboo or Indian ink, came from objects that Gauguin found close at hand; everything from the decorations on the *tapas* (fabrics made from bark) to the spoons, stools, canoes, ear-ornaments and oar-blades came from Maori daily life. He later expressed his wonder at it all: 'More than anybody else, the Marquesan has an incredible feeling for the decorative. If you give him a geometric object of any kind whatsoever, even a lopsided one, he will manage to cover it—most harmoniously— without leaving a single displeasing or jarring empty space. The inspiration of his art is the human figure or face. The face above all. One is constantly amazed to discover that what one imagined to be a strange geometric shape is in fact a face. Always the same thing and yet never the same.'[17] He regretted that there was no museum in Tahiti to preserve an art that was disappearing 'because of the missionaries'.

From that point until his return to France Gauguin's painting fell into two categories: illustrations of local mythology, and landscapes and nudes. If at first he was somewhat disconcerted by what he saw around him and relied mostly on the iconography from Egypt or Java, confessing to Daniel de Monfreid that 'I am content to dig inside myself rather than in nature,'[18] six months later he could justifiably write to Mette that 'I am hard at work, for now I know this land and its smell, and the Tahitians whom I am

175. *Ta Matete* (*The Marketplace*), 1892. Oil on canvas, 73×91.5 cm. Basel, Kunstmuseum.

176. Mural from a Theban tomb, c. 1500-1400 B.C. London, British Museum.

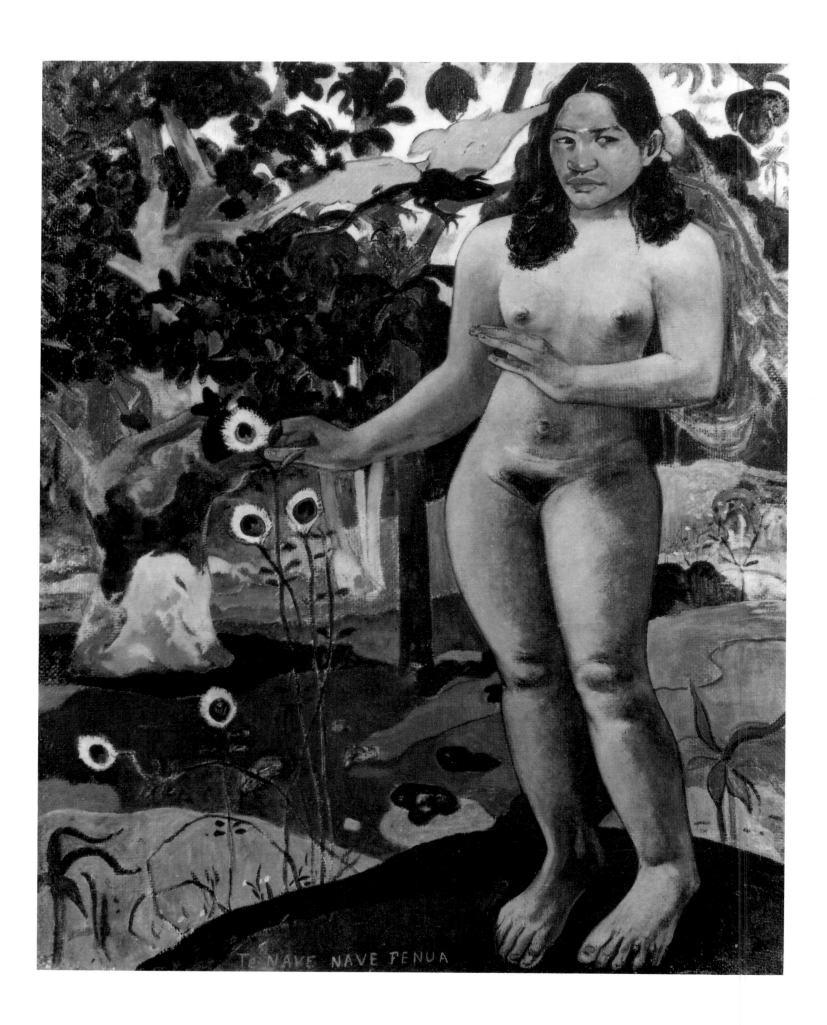

177. *Te nave nave fenua* (*The Delightful Land*), 1892. Oil on canvas, 91×72 cm. Kurashiki, Ohara Museum of Art.

178. *Te nave nave fenua* (*The Delightful Land*), 1892. Gouache on wove paper, 40×32 cm. Grenoble, Musée de Peinture et de Sculpture.

This Tahitian Eve, derived from the famous painting with the same title (fig. 177), holds the same pose as his *Eve Exotique* (fig. 150) painted in France in 1890, and like that one, was inspired by a photograph of a frieze in Borobudur that Gauguin had taken to Tahiti with him. Nevertheless, the body with its large feet, heavy face, and hair ornamented with a *tiare* flower are definitely Tahitian. The myth of an earthly paradise had simply been transposed to the islands of joy: 'It is Eve after the original sin, still able to walk naked and unashamed and keep all her animal beauty as if on the first day,' he wrote in *Diverses Choses*. Did he realize that in Tahitian *nave nave* means sexual pleasure before it means 'delightful'?

She is listening to the whisperings of a fabulous reptile for, since snakes do not exist in the South Seas, the Tahitians saw the Old Testament snake as 'a long lizard without legs', according to Loti in *Rarehu. . .*, a book that had tremendously impressed Gauguin and contributed to his decision to go to Tahiti. Gauguin made the animal more indigenous to Tahiti by giving it legs and a pair of extraordinary red wings. Instead of an apple, Eve is picking flowers that look like peacock feathers, 'eye-flowers' like the ones Odilon Redon invented in lithographs that Gauguin had seen.

This unusual watercolour uses the Pointillist technique that Gauguin had mocked two years earlier in a still life called *Ripipoint*. He used the technique here to delectably model his vahine's body and make the sand glisten like sequins on golden skin that had just emerged from the water. In the background he made a more orthodox use of Neo-Impressionist colour contrasts.

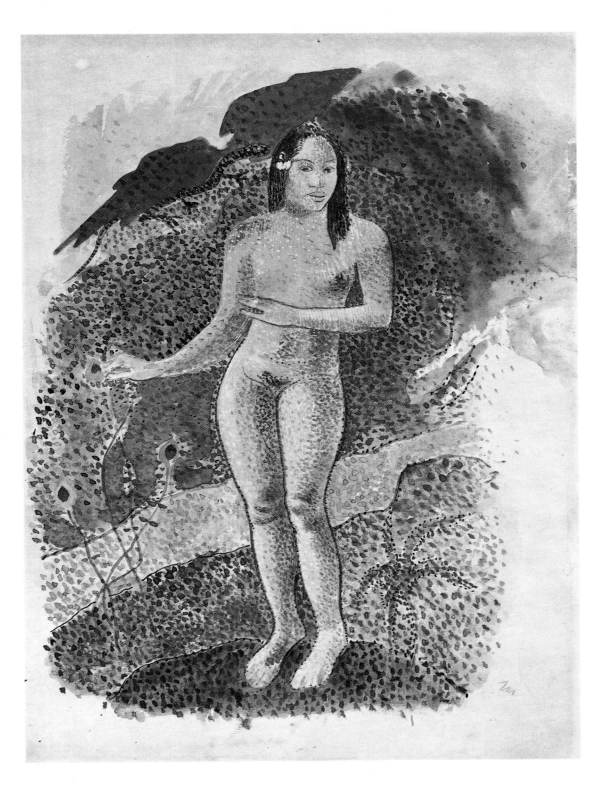

179 to 186. *L'Ancien Culte Mahorie*, 1892. Pen and watercolour on paper. Paris, Musée du Louvre, Department of Drawings.

These are pages from the manuscript that Gauguin, fascinated by local religion and mythology, wrote and illustrated during his first stay in Tahiti. As René Huyghe demonstrated when he published it in facsimile in 1950, it formed the basis for the successive stages of Gauguin's celebrated book, *Noa Noa*. Here he copied out—in phonetic Tahitian and then in French—the legends collected into the book *Voyage aux îles du Grand Océan* by Moerenhout, a French consul and ethnographer of the Romantic period. These particular pages are about the gods *Ariois*, who inhabited the Polynesian Olympus: Paea, or Bora Bora mountain. As with the watercolour *Te nave nave fenua* (*The Delightful Land*) (fig. 178), Gauguin linked the figures to the landscape with a decorative Pointillism that he spread over the mythic scene like a veil. Two young men wearing red and purple *pareus* have come to fetch a young girl—wearing a blue one—for their brother: she was the beautiful Vairumati painted in that same year, 1892, and again in 1897 in a painting of the same title (fig. 244). The ravishing watercolour on the page that follows it depicts the beauty of everyday objects like *pareus*, a low table—*fata*—on which there are exotic fruits and flowers, mangoes, *fei* and *tiares* like the ones in the foreground of *Ia Orana Maria* (fig. 167).

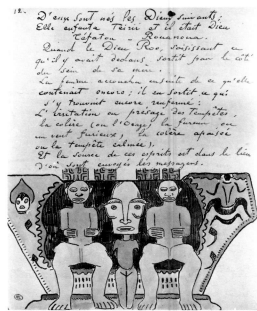

painting so enigmatically are nonetheless Maoris and not Orientals from Batignolles. It has taken me a year to achieve this. . . .'[19]

By bringing the old legends back to life in the simple poses of his models, Gauguin was responding to Baudelaire's demand for 'the transposition of daily life into legend'.[20] What could be a better definition of the portraits of Tehamana in *Te aa no Areois* or *Manao tupapau*?

The young woman sitting on a blue pareu with a sprouting coconut in her hand in *Te aa no Areois* has been given a pose similar to Puvis de Chavannes's *Hope*, adapted to the stiff Egyptian-style front-facing torso on the long thigh shown in profile. The colours are applied in large flat areas; bright yellow palms against the blue mountain, pink flowers against a green background and the earth, and fruit in reds and yellows: characteristically, the upper part is painted in complementary colours and the lower in neighbouring ones (blue-green, yellow, red).

But the most appealing of all the paintings of this local mythology is the celebrated *Manao Tupapau*, a sort of inverted *Olympia* lying on her stomach in which the black maid has been replaced by the spirit of the dead at the upper left.

Eternité de la Matière.

Dialogue entre Tefatou et Hina (les génies de la terre - et la lune.

Hina disait à Fatou; "faites revivre (ou ressusciter) l'homme après sa mort.

Fatou répond: Non je ne le ferai point revivre. La terre mourra; la végétation mourra; elle mourra, ainsi que les hommes qui s'en nourrissent; le sol qui les produit mourra. La terre mourra, la terre finira; elle finira pour ne plus renaître.

Hina répond: Faites comme vous voudrez; moi je ferai revivre la Lune. Et ce que possédait Hina continua d'être; ce que possédait Fatou périt, et l'homme dut mourir."

188. Pierre Puvis de Chavannes, *Hope*, 1877. Oil on canvas, 70.5×82 cm. Paris, Musée d'Orsay.

187. *Vairumati tei oa* (*The Name is Vairumati*), 1892. Oil on canvas, 91×60 cm. Moscow, Pushkin State Museum.

Gauguin was particularly attached to this painting and when he shipped his work to Mette, he asked her not to sell it. He described it at length to her, and again to his daughter in *Cahier pour Aline* under the title *Birth of a Painting*:

'A young Kanaka girl lies on her stomach, revealing a portion of her terrified face. She is on a bed covered with a blue pareu and a light chrome-yellow sheet. . . . I am attracted by a form, by a movement, and I begin to paint them without any other objective than painting a nude. As such, it is a somewhat indecent nude, and yet I want to paint a chaste picture that will show the Kanaka spirit, its nature, its tradition. Since the pareu is intimately connected to the life of the Kanaka people, I use it to cover the bed. The sheet, made of bark cloth, should be yellow. It suggests lamplight. I need a rather frightening background. The colour purple is the obvious choice. There, the musical aspect of the structure has been dealt with. Now I can see only her fear. What kind of fear? Certainly not that felt by Susanna when she was surprised by the Elders. That can't happen in the South Seas. The *Tupapau* (Spirit of the Dead) is the obvious solution. The Kanakas are in constant awe of it. . . . Once I find my *Tupapau* I focus all my attention on it and make it the central theme of my painting. The nude becomes secondary. What is a ghost for a Kanaka? She doesn't go to the theatre or read novels so, when she thinks of death, she is forced to think of someone she already knows. My ghost can therefore only be an ordinary little old woman. . . . The title *Manao Tupapau* has two meanings: either she is thinking about the ghost or the ghost

189. *Te aa no Areois* (*The Seed of the Ariois*), 1892. Oil on canvas, 92×78 cm. New York, Mrs William S. Paley Collection.

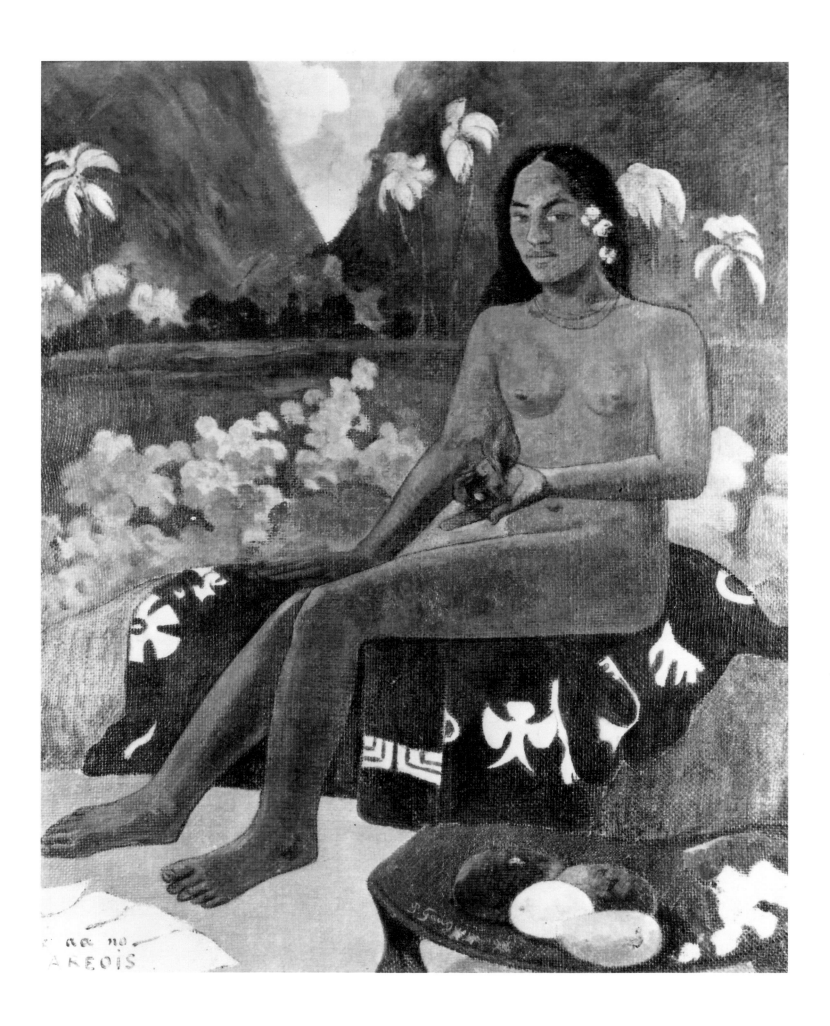

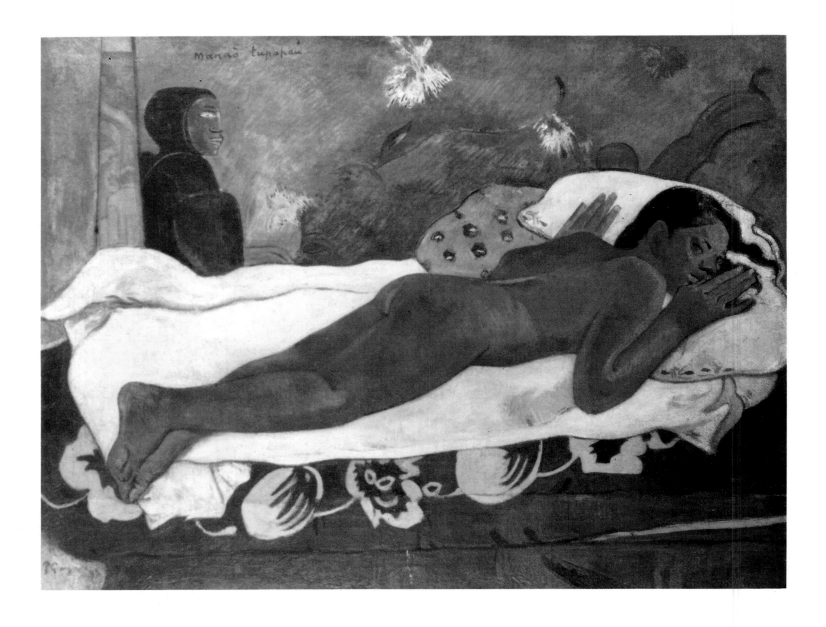

is thinking about her. To sum up: the musical part: wavy horizontal lines, harmonies of orange and blue linked by their derivative yellows and violets and lightened with greenish sparks. The literary part: The Spirit of a living girl linked to the Spirit of the dead. Day and Night.' 'This description has been written for those who always want to know the whys and wherefores.'[21] The painting is a Symbolist transposition of a scene Gauguin described in *Noa Noa*: upon entering the darkened hut one night 'I lit a match and I saw. . . motionless, naked, lying face-down on the bed, her eyes widened in fear, Tehura looking at me without recognition.'

To be honest, despite the painting's obvious charm, the narrative works better for, unfortunately, the white-eyed demon is a purely decorative accessory that inspires neither sacred terror nor fear of death. All too often, this kind of 'literary part' did great harm to the painter's most beautiful works.

Gauguin's sculpture in Polynesia followed the same path as his painting: first he learned the unfamiliar shapes through a new exotic vocabulary, then his interpretation of the local style enabled him to go beyond this kind of limitation. One of his first Tahitian sculptures was *Idol with a Pearl*. The figure is in fact an incarnation of Buddha from a relief in Borobudur (*The Assault of Mara*) which was a major stepping-stone in the development of Gauguin's Tahitian style. His idol is sitting in the lotus position and the wood dome that he used as its niche also comes from the Javanese

190. *Manao tupapau* (*The Spectre
Watches over Her*), 1892. Oil on
canvas, 73×92 cm. Buffalo,
Albright-Knox Art Gallery.

191. Illustrated page from *Cahier pour
Aline*. Paris, Bibliothèque Doucet.

sculpture. *Idol with a Shell* was almost certainly carved later. The Buddhist pose is
still there, but his desire to make it into a purely Polynesian image is visible in the
shell stuck above its head and the geometric frieze that was copied from carvings on
local domestic utensils. The common Polynesian motif of the two little spirits one be-
hind the other, perhaps seated, perhaps dancing, with tattoos on their joints and the
front-facing almond-shaped eye in a face in profile, also appears in a watercolour in
the manuscript of *Ancien Culte Mahorie*.[22]

And yet it was not his dutiful studies in literature and ethnography that best equipped
him to describe the South Seas' unique or mythical qualities. On the contrary, it was
when he limited himself to transmitting a simple, dazzled vision, unadulterated by
Symbolism, that he produced the best of his Tahitian paintings. Two personal tenden-
cies that admirably matched the warm exuberance of Tahiti were given a free rein:
his taste for muted tones enlivened by occasional bursts of colour that Fénéon had
already commented on in his Impressionist works, and his penchant for decorative
arabesques—snaking lianas or unfurling waves, for example—a motif that was soon
to become a feature of Art Nouveau. Gauguin immediately took to these uniquely Tahi-
tian forms, and brought them to fruition in 1892-1893.

The superb series of paintings of women swimming or resting shows Gauguin at
his best, for, instead of expressing 'the terrible' as he thought, they convey grace and

192. Detail of a frieze on a Javanese temple in Borobudur.

193. *Idol with a Shell*, 1893. Height 27 cm. Paris, Musée d'Orsay.

194. *Idol with a Pearl*, 1891-1893. Height 25 cm. Paris, Musée d'Orsay.

195. *Carving of Tehamana*. Polychromed Pua wood, height 25 cm. Paris, Musée d'Orsay.

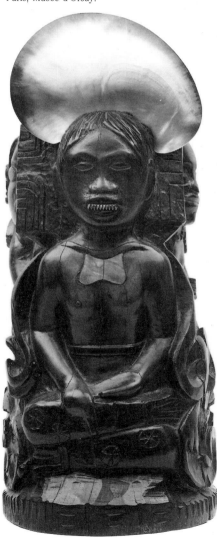

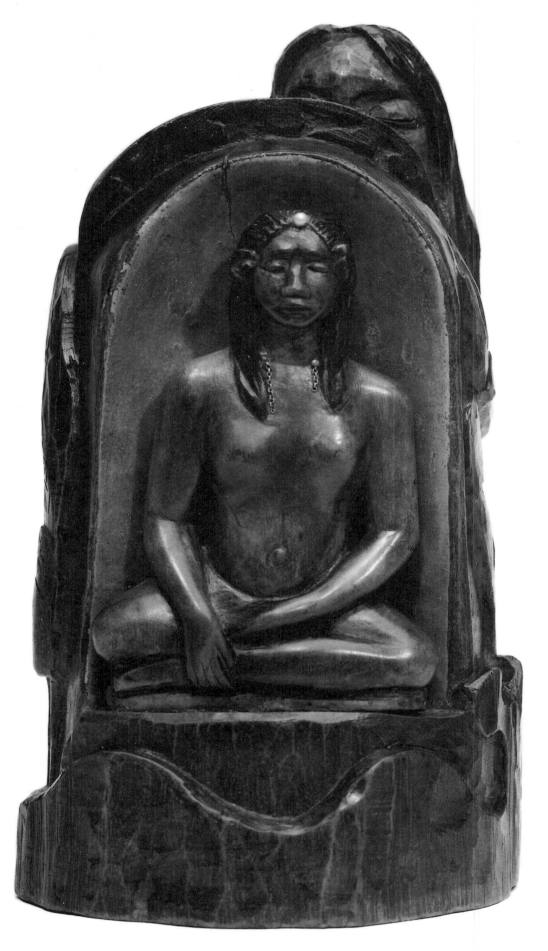

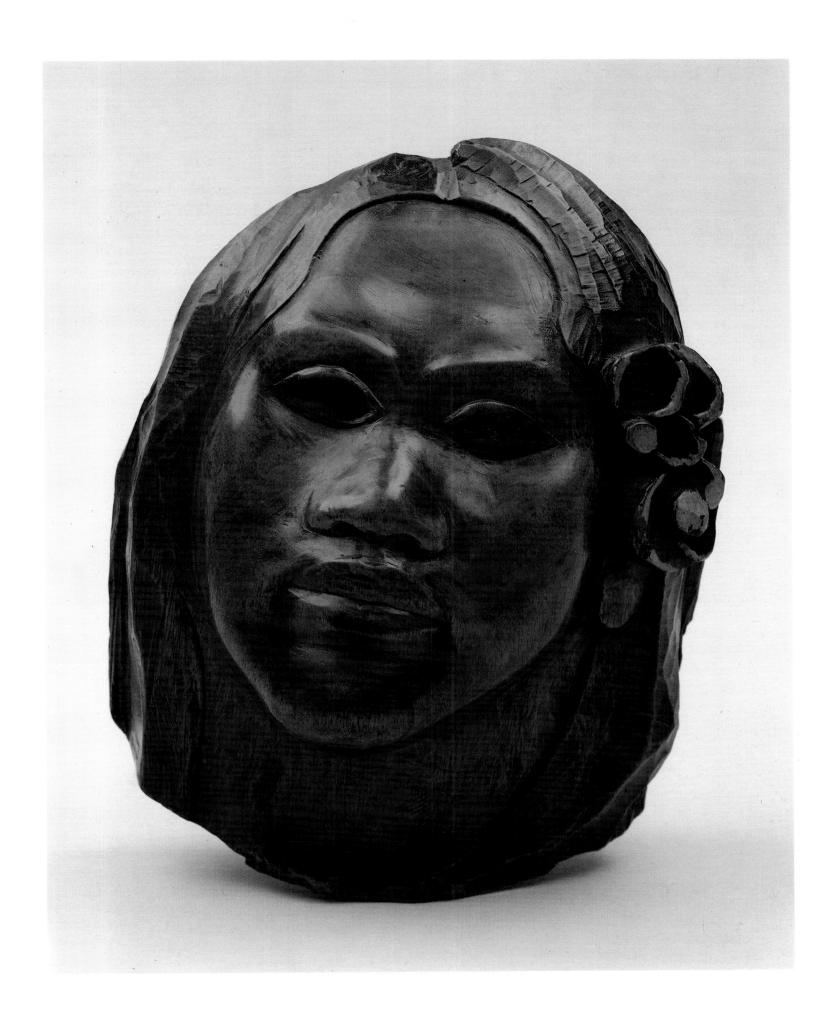

even that 'prettiness' that he swore he hated. *Fatata te Miti* (*By the Sea*) shows the brown backs of two women as they enter the water and has an amazing foreground resembling a 'modern-style' Liberty print in mauve, orange and yellow. Those superb muscular backs to which the women's wet hair clung in wavy masses were among his favourite subjects, whether in the powerful *Tahitian Women Bathing, Vahine no te miti* (*Woman at the Sea*) in Buenos Aires, or in *The Moon and the Earth*, a sort of Maori version of Ingres's *The Spring* which is rendered slightly dissonant by the portrayal of the god Fatu with a beard. The most stunning homage to the Tahitian back also dates from this period. It is *Otahi* (*Alone*), a woman lying on her stomach on the sand with her legs drawn up on either side of her on the same plane as her back, in a position that has an animal repose about it.

These broad-shouldered Tahitian women with their torsos firmly set on their narrow hips and a touch of asexuality that is accentuated by their being seen from the rear, have the anonymity of beautiful animals whose lives and movements are in harmony with nature. As they stand with their legs forming silent, ponderous columns amidst the tumultuous riot of waves or foliage, or obstinately turn their backs on the spectator to walk to the edge of the sea or the shade of the 'pandanus' trees, a chaste wantonness and a tranquil strength emanate from them, giving Gauguin's canvases the pantheistic poetry he had hoped for through their fusion with nature, for they were all almost undoubtedly painted from life.

On the other hand the nudes seen from the front are always more elaborate, having been copied at times from the reliefs at Borobudur, like his *Eve Exotique*, from Puvis de Chavannes or from Greek or Roman antiquities in Gustave Arosa's phototypes.[23] Gauguin's famous remark that 'the big mistake is the Greek—however beautiful it may be' has often been taken too literally, for he was attacking the David-like academicism of the École des Beaux-Arts and not the calm, perfect renditions of the Greeks themselves. In any case, under his guidance, Tahiti frequently took the path of antiquity on its way to becoming a new Arcadia and a Symbolist version of the Golden Age immortalized by Virgil. It appears, for example, that the handsome crouching female nude in *Aha oe feii?* (*What! Are you Jealous?*) was copied from a photograph of a kneeling figure in the Dionysius Theatre below the Parthenon. On a beach painted tender pink near a stretch of calm water whose reflections form a decorative maze, the shapes of two women, one of whom is clearly the sculpture in a feminine Tahitian guise, establish a subtle pictorial relationship between their amber skin, their gestures and their two heads of hair. As he did in *Manao tupapau* and *Vahine no te miti*, Gauguin restrained his modelling to the body, treating the rest of the canvas without depth or shadow. It was either to this painting or to *Two Tahitian Women on the Beach* that he was referring in a letter to Monfreid: 'My latest work is a nude painted *de chic* of two women by the sea, and I think it is actually the best thing I have produced so far.'[24] *De chic*: that is to say not from life, but from memory or imagination—even if, as in *Aha oe feii?*, he had to support these two faculties with some very tangible photographic references.

The Rendez-vous from the same period, of a man holding a horse by the bridle, was copied from Trajan's Column. As for the movement of *The Man With an Axe* discussed earlier, it comes from a horseman in the west frieze of the Parthenon. Gauguin also used local photographs, like the one showing a young Tahitian man drinking at a spring surrounded with ferns that became *Pape Moe* (*Mysterious Water*). In this

Fatata te Miti

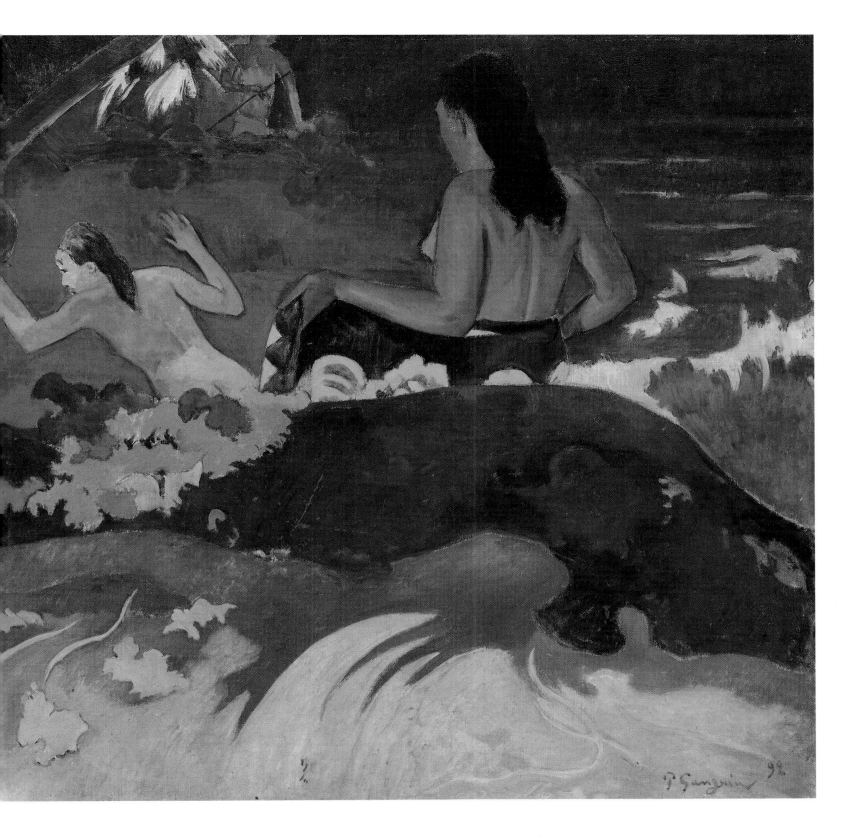

196. *Fatata te Miti* (*Near the Sea*), 1892.
Oil on canvas, 68×92 cm. Washington,
National Gallery of Art.

During the fruitful and happy period of his first stay in Tahiti, Gauguin appeared to take great delight in painting Tahitian women on beaches, always in pairs (figs 165, 204), doubtless his vahine Tehamana and a girlfriend sharing the innocent pleasures of a swim or a gossip before the marvelling eyes of the painter.

Here they are turning their backs on him to enter the water. The one on the left is making the same gesture that the Breton *Ondine* (fig. 116) made three years earlier, and the one on the right is unwrapping her *pareu* to plunge naked into the lagoon under the eyes (out of frame) of the harpoon fisherman whose torso can

be seen at the top. The foreground—a pink beach covered in leaves and a huge root that cuts the composition in two in a long horizonal curve—is amazingly rhythmic and decorative. At the heart of the painting, a bush of blood-red flowers centres it and symbolizes a hot exuberant paradise.

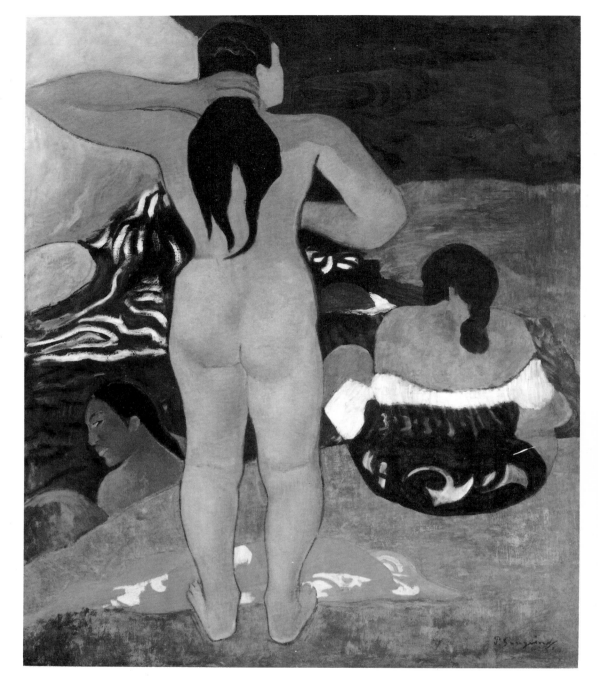

197. *Tahitian Women Bathing*, 1892. Oil on canvas, 112×89 cm. New York, Metropolitan Museum of Art.

198. Gustave Courbet, *La Source*, 1868. Oil on canvas, 120×74.3 cm. New York, Metropolitan Museum of Art.

painting he not only copied the figure, but also firmly 'synthesized' the waterfall and the surrounding rocks and ferns.

As for the Tahitian landscape, Gauguin made it the subject of some of his best paintings a year later, once he became familiar with what he called the 'smell' of an environment that almost overwhelms anyone attempting to express both its wild profusion and its serenity. One of the finest landscapes from this period is surely *Mountains in Tahiti*. Serenity: a great yellow field is spread across the lower third of the canvas and looks as though it had been painted by a Van Gogh at peace with himself at last. Profusion: coconut trees tower over trees and bushes in front of a mountain whose acid greens, deep purple, flaming orange and burnt sienna no longer have anything to do with Cézanne. The beautiful refinement of this assembly of rich colours makes this a masterpiece of peace and equilibrium, the portrait of a fulfilled nature.

Unfortunately, the painter's life did not reflect his painting. His letters show that

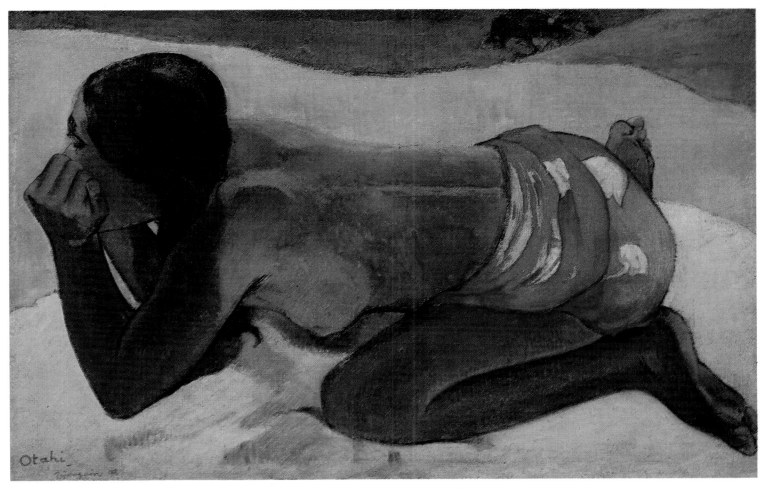

199. *Otahi* (*Alone*), 1893. Oil on canvas, 50×73 cm. Paris, Private Collection.

'I think it is an exceptional piece' is what Gauguin himself said about this painting, and indeed he rarely achieved such a combination of simplicity and modernity in his forms, or an evocation of Tahiti less encumbered by exotic folklore. This nude was probably painted from life, but a watercolour sketch done the year before already shows a Tahitian woman in the same unacademic pose, watching a small animal. We first saw this pose in a Japanese print of sumo wrestlers; but if this is a reminder of someone else's work, it is more like the bending hips and backs of Degas women at their toilette, whose lack of modesty offended the critics at the 1888 exhibition but enchanted Gauguin, who immediately made some sketches of them, one of which is rather similar to *Otahi*. But this relaxed pose—which needs very supple knees and ankles!—was not rare in Tahiti. Gauguin used it to display the innocent animal beauty of the girl: 'not even motherhood could deform those solid hips of hers,' he wrote admiringly in *Diverses Choses*. Her large feet with their pinkish soles and the powerful hand covering her face make this pensive rather than lonely young woman into a sort of Baudelairian giant. She quietly fills the whole of the canvas, which would split were she to move, reducing it to a few strips of pure yellow, pink and blue. When it was shown at the 1906 Salon d'Automne, its monumental chromatic simplicity could not have failed to impress a sculptor like Maillol or a painter like Matisse, both of whom were admirers of Gauguin.

he was ill—he coughed blood that he said was caused by a mild heart attack; in reality, instead of eating 'the fruits of an abundant nature' like a real Tahitian, he lived mainly on the Chinese grocer's preserved goods. He also had syphilis, whose effects had probably already begun to make themselves felt, and his eyes were getting weak. He was miserable, 'at the end of his tether', and in November he wrote, 'My health is not good, it is not that I'm ill (the climate is wonderful), but all these money worries are hurting me and I have aged a lot.'[25] At the end of December he said he was 'totally stagnant'. Despite the fact that he defended his decision to stay in Tahiti against Mette's reproaches that he had cut himself off from Paris—'I am right, I've known what I was about for a long time and why I'm doing it. My artistic centre is in my head and nowhere else, and I'm strong because no one discusses my work and therefore I produce only what is inside of me'—he continually spoke of going back: 'If [being here] wasn't *essential* for my art (and I'm sure of this) I would leave at once,' he wrote

200. *Arii Matamoe* (*Royal End*), 1892.
Oil on canvas, 45×75 cm. Paris,
Private Collection.

'I believe I've struck gold at last, so it
would be a real pity if I were to leave
here,' Gauguin wrote to Monfreid from
Tahiti in June 1892. 'I have just finished
a head of a decapitated Kanaka tidily ar-
ranged on a white cushion in a palace of
my own invention, watched over by wo-
men that I also invented. I think it is a fine
piece of painting. It is not entirely ori-
ginal because I stole it from a piece of
pinewood. I shouldn't admit to it, but what
do you expect, one does what one can,
and when marble or wood sculptures
design a head for one, it is devilishly
tempting to steal it.'
In fact, even if Gauguin crystallized his
fantasy in a subject that already existed
on a piece of wood, it had obviously been
fed by a long mythical and artistic past.
In the Parisian Symbolist circles that he
had just left, the subject of Salome and
the beheading of John the Baptist was
popular among Mallarmé, Puvis de
Chavannes, Gustave Moreau and Odilon
Redon. Also this Maori John the Baptist
came from a religious practice that
Gauguin had read about in Moerenhout's
Voyage aux îles du Grand Océan, from
which he drew the information for his
own *Ancien Culte Mahorie*. It is not
clear whether Gauguin wanted to paint
the macabre trophy of an enemy war-
rior's head or a death cult, for in Tahitian
the title means *Chief* and *Sleep*, and *The
Royal End* is the artist's own interpreta-
tion. One can't help but think of the im-
pressive portrait-vases that Gauguin
produced during the preceding years,
among which his 'guillotined' self-portrait
(figs 119 and 134) shows his almost mor-
bid fascination for this terrible image.

201. *Tahitian Pastorals*, 1892-1893. Oil on canvas, 86×113 cm. Leningrad, Hermitage Museum.

'I have just finished three paintings, two size 30 and one size 50. I think they are my best and since it is the first of January in a few days I have dated the finest of them 1893. For once I've given one of them a French title: ***Pastorales Tahitiennes***, because I can't find a Kanaka equivalent. I don't know why but, even though I used Veronese green and vermilion, it looks like an old Dutch painting or an old tapestry. What can this be ascribed to?' (to Monfreid, December 1892). Gauguin had accurately sensed the classicism of this superbly balanced composition and its exquisite resemblance to one of Van Eyck's paintings on wood through its pure, shining colours. Even the atmosphere is that of an eclogue by Virgil in a world of stronger sensations and colours, in which the flute-playing shepherd has been replaced by a Tahitian woman blowing what Gauguin described in *Noa Noa* as 'the pipe of the ancients, what the Tahitians call a "vivo" '.

Despite the violent colours, there is much gentleness in this scene. The ginger dog in the foreground—which drew heavy sarcasm when it was viewed in Paris in 1893—appears to watch over the tranquillity of the women. A young woman walks towards us like an apparition through the pink flowers on the frangipani tree, her face lit from below, a little like Degas's singers or dancers under the spotlights (here replaced by a supernatural fairy-tale light).

Pastorales Tahitiennes
1892
Paul Gauguin

to her in March 1892. He began to dream of going to the Marquesas to live on 'a little island where there are only three Europeans and where the Polynesians are less spoiled by Western civilization'. Like those of his dreams that did not involve money or business and limited themselves to a departure, this one came true, for he settled on that very island a few years later.

Meanwhile, not only his poverty oppressed him, but a terrible loneliness: 'If De Haan would come life would be most agreeable, and I could talk about art'; also, he was convinced that he had been forgotten in Paris and even that he was being cheated of a portion of the income from his paintings: 'It is absolutely essential that I take care of my affairs in France.'[26] At last a money order from his providential friend Daniel de Monfreid enabled him to pay his debts, board ship and, after a long uncomfortable journey, disembark at Marseilles on 30 August 1893, where he began his shortest, saddest and last stay in Europe.

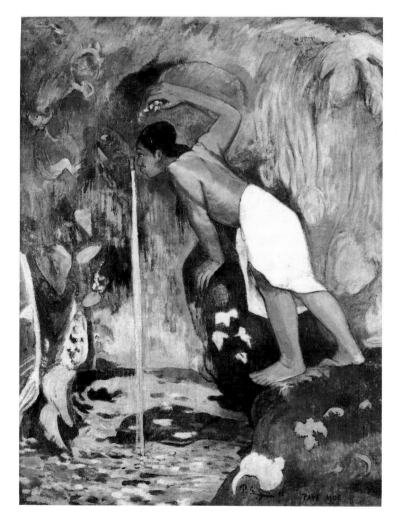

203. Photograph of a Tahitian man drinking at a spring. From *Gauguin in the South Seas* by Bengt Danielsson.

204. *Aha oe feii?* (*What! Are you Jealous?*), 1892. Oil on canvas, 68×92 cm. Moscow, Pushkin State Museum.

202. *Pape Moe* (*Mysterious Water*), 1893. Oil on canvas, 99×75 cm. Switzerland, Private Collection.

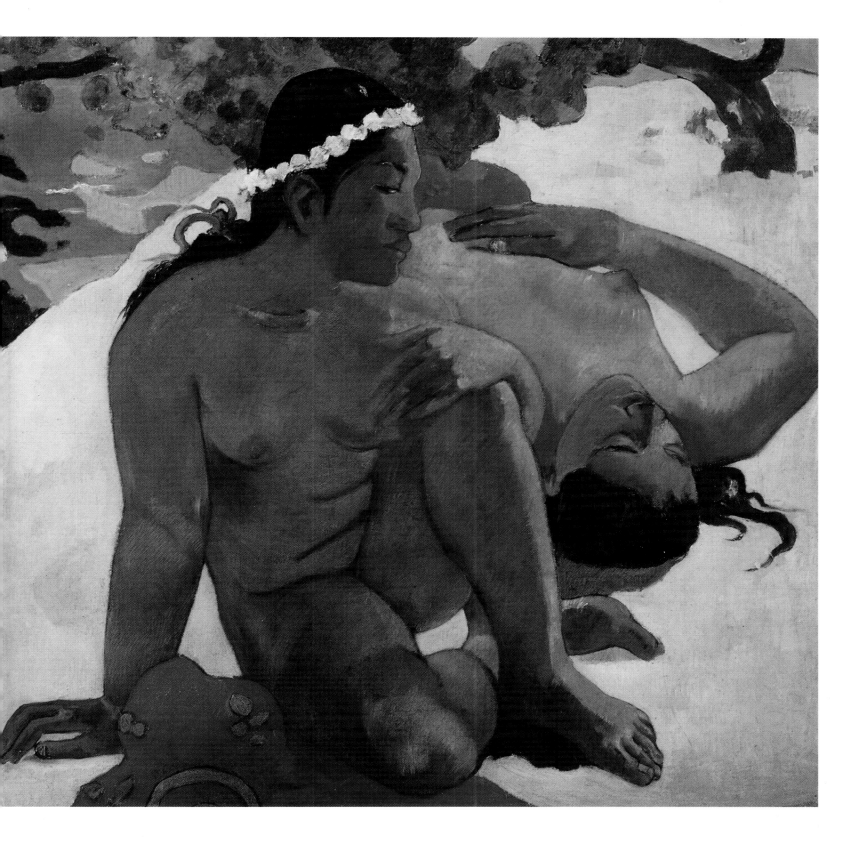

These two women on the beach echoing each other like two inverted playing card queens and firmly united by their silent conversation (the Tahitian title means: Why are you sulking or, Why are angry with me?) were in fact drawn from two very different sources. The woman in the foreground with the strongly modelled legs and left hand, is taken from a photograph of a Greek sculpture, though Gauguin has given her a markedly Tahitian head. The woman on the right with her hair spread over the sand was drawn from life or from sketches. But the most remarkable area of the painting is the upper left triangle, where Gauguin's painting of the water's reflected light and waving roots resulted in an utterly delightful decorative motif. It was in defence of this audacious kind of treatment that Gauguin said to the journalist Tardieu, who interviewed him in Paris in 1895: 'By arranging lines and colours in a subject indifferently taken from life or nature, I achieve symphonies and harmonies that represent nothing that is real in the usual meaning of the word. . . .'

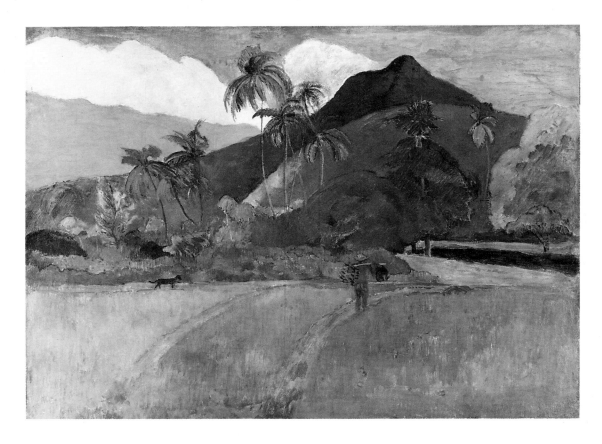

205. *Mountains in Tahiti*, 1891. Oil on canvas, 67.8×92.4 cm. Minneapolis, Institute of Art.

206. *Merahi metua no Tehamana* (*Tehamana Has Many Parents*), 1893. Oil on canvas, 76×54 cm. Chicago, Art Institute.

In this painting Gauguin gave Tehamana an almost sacred dignity. Her powerfully modelled face has the grave calm of the handsome carving he did of her the year before (fig. 195). Carefully dressed and wearing flowers in her hair—white *tiare* and red hibiscus—she is holding her plaited palm-leaf fan like a sceptre. The two dresses she is wearing one over the other are the sober garments that the missionaries required Tahitian women to wear to mass, and that they wore for ceremonial occasions or to the market or the towns: the *pareu* was worn only in the countryside, at the beach or in the seclusion of the home. On her right, below the title, are two beautiful ripe mangoes. The partition behind her is decorated with an imaginary frieze in which Gauguin showed two worshippers moving from right to left towards the goddess Hina. Her front-facing pose, deliberately paralleling the model's, indicates Gauguin's intent to establish a symbolic relationship between the two images, in which the the idol suggests the model's mythic ancestors—whose face, in turn, looks as though it were sculpted in patinated wood. Above her head is a cryptic inscription in much enlarged components of writings found in the Easter Islands. These were one of the curiosities at the Universal Exposition of 1889, and a few samples existed in the parish museum in Tahiti itself. Mysterious and as yet undeciphered, these hieroglyphs are still there today.

Everything in the painting contributes to the suggestion of past grandeur and religious secrets: Tehamana's knowingly enigmatic look and regal air show that for Gauguin these were not yet completely lost.

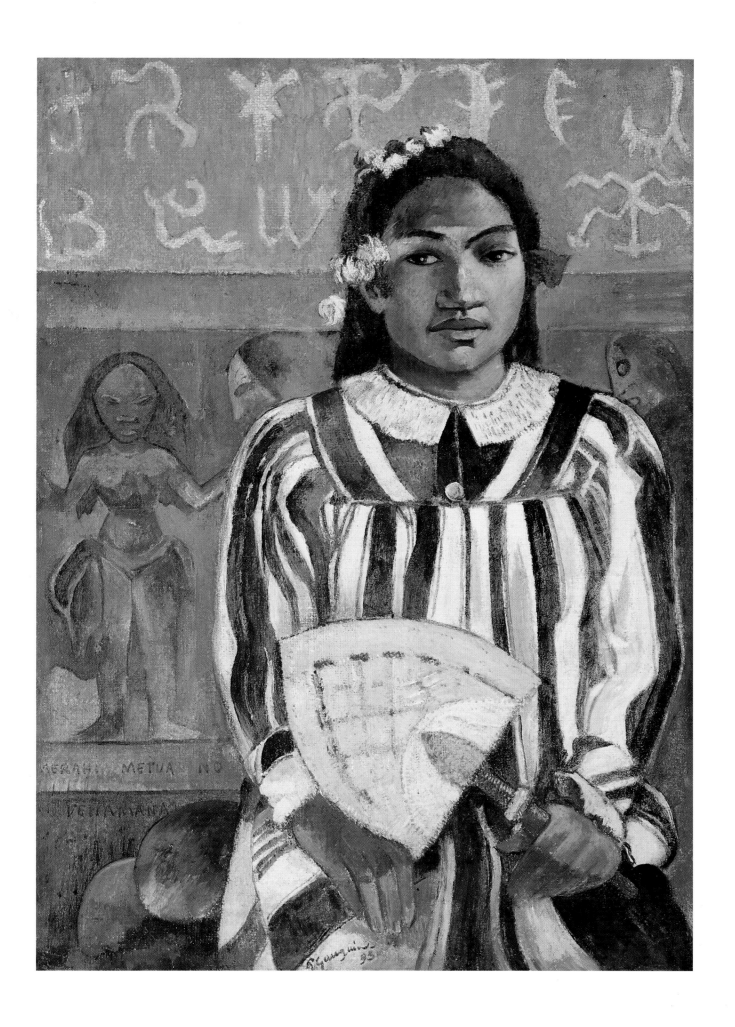

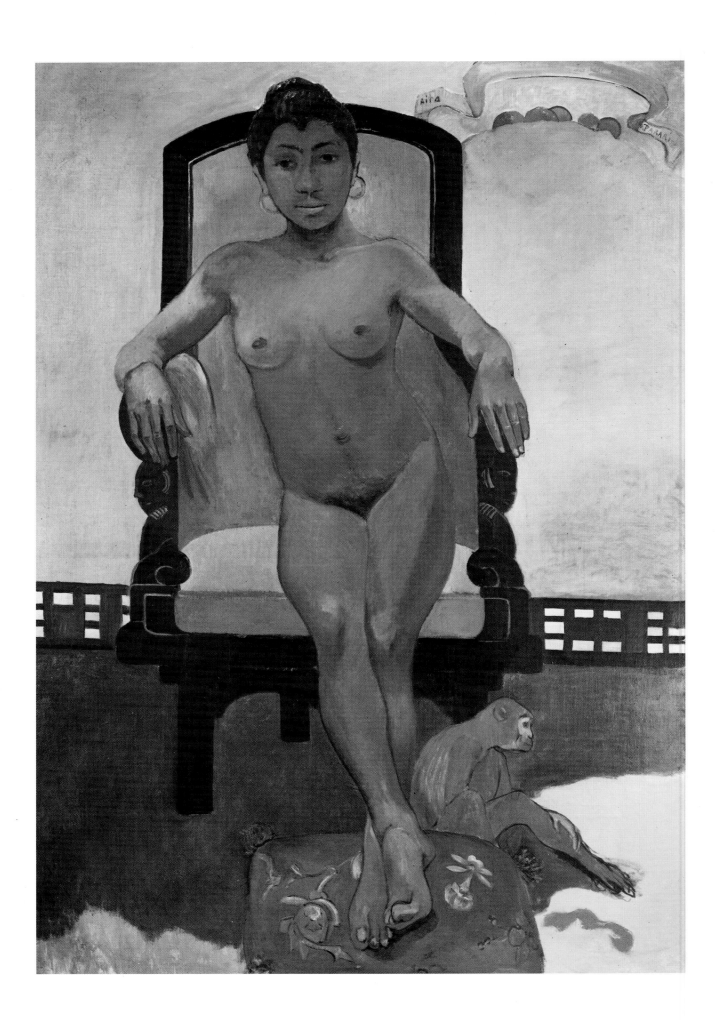

'AT THE MYSTERIOUS HEART OF THOUGHT'

1894-1895

208. Annah the Javanese photographed by Mucha. Danielsson Archives.

207. *Aita tamari vahine Judith te parari* (*The Child-woman Judith Is Not Yet Breached*) or *Annah the Javanese*, 1894. Oil on canvas, 166×81 cm. London, Private Collection.

'Annah the Javanese' was Gauguin's companion in Paris from the end of 1893 to November 1894; everyone that frequented his studio in Rue Vercingétorix left descriptions of her and her pet monkey. The little we know about her comes from Ambroise Vollard's memoirs. It was apparently he who sent the young Indo-Malaysian half-caste, the dismissed servant of a singer friend, to Gauguin as a model: 'The painter was pleased with Annah. He kept her.' She was to rifle his studio in the autumn of 1894, disappear from his life and resurface as Alphonse Mucha's model. However that may be, thanks to her Gauguin produced one of his best exotic nudes. The extremely plain composition is highly original, for if a standing or reclining nude was a traditional theme, one seated naked in an armchair as if on a throne was not. Gauguin carefully underscored the delicate amber body with the spectacular blue of an armchair that he had perhaps carved himself in the 'Maori style' or perhaps simply invented, and that was of a 'barbarian luxury'. The amazing pattern on the skirting-board calls Japan and Viennese Art Nouveau to mind. Gauguin made adroit use of black to support his composition and set off the brutal or exquisite colours. The monkey represents both exoticism and insolent sexuality; Seurat used one a few years earlier in *La Grande Jatte* as the provocative emblem of a prostitute.

Your Paradise is inhabited by an Eve who is not my ideal.

Strindberg.

209. Photograph of Paul Gauguin.

'I shall return with limbs of iron, dark skin, a furious eye: seeing my mask, men will think I am a descendant from a mighty race.'[1] On his return to Paris Gauguin might have reminded his Symbolist friends of Rimbaud, for his 'burnished Inca face' whose leanness, age and tan accentuated its lines, had become quite impressive. In 1891 Mirbeau had already found Gauguin's looks more convincing than his painting: 'He has an extraordinary head.'[2] Added to his striking face, Gauguin's general appearance in that winter of 1893 was of a self-conscious strangeness: '. . . he appeared before the Parisians like a gigantic, haughty Magyar, a Rembrandt from 1635, as he walked along slowly and gravely, leaning his white-gloved hand encircled in silver on a stick that he had carved himself.'[3] Although one is tempted to smile at his naïve exhibitionism, it must be said that his romantic departure for the 'wild' solitude of the South Seas had greatly increased his prestige and everyone was impatient to see the work he had brought back with him.

What had been happening in the world of art while he was away? Seurat had died of diphtheria at the age of thirty-two, a few days before Gauguin sailed for Tahiti in 1891, leaving a great void in the Post-Impressionist movement. His elders, Renoir, Pissarro, Monet and Sisley were each developing very personal styles that the public was beginning to accept and even admire; Gauguin was not far from the truth when he exclaimed 'They are tomorrow's official painters.'[4] Pissarro had abandoned Seurat's Pointillist style in 1890 to go back to his old techniques and Renoir had also resumed a more spontaneous style after an Ingres-like phase. They had both seen their success established at last with one-man shows at Durand-Ruel's gallery in 1892, following Monet's the previous year in which he had shown his celebrated series of fifteen paintings composed at different times of day, called *The Haystacks*. In the years that followed Monet became more and more obsessed with the *instantaneous*: producing the *Poplars* series in 1892, *Cathedrals in Rouen* in 1894 and finally his *Water-lilies*. Gauguin hated Monet's painting, for it was exactly the opposite of his own, and Monet (like Renoir) felt the same way about Gauguin's work. Reporting Gauguin's opinions at the time, Rotonchamp quoted him as saying about the Impressionists: 'They study colour only for its decorative effects, without freedom, staying well within the bounds of realism . . . they examine what can be seen with the naked eye and not what lies at the mysterious heart of thought.'[4]

Only Paul Cézanne escaped Gauguin's censure; for him, as for the younger generation of painters, the painter of Aix became more and more exemplary, both in his dignified seclusion far from the hurly-burly of Paris fashion and in the invincibility of his art. It is a measure of Gauguin's often incredibly prescient judgement that he should have always admired this painter. Cézanne's pure yet 'metaphysical' painting contrasted with the sensual vibrations of Impressionism. His style was imbued with modesty and owed nothing to 'ideas' or literature, and yet his works reached 'the mysterious heart of thought' more directly than Gauguin's elaborate compositions. As a matter of fact, Cézanne's growing status as an artist inevitably harmed Gauguin's.

Paul Cézanne had not exhibited in Paris since 1877, so the only showcase for his painting was Père Tanguy's shop, which became a place of pilgrimage for young painters like Pierre Bonnard, Edouard Vuillard, Aristide Malliol and Maurice Denis, to whom Gauguin had been so important in 1888-1889. The first major text about Cézanne appeared in 1892 in the series of monographs called *Les Hommes d'Aujourdhui*, written by Émile Bernard, who was also the first to report more or less faithfully the painter's celebrated statements on construction, space and volume that were to be so instrumental in the birth of Cubism. It was Ambroise Vollard who, on the advice of Pissarro, gave Cézanne his first one-man show in 1895, just one year before he offered to represent Gauguin—by then back in Tahiti—exclusively. At the end of the century, therefore, one went to Vollard's gallery in the Rue Lafitte if one wanted to see Cézanne or Gauguin: the landscapes of Aix in all their geological grandeur, and the Tropical island depicted with Art Nouveau rhythms, offering all the fascination of a far-off land.

210. Maurice Denis, *Homage to Cézanne*, 1900. Oil on canvas, 180×240 cm. Paris, Musée d'Orsay.

211. Paul Cézanne, *Portrait of Ambroise Vollard*, 1899. Oil on canvas, 100×81 cm. Paris, Musée du Petit Palais.

The newest and perhaps most interesting Parisian artistic event that Gauguin missed while in Tahiti was the exhibition by the Nabis, sometimes described as his pupils, in the Le Barc de Bouteville gallery in December 1891. Along with the younger painters, there were exhibitions by Toulouse-Lautrec, Anquetin, Bernard and the Neo-Impressionists: the whole of Post-Impressionism was found there, except for Gauguin, who nonetheless threw his shadow across more than one canvas.

The world of critics and dealers had also changed considerably. Félix Fénéon, who had been one of the very first to praise Gauguin, had given up writing. Albert Aurier, Gauguin's energetic and lyrical champion, had died of typhoid in October 1892 at the age of twenty-seven. His death, like that of Theo Van Gogh shortly after his brother's,

in fact affected Gauguin's ambition more than it did his sense of friendship, and he made the following astounding comment when he learned the news on his return: 'Poor Aurier has died. We are definitely out of luck.' The tender-hearted Monfreid must have wondered how significant Gauguin's faithful supporters were to the painter on reading this funeral eulogy: '. . . a critic who understood us well and who would have been very useful to us in the future'.[5] Maurice Joyant, a friend of Lautrec's who had replaced Theo Van Gogh in the 'modern painting' department at the Goupil and Valadon gallery, quarrelled with the owners when they refused to take any more of that un-saleable art. As for Durand-Ruel, he was interested mainly in the Impressionists but he agreed to show the Tahitian paintings that November on the persuasion of Degas, who continued to watch over Gauguin like a tutor.

Gauguin feverishly set about preparing the exhibition, renting a studio in Mont-parnasse and getting in touch with 'useful' friends such as Mallarmé and Charles Morice. He decided to enlist Morice's collaboration in writing a book on Tahiti 'that will be helpful in understanding my painting'. He hoped that he would be 'recognized' at long last thanks to this exhibition: 'I am finally going to find out whether going to Tahiti was a folly or not.'[6]

Sadly, apart from the admiration of a few young painters and Degas, who bought a painting—*Hina Tefatou*—and that of a small circle of Symbolist writers, the exhibi-tion was remarkable only for its notoriety. The Maori titles of his paintings were con-sidered mannered and obscure—it must be said that they do not seem to add much to his paintings today, either—but Gauguin was very attached to them and believed that they increased the mystery of his works. Although his colours were no cruder than those of the the Impressionists, they made them acceptable through their effects of flickering light whereas Gauguin's were intensified by his use of them in flat areas. In fact, according to Sérusier, in Pont-Aven Gauguin had often said that 'a square metre of green is greener than a square centimetre of green'—actually a paraphrase of one of Cézanne's witticisms.[7]

The general public's reaction was: 'If you want to entertain your children, send them to the Gauguin exhibition. They will like the colourful pictures of females fresh-ly down from the trees lying on billiard-table cloths, the whole embellished with words of the same ilk.'[8] The reactions of other painters were slightly more sophisticated: most of them were disturbed by Gauguin's rejection of nature where they felt he lacked the imagination to do without it, and by his relying so literally on other cultures. The reac-tion of Pissarro, who considered himself a 'pure painter', is a fair example of this. After seeing the exhibition, he confided to his son Lucien: 'Gauguin is having an exhibition right now that is much admired by the men of letters. They are, it seems, very en-thusiastic about it. The rest of us are baffled and perplexed. I've heard that some painters are unanimously of the opinion that this exotic art is too strongly cast in the Kanaka mould. Only Degas admires it; Monet, Renoir and company find it quite simply bad. I saw Gauguin, who expounded art theories at me and assured me that the future of the young lay in their replenishing themselves in these wild faraway sources! I told him that this art was not for him, that he was a civilized human being, and that there-fore he ought to produce harmonious works. We parted unconvinced.' One can well believe it! Gauguin was now absolutely independent of his ex-teacher, and if Pissarro granted that 'of course, he is not without talent', he nevertheless concluded severely: 'He is always poaching on other people's territories: today it is the turn of the savages in Oceania!'[9]

In the studio he rented in Rue Vercingétorix Gauguin did indeed surround himself with an artificial exoticism. He covered his windows with *fin de siècle* Tahitian land-scapes in the Cloisonnist style, painted his walls a bright chrome yellow to warm up the atmosphere and festooned them with the bric-à-brac of a retired colonial, receiv-ing his visitors in fancy clothes, accompanied by a parrot, a little female monkey and his mistress of the moment, a mulatto. He left a remarkable portrait of her, *Annah the Javanese*, sitting naked in an armchair, as solidly and plainly constructed

212. *Hina tefatou* (*The Moon and Earth*), 1893. Oil on canvas, 112×62 cm. New York, Museum of Modern Art.

The conception, subject and size of this painting made it one of the major works that Gauguin exhibited at the Durand-Ruel gallery on his return from Tahiti in 1893. Contemporaries like Pissarro—with whom we would still agree today—considered the 'folklore' a bit overdone. In his *Ancien Culte Mahorie* (figs 179-186), Gauguin tells us that Fatu is the 'spirit of the earth' and Hina is the goddess of the moon. Hina is trying to convince the god to bring mankind back to life and Fatu replies: the earth and its vegetation is dying, the men who are nourished by it must also disappear. Hina then retorts that she will periodically bring the moon back to life, even if man does perish.

It is this meeting of the elements that Gauguin illustrated here: the earth is masculine and inflexible, a spring the colour of blood flows from it; the goddess interceding for humanity is a beautiful Tahitian seen from behind, slightly stocky, like many Gauguin painted during his first stay on the island. Gauguin's allusion to other nudes near a spring such as Courbet's or Ingres's *The Spring* is clearly visible.

Already the owner of *La Belle Angèle* (fig. 115), Degas was impressed by the beauty and grandeur of this painting. He purchased it at the end of the exhibition and kept it for the rest of his life alongside other Tahitian paintings acquired later: *Te Faaturuma* (*Silence*) (fig. 159), *Te Arii Vahine* (*The Noble Woman* or *Woman with Mangoes*) (fig. 241) and *Mahana no Atua* (*Day of the God*) (fig. 215).

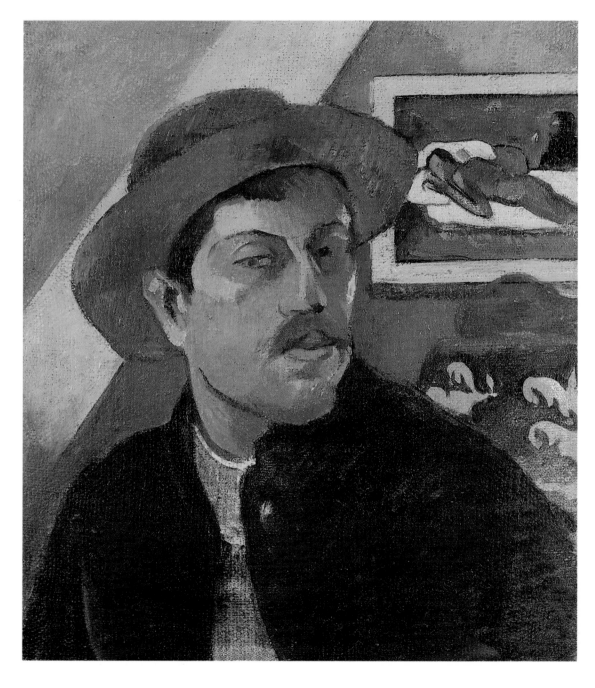

213. *Self-portrait with Hat*, 1894. Oil on canvas, 46 x 38 cm. Paris, Musée d'Orsay.

214. *Self-portrait with Palette*, c. 1894. Oil on canvas, 92×73 cm. New York, Private Collection.

The descriptions we have of Gauguin's appearance in Paris during his last stay in 1894-1895 after his return from Tahiti are sometimes ironic, sometimes impressive: 'wearing that astrakan hat and that enormous dark blue cloak. . . in which he appeared before the Parisians like a gigantic, haughty Magyar, a Rembrandt from 1635' (Seguin, *L'Occident*, March 1903). And indeed it is in this effective and rather traditional guise of the artist with his brush and palette, in the pink and yellow of his Tahitian canvases, that Gauguin poses here. His dress is odd, and he looks as though he had just come back to his studio and picked up his palette without troubling to remove his street clothes. It is true that studios with their large windows were often freezing cold during the Parisian winters, but it appears that Gauguin worked from a photograph (fig. 209)—one that flattered him less than his brush. Of course, the uniformly red background recalls the boldness of *Vision after the Sermon* (fig. 65) which the critic Albert Aurier made the pictorial manifesto of Symbolism. This red indeed represents the Synthetism of which he considered himself the master.

The portrait is dedicated to Charles Morice, the young Symbolist poet who put his pen and his enthusiasm at Gauguin's service in the 1890s, introducing him to other writers who defended his work, such as Mallarmé and Mirbeau; in 1893 he wrote the preface for the catalogue of the exhibition of his Tahitian works at the Durand-Ruel gallery, and, when this portrait was painted, was working with him on the writing of *Noa Noa*.

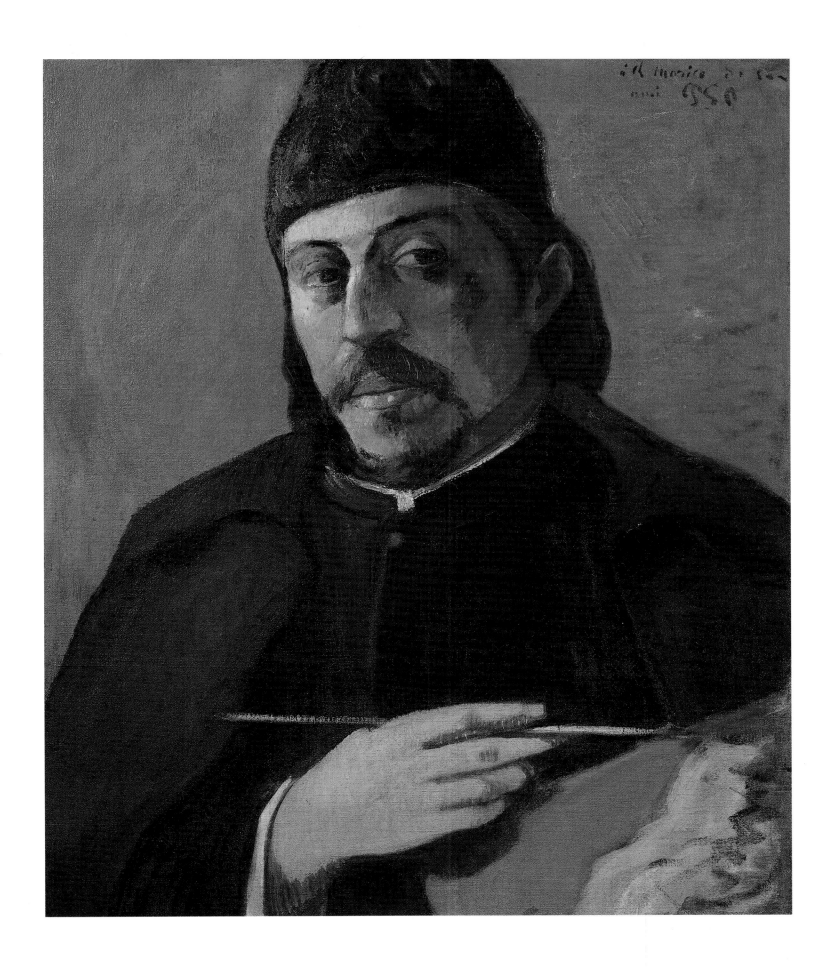

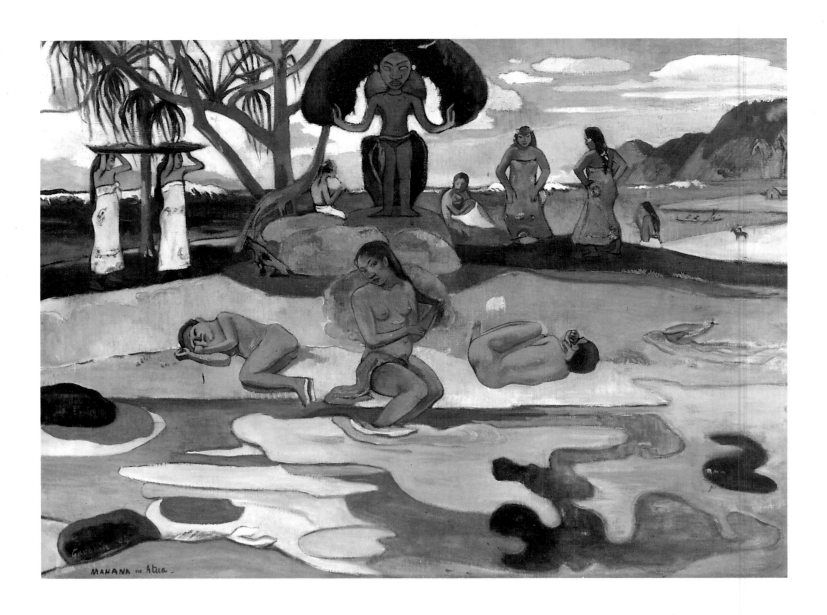

as an early Marquet or Matisse. At the same time that he painted this, he produced a work that was heavy and complicated: *Mahana no Atua (Day of the God)*. The best of Gauguin, his simplicity and power—'I am a mixture of over-sensitivity and savageness'—is scarely visible in this ambitiously mythological painting that he coyly presented 'to the unknown admirer of works of art, hail! and may he forgive the barbariousness of this little opus: certain traits of my soul are probably to blame.'[10]

Throughout his stay in Paris he concentrated his energy on selling the work he had brought back from Tahiti rather than on painting. The staginess of his life became a means of propaganda, like his book with Charles Morice about his life in Tahiti. He and Morice edited it from a first draft written on the island that was itself a development of his *Ancien Culte Mahorie*—a notebook also written there, that was to remain unpublished for fifty years. The book's title could have belonged to one of his paintings: *Noa Noa (The Perfumed Isle)*, a traditional name given to Tahiti. Fancifully composed, rewritten a number of times and larded with Morice's mediocre poems, this famous manuscript saw the light of day during Gauguin's lifetime, but it was to go through a number of transformations before it was restored to what he had originally written.[11] In its best sections, *The Narrator Speaks*, Gauguin recounted how he arrived and settled down in Tahiti. He also wrote about many of the forty-three paintings he brought back, giving these descriptions a poetical and legendary turn of phrase—with the help of Charles Morice—to lend colour to the paintings' creation. Many of the

215. *Mahana no Atua (Day of the God)*, 1894. Oil on canvas, 68. 3×91.5 cm. Chicago, Art Institute.

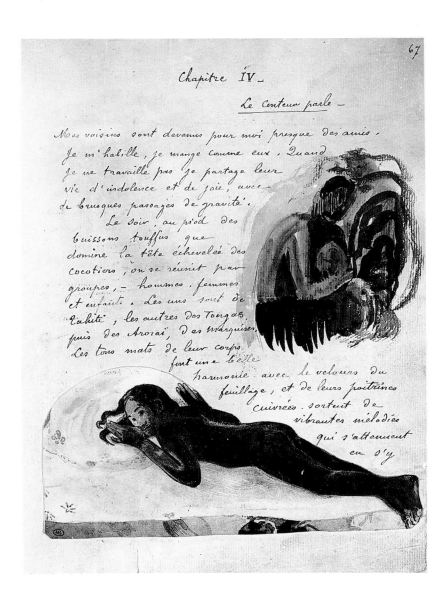

216. *Noa Noa, 'The Narrator Speaks'*. Paris, Musée du Louvre, Department of Drawings.

anecdotes and descriptions have the immediacy of the real, but also describe his paintings accurately: the terrified Tehamana, whom Gauguin found lying face-down in the dark on his return from the village, provided the subject for *Manao Tupapau*, the preparations for a fishing trip are the source of *Man with an Axe* and so forth. However, Gauguin occasionally invented: he wrote at length of how, after going for a walk through the deepest part of the jungle in the heart of the island, he came across a woman standing drinking from a small waterfall who 'ran away like a frightened doe'; but as we know, the painting, *Pape Moe (Mysterious Water)*, was faithfully copied from a photograph that was later found amongst Gauguin's papers—a common practice among painters at that time, that also resulted in some of the most breathtaking of Douanier Rousseau's exotic compositions.

For the pseudo-ethnographical sections of *Noa Noa* Gauguin attempted, by referring to the local legends from Moerenhout's book that he had transcribed into *Ancien Culte Mahorie*, to give his writing and illustrations the atmosphere of that timeless folklore that, to his profound regret, had almost totally disappeared from Tahiti by the end of the century. He tried to reconstruct what he had hoped to find there, and he half admitted that he had to create it artificially: 'The dream that carried me to Tahiti was cruelly contradicted by reality, it was the Tahiti of long ago that I loved and *I refused to resign myself to the fact that it had been completely destroyed*, that this beautiful race had not been able to preserve its magnificent splendour anywhere.'[12]

217. *Noa Noa*, page 55, Hina and Fatu,
watercolour; glued-in photograph. Paris,
Musée du Louvre, Department of
Drawings.

218-219. *Noa Noa*, pages 57 and 75 of
the album, written, illustrated and
decorated with woodcuts and
photographs. Paris, Musée du Louvre,
Department of Drawings.

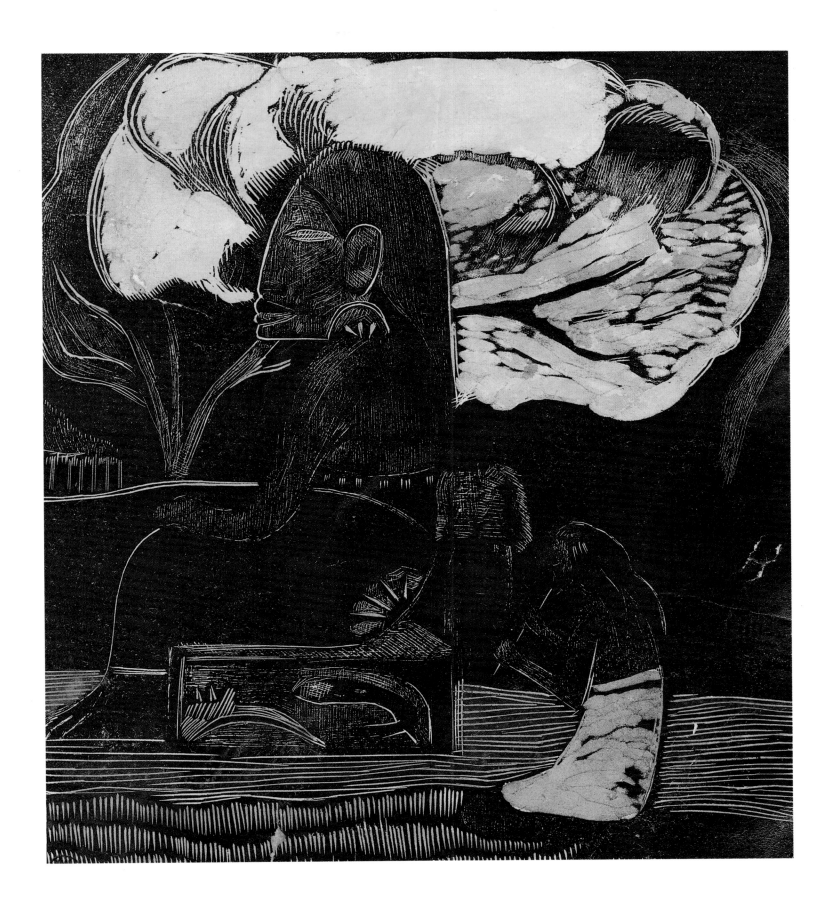

220. *Maruru*, 1894-1895. Enhanced
woodcut glued into *Noa Noa*, page 59.
Paris, Musée du Louvre, Department of
Drawings.

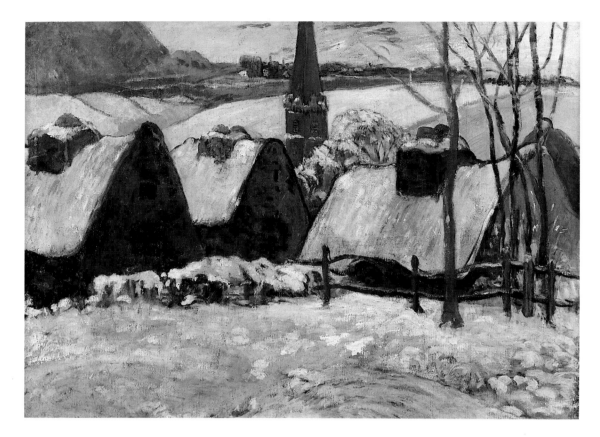

221. *Village in the Snow* (*Brittany*), 1894. Oil on canvas, 62×87 cm. Paris, Musée d'Orsay.

Gauguin's last stay in Brittany took place in 1894, between the artificial grandeur of the studio in Rue Vercingétorix and his final departure for the real Tahiti that he had found unbearable only a few months earlier, but that he now longed to see again. His stay was a disaster: a fight with some sailors on the port of Concarneau who had laughed at him and his companion, Annah the Javanese and her monkey, left him with an open fracture of the leg that kept him in bed for two months and made it impossible for him to paint. Annah vanished, the money he had inherited from an uncle a few months earlier also melted away and the anguish and discomfort of the Breton winter of his previous stay came flooding back, magnified by the morphine Gauguin had to take for the pain of his injury.

He therefore produced very little, perhaps only the famous paintings of Breton villages in the snow that he would take back to Tahiti. Victor Segalen found one of these in Gauguin's studio in Hivaoa after his death and drew the romantic and somewhat hasty conclusion that it was his very last painting, a nostalgic image of Europe in winter, the result of an about-turn in Gauguin's exoticism. But by the autumn of 1894 there was nothing left to attach him to Brittany, even though a few years earlier it had been his first stop along the way to 'elsewhere' and the primitive: 'This succession of disasters, the difficulty of earning a *regular* income despite my reputation, added to my liking for the exotic, have led me to take an irrevocable decision. It is this:

'In December I shall go back [to Paris] and concentrate on selling everything I have, either in one lump or piece by piece. Once I have pocketed the capital, I am going back to Oceania. . . . Nothing can stop me from leaving and it shall be for ever.'[13]

Once again he tried to tempt other painters to join him in a studio in the Tropics, including Armand Seguin, his main disciple during this last stay in Europe. The young painter—who ended up staying behind like the others—later wrote about his friendship with Gauguin and faithfully set down the painter's teachings. Through what he said we can perceive the transformation that Gauguin's 'theories' had undergone during his first stay in Tahiti.

222. *Christmas Night*, 1894. Oil on canvas, 72×83 cm. Josefowitz Collection.

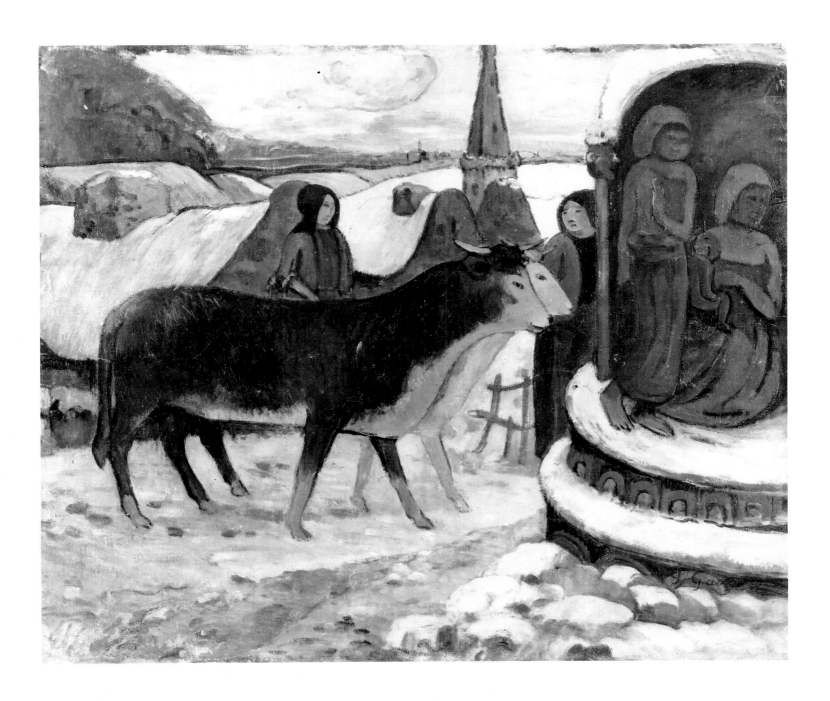

To begin with, judging by his statements at least, he had stripped himself of the Symbolist and Synthetist aesthetics of the Émile Bernard and Sérusier period and, though he continued to quote Wagnerian credos such as 'I believe in sincerity of spirit and truth in art,' he was more concerned with strictly formal problems. Armand Seguin tells of long conversations that were as comforting to the master, unable to paint because of his injury, as they were instructive to the pupil. They show that Gauguin was more and more persuaded of the truth in Baudelaire's theories on colour, and that he felt that the major error of the Neo-Impressionists was 'that absurdity', the law of complementaries. He solemnly set about teaching the attentive Seguin 'the law of derivatives', a sort of counterpoint to the Neo-Impressionist law, that can often be found in his own paintings, which was merely the juxtaposition of secondary colours like purple, green or orange that derived from mixing primary ones. Where the Neo-Impressionists placed a yellow next to its complementary purple to intensify each, Gauguin held that purple was more beautiful placed next to green instead of yellow, which is after all only a slightly heretical interpretation of the same colour credo. Also,

when one looks at Gauguin's paintings one can see that they follow his 'law of derivatives', but so inconsistently that it cannot be held as a definition of his art. On the other hand—again according to Seguin—he showed himself to be just as influenced by Seurat's Symbolist beliefs as he was by Baudelaire's correspondences. He therefore tried to convince the young man of the correlation between colour, direction and feeling: red is vertical, stimulating and ascending; blue is horizontal and calm; as for yellow, it is oblique and perverse! Lastly—and here the painter was passing on one of the great laws of Impressionism—a shadow should never be painted with a darker version of a colour, contrary to what was taught at the École des Beaux-Arts. To support his argument Gauguin reached beyond Renoir to hold up the example of the two great colourists Delacroix and Rubens.

Armand Seguin's testimonial[14]—written nine years after these conversations—is partly confirmed by a contemporary newspaper interview with Gauguin: 'By arranging lines and colours in a subject indifferently taken from life or nature, I achieve symphonies and harmonies that represent nothing that is real in the usual meaning of the word and that express no direct idea, but they must make you think the way music makes you think, without the support of ideas or images, simply through the mysterious affinities between our brain and this kind of arrangement of colours and lines.'[15] This statement was obviously inspired by Baudelaire's doctrines, which Gauguin probably rediscovered on reading Delacroix's *Journals* published between 1893 and 1895. It is difficult to imagine that Gauguin would not have read them.

During Gauguin's last stay in Paris the Modern Style was beginning to appear, and painting was blithely moving towards decorative abstraction. A few years later, in 1898, when Signac's short treatise on Neo-Impressionism appeared, motivated by the oblivion into which Seurat had fallen and by the publication of Delacroix's *Journals*, the language had evolved, but the aesthetic implications remained the same: Signac defined the artist as 'someone who tries to achieve unity in variety through the rhythms of tints and tones' and deplored the fact that the public was concerned with 'the subject of a painting rather than its harmony'.[16] In short, the Neo-Impressionists and Gauguin had the same reactions thirty years later that Delacroix had expressed to Baudelaire

225. *The Young Christian Girl* or *Little Girl in Yellow*, 1894. Oil on canvas, 65×46 cm. Williamstown, Sterling and Francine Clark Institute.

Gauguin painted very little during his last stay in Brittany in the summer of 1894. One could even wonder if this apparently Breton subject indicated by the landscape and that innocent devotion that he associated with the land of processions and 'pardons', was not painted in Paris. What is most striking about this painting is the intensity of the colour of the girl's dress—incidentally, Gauguin himself called it *Little Girl in Yellow*. The ample pinafore recalls the voluminous Tahitian cotton smocks worn in *Vahine no te tiare* (fig. 158) or *Merahi metua no Tehamana* (*Tehamana Has Many Parents*) (fig. 206), to the sleeves of which a typically Breton ribbon appliqué has been added. He emphasized the little girl's reddish hair, topped by a small black cap as if she were on her way to church. Her joined hands and downcast eyes indicate prayer. Gauguin also produced a coloured monotype based on this painting, *The Angelus* (fig. 224), in which the same girl is flanked by two Breton women with joined hands.

224. *The Angelus*, 1894. Monotype on cardboard, 26.5×30 cm. Josefowitz Collection.

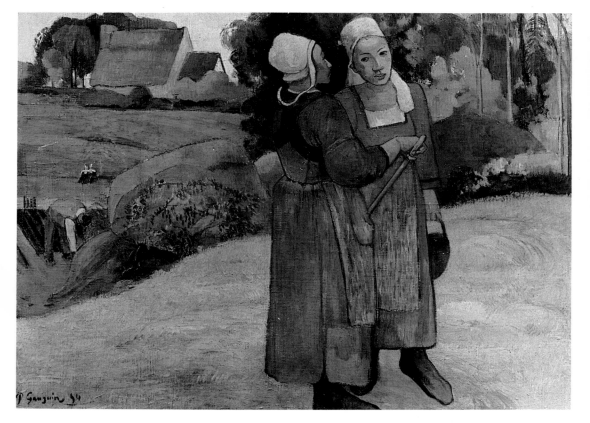

223. *Two Breton Women on a Road*, 1894. Oil on canvas, 66×92 cm. Paris, Musée d'Orsay.

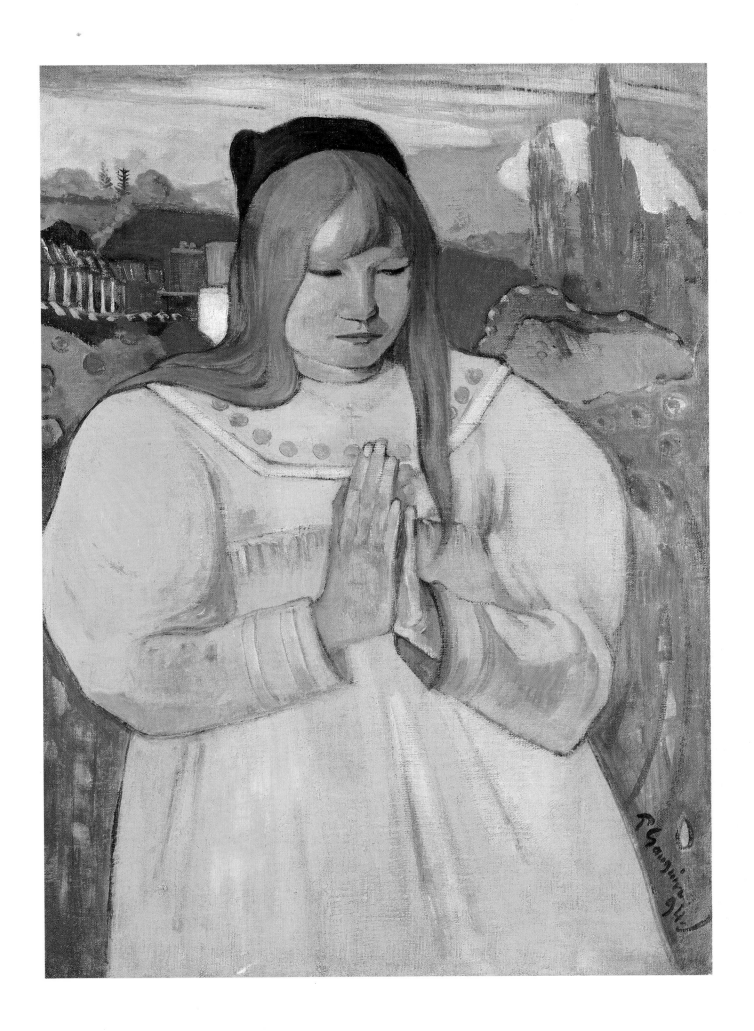

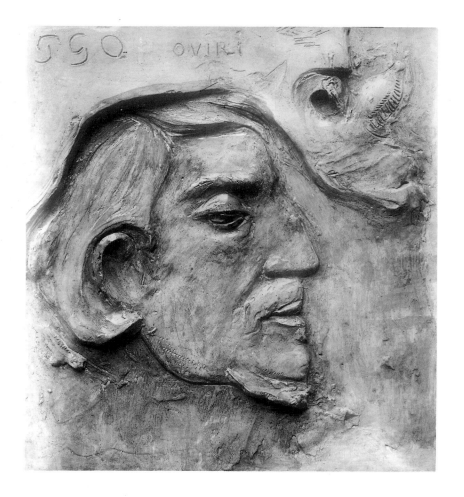

226. *Self-portrait, Oviri* (*Savage*), 1894.
Patinated plaster. Private Collection.

228. *Oviri*, 1894. Partially glazed
stoneware, height 75 cm. Paris,
Musée d'Orsay.

Oviri—savage in Tahitian—is the epithet
that Gauguin applied to himself most
often: 'I am a savage and the civilized feel
it, for in my works there is nothing sur-
prising or disconcerting other than that
savage "in spite of myself". That's why
it is inimitable,' he wrote to Charles
Morice a month before he died.
He modelled this piece of stoneware dur-
ing his last stay in Paris and believed it
was one of his best creations. 'I proudly
declare that no one has ever done that.'
Who is this terrible apparition with long
hair and adolescent breasts? Her staring
face is disproportionate and shocking;
she is holding a blood-stained animal—
Gauguin himself called this sculpture 'the
killer'. Its malevolent primitiveness con-
trasts starkly with the wistful images of
his pictorial Eden in the South Seas. For
Gauguin she was clearly an incarnation
of his own savageness, but also one of
death and the cruel indifference of
nature—in 1900 he wrote to Monfreid
asking him to send it to Tahiti so that it
could be placed on his future grave.
Exhibited in 1906 at the Salon d'Automne
retrospective, she impressed Picasso, who
later used the same pose with the knees
bent to one side and the mixture of 'prim-
itive' monstrousness and female grace, in
the central figure of *Demoiselles
d'Avignon*.

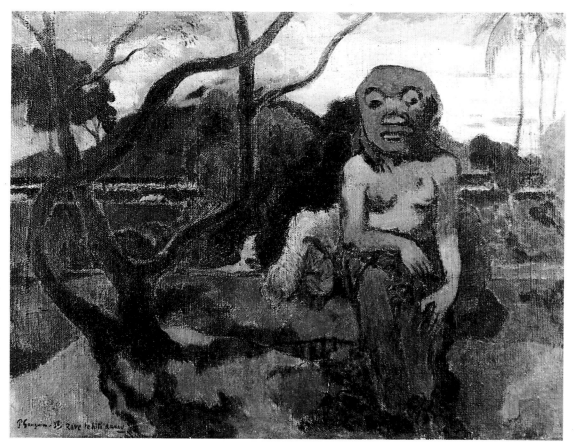

229. *Oviri*, 1895. Woodcut. Paris, Musée
des Arts Africains et Océaniens.

227. *Rave te hiti ramu* (*The Idol*), 1898.
Oil on canvas, 73×92 cm. Leningrad,
Hermitage Museum.

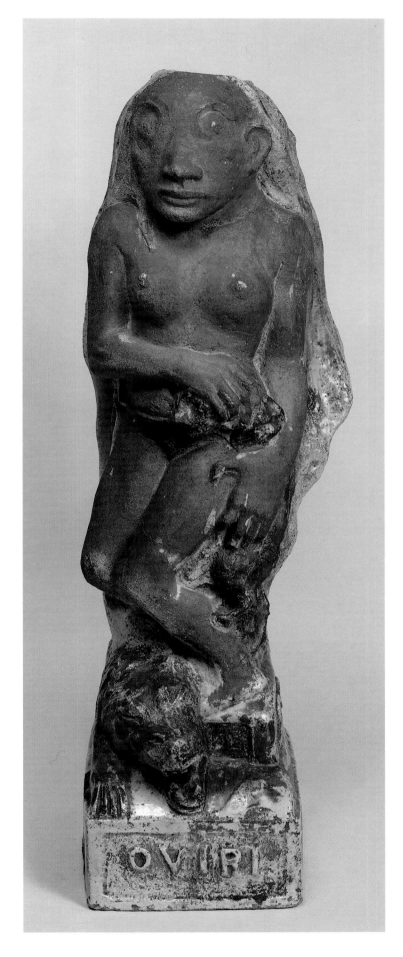

in a letter that they all read with interest in the 1880s: 'Musicalities and arabesques mean nothing to most people, for they look at a painting the way the English look at the countryside through which they are travelling. . .' and 'the mysterious effects of line and colour that are, alas! perceived only by the occasional enthusiast.'[17]

In 1895 there weren't many enthusiasts of Gauguin's painting, either. On coming back from Tahiti he had hoped to dazzle Paris and its painters, dealers, collectors and writers, but painters were disappointed in his work, few dealers or collectors were interested, and the Symbolists were often unimpressed, even though it looks as if he had painted with them in mind. Mallarmé's oft-repeated formula inspired by Gauguin's painting: 'It is incredible that so much mystery can be put into so much brilliance'[18] was perhaps as much an expression of consternation as of admiration. Everything the poet wrote—'I believe that there should only be allusions . . . to name an object is to destroy three-quarters of one's pleasure in it . . . *to suggest*, that's the ideal'[19]—leads one to believe that he was disturbed by the brightness of Gauguin's paintings rather than sensitive to their mystery, nor did he ever actually write about the painter. In a way Seurat's painstaking and controlled elaboration that resulted in such surprisingly delicate opalescent effects is more in line with Mallarmé's poetry than Gauguin's Tahitian Symbolism. At a time when the proliferation of what was known as 'art literature' was greater than ever before, no one, apart from Gustave Geffroy, tackled the 'Gauguin case' in any depth before Victor Segalen after Gauguin's death—admittedly for personal and ethnographical reasons rather than artistic ones—though Mirbeau, who admired above all the 'force of nature' that he perceived in him and whose real artistic leanings were towards Monet and Rodin, did write the occasional benevolent article. Geffroy attempted to define Gauguin in a favourable article, but he talked more about the artist and his ideas than about the painter who 'assembles violent colours with a true sense of harmony' but whose eye 'is hesitant about the nature of the soil and the modelling of a form'—in other words Geffroy reproached Gauguin for not being Cézanne. Although he claimed to know Gauguin very little he was singularly farseeing when he said: 'I feel moved by his intellectual battles, by the contradictions that he so naïvely and forcefully reveals, by the spectacle of a civilized man who would like to achieve happiness through instinct alone.'[20]

Auguste Strindberg's reaction, insofar as it was sincere and not intended for publication, was as aggressively severe about Gauguin as it was about his painting. The author of the already famous *Miss Julie* occasionally attended Gauguin's social gatherings at his studio in Rue Vercingétorix, at which people played guitar and read passages from the working drafts of *Noa Noa*. Gauguin asked him to write a preface for the catalogue of his upcoming sale, but Strindberg declined in a long letter that was published, together with the painter's answer, in lieu of the hoped-for preface. The letter revealed Strindberg's total incomprehension of Gauguin's painting and even an aversion for that 'mish-mash of sun-drenched pictures', a criticism that was aimed at the subjects and not the formal qualities or defects of his canvases. At the time Strindberg himself was producing curious paintings in an abstract pre-tachist style and had just published an article called *Le Hasard dans la production artistique*[21] whose title alone shows just how remote he was from Gauguin's Symbolism. 'You have invented a new earth and sky, but I do not feel at ease in your creation. . . and your Paradise is inhabited by an Eve who is not my ideal.'[22] To this he added yet another description of Gauguin's personality, or rather of the one the painter liked to project: 'I know that this statement will neither surprise nor wound you, for I believe that the hatred of others strengthens you, and your personality delights in the antipathy it arouses and is careful to remain untouched by it all.' Strindberg's voicing of his incomprehension of the artist could not but please Gauguin, who in his public response saw Strindberg's 'revulsion' before his art as'. . . a collision between your conventionality and my wildness. A conventionality that causes you to suffer whereas my wildness rejuvenates me.'[23]

In spite of all the publicity the sale was a failure. Gauguin was forced to buy back 39 of the 49 paintings, of which Degas bought two in addition to seven drawings. The

230. *Auti te pape* (*The Fresh Water is in Motion*), 1898. Woodcut. Paris, Bibliothèque d'Art et Archéologie.

231. *Manao tupapau* (*The Spectre Watches Over Her*), Woodcut. Paris, Musée des Arts Africains et Océaniens.

proceedings of the sale brought to light a young dealer who was to become one of the main buyers of Gauguin's Tahitian paintings: Ambroise Vollard, who bought a drawing. The other dealers, Schmidt and Bernheim Jeune, also only risked buying drawings. In short, Gauguin had far fewer admirers in 1895 than he had at the sale preceding his first departure for Tahiti. The Neo-Impressionists were in the same predicament: the only 'moderns' that people gambled on were the Impressionists; and as for the very young avant-garde, essentially composed of Denis, Bonnard and Vuillard, it survived on poster commissions and private exhibitions. It wasn't until Cézanne was given his first one-man show in 1895—a show that drew the attention of all the younger artists to the work of one who achieved greatness through exclusively pictorial means—that many recognized, as we do today, that this was the major art event of the period. Cézanne's painting brutally relegated Gauguin's to the world of literary images.

Also, in the intervening four years the Symbolism to which Gauguin had adhered in 1891 took a different direction: Moréas's grandiloquence and Charles Morice's idealism were replaced by the mannered humour of Gide's *Le Voyage d'Urien* and Valéry's intellectual sophistication. Wagner and his Valhallah were replaced by Debussy and his *Jeux d'Eau*, and Bonnard's witty Japanese style was more fitting for the age of *La Revue Blanche* than Puvis de Chavannes's ambitiously simple compositions. The mysticism that had presided over the works of Gauguin and Bernard in 1889-1890 took a caricatural turn in the esoteric art of the Rosicrucians.

In this changed milieu Gauguin suffered from being out of date. He felt more and more misunderstood and his disappointment at the failure of his exhibition was particularly bitter. On the evening of the sale it was said that 'Gauguin sobbed like a child.'[24] Feeling rejected on all sides, definitively separated from his wife and children and lonely in spite of faithful friends like Morice and Monfreid, he talked of leaving once and for all to 'bury myself in the Pacific Islands',[25] 'to disappear', 'to end [my] days peacefully with no worries as to what tomorrow will bring and free of the eternal struggle against imbeciles'.[26] He counted on being accompanied by his latest recruits from Pont-Aven, Roderick O'Connor and Seguin—sadly, this wish was to remain unfullfilled, as it had been at his previous departure—and stated: 'Farewell to painting, unless it is as a distraction: my house will be of sculpted wood.'[27] He began to mythically associate the idea of leaving with the idea of death, and he no longer hoped for anything glorious, happy or even productive from his Tahitian Eden. This time there was no literary banquet in his honour and no emotional farewells. When he left that 'dirty' Europe, not realizing he was seeing it for the last time, to return to the Tropics where he expected to be forgotten and laid in a 'flowering tomb', he was forty-seven years old, and in the eight years of artistic life remaining to him he was to produce the best and the worst of his works.

232. *Human Misery, Memories of Brittany*, c. 1895. Woodcut. Paris, Bibliothèque Nationale.

233. *Eve*. Woodcut. Paris, Bibliothèque Nationale.

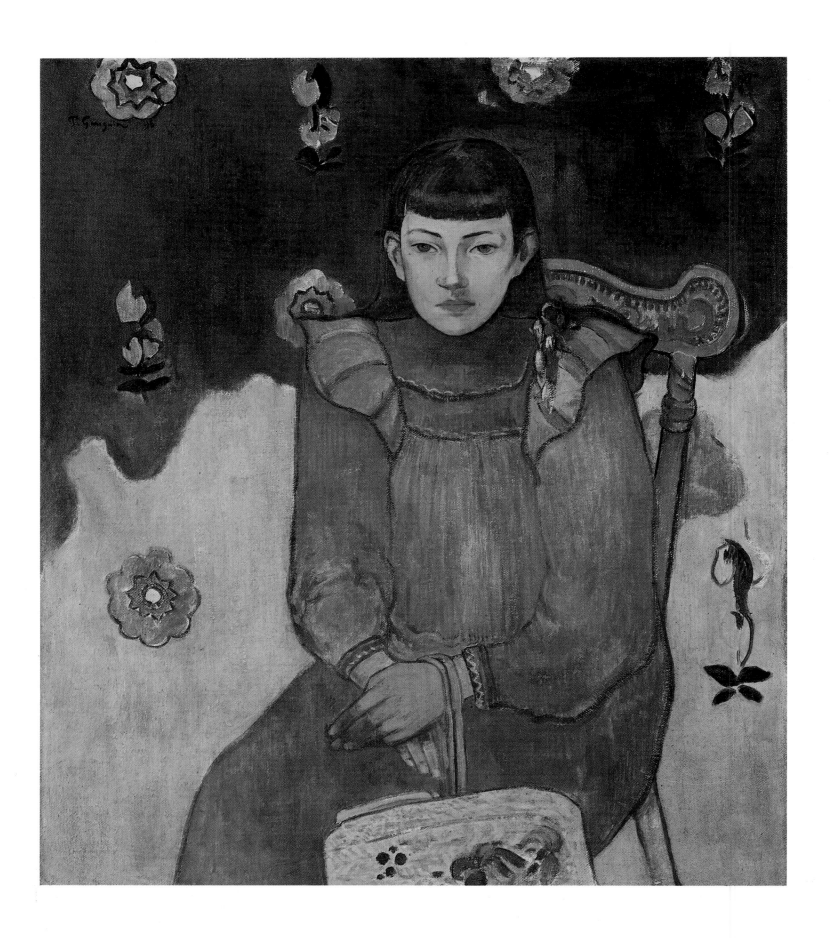

'NEAR GOLGOTHA'
1895-1901

234. *Portrait of Vaïté (Jeanne) Goupil*, 1896. Oil on canvas, 75×64 cm. Copenhagen, Ordrupgaard Collection.

Jeanne—Vaïté was her Tahitian nickname—aged nine, was the youngest daughter of a rich colonial on the island, Auguste Goupil, whom Gauguin met during his first stay in Tahiti; it was he who lent him the book by the ex-French consul who was so interested in Tahiti's past, Moerenhout (see notes to figs 179-186). Gauguin had been asking Goupil to get him portrait commissions for a long while. This was the only one that Goupil came up with but, unlike Miss Bambridge's case (fig. 160), the result appears to have pleased the father so much that, according to Bengt Danielsson, he 'hired' Gauguin to teach his daughters to draw. In any case the portrait is completely successful: graceful—not because of the rather chalky face with the fixed and somewhat supercilious look of a little girl forced to sit still against her will—but because of the well-behaved pose and the serious stare of the child as she holds her woven Tahitian basket. The background wallpaper that the undulating edge of a cast shadow turns from bright pink to purple, gives the painting strength and cheerfulness, expressing all the inherent childishness of this undemonstrative little colonial princess.

This painting was one of the rare canvases by Gauguin to remain behind in Tahiti; thirty years later it was bought there by the Danish collector W. Hansen.

A miserable adventure, this trip to Tahiti of mine.

Gauguin.

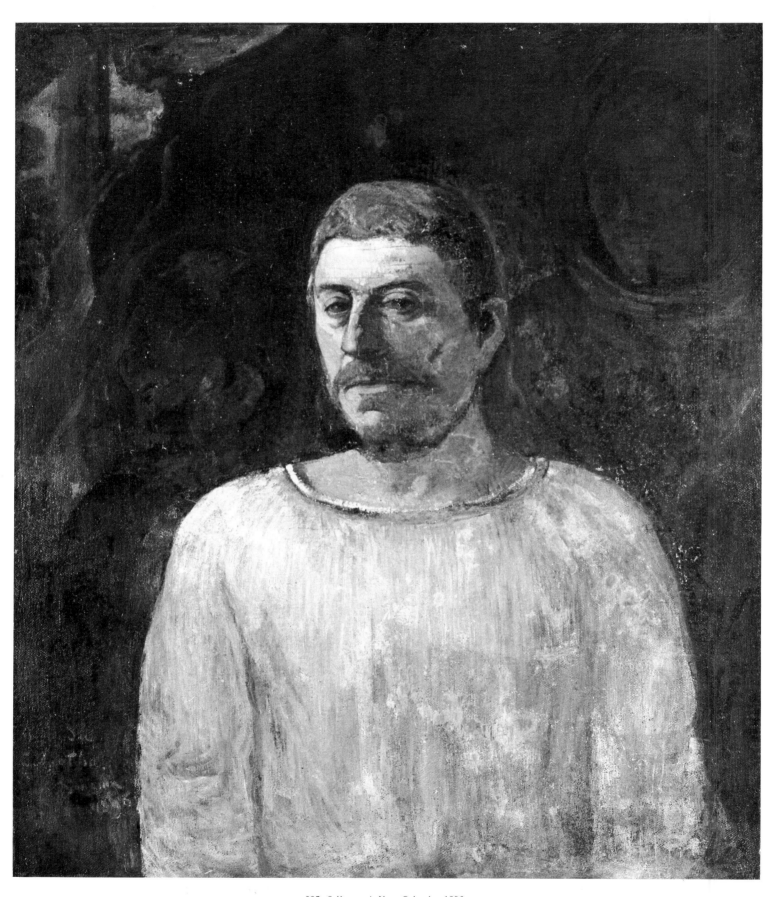

235. *Self-portrait Near Golgotha*, 1896.
Oil on canvas, 76×64 cm. São Paulo,
Museu de Arte Moderna.

One of Gauguin's first paintings on his return to Tahiti was his strange *Self-portrait Near Golgotha*. In this commanding and ingenuous canvas he represented himself as Christ in a biblical tunic whose whiteness sets off the dark 'barbaric' sculptures in the background. He clearly intended to portray himself as betrayed by his disciples and sacrificed to primitive art, to art that was pure. Only his bitter expression and peevish mouth ('the mouth is bad' Eugène Carrière said of it) save this portrait from being ridiculous, even though we no longer find any trace of the sarcastic allusions of some of his earlier self-portraits. His last stay in Paris had finally convinced him that he was a martyr to painting and he entered the solitude and dissolute life of Tahiti as if into a sublime torment, at once sure of, and fearful about, his 'divine spark' of genius. To him this was the ultimate justification of his life as an outcast painter and, when he learned of Mallarmé's death at the end of 1898, he wrote: 'He is another of those who have died a martyr to their art, his life was as beautiful as his works.'[1] Like the Pre-Raphaelites and the Rosicrucians, or William Blake before them, he saw art as a form of redemption and gave it an increasingly religious grandeur. 'Artist, you are a priest: Art is the great mystery,' proclaimed Joséphin Peladan, that turn-of-the-century prophet of the new era and final fall from grace, who pushed esoteric Symbolism to hysterical extremes and whom Gauguin came close to taking seriously. Their beliefs were the same: 'Everything is rotten, everything is finished, decadence is splitting open the Latin edifice and making it crumble'; the words are Péladan's, as are: 'Imperfect sinners that we are, let us at least become valiant knights; may the rose of forms and colours become the great tabernacle.'[2] All this was of course derived from Wagner and Swedenborg, whom Gauguin often quoted and whose concept of art and the artist in the ideal city of *The New Jerusalem* greatly impressed the Symbolists. The Artist was to raise Art from the materialism into which it had fallen: 'Beauty above all conveys the true synthesis of all the spiritual truths that the Church of the New Jerusalem is destined to popularize throughout the world, through the language of correspondences, that is to say through its Symbolism.'[3]

Yes, Gauguin resembled Péladan in some ways and, in his solitude and what could

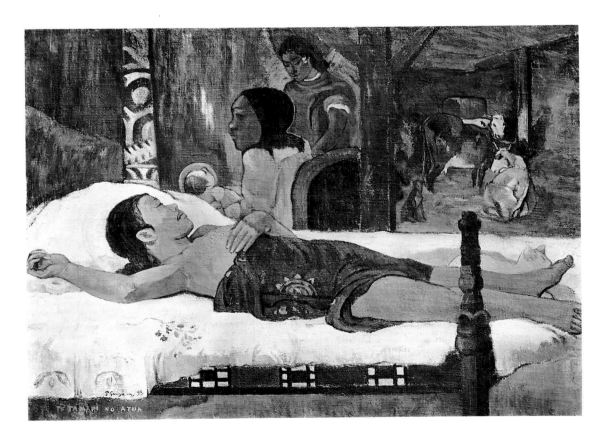

236. *Te tamari no Atua* (*The Child of God*), 1896. Oil on canvas, 96×129 cm. Munich, Neue Pinakothek.

237. *Joseph and Potiphar's Wife*, Oil on canvas, 88.3×117.5 cm. United States, Private Collection.

238. *Nave nave mahana* (*Delightful Day*), 1896. Oil on canvas, 95×130 cm. Lyons, Musée des Beaux-Arts.

Delightful Day is the first frieze in a series that would culminate with the masterpiece *Where Do We Come From? What Are We? Where Are We*

be termed his neurosis, he veered away from the pictorial craftsmanship that Pissarro had been teaching him barely ten years earlier, oscillating between despair—'I am nothing but a failure,'[4] 'I am close to suicide'[5]—and a megalomaniac certainty of the sublime, even sacred aspects of his art and chosen standpoint.

When he regained Tahiti he began by painting biblical themes, like the first time, transposing subjects from the Testaments into Maori images. The Birth of Christ inspired two fairly similar paintings, of which *Te tamari no Atua* (*The Child of God*) is the most successful. It portrays the barely pubescent girl with whom Gauguin lived during this second stay, in childbirth; she is more primitive and reserved and also less graceful than Tehamana. The composition is somewhat clumsy: two scenes enclosed in squares are placed above the young girl reclining on an acid yellow coverlet: on the left the Holy Child (actually Gauguin's) in the arms of a Tahitian woman, and on the right a group of cows in a stable whose very traditional colouring, brushwork and composition form a rather unattractive contrast to the rest of the painting. In fact this section was simply copied from a painting by Tassaert reproduced in the catalogue of the sale of Gustave Arosa's collection, that Gauguin had cut out and added to his 'portable museum'. During the same period he amused himself by copying another of Arosa's photographs,[6] Prud'hon's *Joseph and Potiphar's Wife*, in which he Tahitianized the faces and some of the furnishings.

The whole of his production in 1896 is perplexing and, like his correspondence, betrays how weak and desperate he felt. He began to resemble the colonials he so despised as the abuse of alcohol and recriminations against the administrative interference of under-employed civil servants slowly gave him the reputation of the picturesque and pitiful 'colonial artist'. Already eroded by syphilis,[7] he became soured, litigious and bitter: 'What have I achieved? A total defeat. Nothing but enemies. Bad luck follows me all the time.'[8] He had fled a 'rotten' Europe to a disappointing South Seas whose magnificence no longer thrilled him or inspired hope.

The *fin de siècle* Europe that Gauguin claimed to hate had nevertheless made a deep impression on him during his final stay there. All his large-format works of friezes of figures, the most ambitious of which was *Where Do We Come From? What Are We? Where Are We Going?* were in fact completely in keeping with current Parisian tastes. Puvis de Chavannes's *The Sacred Wood* was followed by new renditions of 'blessed lands'—pagan paradises that were the turn-of-the-century concept of a Mediterranean or timeless golden age. Gauguin produced *Nave nave mahana* (*Delightful Day*), a conventional frieze of Tahitian women standing immobile between two slender trees set against a rich red background. It would be worth studying this classical theme of Paradise as revived in a spirit of pagan humanism between 1895 and 1905. It is to

Going? (fig. 245) and could be the painting described by Gauguin in *Diverses Choses*, a series of notes written in the end pages of his own copy of *Noa Noa* that he had taken to Tahiti in 1895, when he painted this picture: 'The central figure will be a woman who is turning into a statue, she will become an idol but remain a living being nevertheless. . . [she] will stand out against a clump of trees that grow nowhere on earth and are only to be found in Paradise. . . . Fragrant flowers rise up from all sides, children play in the garden, girls pick fruit. . . . The atmosphere of the painting should be as solemn as a religious ceremony, melancholy, and cheerful as children.' A faithful description apart from a few minor details: the emaciated child on the left looks hungry rather than cheerful and the figure in the foreground holding a bowl is more like a woman than an idol. The woman in the flowered red *pareu* behind her is not very Tahitian, but comes straight from the reproductions of paintings by Raphael and Botticelli that Gauguin took with him to Tahiti. Incidentally, it was the great French art historian Henri Focillon who bought this painting in 1913 when he was appointed professor at Lyons University and curator of its museum; it was the first Gauguin to be purchased by a French state collection.

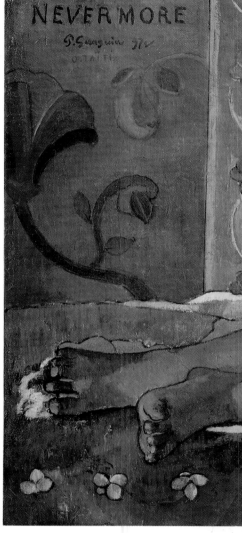

239. *Te rerioa* (*The Dream*), 1897. Oil on canvas, 95×132 cm. London, Courtauld Institute Galleries.

be found in Cézanne's pantheistic vision of *Les Grandes Baigneuses*, in Renoir's carnal Eden, in Signac's or Cross's anarchistic Utopia of which *Au temps de l'harmonie* is an example, or in Hodler's and Bœcklin's theatrical pre-Expressionist compositions. It continued right up to Matisse's *Luxe, Calme et Volupté* of 1904 and his 1906 *La Joie de vivre*, which was more or less the last great painting of this series, and in which Utopia was transformed into a euphoric picnic.

Once again, it must be said that Gauguin's greatness lies in his observation and not in his ambitious following of convention. At the beginning of 1897, at a time when he was hitting the depths of despair and physical decline that would lead to a failed suicide attempt a few months later, Gauguin painted the two poignant canvases *Nevermore* and *Te rerioa* (*The Dream*). Curiously they both look like elaborate and rather stifling versions of two paintings from his first stay in Tahiti. *Nevermore*, a handsome golden nude lying on her side, with an acid yellow enhancing the dark waves of her hair and a touch of vermilion against her leg setting off her brown skin, resembles a more decorative and literary version of *Manao tupapau* (*The Spectre Watches Over Her*). All the tension and simplicity of the 1892 nude seem to have been reworked without dramatic conviction into a coldly sophisticated composition. But if one compares *Te rerioa*, of two back-lit women squatting in a hut, to the 1891 *Te Faaturuma*

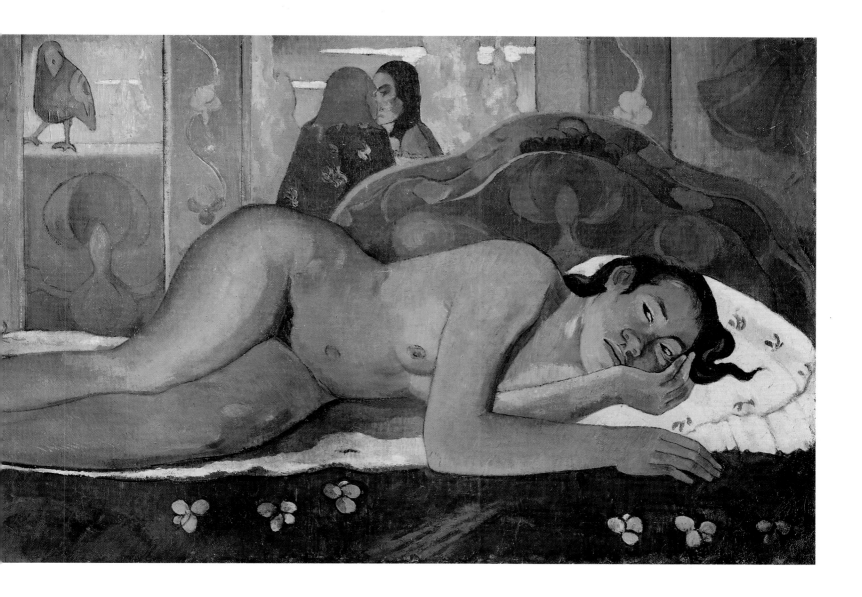

240. *Nevermore*, 1897. Oil on canvas,
60×161 cm. London, Courtauld
Institute Galleries.

'I wanted to suggest a certain past bar-
barian luxury with a simple nude. The
whole is bathed in purposely sad and dull
colours: neither silk, velvet, lawn nor gold
produce this luxury, only plain materials
enriched by the hand of the artist. . . . Its
title is *Nevermore*—not for Poe's raven,
for it is the Devil's bird on the watch' (to
Monfreid, 14 February 1897). The back-
ground indeed gives the impression of a
sumptuous and mysterious bric-à-brac,
and Poe's raven from *Nevermore*, al-

ready associated with Mallarmé (fig. 141)
also makes this painting a homage to that
poet. In it we find a number of other leit-
motivs from Gauguin's work: the back-
ground looks like the wallpaper in earlier
portraits and the two faces placed close
together recall those in *The Follies of
Love* (fig. 132).

But, enhanced by the lemon-yellow pil-
low and the blood-red cloth behind her
left leg, the main subject is the most mag-
nificent and perhaps the most classical
nude of his career. In it we see traces of
his overt admiration for Ingres, and this
'large odalisque' of the Tropics praises
those bodies that he compared to the cor-
seted Western ones in *Avant et Après*:
'The Maori leg runs in an attractive
straight line from the hip to the ankle; the
thigh is quite thick, but not just in its
width, which makes it very round. . . the
skin is golden yellow. . .'

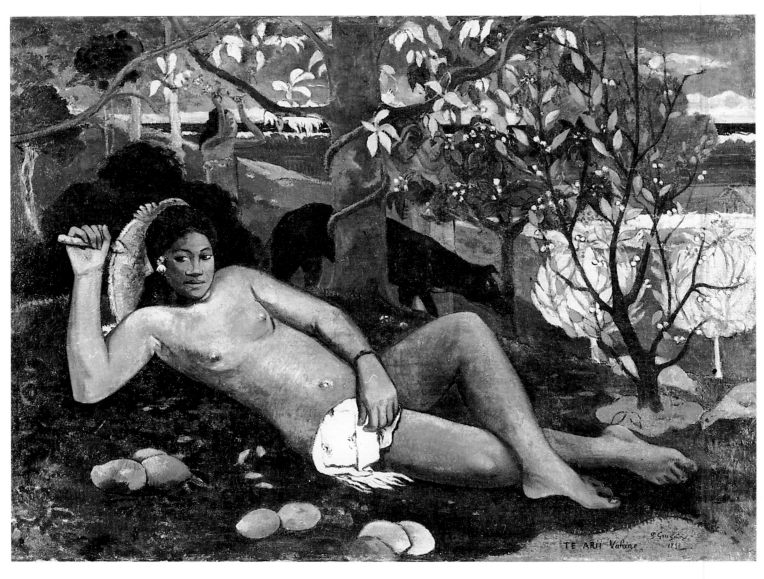

241. *Te arii Vahine* (*The Noble Woman* or *Woman with Mangoes*), 1896. Oil on canvas, 97×130 cm. Moscow, Pushkin State Museum of Fine Arts.

242. Lucas Cranach, *Diana Reclining*, 1537. Oil on wood, 48.5×74.2 cm. Besançon, Musée des Beaux-Arts et d'Archéologie.

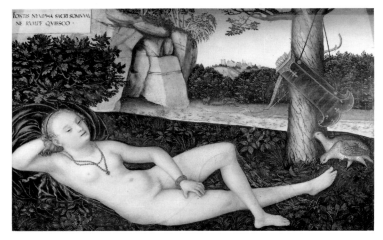

243. Letter illustrated with *Te arii Vahine*, 1896. Pen and watercolour on paper. Paris, Private Collection.

In this letter to Monfreid in 1896 Gauguin describes the painting he had just finished, called *Te arii Vahine*, which means the king's wife: 'I have just finished a canvas measuring 1.30 metres that I again think is better than anything I have done so far: a naked queen, lying on a green carpet of grass, a servant is picking fruit, two old men near a big tree are discussing the Tree of Knowledge; a coastline in the background; this shaky sketch can give you only a vague idea of it.' Gauguin transcribed two famous nudes into this splendid painting with its muted colours: Lucas Cranach's *Diana Reclining*, of which he had a photograph, and of course, Manet's *Olympia* that he had copied a few years earlier (fig. 145) and which he himself described as 'fit for a king', both as a painting and as a woman; more or less the title of this painting. By winding a snake—a reptile not found

in the South Seas—around the tree, he turned his model into an Eve in a Tahitian paradise, where apples are replaced by mangoes, and the world of sin by the nonchalant splendour of innocent bodies.

à faire sinon sans fruit. Je viens de faire une toile de 1m.30 sur ¹mètre, que je crois encore meilleure que tout auparavant; une reine nue couchée sur un tapis vert; une servante cueille des fruits, deux vieillards près du

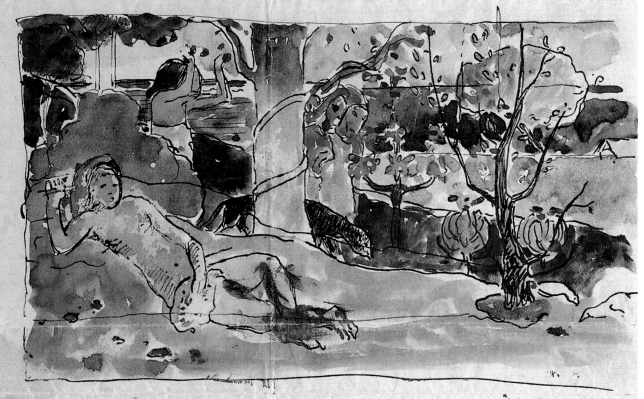

gros arbre discutent sur l'arbre de la science; fond de rivage; ce léger croquis tremboté ne vous donnera qu'une vague idée. Je crois qu'en couleur je n'ai jamais fait une chose d'une aussi grande sonorité grave. Les arbres sont en fleur, le chien garde, les deux colombes à droite roucoulent.

à quoi bon envoyer cette toile s'il y en a tant d'autres qui ne se vendent pas et font hurler. Celle-là fera hurler encore plus. Je suis donc condamné à mourir de bonne volonté pour ne pas mourir de faim. Et dire qu'il y a des hommes âgés qui agissent avec la plus grande légèreté et que la vie d'un homme honnête en dépend: je parle de Lévy. Sans lui je n'aurai

(*Silence*) from which the setting and the woman on the right are taken, or to the remarkable 1892 *The Siesta*, which was of a similar scene in the open air with the same woman squatting in profile, one cannot but be startled. In a few years Gauguin's art had turned from light-hearted to oppressive, from a tremendous simplicity of touch to a sort of convoluted mannerism, and from joyous and subtle colouring to dull and weighty tones. In the two earlier paintings Gauguin portrayed gentle creatures momentarily overcome by the heat, here he painted the *idea* of two women crushed for ever by a tragic literary fate in a decor of erotico-symbolic friezes. 'Everything in this canvas is a dream,' Gauguin said about it, adding: 'People will say that all this is beside the point. Who knows? Perhaps it isn't.'[9]

How could he not have doubted himself? For a man as eager for approval and glory as Gauguin, the failure of his last stay in Paris must have added its burden to the distress caused by his illness, poverty and solitude, compounded shortly afterwards by the belated news of the death of his favourite child, his daughter Aline. 'You are about to receive some canvases, I'm not up to judging them myself,' he wrote to Monfreid. He even finished a letter to his friend in September 1897 with these disenchanted words: 'Crazy, sad and a miserable adventure, this trip to Tahiti of mine.'[10]

Cruel doubts, but perhaps essential doubts. At the lowest point in his depression, just before his suicide attempt, Gauguin painted his most famous work, *Where Do We Come From? . . .* with the intention of making it his pictorial and ideological testament.

Although Gauguin was vain enough to insist that 'this is not a painting done in the manner of a Puvis de Chavannes with studies after nature followed by a preparatory cartoon, etc. It is all done from memory, off the tip of my brush,'[11] it was nevertheless a synthesis of components that are found in earlier works, and that had served, in a manner of speaking, as rough works over the years for this large composition (just short of four metres wide). Furthermore, there is no painter of the period that this work makes one think of more than Puvis de Chavannes. Gauguin, like Seurat, had followed this artist's development with interest and, ever since the 1876 Salon where Puvis exhibited for the first time, he had watched the progress of his grand projects for the decoration of the Pantheon. Gauguin's admiration was undoubtedly revived during his last stay in Paris by that artist's triumphant exhibition in 1894.

It would be fastidious but not too difficult to find the source of each detail in this painting in Gauguin's earlier canvases, beginning with his Breton *Eve* of 1889, who was transformed into the old woman on the left—he even reproduced the tentacular roots above her head—to the child eating fruit in the centre whom he had painted the year before in *Nave nave mahana* (*Delightful Day*), or even the kitten lapping at the same bowl in the same position as one in a little painting and a fan from 1888. The central figure is an allegorical version of the nude with uplifted arms painted in the early months of Gauguin's first stay in Tahiti: *The Man with an Axe*.[12]

The general atmosphere is that of a wild 'sacred wood', but here the Tropics appear sad, and the colours and abstract lines, like the eyes and gestures of the figures,

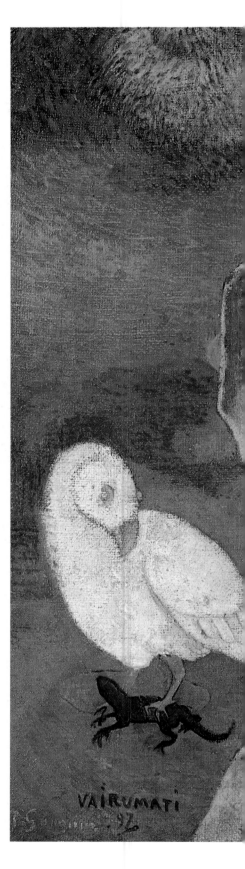

244. *Vairumati*, 1897. Oil on canvas, 73×94 cm. Paris, Musée d'Orsay.

In this painting Gauguin included a figure from one of his favourite Maori legends that he had already painted twice before during his first stay on the island, in *The Name is Vairumati* (fig. 187) and *The Seed of the Ariois* (fig. 189). In *Ancien Culte Mahorie* he tells how the god Oro came down from his Bora Bora Olympus and took a beautiful young girl from the island—Vairumati—as his wife; their union gave birth to the Ariois. Here the queen or goddess is seated in front of a decoration forming a sort of nimbus and a throne that is more Chinese than Maori. The two followers or worshippers on the upper right are from a Borobudur relief; the painting as a whole is particularly hieratic and geometric, and it was at this time that Gauguin sent the following advice to Monfreid: 'Always bear the Persians, the Cambodians and a little of the Egyptians in mind' (October 1897).
From *Where Do We Come From? What Are We? Where Are We Going?* (fig. 245), of the same period, he painted the 'strange white bird holding a lizard in its claws, [which] represents the futility of vain words' and the same nude model in the same pose. Placed near the Peruvian mummy that had symbolized old age and death in Le Pouldu almost ten years earlier (*Life and Death*, fig. 118), the beautiful and fertile Vairumati therefore represented, for Gauguin, the forces of life and youth.

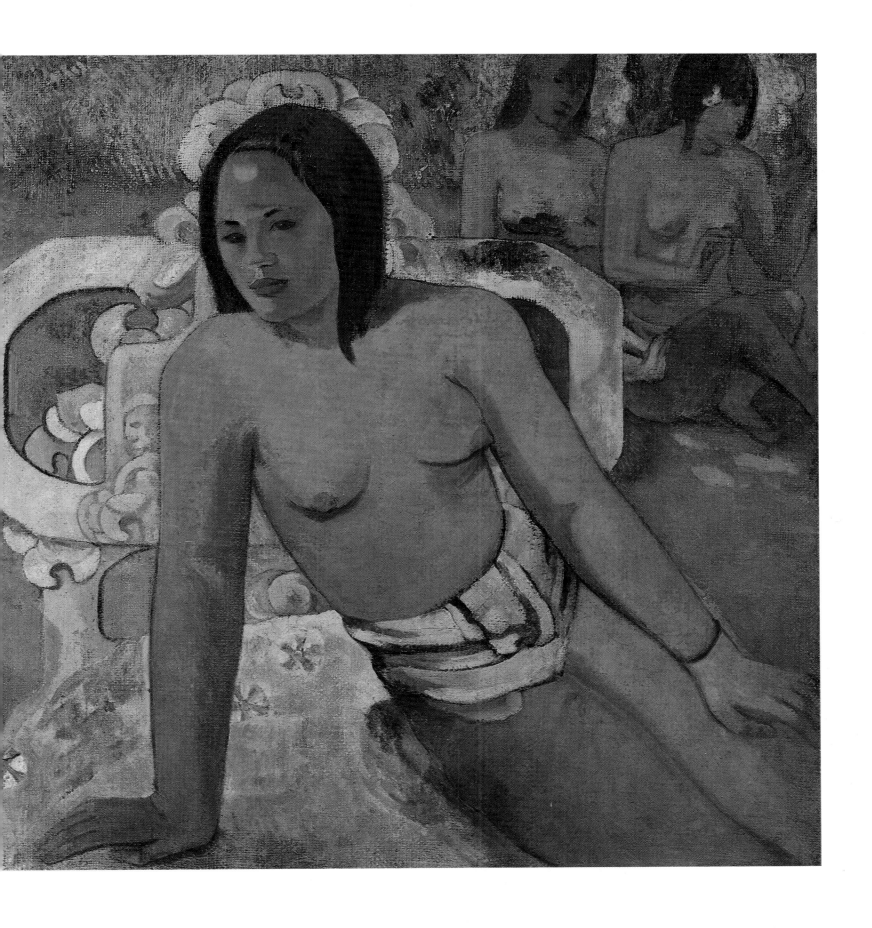

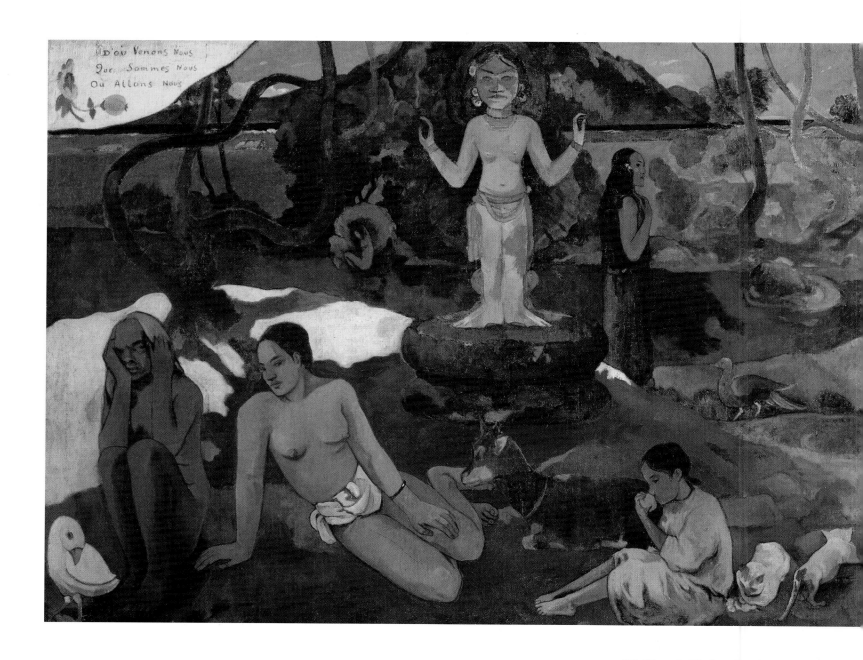

245. *Where Do We Come From? What Are We? Where Are We Going?*, 1897. Oil on canvas, 139×374.5 cm. Boston, Museum of Fine Arts.

246. Pierre Puvis de Chavannes, *The Sacred Wood*, 1885. Lyons, Musée des Beaux-Arts.

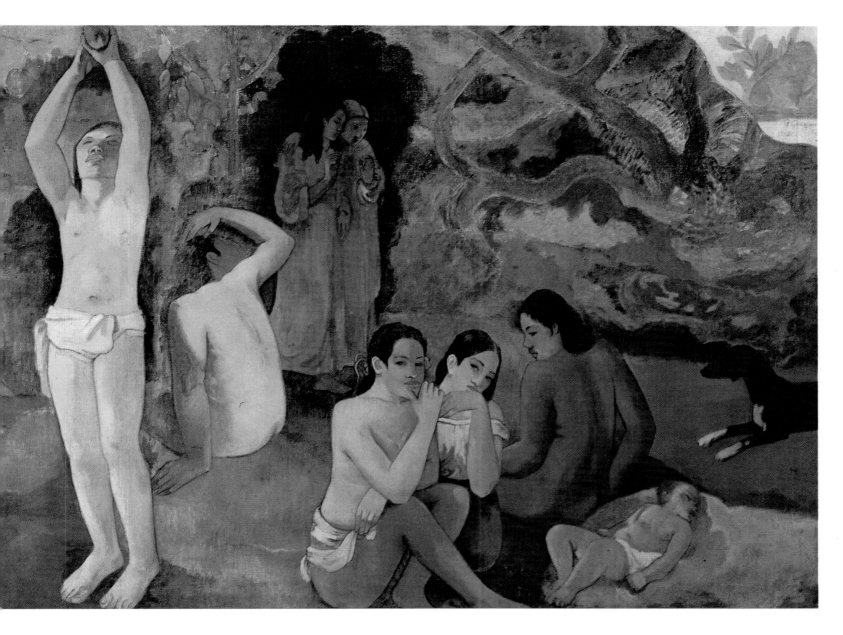

Février 1898 -

Mon cher Daniel.

Je ne vous ai pas écrit le mois dernier, je n'avais plus rien à vous dire sinon répéter, puis ensuite je n'en avais pas le courage. Aussitôt le courrier arrivé, n'ayant rien reçu de chaudet, ma santé tout à coup presque rétablie c'est à dire sans plus de chance de mourir naturellement j'ai voulu me tuer. Je suis parti me cacher dans la montagne où mon cadavre aurait été dévoré par les fourmis. Je n'avais pas de révolver mais j'avais de l'arsenic que j'avais thésaurisé durant ma maladie d'exéma: est ce la dose qui était trop forte, ou bien le fait des vomissements qui ont annulé l'action du poison en le rejetant, je ne sais. Enfin après une nuit de terribles souffrances je suis rentré au logis. Durant tout ce mois j'ai été tracassé par des pressions aux tempes, puis des étourdissements, des nausées à mes repas minimes. Je reçois ce mois-ci 700ᶠ de chaudet et 150ᶠ de mauffra : avec cela je paye les créanciers les plus acharnés, et recontinue à vivre comme avant, de misères et de honte jusqu'au mois de Mai où la banque me fera saisir et vendre à vil prix ce que je possède entre autres mes tableaux. Enfin nous verrons à cette époque à recommencer d'une autre façon. Il faut vous dire que ma résolution était bien prise pour le mois de Décembre alors j'ai voulu avant de mourir peindre une grande toile que j'avais en tête et durant tout le mois j'ai travaillé jour et nuit dans une fièvre inouie. Dame ce n'est pas une toile faite comme un Puvis de chavannes, études d'après nature, puis carton préparatoire etc. Tout cela est fait de chic au bout de la brosse, sur une toile à sac pleine de noeuds et rugosités aussi l'aspect en est terriblement fruste. D'où venons nous? On dira que c'est lâché etc....
que sommes nous?
Où allons nous?

228 GAUGUIN

247. Illustrated letter to Daniel de
Monfreid, February 1898. Paris, Private
Collection.

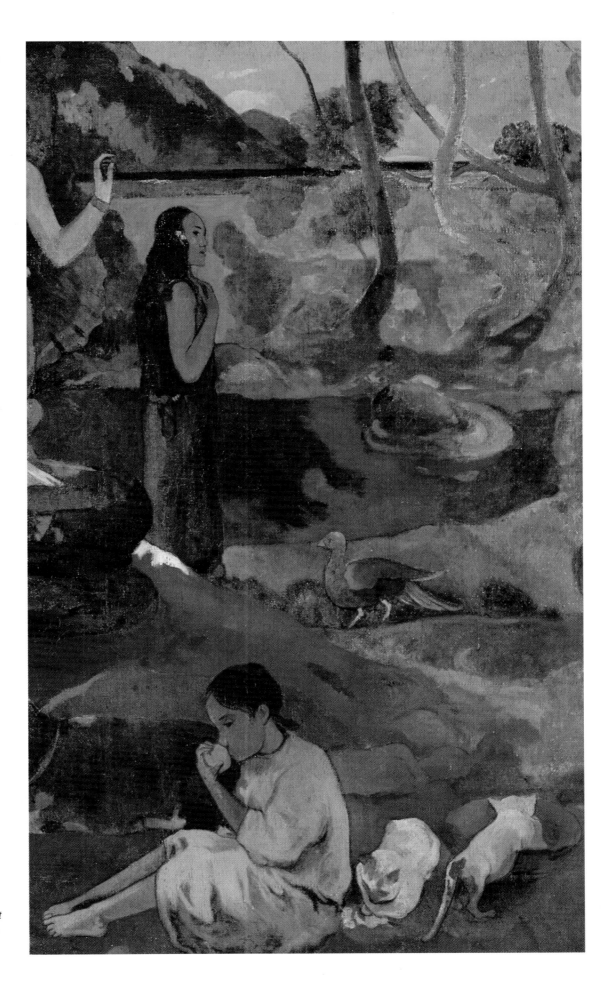

248. *Where Do We Come From? What
Are We? Where Are We Going?* detail,
1897. Oil on canvas, 139×374.5 cm.
Boston, Museum of Fine Arts.

express misgiving and a dismal resignation at the idea of death that so haunted the painter. The composition shows just how awkward Gauguin could be in the orchestration of numerous components compared to Puvis de Chavannes, Seurat or Cézanne. Indeed, he was reasonably conscious of this: 'The more I look at it, the more I discover *enormous mathematical* errors that I don't want to alter at any price.'[13] The improvised aspect that he congratulated himself on is due as much to the brushwork as to the composition of the figures, whose isolation from each other, against the precepts of the École des Beaux-Arts, he was well aware of: 'It doesn't stink of models, craft or so-called rules.' The painting definitely satisfied him as it stood: 'I have attempted to translate my dream into an evocative setting with the greatest possible simplicity of my craft, without resorting to literary means, a difficult task. . .' and: 'Not only do I believe that this painting surpasses all the ones gone before, I also think that I shall never paint a better or even another one like it.'[14] Another one like it, indeed not, though insofar as modern taste is concerned, we would consider that he painted a better one in the years left to him. However, Gauguin would never produce another composition in which he so deliberately transcribed a philosophical idea, or one in which his anguish and depression are so clearly visible.

The subject, curiously, is analogous to the subject of Edvard Munch's *Dance of Life*. Although this painting was first exhibited at the Salon des Indépendants that same year of 1897, Munch, a friend of Strindberg's, had been working on it since 1892; perhaps the writer described it to Gauguin during one of those evenings at the Rue Vercingétorix in 1894, a few months after he met his compatriot. In any event Munch's subject is highly Symbolist, though very different from Gauguin's classic-archaic interpretation, and his strong pictorial effects owe much to Gauguin's Pont-Aven work that he so admired.

The title of Gauguin's painting may have come from a book. In Balzac's *Séraphita*, a story that according to several sources Gauguin particularly liked, we find the following philosophical theme already presented as a vision: 'My words take on the brilliant shapes of dreams and clothe themselves in images, then flame up and fall on you. . . does this visual thinking lead you to understand humanity? Where it comes from? Where it is going?' Or it may be drawn from Carlyle's *Sartor Resartus* that Meyer de Haan must have read to him in Brittany and that Gauguin used as an emblem in the portrait he painted of his friend in 1889. In Taine's French adaptation of the book, entitled *Thomas Graindorge*, it was translated as: 'Where do we come from? O God, where are we going?'[15] In the original English text one finds the formula as it appears on the painting.

One perceives that Gauguin not only summarized his entire stock of forms in this masterpiece, but what we could call his ideological folklore. In it we find a sublime Tahiti, like the one he had dreamed of in Paris: '. . .under winterless skies, on a magnificently fertile soil, the Tahitian merely has to raise his arm to pick his food.'[16] These lines were written in 1890, before his first visit, but they already perfectly describe the central figure, the epitome of the noble savage with the unreal body of a hermaphrodite. Indolent female savages incarnate the stages of a life that, from childhood to old age, Gauguin saw as spent in animal innocence. By clothing the two pensive passers-by in the middle ground, he obviously wanted them to express a western philosophical anxiety: 'Two figures dressed in purple are lost in thought; a huge figure intentionally shown seated despite the perspective, raises its arms in the air and looks in amazement at the two people who dare to question their destiny.'[17]

Haunted at the time by the idea of death, the next world and religion, he wrote a recently published manuscript, *L'Esprit moderne et le Catholicisme*, in which he discussed, as in *Diverses Choses*,[18] the theme of the corruption of the Gospel by the Church. Here he resembled Renan, and indeed compared himself to him, though Gauguin possessed a greater spirit of evangelism. His wranglings with the local civil and religious authorities in Tahiti made him more and more bitter against a society to which he could not adapt. The cover illustration and some of the pages of this manuscript are indicative of Gauguin's bizarre cultural and mythological syncretism:

249. Edvard Munch, *The Dance of Life*, 1899. Oil on canvas, 125.5×190.5 cm. Oslo, Nasjonalgalleriet.

250. *L'Esprit Moderne et le Catholicisme* (cover), 1897-1898. Monotype, 31.8×19.2 cm. Saint Louis, Art Museum.

251. *Paradise Lost*, engraving glued onto the cover of *L'Esprit Moderne et le Catholicisme*. Saint Louis, Art Museum.

252. *Faa Iheihe* (*Tahitian Pastoral*), 1898. Oil on canvas, 54×169 cm. London, Tate Gallery.

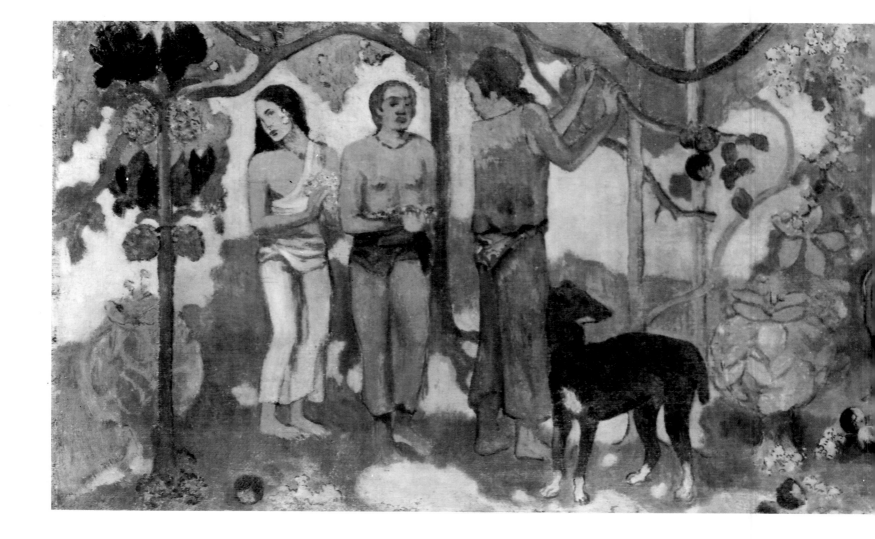

the cover, decorated with figures of Tahitian women, has the traditional heraldic lily of the French kings alongside a Maori decorative motif on either side of the title. A woodcut called *Paradise Lost*, a Tahitian scene, demonstrates the conviction with which Gauguin identified colonialism with Original Sin, the West and the corrupting Tree of Knowledge. According to him, the Catholic Church was to the Gospel what the industrial age was to a mythic and bucolic Tahiti, for the South Sea islanders had always attracted Gauguin with their grace, a grace that was as much spiritual as physical—noble savages instead of early Christians. This very Mediterranean concept of the Golden Age somehow prevented Gauguin from ever understanding the real Tahitians, and he always lent them a biblical rather than a primitive mental universe. In all of his paintings, of which *Where Do We Come From? . . .* is the most highly developed, he proceeded just as the Pre-Raphaelites had with Renaissance art. Tahiti and Florence are both misleading settings inhabited by an ideology that was in fact a very turn-of-the-century Parisian one in the first instance and a very English Romantic one in the second. The preciousness and the icon-like style of a long panel entitled *Faa Iheihe* (*Tahitian Pastoral*) painted a few months after *Where Do We Come From? . . .* makes it almost a caricature of this Eden-like view of Tahiti. Surrounding a reddish idol that is yet another obsessive version of the Javanese goddess from Borobudur, we see a black dog copied from a Courbet reproduced in the Arosa catalogue and some graceful lianas encircling a Tahitiano-Buddhist celebration against a flame and gold background, all of which make this painting one of the loveliest and the most mannered of Gauguin's works.

The real mystery of *Where Do We Come From? . . .* lies elsewhere. Despite being a sort of recapitulation of Gauguin's pictorial past, it was on account of this work that he managed, in his solitude, to face up to the most pertinent questions he had asked

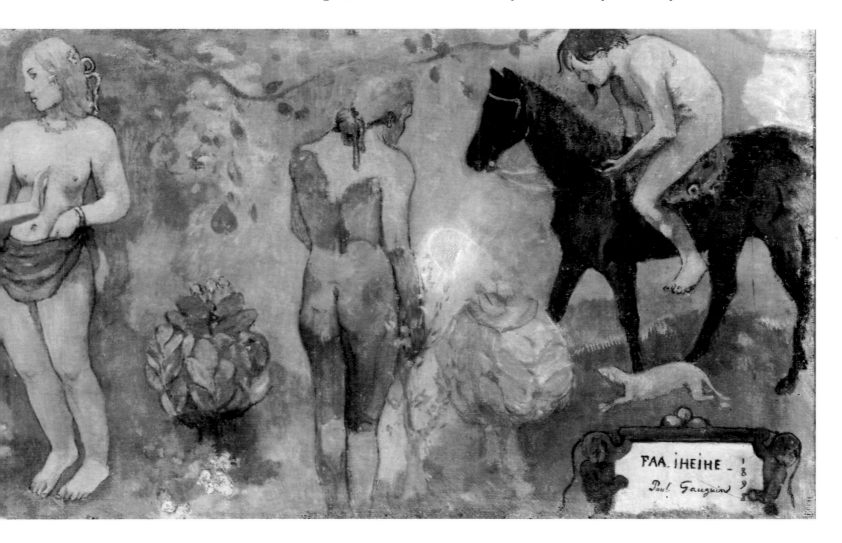

himself since the year spent with Émile Bernard and Van Gogh. Interestingly enough, these problems were also those that would haunt the young European painters over the ensuing half-century, and included the need for absolute freedom in painting. For example, it seems that during that year he minutely analysed the problem of the passage from inspiration to execution. He was driven by the desire to preserve all the freshness and truth of the unconscious impulse: 'Where does the execution of a painting begin, where does it end? At the moment in which extreme feelings are blending in the depth of one's being, at the moment when they explode and all one's ideas burst forth like lava from a volcano, is there not a blossoming of a work that has suddenly been created, a brutal one if you like, but great and seemingly superhuman?'[19] He believed that his painting—in spite of its many references—had the authority of that which is born from instinct. He echoed the most fashionable preoccupations of contemporary philosophy, those of a privileged creative power born of instinct and 'life force'. At the same time, he was moving in a direction that would have a vast impact on the last of his works, and that would soon lead him to greater freedom and independence from an often burdensome Symbolist ideology. Talking about the '*pompier*' painter Bouguereau, he mocked the 'artistic will' and evoked the charm of the '*non finito*' several times, like the Romantic Delacroix of the *Journals* that he might have taken with him. Incidentally, he turned once again to this Romantic painter in response to the critic Fontainas who had deplored the monotony of his colours, to that Delacroix whose 'dark cloak of repeated harmonies of brown and muted violets suggests drama' and immediately afterwards he described the mythic Tahiti that he despairingly searched for in everyday life in these Baudelairian terms: 'Here, near my hut, surrounded by silence, I dream of violent harmonies in the intoxicating fragrances of nature. [I feel] a delight that is born of I know not what sacred dread that I sense in the immemorial. Another age, whose scent of extasy I inhale in the present.'[20]

Between his suicide attempt in the winter of 1898 and his departure for Hivaoa in the Marquesas Islands in the summer of 1901, Gauguin spent more time poring over the registers of the Public Works Department in Tahiti (where he had been forced to take a job as draftsman in order to survive) than he did painting, expending his remaining energy on the production of two illustrated satirical reviews—*Les Guêpes* (The Wasps) and *Le Sourire*[21] (The Smile), in which he vented his hatred of colonials and 'society', as well as what has to be called a genuine persecution complex.

254. *Illustrated Menu*, 1899. Pen and watercolour. Paris, Private Collection.

Gauguin illustrated a series of eleven menus for a party in Tahiti. The Franco-Tahitian dishes are mouth-watering: one supposes that the assorted *foutinaises* were the hors d'œuvre; *Puaha oviri* baked in a Kanaka oven was wild piglet baked in a sand pit, followed by a very cosmopolitan 'roast beef'.

On each menu Gauguin drew little caricatures of local subjects or from his personal memories—the police commissioner in his pith helmet, a dog having a wash, a little Breton peasant wearing clogs next to a young Tahitian in a *pareu*. Here a pronouncedly Tahitian woman is staring bleakly at a sharp-chinned Breton woman wearing a coif: two types of Gauguin's 'primitive' humanity in a comic confrontation: 'Hi, you Breton woman (*Protane*),' says the first, to which the naïve 'goose' replies solemnly, 'Good-day to you, young Tahitian lady.'

253. *Le Sourire, journal sérieux.* Illustrated manuscript. Paris, Musée du Louvre, Department of Drawings.

Menu
Foutimaises assorties
Puaka Oviri au four canaque
Moa Upupa Sauce Coco
Roti Boeuf à la française
Salade !!! aita } apperitifs
 Desserts } Vin colonial

Eaha ! oe Protane
novau Vahine Tahiti

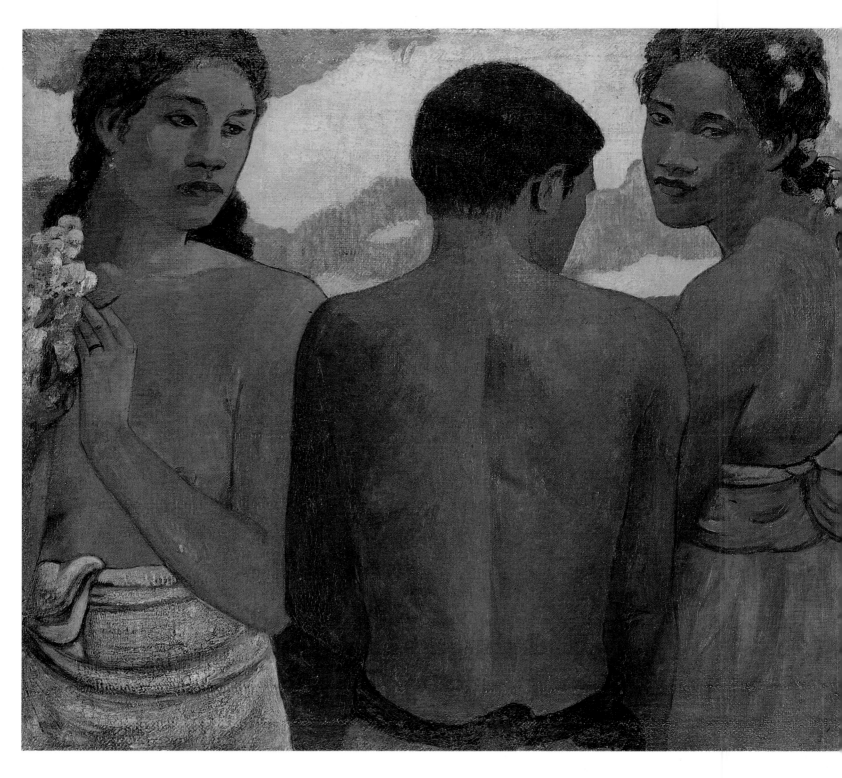

255. *Three Tahitians* or *Conversation*,
1899. Oil on canvas, 73×93 cm.
Edinburgh, National Galleries of
Scotland.

The classic aspect of Gauguin's painting
has often been remarked upon, by
Maurice Denis or Robert Rey, for in-
stance, and this painting is a brilliant ex-
ample of it. The composition is direct and
powerful; it is a fresh version of the Three
Graces even though the middle figure is

a man—a Tahitian Paris between two
beauties, one of whom holds a fruit and
the other flowers. His powerful back is
the axis between the two symmetrical
forces of colour and form, with a sharp
green accent on the left (a mango?), and
one on the right formed by the leaves
above the young girl's head. Their skin
looks like antique patinated bronze and
the undiluted colours which surround the
bodies, bright yellow and red and yellow,
loudly proclaim Gauguin's belief: the

greatness of Phidias and Raphael was no
longer found in the declining West, it be-
longed to the artist who refreshed his
genius in the primitive world.

The idea for this group might also have
come from the refrain of a Tahitian song
called *Oviri* (The Wild One), which
Danielsson believes may have inspired the
title of the stoneware piece (fig. 228).

My heart is caught between two women
Both of whom lament
Whilst my heart and the flute sing.

256. *Portrait of a Woman and a Young Man*, 1899. Oil on canvas, 95×61 cm. Pasadena, Norton Simon Museum.

During the few years following the portrait of Vaïté Goupil (fig. 234) Gauguin had no model to pose for him, nor was he to use one often afterwards, for he preferred photographs. If only for this reason, this double portrait is an exceptional work. The identity of these two Tahitians looking squarely at the painter, posing as stiffly and seriously as if for a photograph, is unknown. Is the woman in the wicker armchair a mother with her son? Were they neighbours or Tahitian friends of Gauguin's? Nothing is known about this painting except that the painter, who must have liked it, took it to the Marquesas Islands with him, and that it was among the last batch of canvases sent to Vollard. Gauguin gave the woman a pose somewhat reminiscent of the one in *Vahine no te Tiare (Wo-man with a Flower)* (fig. 158). The yellow background decorated with a green floral pattern also recalls that painting. But he had never used such extremely forceful colour contrasts before: the pink of the dress underscored by a green collar contrasts with the sulphurous yellow and strident green of the background; these delicate, acid, almost fluorescent tones enhance the placid brown faces and their attentive eyes, enveloping them in a primitive radiance.

257. *The White Horse*, 1898. Oil on canvas, 141×91 cm. Paris, Musée d'Orsay.

258. Relief from the west frieze on the Parthenon, reproduced in *Frises du Parthénon*, a book illustrated with Gustave Arosa's photographs.

In the spring of 1899 Maurice Denis invited him to take part in a collective show with the painters who had participated in the exhibition at the Café Volpini; Gauguin's reply reveals both an awareness of his position among the young painters and the pain of his solitude. The man whom Sérusier called the 'dean of the Nabis' stressed the ten years that stood between him and the Pont-Aven period: 'I wanted to dare all at the time, to *free*, as it were, the new generation and then work at acquiring a little talent. The first part of my plan has borne its fruit.'[22] He feared, he said ironically, that he would be taken for the pupil in such an exhibition, and suspected that in Paris, during his absence, painting had become 'freer' than he imagined, making his own work run the risk of no longer being 'part of the movement'. But the reason—'the real reason', he added—for his refusal was that he did not have enough canvases: 'my work is finished'. Those people in Paris who knew the uneasy narcissism of the painter might have taken what seems to have become a reality in 1899 for a pose. Apart from a few canvases he painted very little, even, according to him, not at all 'except on Sundays and holidays' and indeed it appears that he did not paint anything the following year.

And yet, among the paintings he produced during that period, we find the most relaxed and perhaps truly Tahitian works of his career. The charming *Bathers at Tahiti* and above all *The White Horse,* inspired by a relief in the west frieze of the Parthenon—a curious choice in light of what he had just written at the time: 'I am far, very far indeed from the horses in the Parthenon'[23]—are, in their manifest simplicity, full of the strangeness that Gauguin tried to achieve in elaborate and deliberate compositions like *Where Do We Come From? . . .* In *The White Horse* an overhead perspective like the ones that he often used in Pont-Aven places the landscape on the same plane as the painting. The undulating pattern of blue branches gives this scene of naked horsemen watering their mounts that 'timeless' distancing that his more studied paintings so often lacked; this work is an example of the best of Gauguin, that difficult balance between the poetic and the decorative.

The force and tranquil grace of the female figures of his first Tahitian paintings is to be found in *Three Tahitians* or *Conversation* and in the famous *Two Tahitian Women,* whose subject may have come from a somewhat risqué Parisian illustration of 1885 called *The Apple Seller,*[24] but Gauguin's sensual idealization is to this iconographic source what Baudelaire's

'Flawless fruits innocent of all outrage

Whose smooth firm flesh asks to be bitten into'

could be to a poem by Paul de Kock or Willy. Details like the gold and green splashes of the background recall the Impressionists; others, like the simplification of the blue and pink skirt or the women's shoulders, herald Matisse's decorative rhythms. In two variations on the theme of motherhood he even more powerfully developed his system of rhythmically interlocking areas of colour, always associating non-complementary colours and values: an absinthe yellow surrounds an acid pink, a deep blue accompanies a dark green, and so on.

And yet, while he felt a need for greater freedom, he believed that he lacked the strength and imagination to achieve it. He tirelessly repeated the same subjects of seated women, already borrowed from his photographic repertory during his first stay in Tahiti: Borobudur, Greece, Trajan's Column; whether it was in *The Great Buddha* or the popular albeit somewhat ordinary *And the Gold of their Bodies.*

In 1901 he painted a series of still lifes, each of which was a more or less conscious homage to the European painters he admired: *Still-life with Sunflowers on an Armchair* is obviously inspired by Van Gogh; another version of the same painting in which some of the flowers have been given an eye in the centre is a reference to Odilon Redon. But the best of this series of still lifes is perhaps *Still-life with 'Hope'.* The background in the left corner has two reproductions that Gauguin had pinned to the wall of his hut, one of Puvis de Chavannes's *Hope,* a painting that he much admired and that influenced his own handsome *Te aa no Areois* (*The Seed of the Ariois*) from 1892, and the other possibly a reproduction of a monotype by Degas.

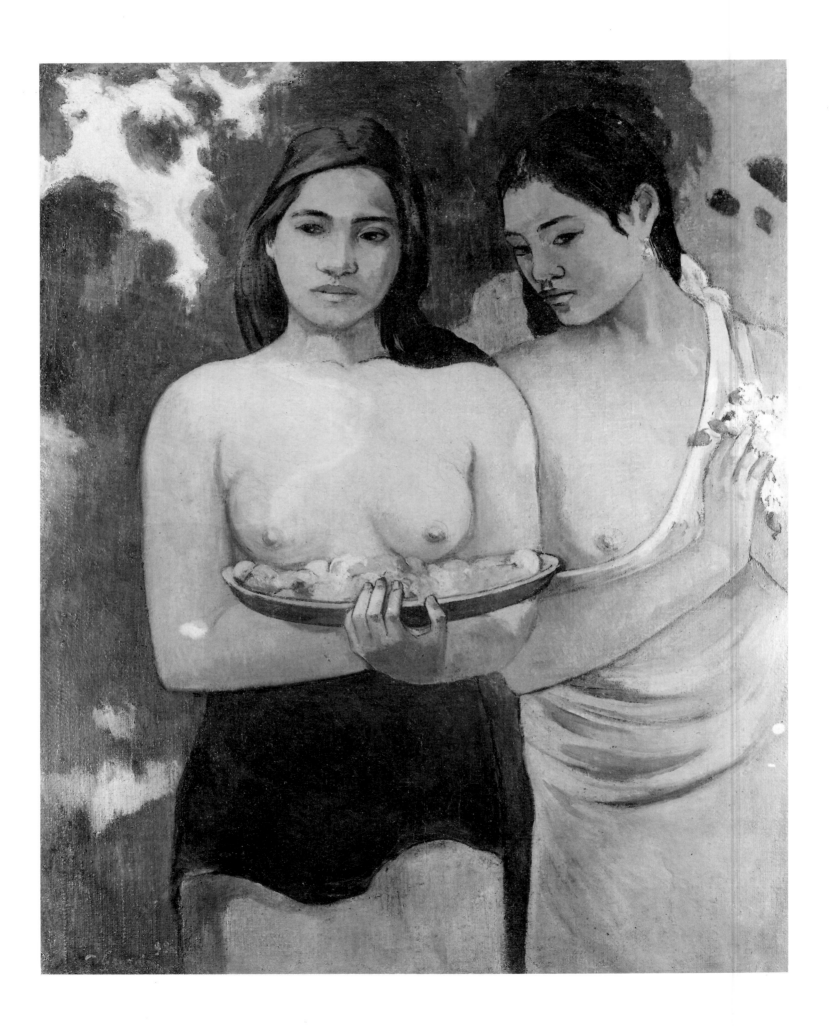

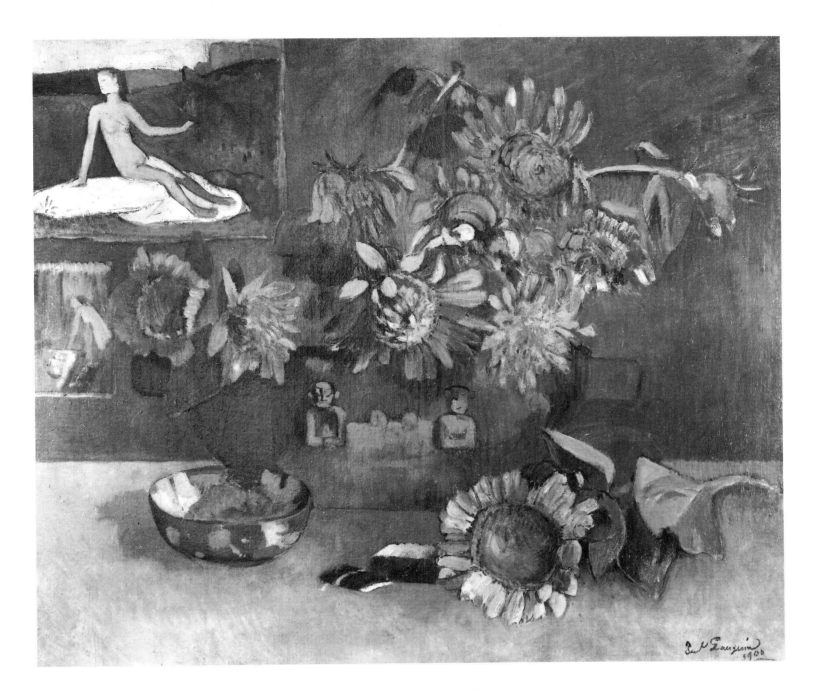

260. *Still-life with 'Hope'*, 1901. Oil on canvas, 65×77 cm. New York, Private Collection.

259. *Two Tahitian Women*, 1899. Oil on canvas, 94×72.4 cm. New York, Metropolitan Museum of Art.

Everything about him at the time betrays the weakening of his imagination and the deepening of his *angst*: 'I am eager for your next letter in which you will perhaps discuss the paintings that I sent you; I'm anxious to know whether I am making a mistake,' and 'there is no real satisfaction to be found except *inside oneself*, and at the moment I disgust myself,'[25] and two months later: 'I am going to be fifty-one, threadbare, worn out; my eyesight is getting worse every day with the result that the necessary energy for this ceaseless struggle is often lacking.'[26]

There is something childish and pathetic about the oft-repeated solutions that Gauguin found for the disarray in his life and painting: to flee in the hope of finding 'yonder', 'elsewhere', in short, further away, what he had been pursuing step by step ever since his first journey to Brittany. This time he was leaving a Tahiti spoiled by Europe for yet another primitive Cythera of lost paradises. Here are the overt reasons, unchanged since Pont-Aven, to which Gauguin's motivations have often wrongly been solely attributed: 'I shall go and live on one of the Marquesas Islands where life is easy and inexpensive,'[27] and 'I am counting on the Marquesas, for the ease with which

one can find models there, something that is becoming harder and harder to do in Tahiti. . . .' But the real reasons soon appeared: 'With the landscapes that I shall find there—in short, things that are completely new and even wilder, I shall produce some good things. My imagination was beginning to cool here.'[28] He wanted to shake it up and put 'new and *terrifying* things' into his painting. Of course he had already thought of leaving Tahiti for less developed islands during his first stay: 'I would have liked to go and work on the Marquesas Islands for it would have been a *great help* to me.'[29] Incidentally, Hivaoa—known as La Dominique at the time—where Gauguin would indeed settle during the summer of 1901, had been mentioned by Pierre Loti in *Rarehu . . .* as a fascinating island where 'cannibalism still holds sway' as opposed to a Tahiti overrun by 'our stupid colonial civilization'.

Gauguin felt renewed hope at the mere idea of coming closer to the primitive and mysterious 'ancient splendour' that had eluded him so far. After his attempted suicide and the years of decline this was to be the source of the painter's last burst of energy, akin to what Rimbaud described thus: 'But just lately, finding myself at my last gasp, I thought to look for the key of past banquets, at which I might find my appetite again.'[30]

261. *Still-life with Sunflowers and Mangoes*, 1901. Oil on canvas, 93 × 73 cm. Lausanne, Private Collection.

In 1898 Gauguin wrote to Daniel de Monfreid: 'I would like you to send me some bulbs and flower seeds. Plain dahlias, nasturtiums, various sunflowers that can stand a hot climate. . . as you know, I adore flowers.' This still life is undoubtedly the result of his Tahitian gardening, painted shortly before he left for the Marquesas in the autumn of 1901. The vase, almost certainly made of wood, looks Polynesian, and the mangoes add an exotic touch to what would otherwise have been a mere homage to the Old World and its artists. Indeed the flower at the top of the picture obviously alludes to those Odilon Redon painted, but above all the sunflowers are a tribute to the memory of Vincent Van Gogh, who had decorated Gauguin's room with paintings of these flowers to welcome him to Arles, and whom Gauguin had in turn asked for one of these typical Van Gogh works as a reminder of his stay with him.

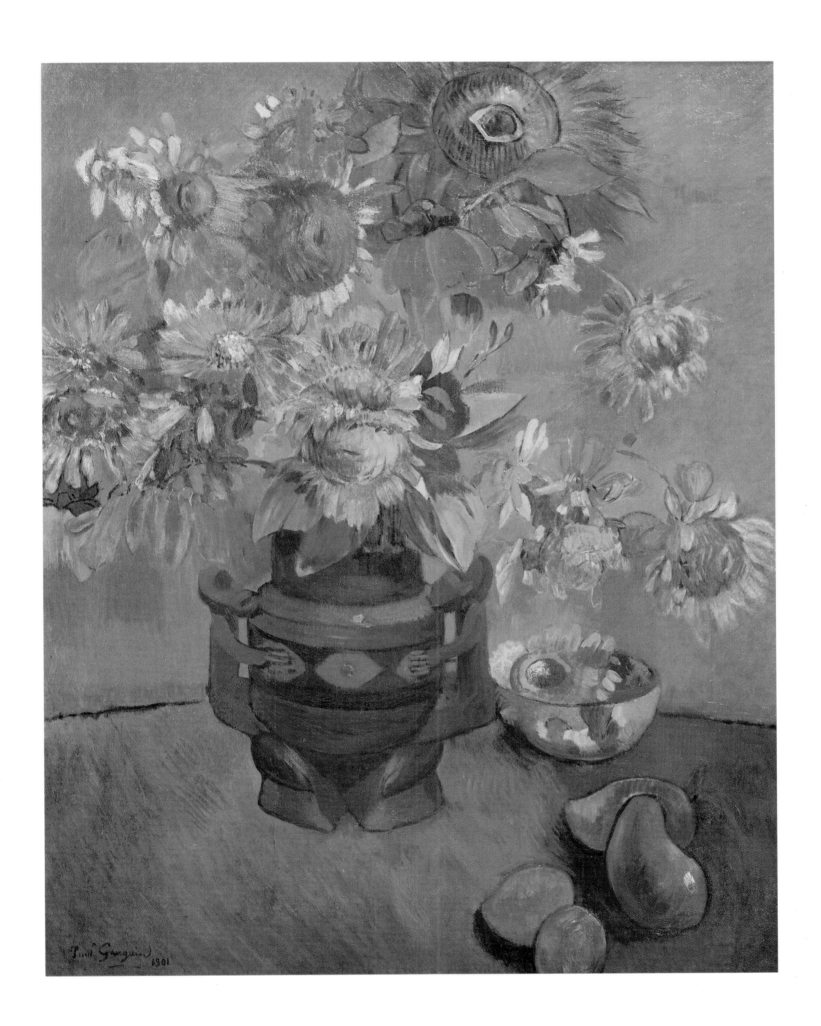

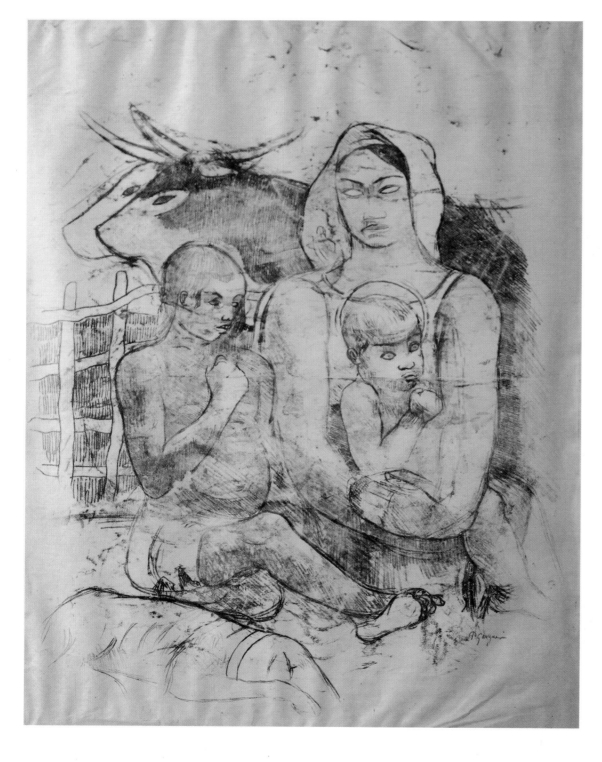

263. *The Hut*, c. 1900. Monotype enhanced with crayon, 58×44 cm. Paris, Private Collection.

This superb monotype is a good example of Gauguin's classicism because of its elaborate composition—a large triangle whose apex is the curtains and whose base is the woman's stretched-out leg—and the pure lines of its drawing (we know that Gauguin esteemed Ingres). But the simplification of the forms and the mixed technique (monotype, line, wash) situate this work among the pictorial experiments of the turn of the century, reminding one of the young Picasso's pre-Cubist drawings.

The scene is drawn from life, and seems to be taking place on a veranda covered in mats, like *The Siesta* (fig. 164). Two Tahitian women are ironing their laundry on the floor. The one facing us with her *pareu* knotted under her naked breasts is holding a charcoal iron in her left hand; the other one with her back to us appears to be using a similar iron with both hands; Gauguin structured the entire composition from her outstretched left leg up to her right knee. In the foreground a cat suckles her kittens. The overall impression is of a calm and welcoming domesticity.

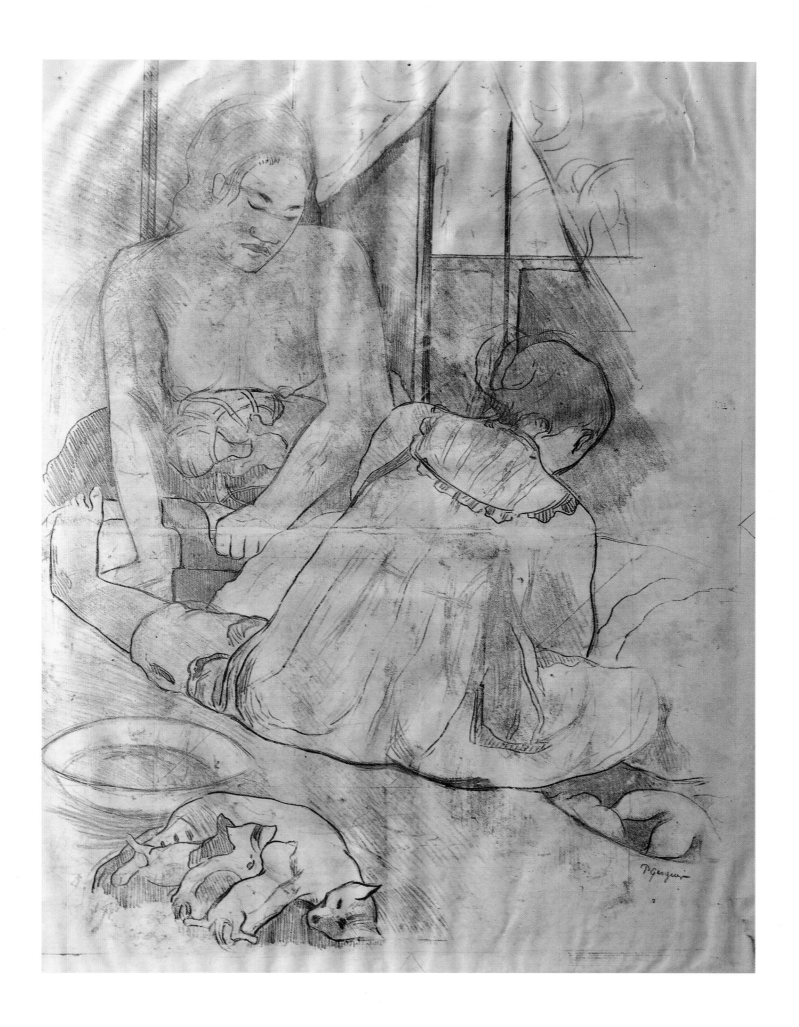

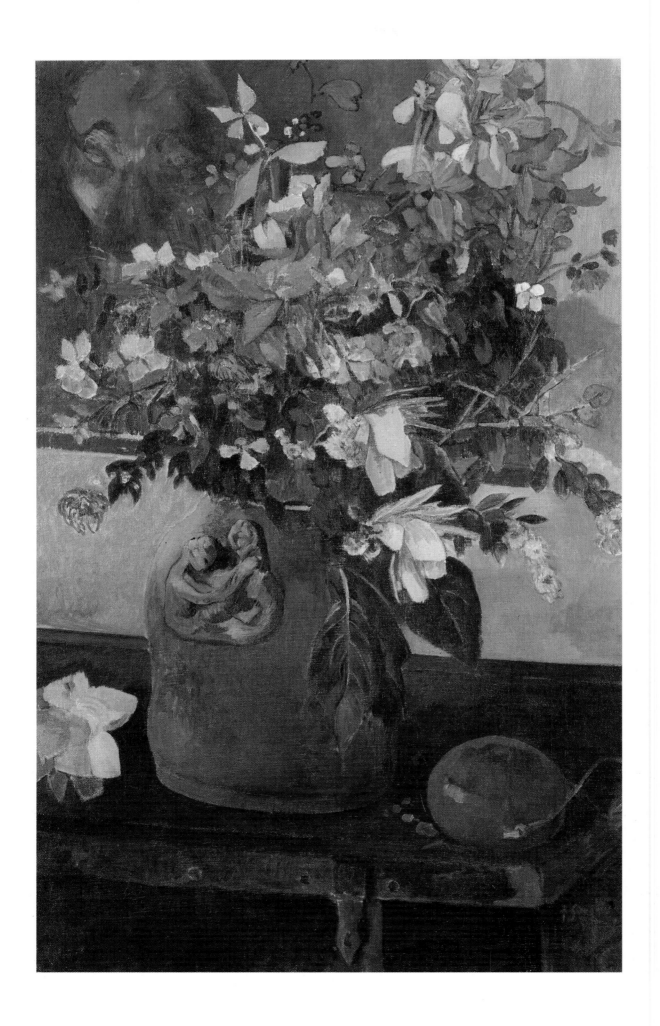

'THE RIGHT TO DARE ALL'

1901-1903

264. *Still-life with Bouquet of Flowers*, c. 1900-1901. Oil on canvas, 95×62 cm. London, Private Collection.

Ambroise Vollard asked Gauguin to paint still lifes of flowers since they were probably easier to sell. Gauguin replied that he had very few: 'This is because. . . I do not paint from life—even less nowadays than I used to. All my creativity stems from my wild imagination, and when I'm tired of painting figures (my favourite subject), I begin a still life that I finish without a model. Also, this is not really a place that grows many flowers' (Tahiti, January 1900). Nevertheless Gauguin did paint—and definitely from nature—a bunch of coloured leaves interspersed with a few pink oleanders in a ceramic pot. The pot itself could easily be one made by himself, judging by the medallion of the embracing couple, like the one in his woodcarving *Te Faruru* (To Make Love). We know that many of the objects that he made to decorate his last home have since disappeared.

As he said to Vollard, after the initial observation from life, he added some unusual imaginary details to the painting, like the face that appears at the top left corner, which could be a sculpture, a neighbour passing by outside a window, the painter's face distorted by a mirror, or the frightening arrival of a *Tupapau*.

Adieu voyage, adieu sauvage.

Claude Lévi-Strauss.

At Hivaoa, in the Marquesas Islands, where he landed in the autumn of 1901, a new feeling of security gave Gauguin the peace of mind that he had long complained of having lost and that he needed in order to work[1]. However, he spent the best part of the life remaining to him indulging in various excesses, not least of which was a penchant for petty disputes and a pugnaciousness that he generously employed on behalf of the 'natives', who loved him for it. Sadly this energy was more often than not out of proportion to the results in his quarrels with the local officials and priests: 'I have to put up a terrible fight here in the Marquesas against the local administration and the police.'[2] He also wrote a great deal: a work that became *Avant et Après*, his memoirs and artistic manifesto, and another called *Racontars de rapin*, which is more interesting for what it tells us about the painter's state of mind at the end of his life than for what it contributes to the history of painting.

Isolated in a harsher landscape on an island that was more primitive and considerably poorer than Tahiti, he could not but have felt a degree of defiance and despair when he christened the hut that he built 'the house of pleasure'.[3] 'The animal nature in us all is not as despicable as they say. Those diabolical Greeks, who understood it all, dreamed up Antus, who renewed his strength by touching the soil. The earth is our animality, believe me,'[4] he wrote.

Whether it was due to Hivaoa's soil or the adolescent girls who lived on it, Gauguin did indeed recover the energy to produce some of his finest works before he died. They were the most liberated paintings of his career, and the least encumbered with Symbolist intentions for, by the time he settled in the 'flowering tomb' of the Marquesas Islands, he had slowly but consciously divested himself of their ideology. Although he painted canvases such as *Primitive Tales*, in which a Polynesian-looking Buddha is bizarrely associated with Meyer de Haan's portrait, he produced many more whose subject is purely 'the gold of their bodies' and the celebration of a lavish nature inhabited by unpolished and ingenuous beauties, in which no traces of literature can be found. He wrote to Monfreid, saying: 'You know my opinion of all those wrong ideas from Symbolist literature and the like on painting. I need not repeat myself since we agree on the subject—posterity also agrees, since healthy works survive unaltered regardless of all the critico-literary lucubrations in the world.'[5]

Judging by his writings and paintings, Gauguin was confident of his abilities once more—at a time when he had apparently abandoned all hope. For example, his defence of those Tahitian paintings that had been so badly received during his last stay in Paris shows just how aware he was of what he was doing. They had been criticized for their lack of depth and modelling, but: 'any linear perspective would be meaningless. In order to suggest a luxuriant and unruly nature and a Tropical sun that sets fire to everything it touches, it was essential to give my figures an appropriate background. It is indeed life in the *open air*, but its forms are nonetheless intimate,'[6] which is to say that he aimed at achieving an Impressionism that was remodelled by Symbolism without being destroyed by it. It could be said that Gauguin was rejecting literature, and it is significant that he abandoned his Maori titles as exotic symbols that he no longer needed. He painted only for his personal pleasure or glory, though he suspected that any glory would be posthumous.

This may account for the simplicity, strength and grace of his last paintings, a grace he had so far resisted in his horror of 'the pretty' but which he could not help associating with grace of another sort, a metaphysical one that he attributed to the natives, the heirs of a lost truth. *Woman with a Fan* was painted from life, for the photograph reproduced here was taken while Gauguin worked.[7] The absolutely plain background, the spontaneity of the pose and the light modelling of the face make this one of Gauguin's most natural works, and he quite unaffectedly achieved 'that indescribable something that is ancient, solemn and religious in their gestures and unusual immobility. In their dreaming eyes, the clouded surface of an unfathomable mystery'[8] he had so often tried to capture. We find this same inscrutable, melancholy, animal-like stare in *Portraits of Women*, this time painted from a photograph, and the same slow gestures in *The Call*. In this last painting the central figures, undoubtedly drawn from

265. *Primitive Tales*, 1902. Oil on canvas, 130×89 cm. Essen, Folkwang Museum.

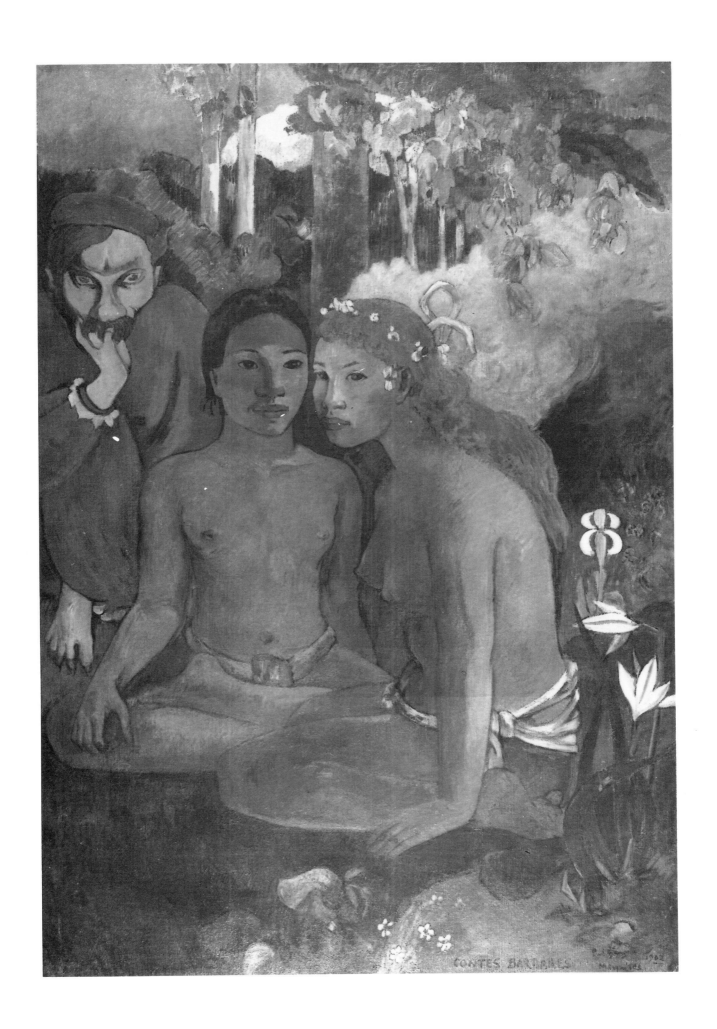

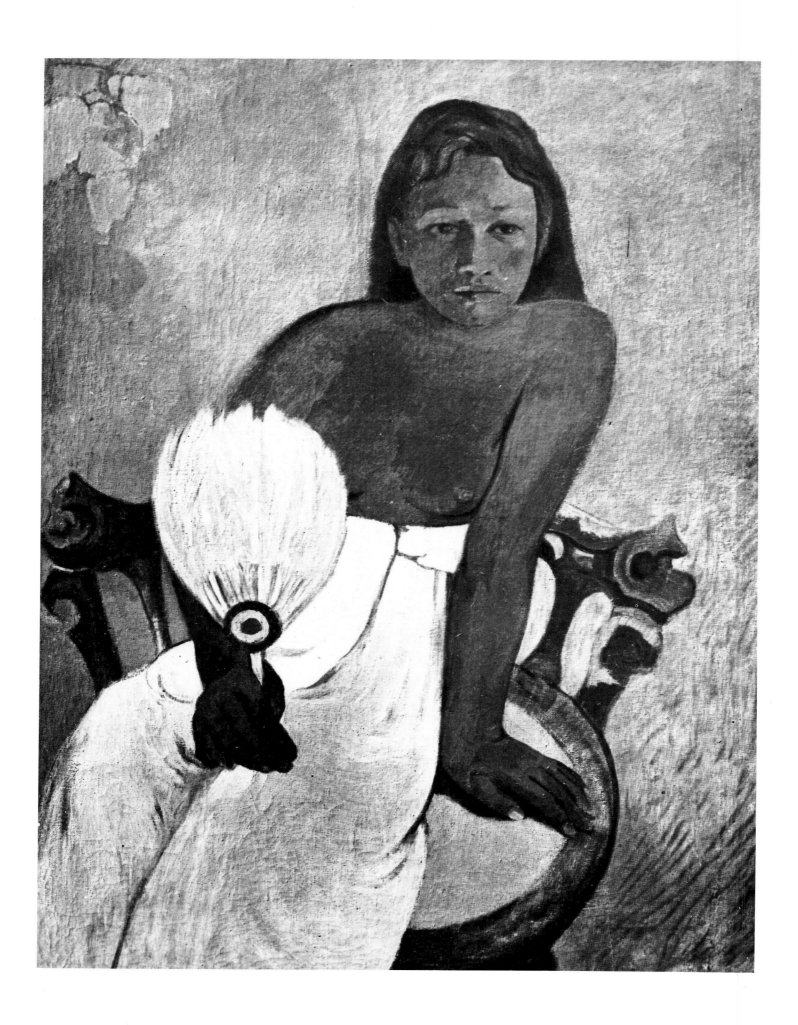

266. *Woman with a Fan*, 1902. Oil on canvas, 92×73 cm. Essen, Folkwang Museum.

267. Gauguin's model posing for *Woman with a Fan*. Photograph.

268. *Two Women.* Photograph.
B. Danielsson Archives.

269. *Portraits of Women,* 1901-1902?
Oil on canvas, 73×92 cm. Palm
Springs, Private Collection.

a frieze from the Parthenon, were his last homage to 'those diabolical Greeks, who understood it all' and to Puvis de Chavannes. Gauguin wrote at the time that Puvis de Chavannes 'crushed him with his talent' but he added, however, 'Each to his own age.'[9] In reality this strange harmony in pinks, reds, mauves and oranges is closer to the future Matisse and to a whole facet of German Expressionism than it is to the powdery compositions of the painter of *The Sacred Wood*.

The impressive series of *Riders on the Beach*, of 1902, the strangest of which is perhaps the one in the Essen Museum, must be counted amongst Gauguin's most handsome, free, even modern paintings, despite all they owe to Degas's paintings of the races.[10] These horsemen whose backs we can see leaving the stage, as their creator was soon to do, could be said to be making way for the entrance of Picasso's Rose Period acrobats two years later, for they have the same sad nonchalance and brushwork. While he used exactly the same poses as Degas's jockeys concentrating on their nervous mounts, and placed the same undefined open space around them, the atmosphere is relaxed, timeless and detached; he evoked a kind of soft wildness with purely formal techniques that lend the painting a modernity that almost surpasses that of Picasso's expressively sentimental Rose Period.

During his second stay in Tahiti, and particularly in Hivaoa from 1902 to his death in May 1903, Gauguin was definitively cut off from that artistic world whose muffled sounds reached him only through Monfreid's and Fontainas's letters. Everything he wrote or painted articulated an already familiar idea that was to become obsessive: the will to freedom in art. As if he knew he was about to die, he reviewed his life

270. *Rider*. Monotype, 50×44 cm. Paris, Musée des Arts Africains et Océaniens.

271. *Riders*, 1901. Oil on canvas,
73×92 cm. Moscow, Pushkin State
Museum.

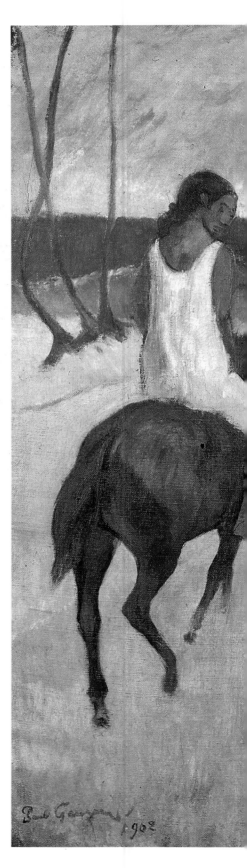

272. *Riders on the Beach*, 1902. Oil on canvas, 66×76 cm. Essen, Folkwang Museum.

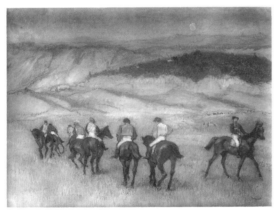

273. Degas, *Before the Race*, detail. Pastel, 50×63 cm. Location unknown.

274. *Riders on the Beach*, 1902. Oil on canvas, 73×92 cm. London, Private Collection.

In 1902 Gauguin painted two versions of a ride on the same bright pink beach in Hivaoa where the sand is heavily coloured by coral dust. This one is the largest and most finished of the two. The influence of the paintings of races by his beloved Degas is evident, but the woman in the shift on the left and the young bare-chested Marquesan on the right appear to be drawn from life. In any case this kind of bareback race must have taken place frequently on Hivaoa: there were more horses on the Marquesas Islands than in Tahiti, where they were mainly used for carriages. This kind of 'primitive' scene could hardly have displeased Gauguin.

On the other hand the galloping figures on grey horses in the upper right corner were imaginary. Despite their brightly coloured red and yellow clothes, they remind one of hooded *Tupapaus*, like the one in *Manao tupapau* (*The Spectre Watches over Her*) (fig. 190). We know how much Gauguin liked to associate his paintings with myths: they are at once 'horsemen of the Apocalypse'—he had stuck an engraving of this subject by Dürer into *Noa Noa*—and Maori demons. He had already portrayed a similar hooded rider in a monotype evocatively called *The Nightmare*. This mixture of artistic memories, observations from life and inventions is typical of Gauguin, who combined his sources with great naturalness into a robust composition that is at once realistic and permeated with mystery.

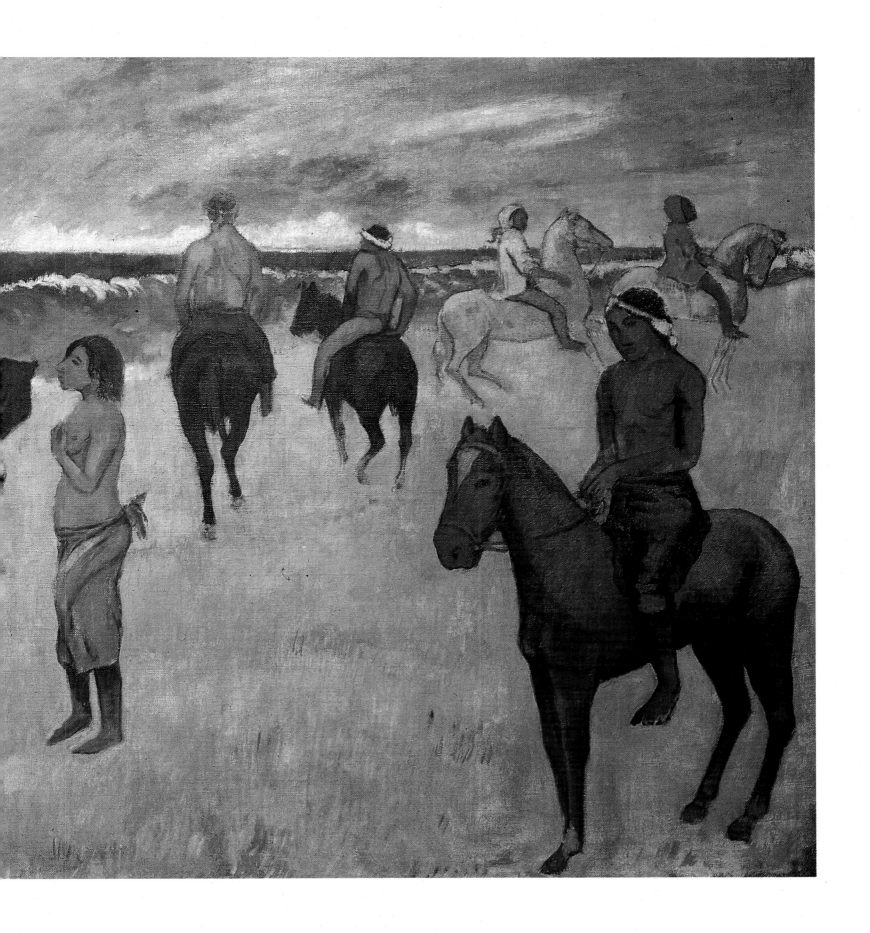

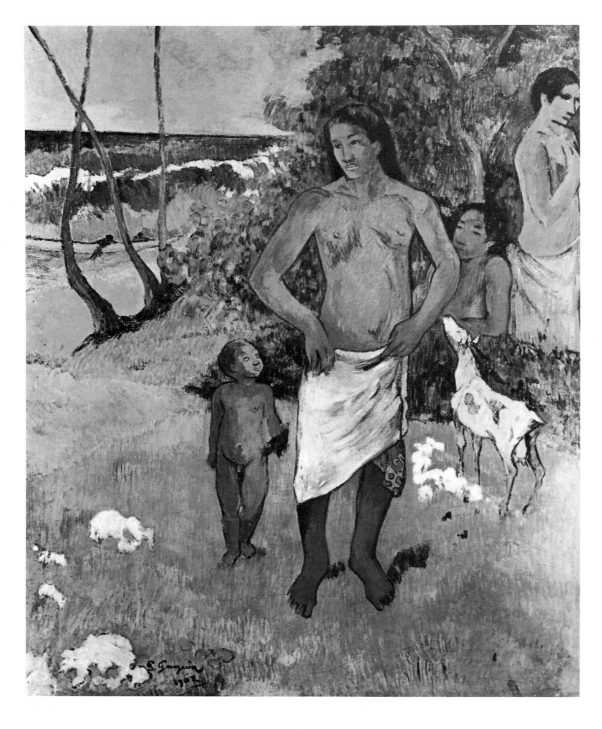

275. *Bathers*, 1902. Oil on canvas, 73×92 cm. Private Collection.

276. *Still-life with Apples and Flowers*, 1901-1902. Oil on canvas, 66×76 cm. Lausanne, Private Collection.

This still life owes its brilliance to Gauguin's unique qualities both as a painter and a colourist. Apart from the arrangement of objects according to the relationship of colour and form, its simplicity and lack of stage management hark back to the beginning of his career, when he was under the influence of Cézanne. There is not a touch of Symbolism, not the slightest reminder of Redon and no apparition like the one we find in *Still-life with Bouquet of Flowers* (fig. 264).

Spread over a trunk that he used elsewhere (see fig. 264), the white table-cloth has Cézanne-like folds, and the bowl of green fruit also evokes his work. Like the best of his Breton still lifes (figs 68 and 120) this one suggests an exotic gourmandise in its opposition of oranges and reds to the pink oleanders and the vermilion peppers placed artlessly in a black rimmed earthenware bowl. The splendid shimmering yellow background gives this simple picture of fruit and flowers the aura of a religious painting with a gold background, conferring a touch of nobility and munificence on this Marquesan 'offering'.

and work in an attempt to justify them, writing endlessly of his courage, the only one of his qualities he was sure of: 'I willed myself to will', and very little about his genius, that he no longer really believed in when he compared himself to the painters of the past: 'I enjoy imagining what Delacroix would do had he been born thirty years later and undertaken the struggle that I have dared to undertake. With his luck and above all his genius, what a Renaissance would be taking place in art today.'[11]

Nevertheless, Gauguin was fully conscious of being an intermediary in a period of evolution, a go-between at a decisive moment in the history of painting. Wrapped in his profound and final solitude, he sensed that he shared or even anticipated the concerns of the younger generation of painters, those about whom he said: 'It is no coincidence that a whole new generation has arisen who amaze us with their intelligence and the variety of their art, and appear to be solving problems daily that we

had never even dreamed of.'[12] He harped on his role as a Messiah and moral leader, stating that 'I know *I am right* insofar as art is concerned, but have I the strength to put it across in a positive way? In any event I shall have done my duty and if my works do not survive, there will always be the memory of an artist who freed painting from many of its outdated academic and Symbolist constraints.'[13] Curiously enough for someone so steeped in spiritualism and tradition, he saw himself, like the turn-of-the-century positivists, from a historical perspective: believing in the progress of sensibility, in an 'avant-garde' that would take up the accomplishments of the previous generation and carry them further: 'What matters to me is what there is today, for it will lead the march of the twentieth century,'[14] and elsewhere he advised young artists to 'tackle the strongest abstractions' and 'vanquish timidity, regardless of how much ridicule might result from it.' Despite all this, Gauguin sensed that he himself had not achieved that freedom, of which he wrote as if handing down a magic formula, either in his own life or even to a certain extent in his painting. Although he lived in the Pacific, he was the product of that European art that he himself had helped

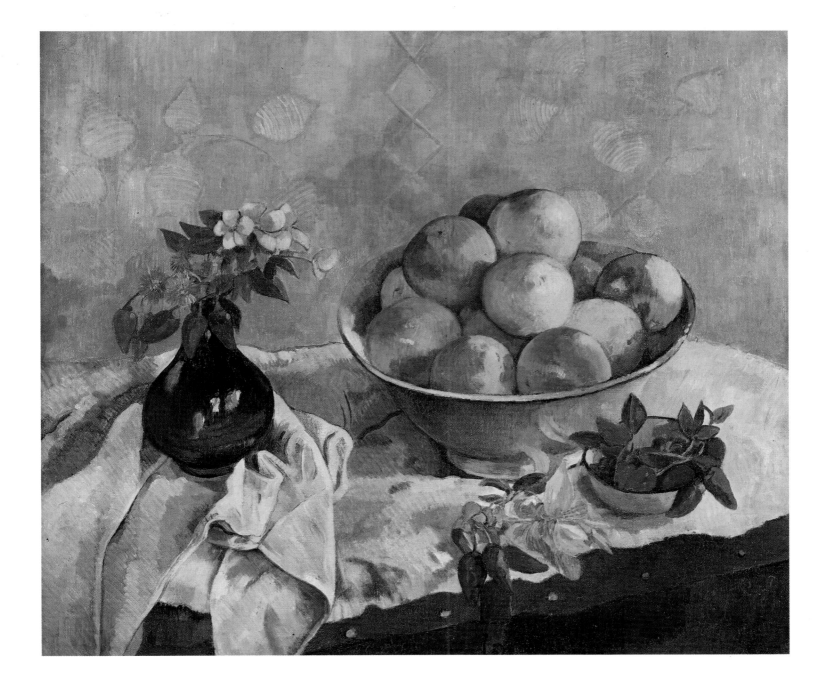

277. Sketch of Gauguin's Hut done by Le Bronnec after a drawing by Tioka's nephew, who often visited Gauguin (published by the *Gazette des Beaux-Arts* in 1956).

278. Lintels from '*The House of Pleasure*', 1902. Carved and painted redwood (five lintels/jambs: L: 2.44 m; vertical jambs: L: 2m and 1.60 m; bases: L: 2m). Paris, Musée d'Orsay.

At Atuona, in Hivaoa, Gauguin was at last able to build the large studio-hut that he had been dreaming of for so long (fig. 277). One entered by an outside ladder into a bedroom on the first floor that led to the studio. Victor Segalen, who saw it shortly after Gauguin's death, described 'this well-constructed, raised-up Marquesan hut with its large roof of plaited Pandanus leaves. Up there, on the lintel over the front door was the entrance motto.' The five reliefs surrounded the outer part of the door in the style of a number of Maori houses from which Gauguin took his inspiration, as can be seen in a photograph discovered among his papers after his death.

The standing female nudes on either side lift their arms as though they were hold-

ing up the lintel and welcoming the visitor. On the plinths to the right and left two reliefs were given the same titles as the Breton woodcarvings made twelve years earlier: *Be Mysterious* and *Be in Love and You Will Be Happy* (figs 133 and 137). They also contain a number of familiar motifs—faces, animals—belonging to his Polynesian paintings, as if he were cataloguing fifteen years of work.

The provocative motto brings to mind what Gauguin once wrote in this same house: 'Nail an obviously indecent thing above your door and you will be rid of honest people, the most insufferable in God's creation!' (*Avant et Après*).

to form, and, regardless of what he said, he remained pathetically attached to a Symbolist Paris that no longer existed and to that Old World that he had so obstinately tried to escape. The last manuscript by the man who signed his letters to his friends 'we others, the natives of the Marquesas' ends with a declaration of the good and loyally patriotic services rendered by his brother painters and himself: 'Here, in my opinion, is something to console us for the loss of our two provinces [Alsace and Lorraine], for we have conquered all Europe with it, and, especially recently, we have used it to create freedom in the visual arts.'[15]

What Gauguin had sought from the beginning in Japanese, Indonesian and Peruvian art, and finally in the Maori civilization in the Pacific, and which was not unrelated to Ruskin's rejection of the modern world and an industrial civilization, was an ultimate primeval freedom. Hivaoa finally put an end to what we could term this misconception, for it was there that he came the closest to true primitive art: he discovered one of the rare surviving Polynesian artefacts, a large stone Tiki in a valley on the island, and copied it as he had copied Marquesan decorations for the illustrations of *Noa Noa* and *L'Ancien Culte Mahorie*.[16] But the use he made of all this was purely decorative, like the colonially 'barbaric' pastiches carved on the lintels of *The House of Pleasure*. And yet Gauguin was the first to explore this field and it is obvious that the German Expressionists, and Matisse, Picasso and Derain before them, owed their discovery of African art in great part to him. Incidentally, this discovery was made in 1906, a year that in Paris could be called 'the Gauguin year' because of the major retrospective comprising 227 of his works at the Salon d'Automne: this is probably not a coincidence, for a few years earlier Gauguin said prophetically that 'you will always find mother's milk in Primitive art.'[17]

And yet Gauguin played an essential part in his successors' discovery of primitivism only because of a misunderstanding. For him primitive art was an emotional stimulus rather than the renewal of forms it was for them: 'Another age, whose scent of extasy I inhale in the present'[18] he said of Tahiti after having approached Brittany with the sensitivity of Pierre Loti, who saw it as 'a land utterly steeped in a feeling of the past'.[19] Such an incredibly romantic view of the primitive brings Gauguin closer to Loti than to the Picasso who painted *Les Demoiselles d'Avignon*. Also, for Gauguin as for the critic Albert Aurier, the word *primitive* covered 'every school and every period in which art was still purely traditional and unsullied by sacrilegious desires for realism and illusionism'.[20]

Lastly, the primitive stood for original good, the gift of the gods, grace and all that cannot be learned: 'In a man's work' there are 'two kinds of beauty, one that is instinctive and another that can be learned'.[21] The primeval part of an artist, the one he possesses in spite of himself, the one that learning, culture or his artistic development cannot alter, is that innate beauty, that lost grace of which only creative or primitive man has the secret. In his last letter to Charles Morice written less than a month before he died, he paradoxically quoted Raphael, the prime example, the 'canon' of academic art: 'Raphael's extreme skill doesn't daunt me, nor does it stop me from feeling or understanding his primordial quality—that instinct for the Beautiful—for a moment. Raphael was born beautiful. Everything else about him was merely alterations.'[22]

Raphael was born beautiful; Gauguin's quasi-religious conviction is terribly moving. In this one sentence he expressed all of his aristocratic individuality: there are indeed some painters who possess grace!

And he knew it—this may be one of the clues to that deep sadness inherent in Gauguin's art, a sadness that increased throughout his development until it became almost the dominant aspect of his work: Gauguin the painter was not 'born beautiful'; if he became so, it is precisely because of the 'alterations' of which he spoke; that is to say the striving, the learning, that painful, anxiety-ridden conquest of freedom, his meticulous search for the primeval, for a lost paradise of form that he was never sure he had really found. Throughout his life, partly due to his literary pose and overwhelmingly candid romantic 'self', and partly due to a very real intuition about the artistic problems of his epoch, Gauguin earned what he called 'the right to dare all'.[23] His

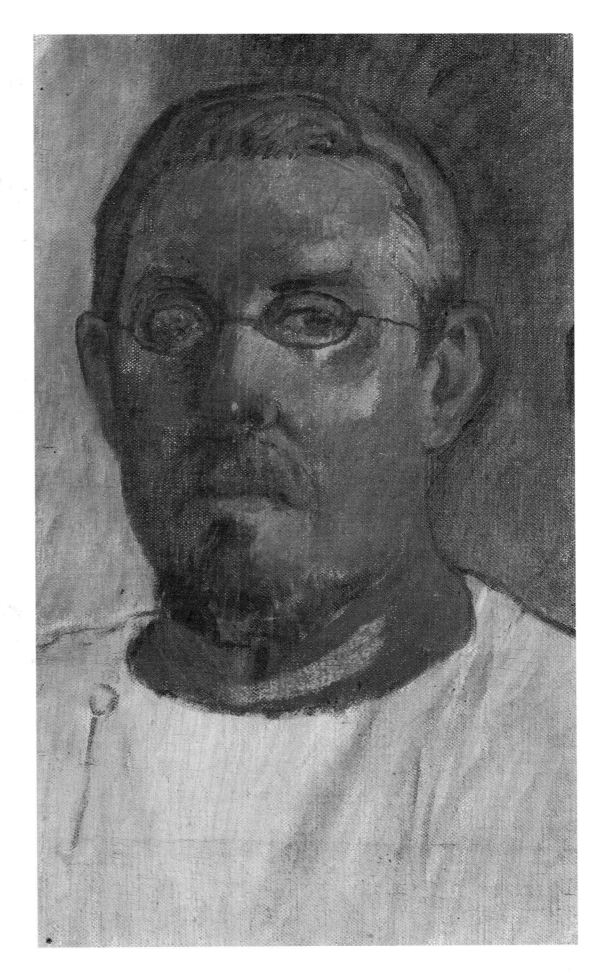

279. *Self-portrait*, 1903? Oil on canvas mounted on wood, 42×45 cm. Basel, Kunstmuseum.

This portrait must be the last in the long series that Gauguin did of himself throughout his life. Like most of them, it was given to a close friend, in this case the person who took care of him during the last few months of his life. Ky Dong, a young Annamese exiled to Hivaoa, was a 'rebel', and this could not have failed to endear him to Gauguin. In this last moving self-portrait, the painter abandoned all posturing, façade, disguise or statement. He is no longer the Impressionist Jean Valjean (fig. 72), nor the Modernist Christ (fig. 122) nor the hooknosed Inca of Le Pouldu (fig. 108); he is simply a worn-out man who has dropped his masks and gazes from behind his reading glasses with the directness and abnegation of the last self-portraits by Chardin or Bonnard. 'All my former energy is leaving me bit by bit,' he wrote in his last letter to his faithful friend Monfreid less than a month before he died, around the probable date of this touching self-portrait.

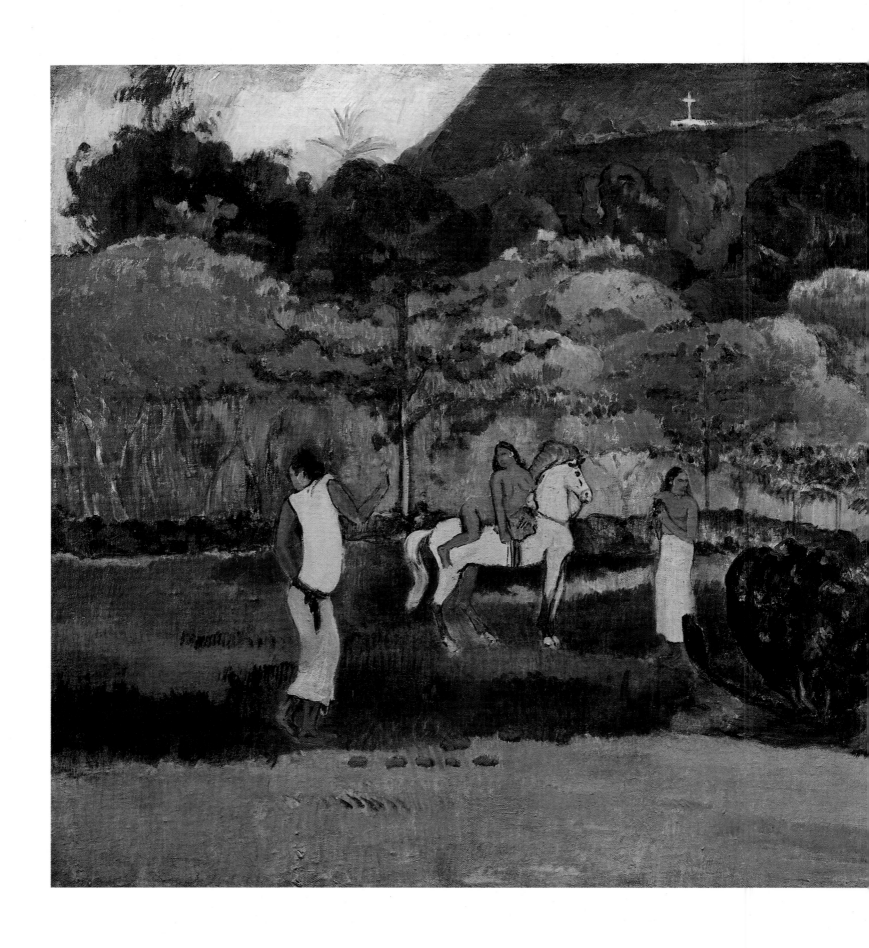

anxiety gave his painting a melancholy and splendour that were both naïve and morbid, whether he painted Brittany or the South Sea Islands. His decorative impulses and Symbolist concepts luckily never quite succeeded in suppressing these qualities. But Gauguin fully realized the revolutionary implications of his half-understood pictorial freedom: 'The painters who take advantage of this freedom today owe some of it to me.'[24] A few months before he died on 8 May 1903, he could justifiably say, as if he were handing down that 'flight forward' he had taken in his own artistic and personal life to modern art, 'The machine is up and running.'[25]

280. *Women and White Horse*, 1903. Oil on canvas, 73×92 cm. Boston, Museum of Fine Arts.

Gauguin painted very little during the last few months of his life: there are four dated canvases; this one is perhaps his last. It features a superb landscape in Hivaoa with great mountains descending abruptly into the sea and lush, flamboyant vegetation. The three figures are taken from earlier paintings; the only change Gauguin made was to mount the little naked woman on a white horse instead of the black one she rode in *Change of Residence* (Stockholm, National Museum of Fine Arts), painted the year before. The white cross at the top of the hill that so strangely suggests a tomb only a few weeks before the artist's death, is in fact the Atuona Mission roof. Notwithstanding its colourfulness, this painting is saturated with the melancholy of the manuscript that Gauguin was in the process of finishing, *Avant et Après*: 'Outside my window, here in the Marquesas at Atuona, everything is growing dark, the dancing is over, the sweet songs have died away. . . .'

281. Card announcing Gauguin's death. Private Collection.

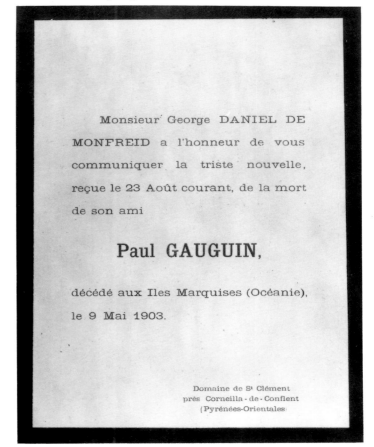

Monsieur George DANIEL DE MONFREID a l'honneur de vous communiquer la triste nouvelle, reçue le 23 Août courant, de la mort de son ami

Paul GAUGUIN,

décédé aux Iles Marquises (Océanie), le 9 Mai 1903.

Domaine de St Clément
près Corneilla-de-Conflent
(Pyrénées-Orientales)

282. *Self-portrait*. Drawing. Private Collection.

FROM WAGNER
TO MATISSE

The machine is up and running.

Gauguin.

Ever since Cézanne, then painters such as Matisse, Bonnard, Kandinsky and even to some degree Picasso, we have tended to associate pictorial revolutions with artists who put their art before their lives. Gauguin's romantic life, his bombast, his inordinate liking for 'literature' that was often in bad taste, and the unequal quality of his paintings that almost always owed something to another artist or to a different civilization, made the 'connoisseurs' suspicious of his work. At the beginning of the twentieth century most critics would have agreed with Élie Faure's condemnation of Gauguin: 'The strong man . . . has no need to flee the city, to go live, with Gauguin, among the primitives of today. . . to build burning landscapes whose tense, disoriented sensuality fails to mask their deficiencies and want of vigour, and that stop short before the façades of Cézanne's buildings.'[1] The painters who could be said to have taught Gauguin his trade judged him with equal severity, even going so far as to deny him any painterly qualities at all. Gauguin's rejection of modelling and spatial structure drew this comment from Cézanne: 'Gauguin was not a painter, he merely produced Chinese puzzles,'[2] and Pissarro, always suspicious of Gauguin's eclecticism, said that 'his fundamental nature is anti-art, and is more drawn towards juggling with knick-knacks'.[3]

On the other hand, at one time or another Gauguin was the 'great artist' incarnate for most of the younger painters. For the Nabis he was 'the unchallenged master, whose paradoxes we gladly accepted, whose talent, gift for conversation, gestures and physical strength we admired—as we did his practical jokes, his inexhaustible imagination, his head for alcohol and his romantic appearance. The secret of his ascendancy over us lay in the one or two ideas that he passed on to us: they were utterly simple in their truth, and absolutely essential at a time when none of us had any training,'[4] except that for Bonnard, it was the sensitive and 'painterly' aspects of his Tropical Impressionism of 1887 and 1888 that counted, and not Gauguin's ideas.

283. Pablo Picasso, *Life* detail, 1903. Oil on canvas, 197×127.5 cm. Cleveland Museum of Art.

284. *Where Do We Come From? What Are We? Where Are We Going?* detail, 1897. Oil on canvas, 139×374.5 cm. Boston, Museum of Fine Arts.

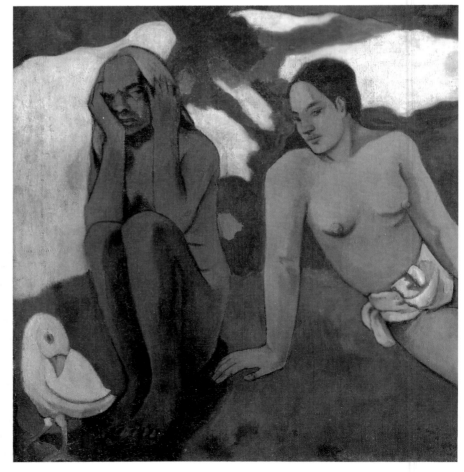

A few years later, it was Picasso's turn to be attracted to Gauguin's painting. When he visited Paris in the autumn of 1900—finally settling there in April 1904—he could have seen the newly painted works from the Marquesas Islands as they arrived at Ambroise Vollard's gallery. Picasso was evidently impressed by *Where Do We Come From? What Are We? Where Are We Going?*, for a number of his paintings were influenced by it, particularly *Life*, in which he reproduced the crouching figure from Gauguin's masterpiece, as if the two painters were united in a decorative Expressionism by the same emotional Symbolism of the destiny of Mankind.

If not Gauguin, then who else at that time provided such a straightforward example of expressiveness, not just in subject matter but in line and colour? After Steinlen and Toulouse-Lautrec, it was surely Gauguin who contributed to Picasso's abandoning his Montmartre Expressionism in 1905 in favour of a more universal sentimentality and sensibility.

Picasso might have lingered over two portraits by Gauguin among the other souvenirs dating from his compatriot Paco Durio's friendship with the painter in 1894, during Gauguin's final sojourn in Paris. In these portraits Gauguin coupled a powerfully pictorial rhythm with great emotional intensity. One of them was the portrait of his mother, Aline Chazal—whose face Gauguin gave to his first Tropical Eve—painted after a photograph, and the other an excellent *Head of a Breton Woman*, with sharp eyes in a somnolent face, whose expression and large areas of flat colour Picasso imitated to different ends in his portrait of Gertrude Stein in 1906.

During the same period Matisse abandoned his Neo-Impressionist style to begin producing paintings like *La Joie de vivre* of 1905, which were both decorative and mythical, echoing Gauguin's Tahitian works without their turn-of-the-century Symbolism.

Matisse's appreciation of Gauguin's work went as far back as 1898, when he bought

285. Pablo Picasso, *Gertrude Stein*, 1906. Oil on canvas, 100×81 cm. New York, Metropolitan Museum of Art.

286. *Head of a Breton Woman*, 1894. Gouache on cardboard, 27x36 cm. Private Collection (Ex-Paco Durrio Collection).

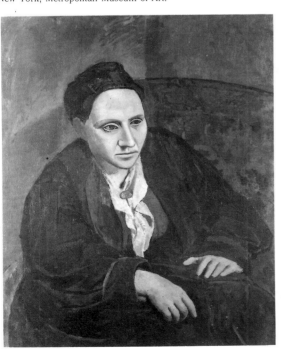

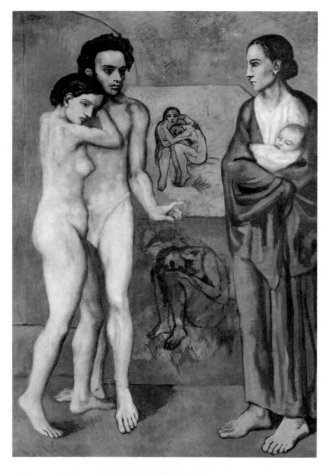

287. Pablo Picasso, *Life*, 1903. Oil on canvas, 197×127.5 cm. Cleveland Museum of Art.

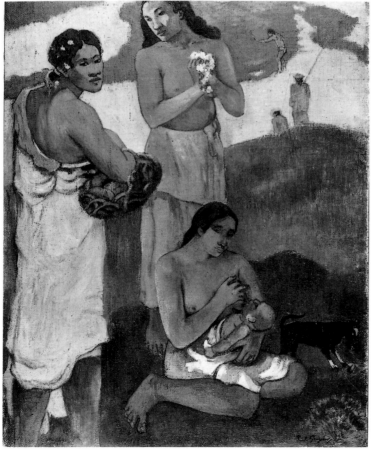

288. *Women at the Seaside*, 1899. Oil on canvas, 94×72 cm. Leningrad, Hermitage Museum.

290. *Oviri* (Savage).
Monotype, 29×20 cm.

289. Pablo Picasso, *Les Demoiselles
d'Avignon*, detail, 1907. Oil on canvas,
245×235 cm. New York, Museum of
Modern Art.

one of Gauguin's most intensely simplified portraits from Vollard: it was one of his earliest Tahitian paintings, *Young Man with Flower*. The wicked archaism of some of Matisse's paintings, their flat areas of outlined colours, like his *Marguerite* of 1906 that once belonged to Picasso, are unambiguous reminders of Gauguin's Pont-Aven painting, particularly his 1890 *A Monsieur Loulou*.

Besides Gauguin's decorativeness, his technique of flat, interlocking coloured shapes and his total disregard of the accepted view of space in favour of an entirely new kind of flat-space—that of the canvas's surface—which began with *Still-life with Three Puppies* in Pont-Aven and ended with the nudes painted in the Marquesas Islands, he was also the first to paint those 'primitive' forms that appear in the work of the painters who followed him. Modigliani, for instance, partially discovered his own taste for the archaic and the arabesque when he reached Paris and saw the 1906 Gauguin retrospective. But more than any other painter it was Henri Matisse who truly developed the brilliance and intelligence of Gauguin's rhythms. Matisse's paradisiacal themes—*La Joie de vivre*, the series called *Luxe*, *La Danse*, etc.—were a modern version of Gauguin's exotic Symbolist Eden. 'Lagoons, are you not one of the seven wonders of the painter's paradise?'[5] Matisse wrote at the end of his life, long after he had broken away from the painter of Tahiti. But here again there is a sort of misreading of Gauguin's art.

Gauguin's Eden was a melancholy Eden. The vividness of his detail underlined the mute anxiety that, from Brittany to Hivaoa, bathed the decorative rhythms of his paintings in sadness. A gracious world oppressed by a feeling of suffocation: this perhaps best describes the special beauty of Gauguin's art, better than the mystery he wished to convey. Pictorially speaking the charm is the same: pure painting from the imagination, often achieved through sometimes unwieldy techniques and a craft that was as laboured as it was sophisticated. Perhaps no other painter strove quite so systematically for artistic 'freedom', nor gave the impression of achieving it at the cost of so much effort. Gauguin's unending struggle to find a completely personal style was

291. *A Monsieur Loulou*, 1890. Oil on canvas, 55×46 cm. Merion, Barnes Foundation.

292. Henri Matisse, *Marguerite*, 1906-1907. Oil on canvas, 65×54 cm. Paris, Musée Picasso.

293. Henri Matisse, *La Joie de vivre*, 1905-1906. Oil on canvas, 174×238 cm. Merion, Barnes Foundation.

294. *Where Do We Come From? What Are We? Where Are We Going?* detail, 1897. Oil on canvas, 139×374.5 cm. Boston, Museum of Fine Arts.

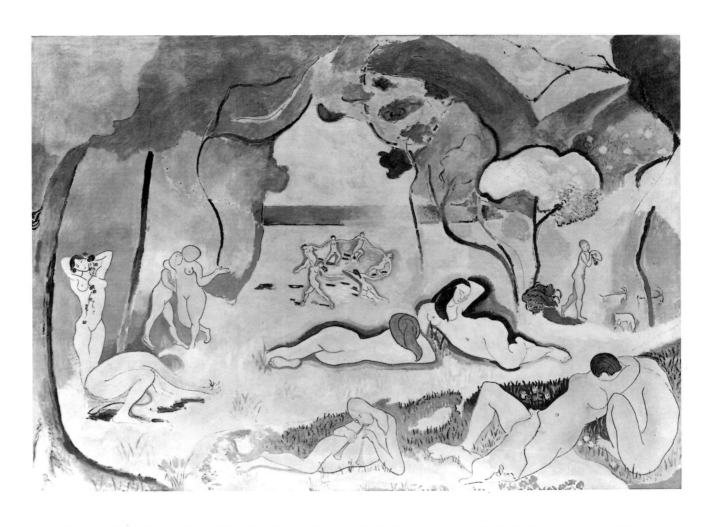

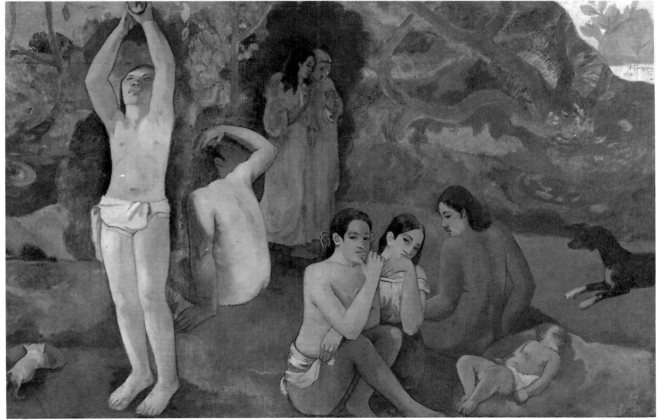

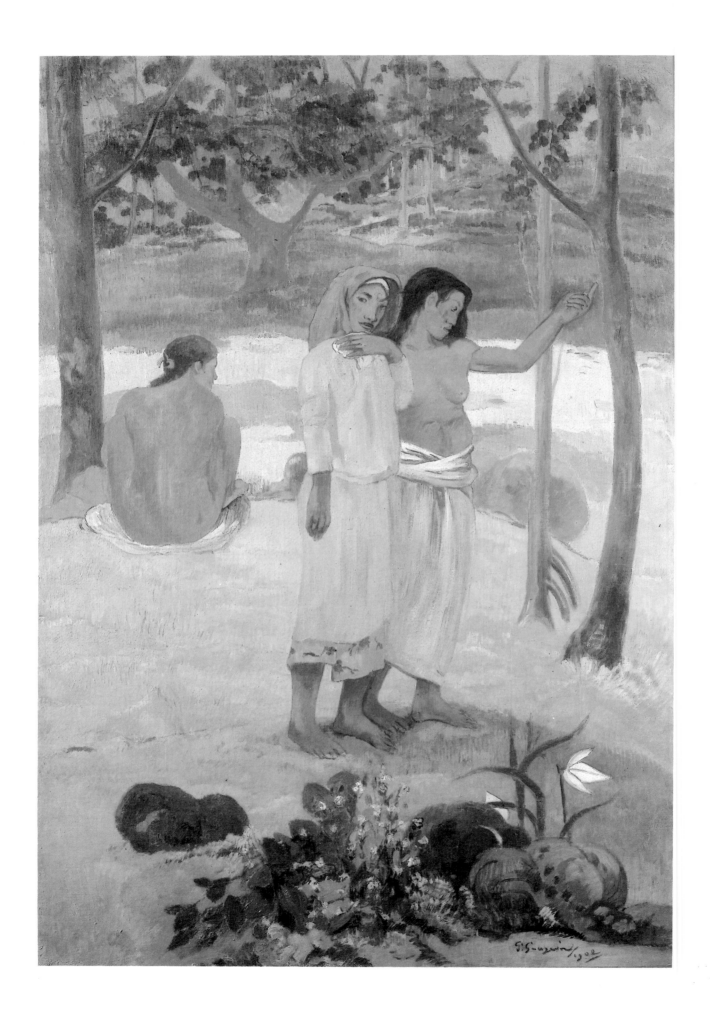

274 GAUGUIN

pitiful to the last, and led him, at the end of his life, to make this astonishing—albeit sincere—statement, for a man who owed so much to other people's art: 'Everything I learned from others stood in my way. I can therefore say: nobody taught me anything; and it is true that I know very little! But I am satisfied with that little because it is the real me.'[6]

But all this has contributed to making Gauguin a major influence in painting today. Gauguin lived during a critical period in art in every sense, and, before Picasso, was the first to feel the need to 'recapitulate' it. He wanted to start afresh and somewhat ingenuously longed to bring back *all* the styles that preceded classical art. When he looked at the paintings of the Italian Quattrocento or the German Renaissance in the Louvre, the Memlings in Brugge, Javanese art in the Musée Guimet and at the Universal Exposition, reproductions of Greek art, the Peruvian pottery he remembered from his childhood, and the Japanese prints that were to be found in every artist's studio, he did not choose the somewhat ironic standpoint taken by Picasso when he copied Velasquez's *Las Meninas* or antique Mediterranean sculpture. Gauguin's art was not yet an art of allusion that played wittily with references and pastiches in an era of cultural surfeit and critique; and yet already his attitude to painting shocked purists like Cézanne or Pissarro, and could perhaps have been properly appreciated only by painters such as Degas or Manet.

Gauguin's feeling for the past was nevertheless always a Symbolist one. The mixture of cultures so distant in time and space resulted in a synthesis of forms that perhaps was differentiated from nineteenth-century academic eclecticism only by Gauguin's emphasis on primitive art and barbarian cultures. But it was not just man's cultural heritage that needed to be synthesized. To revive tradition was not enough; it was also necessary—and this is true Symbolism—to invent an art-form that synthesized every means through which man expressed his feelings about the world and his gods. It was especially important—and this had been the dream of all the nineteenth-century poets—that art absorb literature and, above all, music. In other words, art had to acquire what had so far been the preserve of Religion.

Even when Gauguin was still an Impressionist, he was searching for a key: it is easier to understand Cézanne's mistrust of him when one considers what Gauguin demanded as far back as 1881: 'the exact formula of a work that is acceptable to everyone' and 'the recipe for reducing the exaggerated expression of all emotions into a single process'.[7] Gauguin searched for this 'formula' throughout his life and, fascinated by Baudelaire's sensitive desire for 'the transposition of daily life into legend'[8] and the aesthetic credo of someone like Wagner, he hoped to rediscover a great mythical and primitive art, a timeless human opera. The most curious aspect of Gauguin's *œuvre* is that, after living a romantic adventure and sincerely believing in the images that described it, he made painting itself into such a sacred act that the liberties he took with it ultimately led to modern art. For it was the painting that became the absolute, not life. In his pursuit of a lost grace and what Rimbaud had called 'the key of past banquets'—both a quest for a universal primitiveness and a personal unconscious—he contributed almost incidentally to the freedom of painting. For many psychological and literary reasons, the canvas became a metaphysical object, and each colour or arabesque took on an individual meaning that permitted Gauguin to dare as as much he pleased. 'All art is at once surface and symbol,'[9] Oscar Wilde wrote in the 1890s, and nothing could describe Gauguin's painting better, if one takes into account the fact that Symbolism, which often spoiled his work, also probably helped him develop the rhythms and colours that heralded Fauvism and the beginnings of Abstract Art. For Gauguin, colour was a religious component and not an indication of reality: stripped down, freed from any descriptive role, colour automatically became a symbol of emotion, the expression of a feeling, then a cry, a form, a stain, and finally a purely abstract element. The paradox in Gauguin's work is that he began with an aestheticism that was closer to the Pre-Raphaelites than to Cézanne, and that was heavy with an often literal Romantic Symbolism, and yet he succeeded, at times quite deliberately, in preparing the ground for 'pure painting'.

295. *The Call*, 1902. Oil on canvas, 130×90. Cleveland Museum of Art.

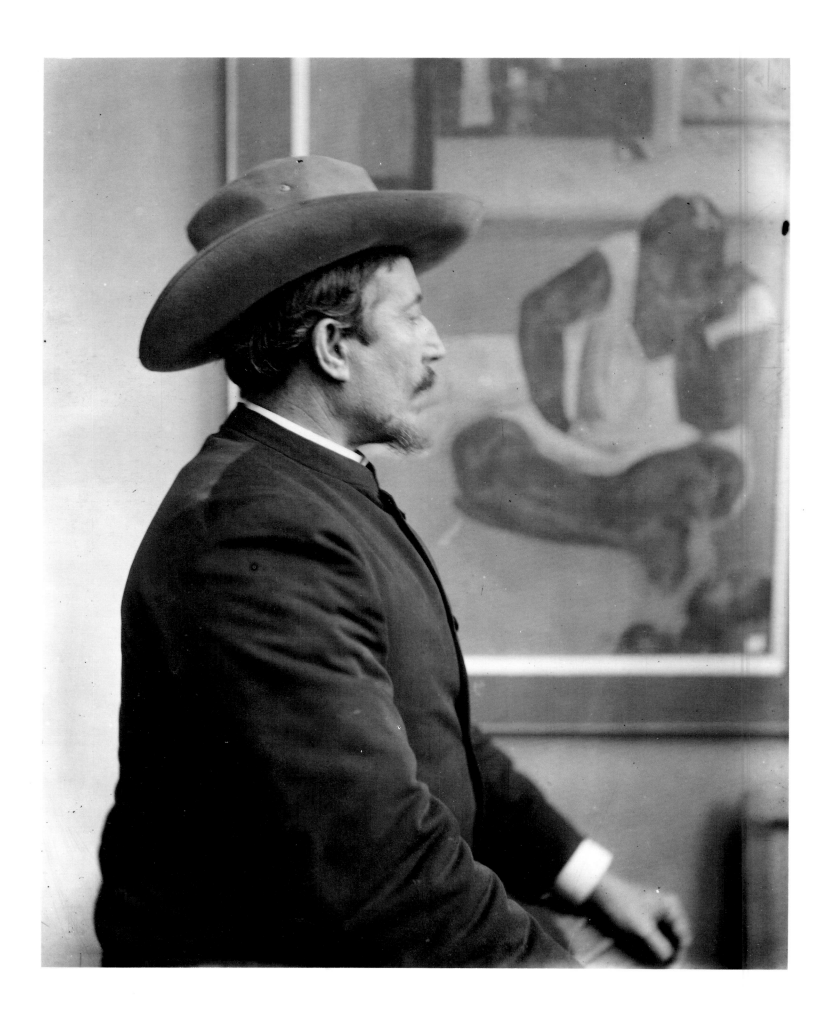

BIOGRAPHY

<table>
<tr><td></td><td>GAUGUIN</td><td>CONTEMPORARY EVENTS</td></tr>
<tr><td>1848</td><td>June 7, birth of Paul Gauguin in Paris, the son of Clovis Gauguin, an anti-monarchist journalist, and Aline Chazal, the daughter of Flora Tristan. An older sister, Marie, was born in 1847.</td><td>Paris: Revolution of 1848.
London: Formation of the Pre-Raphaelite Brotherhood.</td></tr>
</table>

297. Aline Gauguin by Jules Laure. Saint-Germain-en-Laye, Musée Départemental du Prieuré, Maurice Malingue Donation.

298. Gauguin aged two, by Jules Laure. Saint-Germain-en-Laye, Musée Départemental du Prieuré, Maurice Malingue Donation.

<table>
<tr><td>1849</td><td>The Gauguin family leaves for Peru, fleeing the new government and their financial difficulties.
30 October, sudden death of Clovis Gauguin at Port Famine, Chile.
Aline goes to live with her children in Lima, at the home of her great-uncle, Don Pio Tristan y Moscoso.</td><td></td></tr>
<tr><td>1854</td><td>Return to France. Paul goes to boarding school in Orléans. Unable to adapt to his new life, he is a poor student and has the reputation of being touchy and withdrawn.</td><td>1855: Exposition Universelle. Courbet exhibits works in his 'Pavillon du Réalisme'.
Pissarro, aged twenty-five, arrives in Paris.</td></tr>
<tr><td>1861</td><td>Aline settles in Paris. Paul stays at school in Orléans.</td><td></td></tr>
<tr><td>1862</td><td>Paul enters the boarding school of the Rue d'Enfer in Paris.</td><td>Meeting of the future Impressionists at the Gleyre Studio at the Ecole des Beaux-Arts.</td></tr>
<tr><td>1863</td><td></td><td>Salon des Refusés.
Death of Delacroix.</td></tr>
<tr><td>1864</td><td>Paul goes back to school in Orléans. His mother wants him to go to the naval academy, but his school grades are so bad that his teachers decide against presenting him.</td><td></td></tr>
</table>

296. Photograph of Gauguin, winter 1893-1894, taken in front of his painting *Te Faaturuma* (*Silence*).

	GAUGUIN	CONTEMPORARY EVENTS
1865	7 December, seventeen-year-old Paul embarks as a ship's apprentice on board the *Luzitano* at Le Havre.	Manet's *Olympia* creates a scandal at the Salon.
1866	He is promoted to Second Lieutenant aboard the *Chile*.	Monet, *Camille*. Birth of Kandinsky. Taine, *La Philosophie de l'art*.
1867	Travels around the world. While in India, he learns of his mother's death.	Death of Baudelaire and Ingres. Birth of Bonnard. Manet, *The Execution of the Emperor Maximilien*.
1868	Returns to Paris. Gustave Arosa, photographer and art collector, one of the first to buy Impressionist paintings, is Gauguin's guardian. Paul does his military service at Cherbourg, aboard the *Jérôme-Napoléon*.	Manet, *Portrait of Zola*.
1869		Birth of Matisse. Monet and Renoir paint at La Grenouillère.
1870	The *Jérôme-Napoléon* takes part in naval engagements in the North Sea.	Franco-Prussian war. 4 September, beginning of the Third Republic.
1871	23 June, Gauguin is discharged at Toulon.	The Paris Commune. Pissarro and Monet in London.
1872	In Paris, Gustave Arosa finds Paul a job with the Bertin brokerage firm in Rue Lafitte. Encouraged by Arosa and his daughter, an amateur painter, Gauguin begins to draw and perhaps also to paint landscapes.	
1873	Gauguin makes a success of his new job. In November he marries a young Danish woman, Mette Gad.	Rimbaud, *Une Saison en enfer*.

299. Photograph of Mette Gauguin in Copenhagen. Maurice Malingue Collection.

300. Photograph of Gauguin in 1873. Maurice Malingue Collection.

	GAUGUIN	CONTEMPORARY EVENTS
1874	Becomes friendly with a colleague and amateur painter, Émile Schuffenecker, who takes him to evening classes at the Academie Colarossi in Rue de la Grande-Chaumière. 31 August, his first child, Émile, is born.	First exhibition of the Impressionist group at Nadar's studio.
1876	Exhibits *Landscape at Viroflay* at the Salon. Buys Impressionist works.	Monet, *Gare Saint-Lazare* series. Renoir, *Le Moulin de la Galette.*
1877	Probable date of his first meeting with Pissarro. 24 December, birth of his second child, Aline.	Death of Courbet.
1878	Gauguin is thirty. Sale of the Arosa collection.	Seurat enters the Ecole des Beaux-Arts; Van Gogh preaches in the Borinage. Opening of the Musée Ethnographique (the future Musée de l'Homme) at the Trocadéro.
1879	Takes part in the fourth Impressionist exhibition; his work is noticed and praised by J.-K. Huysmans. May 10, birth of a third child, Clovis. Spends the summer at Pontoise near Pissarro, and paints.	
1880	Takes part in the fifth Impressionist exhibition.	
1881	Takes part in the sixth Impressionist exhibition (eight paintings). Again noticed by Huysmans.	Birth of Picasso.
1882	12 April, birth of his fourth child, Jean-René. Exhibits 12 works at the seventh Impressionist exhibition after having lost his job at the insurance company he had been working for since 1880.	Pierre Loti: *Rarehu, ou le mariage de Loti.* January, Failure of the Union Générale, causing the Stock Market to collapse.
1883	Gauguin, aged thirty-five, devotes himself entirely to painting. December 6, birth of his fifth child, Paul (Pola).	Death of Gustave Arosa. Death of Manet and Wagner. Odilon Redon: *Les Origines*, a series of Symbolist lithographs.
1884	January, the Gauguins move to Rouen, near Pissarro. July, Mette goes home to Copenhagen. November, Paul joins her in Copenhagen where, to earn his living, he becomes a tarpaulin salesman for Dillies & Co.	Creation of the Salon des Indépendants. Seurat: *Bathers at Asnières.* J.-K. Huysmans: *A Rebours.*
1885	June, Gauguin returns to Paris alone. He is obliged to sell part of his collection.	Van Gogh: *The Potato Eaters.* Seurat: *La Grande Jatte.*
1886	Gauguin undergoes great hardship during the winter in Paris. Earns money by becoming among other things, a bill-sticker. July, first visit to Pont-Aven. Meets Charles Laval and Émile Bernard. Begins to make ceramics with Chaplet.	Eighth and last Impressionist exhibition. J. Moréas: *Symbolist Manifesto.* Rimbaud: *Illuminations.*
1887	April, short visit from Mette. Gauguin leaves for Panama with Laval. After having worked on the construction of the canal, the two artists go to Martinique to paint.	Pissarro adopts Seurat's Neo-Impressionist style. Premiere of Wagner's *Lohengrin* at the Paris Opera.

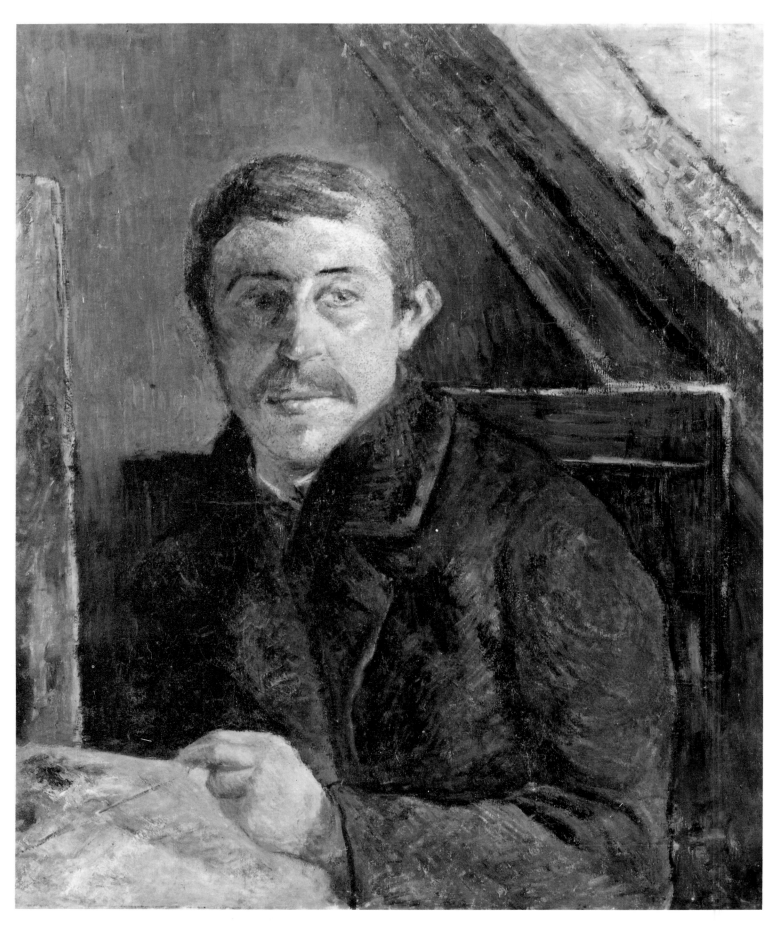

301. *Self-portrait*, 1885. Oil on canvas, 65×54 cm. Berne, Private Collection.

302. Paul and Mette Gauguin at the time of their marriage in 1873. Maurice Malingue Collection.

303. *Self-portrait for Carrière*, 1886-1890. Oil on canvas, 41×33 cm. Washington, National Gallery of Art.

304. *Aline and Pola*, 1885. Pastel on paper, 70.5×52 cm. Mr and Mrs David Lloyd Kreeger Collection.

	GAUGUIN	CONTEMPORARY EVENTS
1888	Spends almost the entire year at Pont-Aven in the company of Laval, Bernard and Meyer de Haan. 23 October, joins Van Gogh in Arles. 26 December, leaves Arles after the dramatic episode of the mutilated ear (23 December).	Mallarmé translates Whistler's *Ten O'Clock*. Seurat: *Les Poseuses*. Barrès: *Sous l'œil des barbares*. Van Gogh institutionalized.
1889	Organizes a group exhibition held June-October at the Café Volpini, on the fringes of the Universal Exposition, with the help of Schuffenecker. October, returns to Pont-Aven, then moves to Le Pouldu. Exhibits in Brussels with the Groupe des XX.	Universal Exposition. The Eiffel Tower. Bergson: *Les Données immédiates de la conscience*. Lautrec: *Le Moulin de la Galette*.
1890	February-June, in Paris. Decides to go away and create a 'Studio in the Tropics', planned successively in Martinique, Indo-China, Madagascar and finally in Tahiti. June-November, at Le Pouldu.	Creation of *Le Mercure de France*. Monet: *Poplars* series. Cézanne: *The Card Players*. 29 July, Van Gogh commits suicide at Auvers-sur-Oise.
1891	Winter 1890-1891, frequents the Symbolists, becomes friends with Albert Aurier, Charles Morice, Daniel de Monfreid, Odilon Redon, Carrière and, more distantly, with Mallarmé. 2 February, auction of his paintings at the Hotel Drouot to finance his trip to Tahiti. March, sees his wife and children in Copenhagen for the last time. 23 March, banquet in honour of his departure presided over by Mallarmé. 4 April, leaves Paris; he is forty-three. 9 June, arrives in Tahiti. September, moves to Mataiea, 45 km from Papeete.	Death of Seurat in Paris and Rimbaud in Marseilles. Creation of *La Revue Blanche*. Albert Aurier: *Manifeste de la peinture symboliste*.

305. Gauguin in an amateur snapshot from Pont-Aven in 1888? Maurice Malingue Collection.

306. Paul Sérusier, *Gauguin Rowing*, detail c. 1889? Drawing. Paris, Musée du Louvre, Department of Drawings.

307. Paul Sérusier, *Gauguin Playing the Accordion*, 1893-1894. Drawing. Paris, Musée du Louvre, Department of Drawings.

308. Gauguin between his son Émile and his daughter Aline in Copenhagen in March 1891. Maurice Malingue Collection.

309. Mette Gauguin and her five children in Copenhagen in 1888.

310. Gauguin in 1891, photographed by the painter Boutet de Monvel in Paris. Saint-Germain-en-Laye, Musée Départemental du Prieuré, Maurice Malingue Donation.

311. Photograph of Gauguin taken on 13 February 1891. Saint-Germain-en-Laye, Musée Départemental du Prieuré, Maurice Malingue Donation.

	GAUGUIN	CONTEMPORARY EVENTS
1892	Lives several months with Tehamana, called Tehura in *Noa Noa*. Plans to return to France.	The Panama scandal. Matisse and Rouault join Moreau's studio at the Ecole des Beaux-Arts. Exhibition of the Nabis at Le Barc de Bouteville's gallery. Death of Albert Aurier.
1893	4 June, leaves Tahiti. 30 August, arrives in Marseilles. Inherits from an uncle in Orléans. November, his exhibition at Durand-Ruel's ends in financial disaster. Works with Charles Morice on the final editing of *Noa Noa*. Moves into a studio in Rue Vercingétorix, Paris.	Anarchist bombings. Creation of the *Sezession* Movement in Munich. Opening of Ambroise Vollard's gallery.
1894	Liaison with 'Annah the Javanese'. February, trip to Belgium (Brussels, Brugge and Antwerp) on the occasion of the exhibition of *La Libre Esthétique*. May-November, Pont-Aven. Friendship with Armand Seguin. Bedridden for two months with a fracture after a fight.	Assassination of Sadi Carnot. Caillebotte bequest to the Musée du Luxembourg.
1895	18 February, sale of Gauguin's paintings at the Hôtel Drouot, with a catalogue prefaced by a letter from Strindberg; another financial fiasco, few reviews. First symptoms of syphilis, it appears. 3 July, Gauguin leaves from Marseilles for Tahiti, arrives on 9 September. He is forty-seven and will never return to Europe.	December 28, historical first film show by the Lumière brothers at the Grand Café. Paul Valéry: *Monsieur Teste*. Cézanne's first one-man show (at Vollard's).
1896	Tahiti. Lives with Pahura, his new vahine. Long stay in hospital (results of his fracture? heart problems? syphilis?). Increasing financial difficulties.	Bonnard's first one-man show (at Durand-Ruel's). Kandinsky moves to Munich. Opening of Bing's Art Nouveau gallery in Paris.

	GAUGUIN	CONTEMPORARY EVENTS

1897

19 January, death of Aline, his favourite child.
Gauguin learns the news in April.
End of his correspondence with Mette.

Douanier Rousseau: *The Sleeping Gypsy*.
Excerpts from *Noa Noa* published in *La Revue Blanche*.

312. Aline in a black shawl,
photographed by Julie Lauberg c. 1895.
Saint-Germain-en-Laye, Musée
Départemental du Prieuré, Maurice
Malingue Donation.

313. *Self-portrait for His Friend Daniel*,
1897. Oil on canvas, 39×35 cm. Paris,
Musée d'Orsay.

1898

January, attempts suicide by arsenic.
May, employed at the Public Works Department in Papeete.
Pahura, his vahine, becomes pregnant and leaves him.

Death of Mallarmé, Puvis de Chavannes and Gustave Moreau.
The Dreyfus affair.
Tolstoy: *What is Art?*
Gauguin exhibition at Vollard's.

1899

January, the sale of some paintings enables him to quit his office job.
Writes and illustrates a local satirical newspaper, *Le Sourire*.

Cézanne: *Portrait of Ambroise Vollard*.

1900

For the first time, thanks to Vollard and some collectors (Fayet, Bibesco), Gauguin earns a decent living from his painting. He is frequently ill and paints little. Publishes the review *Les Guêpes*.

Triumph of Art Nouveau at the Universal Exposition.
Death of Ruskin.
Picasso's first stay in Paris.
Freud: *The Interpretation of Dreams*.

1901

September, leaves for Hivaoa in the Marquesan archipelago. Settles at Atuona where he builds and decorates his 'House of Pleasure'. New vahines: Vahehoho and a few others.

Death of Toulouse-Lautrec.
The Van Gogh exhibition at Bernheim's influences the Fauvists.
Picasso: *Child with a Pigeon*.

1902

Increasingly incapacitated (leg sores, syphilis, alcohol), paints little.
Begins to write *Racontars de rapin* and *Avant et Après*.

Kandinsky starts an art school in Munich.

1903

January, cyclone in the Marquesas.
Problems with local police and church officials: Gauguin is accused of encouraging 'native anarchy' against the colonial authorities.
8 May, Gauguin dies at the age of fifty-five.

Death of Pissarro.
Creation of the Salon d'Automne, which opens with a Gauguin retrospective.

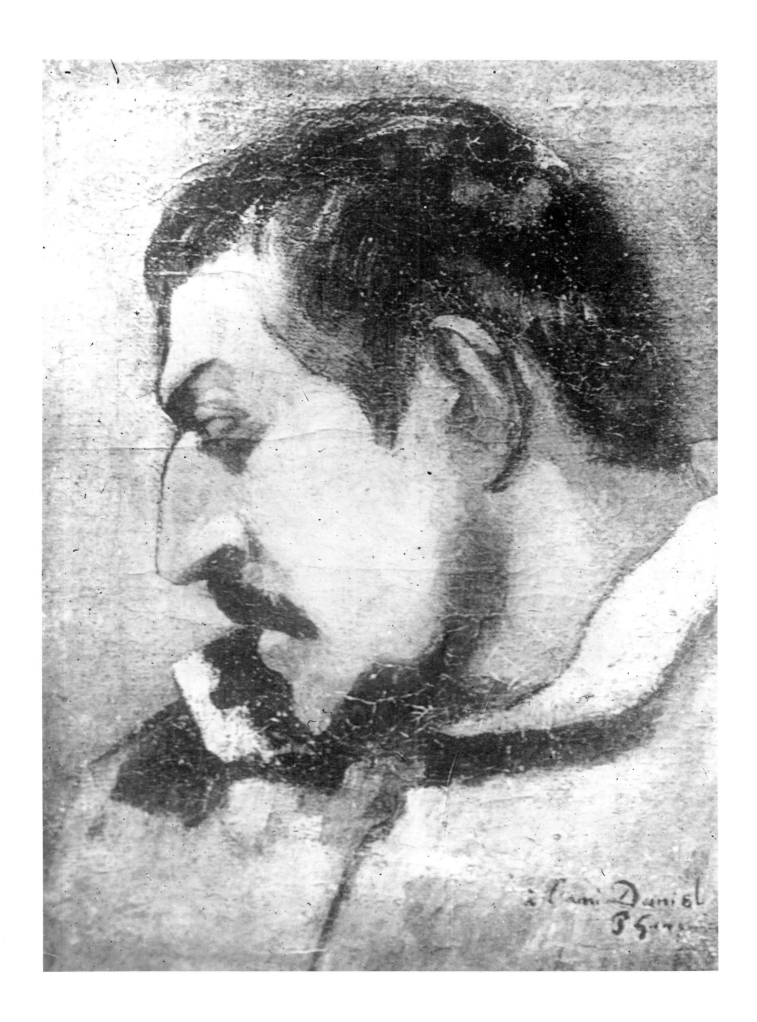

NOTES

THE SUNDAY IMPRESSIONIST—1873-1885

1. This painting does not date from 1871, as has been believed. On Gauguin's beginnings as an artist, see Merete Bodelsen, 'The Dating of Gauguin's Early Painting', in *Burlington Magazine*, June 1965; and the article on errors in dating in *Catalogue de l'œuvre peint de P. Gauguin*, ed. G. Wildenstein, 1964; 'The Wildenstein-Cogniat Catalogue', in *Burlington Magazine*, January 1966; and the chronology established by Isabelle Cahn and Gloria Groom for the catalogue of the 1988-1989 *Gauguin Retrospective*.

2. See Ursula F. Marks Vandenbroucke, 'Gauguin, ses origines et sa formation artistique', in the special issue devoted to Gauguin of the *Gazette des Beaux-Arts*, May-June 1958, vol. 47, and Isabelle Cahn, *op. cit.*

3. Gauguin, *Avant et Après*, Paris, 1923, p. 2.

4. Eliphas Lévi, alias Constant, quoted by Ursula F. Marks Vandenbroucke, *op. cit.*, note 2.

5. *Cf.* Ursula F. Marks Vandenbroucke, *op. cit.*, note 2.

6. *Avant et Après*, *op. cit.*, p. 134 ff.

7. *Ibid.*, p. 25.

8. Zola's *L'Assommoir* and the Goncourts' *La Fille Elisa* were published three years earlier, in 1877.

9. J.-K. Huysmans, article reprinted in *L'Art moderne*, Charpentier, Paris, 1883, p. 238.

10. Gauguin may have frequented the Académie Colarossi. *Cf.* Mette Gauguin's letter to Rotonchamp, in J. de Rotonchamp, *Gauguin*, Paris, 1925, p. 18.

11. Gauguin, *Racontars de rapin*, 1951, p. 35.

12. *Cf.* John Rewald, The History of Impressionism, Museum of Modern Art, New York, 1973. (The edition used in the preparation of this volume is John Rewald, *Histoire de l'impressionisme*, Livre de Poche illustré, Paris, 1965.)

13. *Cf.* Merete Bodelsen, 'Gauguin's Cézannes', in *Burlington Magazine*, May 1962, pp. 204-211.

14. Letter to Camille Pissarro quoted by J. Rewald, in *Paul Gauguin: Carnet de croquis 1884-1888*, in which the *Notes synthétiques* appear on pp. 57-64, facsimile edition New York, Paris, 1963.

15. *Avant et Après*, *op. cit.*, p. 115.

16. Open letter to Gauguin, see ch. 8 below.

17. *Cf.* Daniel Halévy's preface to *Lettres de Degas*, p. VIII, Paris, 1931.

18. *Avant et Après*, *op. cit.*, p. 115.

19. *Cf.* Charles Chassé, 'Le sort de Gauguin est lié au krach de 1882', *Connaissance des arts*, February 1959.
In fact, between 1880 and 1883, Gauguin worked for the Thomereau insurance company, 93, Rue de Richelieu, from which he was fired.

20. 31 October 1883, in *Correspondance de Camille Pissarro*, edited by J. Bailly-Hertzberg, Paris, 1986, p. 8.

21. *Ibid.*, p. 66.

22. J.-K. Huysmans, in *L'Art moderne*, *op. cit.*, p. 264.

23. *Cf.* C. Gray, *Sculpture and Ceramics of P. Gauguin*, Baltimore, 1963, cat. no. 8.

24. For a basic bibliography on the Japanese influence, see the *Paris-Tokyo* exhibition catalogue, Paris, 1988.

25. See R. Schmutzler, *Art Nouveau*, New York, 1962; S. Tschudi Madsen, *Art Nouveau*, London, 1967; and Jean-Paul Bouillon, *Journal de l'art nouveau*, Geneva, 1985.

26. The appearance of Cézanne's influence after that of Degas and Pissarro has been studied by H. Rostrup, 'Eventails et pastels de Gauguin', in *Gazette des Beaux-Arts*, vol. LVI, 1950.

27. Quoted by A. Vollard, *Cézanne*, 1919, and Charles Morice (quoting Mirbeau's account), in *Paul Gauguin*, Paris, 1920, p. 228.

28. *Correspondance de Paul Gauguin*, vol. I (1873-1888), edition compiled by Victor Merlhès, Singer-Polignac Foundation, 1984, p. 78 *et seq.* (this publication will be referred to below as *Merlhès*).

29. In *Racontars de rapin, op. cit.* See also H. Rostrup, 'Gauguin et le Danemark', in the special issue of *Gazette des Beaux-Arts, op. cit.*

30. To Schuffenecker, 14 January 1885, *Merlhès*, p. 87.

THE FIRST JOURNEYS—1885-1887

1. 14 January 1885, *Merlhès*, pp. 87-89.

2. Baudelaire, *L'Art romantique*, Paris 1885, p. 11. Reprinted in Baudelaire, *Œuvres*, Éditions de la Pléiade, 1954, p. 854 ff.

3. Félix Fénéon, 'Les Impressionistes en 1886', reprinted in Fénéon, *Œuvres plus que complètes*, edited by Joan Halperin, Droz, Geneva, 1970, vol. I, pp. 35 and 55.

4. 14 January 1885, *Merlhès*, p. 88.

5. Excerpt from a letter to Pissarro, published by J. Rewald in *Notes synthétiques, op. cit.*, ch. 1, note 13, and *Merlhès,* p. 107.

6. Late November 1885, *Merlhès,* p. 118.

7. J.-E. Blanche, *De Gauguin à la Revue nègre*, Paris, 1928, p. 5.

8. Félix Fénéon, *Œuvres, op. cit.*

9. In *La Cravache*, 6 July 1889, reprinted in Fénéon, *Œuvres, op. cit.*, p. 109.

10. J. Rewald, *op. cit.*, in *Notes synthétiques.*

11. Discussed by W. Homer, *Seurat and the Science of Painting*, M.I.T. Press, Cambridge, 1966, p. 289, note 27, and by Henry Dorra.

12. Text by Zumbul-Zadé recopied by Gauguin in *Avant et Après*, ed. Grés, pp. 56 and 60. According to Gustave Kahn (preface to *Les Dessins de Seurat*, Paris, 1926), it is indeed 'Gauguin's paper'.

13. In *Le Gaulois*, republished as *Par les champs et par les grèves*, by Charpentier, the publisher of the Impressionists.

14. Maurice Barrès, in *Le Voltaire*, 16 and 26 August 1886.

15. To Mette, July 1886, *Merlhès,* p. 137.

16. Gray, *Sculpture and Ceramics of P. Gauguin, op. cit.*, cat. no. 9.

17. To Mette, late July 1886, *Merlhès,* p. 126.

18. See Gray's excellent study on this subject, *op. cit.*

19. This aspect of Gauguin's surviving work is not very well known: after coming to Paris in 1887, Mette took almost all of his ceramic pieces back to Copenhagen to sell them. Most are still in Danish collections and museums. *Cf.* Merete Bodelsen, *Gauguin Ceramics in Danish Collections*, Copenhagen, 1960.

20. *Avant et Après, op. cit.*, p. 234.

21. Gray, *op. cit.*, cat. no. 4.

22. Paul Gauguin, 'Notes sur l'art à l'Exposition universelle', in *Le Moderniste illustré*, 4 July 1889.

23. In *Avant et Après, op. cit.*

24. *Cf.* note 22.

25. To Bracquemond, *Merlhès,* p. 143.

26. *Correspondance de Camille Pissarro, op. cit.*, pt. 2, p. 121.

27. To Mette, early April 1887, *Merlhès,* p. 147.

28. *Ibid.*

29. Ibid.

30. Merlhès, p. 147.

31. See J. Rewald, *Post-Impressionism*, (bibliography).

32. Merlhès, p. 142.

BRITTANY IN THE JAPANESE STYLE BY A 'SAVAGE FROM PERU'—1888

1. To Mette, 24 November 1887, *Merlhes,* p. 165.

2. *Avant et Après, op. cit.*, p. 208.

3. To Mette, February 1888, *Merlhès,* p. 169.

4. To Schuffenecker, 8 July 1888, *Merlhès,* p. 198.

5. Paul Verlaine, 'Pauvre Gaspard', copied by Gauguin in *Cahier pour Aline,* facsimile ed. by S. Damiron, Paris, 1963.

6. To Mette, February 1888, *Merlhès,* p. 170.

7. Émile Bernard, 'Notes sur l'Ecole dite de Pont-Aven', in *Mercure de France*, December 1903.

8. Vincent Van Gogh, *Correspondance générale*, pt. III, letter 510 F, Gallimard-Grasset, 1960. Future references to the Van Gogh correspondence will contain only the number of the letter.

9. E. Dujardin, 'Le Cloisonnisme', in *Revue indépendante*, 19 March 1888. See B. Welch Ovcharov, *Vincent Van Gogh and the Birth of Cloisonnism*, Toronto-Amsterdam, 1981.

10. *Cf.*, Y. Thirion, 'L'Influence de l'estampe japonaise dans l'œuvre de Gauguin', in the special issue of *Gazette des Beaux-Arts*, May-June 1958, vol 47.

11. To Schuffenecker, 14 August 1888, *Merlhès,* p. 210.

12. Vincent Van Gogh to Émile Bernard, April 1888, B 3 F.

13. Vincent Van Gogh to his brother Theo, August 1888, 527 F.

14. *Cf.* Merete Bodelsen, 'The Missing Link in Gauguin's Cloisonnism', in *Gazette des Beaux-Arts,* May-June 1959, pp. 319-344.

15. *Cf.*, Y. Thirion, *op. cit.*

16. *Merlhès,* p. 232.

17. *Lettres de Pissarro à son fils Lucien*, Paris, 1950, p. 234.

18. Letter to Schuffenecker, 8 October 1888, *Merlhès,* p. 249.

19. *Cf.,*Y. Thirion, *op. cit.*

20. Vincent Van Gogh to his brother Theo, 544 F.

21. Letter to Schuffenecker, 8 October 1888, Merlhès, p. 249.

22. *Merlhès,* pp. 234-235.

23. Vincent Van Gogh to Émile Bernard, 29 May 1888, 492 F.

24. Vincent Van Gogh to his sister, early April 1888, W 3 N.

25. Vincent Van Gogh to Émile Bernard, May 1888, B 5 F.

26. To Émile Bernard, November 1888, *Merlhès,* p. 274. On the reasons for Gauguin's choice of Tahiti, see B. Danielsson, *Gauguin à Tahiti et aux îles Marquises*, Paris, 1975, pp. 30-35.

27. Vincent Van Gogh to his brother Theo, 523 F.

28. Maurice Denis, 'L'Influence de Paul Gauguin', in *L'Occident*, October 1903. *Cf. Du symbolisme au classicisme,* Hermann, Paris, 1964.

29. To Schuffenecker, 16 October 1888, *Merlhès,* p. 255.

30. To Émile Bernard, *Merlhès,* p. 270.

31. To Schuffenecker, 16 October 1888, *Merlhès,* p. 255.

32. *Avant et Après, op. cit.*, p. 17.

33. To Émile Bernard, about his work in December 1888, letter of December 1889, B 21 F.

34. To Émile Bernard, November, *Merlhès,* p. 275.

35. Vincent Van Gogh to Émile Bernard, late October 1888, letter B 19aF.

36. Vincent Van Gogh to his brother Theo: 'Gauguin would have dropped us completely if Laval had had any money to speak of.' 10 September 1888, 535 F.

37. J. Dolent, quoted by C. Morice, *Paul Gauguin, op. cit.*, p. 6.

38. Related by Gauguin in *Avant et Après, op. cit.*, p. 20.

GAUGUIN, BAUDELAIRE AND THE EIFFEL TOWER—1889

1. A. Fontainas, *Souvenirs sur le symbolisme*, Paris (undated), p. 32.

2. The Musée Guimet opened to the public in 1888, one year before the Exposition Universelle. It was originally not just an art museum, but a 'museum of the history of religions', and so must have been doubly interesting to Gauguin.

3. Letter from J.-K. Huysmans to Mallarmé, 1st January 1889, quoted in H. Mondor, *Vie de Mallarmé*, p. 554.

4. P. Gauguin, 'Notes sur l'Exposition Universelle', *Le Modernisme illustré*, article cited above.

5. To Schuffenecker, in *Lettres de Gauguin à sa femme et à ses amis*, published by Maurice Malingue, Grasset, 1946, p. 153. This edition will be referred to below as *Malingue*.

6. Theo to Vincent Van Gogh, 16 June 1889. Letter quoted by J. Rewald, *op. cit.,* p. 168.

7. Reported by Maurice Denis, 'L'Influence de Paul Gauguin', 1903, republished in *Du Symbolisme au classicisme, op. cit.,* p. 52.

8. Paul Sérusier to Maurice Denis, in P. Sérusier, *A.B.C. de la peinture*, Floury, Paris, 1950.

9. Félix Fénéon, review of 'L'Exposition Volpini', *La Cravache*, 6 July 1889, republished *op. cit.,* pp. 156-157.

10. Charles Morice, in *Le Temps*, August 1888.

11. Maurice Denis, 'Définition du néo-traditionnalisme', *Art et Critique*, August 1890, republished *op. cit.*

12. Reported by Charles Chassé, 'De quand date le synthétisme de Gauguin?' in *L'Amour de l'art*, April 1938.

13. Charles Baudelaire, *L'Art romantique*, 1885 ed., p. 11.

14. Charles Baudelaire, L'Art mnémonique, *ibid.*, p. 73.

THE PREY OF 'THE MEN OF LETTERS'—1889-1890

1. Octave Mirbeau, *L'Echo de Paris*, 16 February 1891.

2. To Émile Bernard, August 1889, *Malingue*, p. 162.

3. To Émile Bernard, September 1889, *Malingue*, p. 166.

4. To Émile Bernard, November 1889, *Malingue*, p. 174.

5. *Cf.* M. Van Hook, 'A Self Portrait by Gauguin', in *Gazette des Beaux-Arts*, December 1942.

6. Charles Baudelaire, 'Richard Wagner et Tannhäuser', in *L'Art romantique*, 1885, p. 228. See also H. Dorra, 'Le texte Wagner et Gauguin', in *Bulletin de la Société de l'art français*, 1984, p. 281 ff.

7. *Cf.* Gray cat. *op. cit.*, no. 88.

8. 'I like Brittany, I find wildness and the primitive there. When my clogs echo on the granite, I hear the muted, matte and powerful tone that I look for in painting.' Letter to Schuffenecker, February 1888, *Merlhès*, p. 172.

9. To Schuffenecker, June 1888, *Merlhès*, p. 132.

10. To Émile Bernard, September 1889, *Malingue*, p. 167.

11. To Madeleine Bernard, November 1889, *Malingue*, p. 180.

12. To Émile Bernard, August 1889, *Malingue*, p. 163.

13. Charles Morice, *Paul Gauguin*, Paris, 1920.

14. Félix Fénéon, in *Le Chat noir*, 23 May 1891 (Halperin, *op. cit.*, p. 153).

15. *Cf.* Albert Aurier, *Œuvres posthumes*. On the first study of the relationship between Aurier's poetry and Gauguin's painting, see S. Lövgren, *The Genesis of Modernism*, Uppsala, 1959, p. 110.

16. To Émile Bernard, November 1889, *Malingue*, p. 172.

17. Albert Aurier, 'Le symbolisme en peinture', *op. cit.,* p. 293.

18. To Émile Bernard, September 1889, *Malingue*, p. 166.

19. Albert Aurier, *op. cit.*

20. To Émile Bernard, early September 1889, *Malingue*, p. 166.

21. Vincent Van Gogh to his brother Theo, 615 F.

22. Albert Aurier, 'Le Symbolisme en peinture', *op. cit.*

23. Pissarro to Lucien, 13 May 1891, *Lettres*, p. 246.

24. Pissarro to Lucien, 20 April 1891, *id.*, p. 235.

25. 'Gauguin, before the Surrealists, was the first painter who realized that he had a magician inside him', André Breton, *L'Art magique*, 1957, p. 216.

26. Quoted by Jules Renard in his Journal, 3 December 1891.

THE STUDIO IN THE TROPICS—1890

1. Vincent Van Gogh to his brother Theo, 28 January 1889, letter 574 F.

2. Vincent Van Gogh to his brother Theo, July 1890, letter 646 F.

3. Jules Renard, Journal, 15 April 1891.

4. *Cf.* text by Gauguin on Redon first published by J. Loize, *Les Nouvelles littéraires*, 7 May 1953, and Gauguin's letters in *Lettres à Odilon Redon*, by Arï Redon and Roseline Bacou, J. Corti, Paris, 1960.

5. A public subscription organized by Claude Monet the year before forced this scandal-tainted work on the Musée du Luxembourg, the museum of modern art in Paris.

6. To Émile Bernard, *Malingue*, p. 136.

7. To Émile Bernard, *ibid*, p. 191.

8. To Schuffenecker, autumn 1890, in A. Alexandre, *Paul Gauguin, sa vie et le sens de son œuvre*, Paris, 1920, p. 110.

9. Vincent Van Gogh to Émile Bernard, June 1888, letter B 6 F.

10. To Émile Bernard, June 1890, *Malingue*, p. 193.

11. To Émile Bernard, July 1890, *ibid*, p. 198.

12. To Émile Bernard, August 1890, *ibid*, p. 200.

13. Article by Octave Mirabeau in *Le Figaro*, 16 February 1891.

14. To Émile Bernard, June 1890, *Malingue*, p. 193.

15. To Émile Bernard, October 1888, *ibid*, p. 136.

16. To Émile Bernard, June 1890, *ibid*, p. 193.

17. To Odilon Redon, in *Lettres à Odilon Redon, op. cit.*, no. 47.

18. H. Dorra, 'The First Eve in Gauguin's Eden', in *Gazette des Beaux-Arts*, March 1953, pp. 189-202.

19. *Avant et Après, op. cit.,* p. 138.

20. To Mette, February 1890, *Malingue,* p. 194.

21. In *Essais de psychologie contemporaine,*1883

22. Arthur Rimbaud, *Une Saison en enfer,* Éditions de La Vogue, 1887, p. 9.

23. Letter to Redon, *op. cit.,* no. 4.

A SEASON IN PARADISE—1891-1893

1. *Noa Noa,* edited by Loize, A. Balland. On the genesis of *Noa Noa,* the modifications of the manuscript and Charles Morice's alterations, see the detailed study by Jean Loize which precedes Gauguin's original text, the most authentic of the various versions of *Noa Noa.* Quotations given here are from this edition.

2. *Ibid.,* pp. 24-25.

3. Pierre Loti, *Rarehu. . ., op. cit.*

4. *Noa Noa, op. cit.,* p. 20.

5. Jénot, 'Le premier séjour de Gauguin à Tahiti', special issue of *Gazette des Beaux-Arts,* January-April 1958.

6. See Bengt Danielsson, *Gauguin à Tahiti et aux Marquises,* 1975 (French edition), ch. IV. The author, who lived in South Pacific for a long time, very patiently and precisely retraced the history of Gauguin's life in Polynesia.

7. *Noa Noa, op. cit.,* p. 35.

8. To Mette, July 1891, *Malingue,* p. 218.

9. The curator, Léonce Bénédicte, unfortunately refused the gift. It is now in the Metropolitan Museum of Art in New York.

10. *Noa Noa, op. cit.,* p. 22.

11. To Odilon Redon, *op. cit.,* p. 193.

12. *Cf.* J. Teilhet-Fisk, *Paradise Reviewed,* p. 62. See in particular, K. Varnedoe, 'Gauguin', in *Primitivism in 20th-Century Art,* Museum of Modern Art, New York, 1984.

13. This relationship was studied for the first time by B.

Dorival, 'Sources of the Art of Gauguin from Java, Egypt and Ancient Greece', *Burlington Magazine,* April and July 1951.

14. Quoted by B. Danielsson, *op. cit.*

15. See René Huyghe's comparison between the texts of *Ancien Culte mahorie* and the *Voyage aux îles du Grand Océan* by J.A Moerenhout, in his edition of *Ancien Culte mahorie,* La Palme, Paris, 1951, appendix II, p. 60.

16. *Ancien Culte mahorie,* p. 19.

17. *Avant et Après, op. cit.,* p. 80.

18. 7 November 1891, *Lettres à G. Daniel de Monfreid,* edited by V. Segalen, Plon, Paris, 1950, p. 2. This publication will be referred to below as *Segalen.*

19. To Mette, July 1892, *Malingue,* pp. 229-230.

20. In Charles Baudelaire *L'Art romantique,* 1885 ed., p. 74.

21. *Cahiers pour Aline,* facsimile ed., *op. cit.*

22. Gray, *op. cit.,* cat. no. 94.

23. Phototype plates reproduced by Arosa for Charles Yriarte, *Les Frises du Parthénon,* 1868, and for Wilhelm Fröhner, *La Colonne Trajane,* 3 vol., 1870. Source found by W. M. Kane, 'Gauguin's le Cheval Blanc, Sources and Syncretic Meanings', *Burlington Magazine,* July 1966.

24. To Monfreid, August 1892, *Malingue,* p. 231.

25. To Monfreid, 5 November 1892, *Segalen,* p. 13.

26. To Mette, April-May 1893, *Malingue,* p. 242.

AT THE MYSTERIOUS HEART OF THOUGHT—1894-1895

1. Arthur Rimbaud, *Une Saison en enfer, op. cit.,* p. 9.

2. Mirbeau to Claude Monet, January 1891, published in *Cahiers d'Aujourd'hui,* no. 9, 1922.

3. Armand Seguin, 'Paul Gauguin', in *L'Occident,* March 1903.

4. Quoted by J. de Rotonchamp, *Gauguin, op. cit.*

5. To Monfreid, 11 February 1893, *Segalen,* p. 20.

6. Letter to Mette, October 1893, *Malingue,* p. 249.

7. Paul Sérusier, *L'A.B.C. de la peinture,* Paris, 1921: Cézanne's statement was first quoted by Duranty.

8. Gauguin reproduces this article in the notes he wrote at the back of his copy of *Noa Noa,* in 1896-1897.

9. Pissarro to Lucien, 23 November 1893, in *Letters, op. cit.,* p. 217.

10. Note published by J. Rewald in *Gauguin's Drawings,* 1958, p. 98.

11. *Cf.* J. Loize, *Noa Noa par P. Gauguin, op. cit.,* and N. Wadley, *Noa Noa, Gauguin's Tahiti,* London, 1985.

12. In the introduction to *Noa Noa,* pp. 33-35 (our italics), in the version revised by Charles Morice.

13. Letter to Molard, September 1894, *Malingue,* p. 260.

14. Armand Seguin, 'Paul Gauguin', in *L'Occident,* article previously cited.

15. Gauguin interviewed by E. Tardieu in *L'Echo de Paris,* 13 May 1895.

16. Paul Signac, *D'Eugène Delacroix au néo-impressionisme,* republished by Hermann, Paris, 1987, p. 133.

17. Philippe Burty, *Lettres de Eugène Delacroix,* 1880, p. 269.

18. Quoted in *Noa Noa* and in Gauguin's letter to Fontainas, *Malingue,* p. 288.

19. Mallarmé, reply to Jules Huret, 'Enquête sur l'évolution littéraire', *Le Figaro,* March-July 1891.

20. G. Geffroy, in *Le Journal,* 12 November 1893.

21. A. Strindberg, *Le Hasard dans la production artistique,* 1894, reprinted in the catalogue on the Strindberg exhibition, Musée d'Art Moderne, Paris, 1962.

22. The two letters by Strindberg and Gauguin were printed in the catalogue of the Gauguin sale held at the Hôtel Drouot on 18 February 1895.

23. *Ibid.*

24. Quoted by Maufra, *L'Occident,* May 1903.

25. To Maurice Denis, March 1895, *Malingue,* p. 267.

26. To Monfreid, November 1894, *Segalen,* p. 36.

27. To Monfreid, *ibid.*

NEAR GOLGOTHA—1895-1901

1. To Monfreid, 12 December 1898, *Segalen*, p. 113.

2. Joséphin Péladan, *Comment on devient artiste*, Paris, 1894.

3. Swedenborg, *La Nouvelle Jérusalem*, trans. and commentary, Hermann, Paris, 1889, p. 203.

4. To Monfreid, April 1896, *Segalen*, p. 43.

5. To Charles Morice, May 1896, *Malingue*, p. 273.

6. Charles Clément, *Prud'hon*, photographs by Arosa, 1872.

7. His illness continued to worsen; Gauguin was probably syphilitic by the time he returned to Paris in 1893.

8. To Monfreid, April 1896, *Segalen*, p. 43.

9. To Monfreid, 12 March 1897, *Segalen*, p. 66.

10. To Monfreid, 10 September 1897, *Segalen*, p. 80.

11. To Monfreid, February 1898, *Segalen*, p. 91.

12. See G. Wildenstein, 'L'Idéologie et l'esthétique dans deux tableaux clefs de Gauguin', in the special issue on Gauguin, *Gazette des Beaux-Arts, op. cit.*

13. To Monfreid, March 1898, *Segalen*, p. 94.

14. To Monfreid, *ibid.*

15. See Rookmaker, *Synthetist Art Theories*, Amsterdam, 1959, and V. Jirat-Wasiutynsky, *Paul Gauguin in the Context of Symbolism*, New York, 1978.

16. See above, ch. VI, note 8. This figure was inspired by a Rembrandt engraving; *cf.* R. Field, 'Gauguin, plagiaire ou créateur', in *Gauguin*, Hachette, Paris, 1961.

17. To Monfreid, February 1898, *Segalen*, p. 91.

18. *L'Esprit moderne et le Catholicisme* belongs to the University of Saint Louis, and the manuscript called *Diverses Choses*, written in 1896-1898 at the end of the *Noa Noa* manuscript, is now in the Department of Drawings at the Musée du Louvre.

19. To Monfreid, March 1898, *Segalen*, p. 95.

20. To Fontainas, March 1899, *Malingue*, pp. 287-288.

21. *Cf.* facsimile edition by L. J. Bouge, Maisonneuve, Paris, 1952.

22. To Maurice Denis, June 1899, *Malingue*, p. 291.

23. *Diverses Choses, op. cit.*, p. 207.

24. Published in *Le Courrier français* in 1884 and 1885. *Cf.* Y. Thirion, unpublished thesis, quoted by Dorival, *Gauguin*, p. 60.

25. To Monfreid, 12 December 1898, *Segalen*, p. 112.

26. To Monfreid, 21 February 1899, *Segalen*, p. 117.

27. To Monfreid, April 1901, *Segalen*, p. 171.

28. To Monfreid, June 1901, *Segalen*, p. 175.

29. To Mette, May 1893, *Malingue*, p. 242.

30. Arthur Rimbaud, *Une Saison en enfer, op. cit.*, p. 6.

THE RIGHT TO DARE ALL—1901-1903

1. The sale of his house in Tahiti and his contract with the young art dealer Ambroise Vollard brought Gauguin a measure of financial security See G. Le Bronec's article in *Gazette des Beaux-Arts*, 'Les Dernières années', and *Letters to A. Vollard and A. Fontainas*, edited by J. Rewald, San Francisco, 1943.

2. To Charles Morice, February 1903, *Malingue*, p. 310.

3. The five carved bas-reliefs decorating Gauguin's house in Hivaoa are now in the Musée d'Orsay.

4. To Monfreid, 25 August 1902, *Segalen*, p. 195.

5. To Monfreid, November 1901, *Segalen*, p. 187.

6. *Diverses Choses, op. cit.*, p. 256.

7. See Danielsson, *op. cit.*, p. 272, according to Louis Grelet's account.

8. To Fontainas, March 1899, *Malingue*, p. 289.

9. *Ibid.*

10. See in particular W. M. Kane's analysis in 'Gauguin's le Cheval Blanc', article quoted above.

11. *Diverses Choses, op. cit.*, p. 220.

12. *Ibid.*, p. 80. In reality Gauguin was thinking of Vuillard, Bonnard and Maurice Denis.

13. To Monfreid, November 1901, *Segalen*, p. 188.

14. *Racontars de rapin, op. cit.*, p. 78.

15. *Racontars de rapin, op. cit.*, p. 80.

16. Cf. Merete Bodelsen, 'Gauguin et le Dieu des Marquises', *Gazette des Beaux-Arts*, 1961, and K. Varnedoe's update in *Primitivism op. cit.*

17. *Diverses Choses, op. cit.*, p. 223.

18. To Fontainas, March 1899, *Malingue*, pp. 287-288.

19. In *Le Moderniste*, 30 August 1885, signed Jacques le Mélancolique.

20. Albert Aurier, *Œuvres posthumes*, p. 304. Probably written in 1892.

21. To Charles Morice, April 1903, *Malingue*, p. 319.

22. To Charles Morice, *ibid.*

23. To Monfreid, October 1902, *Segalen*, p. 199.

24. *Avant et Après, op. cit.*

25. *Ibid.*

FROM WAGNER TO MATISSE

1. Elie Faure, *Histoire de l'art*, Livre de Poche illustré, 1966 ed.

2. Told by Émile Bernard, *Sur Paul Cézanne*, p. 31, Paris, 1925.

3. Pissarro, *Lettres à son fils Lucien, op. cit.*, p. 132.

4. Maurice Denis, 'L'Influence de Paul Gauguin', *L'Occident*, September 1903, reprinted in *Du Symbolisme au classicisme, op. cit.*

5. Matisse, in *Jazz*, 1947, reprinted in *Ecrits et propos sur l'art*, Hermann, Paris, 1972.

6. To Charles Morice, April 1903, *Malingue*, p. 319.

7. To Camille Pissarro, quoted by J. Rewald, *Histoire de l'impressionisme*, pt II, *op. cit.*, p. 119.

8. Charles Baudelaire, *l'Art romantique*, 1885 ed., p. 74.

9. Oscar Wilde, preface to *The Picture of Dorian Grey*, Penguin, London, 1962, p. 6.

GAUGUIN'S PAINTINGS
IN MUSEUMS

It is interesting to note that while Gauguin is very respectably represented in French museums, his presence is even more spectacular in Scandinavia and in the Soviet Union, which could be said to be the polar opposites of his landscapes. Oslo, Stockholm and above all Copenhagen, the home of his wife and children, possess many canvases from his Impressionist and Breton periods. The collections in the museums in Leningrad and Moscow were formed largely from those belonging to Shchukin and Morosov, who purchased them from Ambroise Vollard. They share the largest series of canvases from Tahiti and Hivaoa. However, Gauguin's most famous paintings—whether because they were chosen later, from a better perspective, or were bequeathed by enlightened collectors—are in the Musée d'Orsay and a number of American museums. Gauguin is also well represented in Great Britain, Germany and Japan.

WESTERN EUROPE

BELGIUM

BRUSSELS, Musées Royaux des Beaux-Arts de Belgique.
Brittany Conversations, 1888.
The Green Christ, 1889.
Portrait of Suzanne Bambridge (Tahiti), 1891.
LIÈGE, Musée des Beaux-Arts.
Marquesan Man in a Red Cape or
The Enchanter (Hivaoa), 1902.

DENMARK

COPENHAGEN, Ny Carlsberg Glyptotek.
House in the Country, 1874.
Garden in the Snow, 1879.
Nude Study or *Suzanne Sewing*, 1880.
The Painter's Family in the Garden at Rue Carcel, 1882.
Snow Scene, Rue Carcel,
1882-1883.
Osny, a Climbing Path, 1883.
The Poplars, 1883.
Skaters at Frederiksberg Park, 1885.
Fan with Landscape after Cézanne, 1885.
By the Sea (Martinique), 1887.
Breton Women and Calf, 1888.
Girl Tending Cows (Brittany), 1889.
Still-life with Onions, 1889.
Portrait of Two Children, 1890.
Vahine no te tiare (*Girl with a Flower*)
(Tahiti), 1891.

Tahitian Village, 1892.
The Green Christ, 1889.
Apatarao or *In Papeete*, 1893.
Arearea no varua ino (*The Amusement of the Evil Spirit*), 1894.
Faa Ara or *The Awakening*, 1898.
Ordrupgaard Collection.
Sleeping Child or *The Little Dreamer* (*Study*),
1881.
Blue Trees, 1888.
Human Misery or *Grape Harvest* (Arles), 1888.
Portrait of Vaïte (Jeanne) Goupil, 1896.
Tahitian Woman, 1898.
Adam and Eve (Hivaoa), 1902.

FINLAND

HELSINKI, The Atheneum Art Museum.
Mahana maa (*Market Day*), 1892.
Landscape with Pig and Horse, 1903.

FRANCE

GRENOBLE, Musée de Peinture
et de Sculpture.
Portrait of Madeleine Bernard, 1888.
LYONS, Musée des Beaux-Arts.
Nave nave mahana (*Delightful Day*), 1896.
ORLÉANS, Musée des Beaux-Arts.
Still-life: Fête Gloanec, 1889.

PARIS, Musée d'Orsay.
The Seine at Iena Bridge, 1875.
Still-life with Japanese Peonies and Mandolin, 1885.
Haymaking, 1888.
Window with View of the Sea, 1888.
The Alyscamps, 1888.
Schuffenecker's Family, 1889.
La Belle Angèle, 1889.
Yellow Haystacks, 1889.
Still-life with Fan, 1889.
The Meal or *The Bananas*, 1891.
Tahitian Women or *On the Beach*, 1891.
Arearea (*Amusements*), 1892.
Village in the Snow (Brittany), 1894.
The David Mill, 1894.
Self-portrait with Hat, 1894.
Two Breton Women on a Road, 1894.
Self-portrait for His Friend Daniel, 1897.
Vairumati, 1897.
The White Horse, 1898.
And the Gold of their Bodies, 1901.
Family Stroll, 1901.
Musée des Beaux-Arts de la Ville, Petit Palais.
The Sculptor Aubé and his Son, 1882.
Man with a Staff, 1889.
Musée des Arts Décoratifs.
Seascape with Cow on the Edge of a Cliff, 1888.
RENNES, Musée des Beaux-Arts.
Still-life with Flowers at a Window, 1881.
Still-life with Oranges, 1881.
RHEIMS, Musée des Beaux-Arts.
Still-life, Roses and Statuette, 1890.
Pas manger li (*Still-life*), 1895.
SAINT-GERMAIN-EN-LAYE, Musée du Prieuré.
La Fille du patron, 1886.
STRASBOURG, Musée des Beaux-Arts.
Still-life with Engraving after Delacroix, 1895.
TROYES, Musée d'Art Moderne.
Young Mulatto (Tahiti), 1891.

GREAT BRITAIN

BIRMINGHAM, The Barber Institute.
Bathers at Tahiti, 1897.
EDINBURGH, The National Galleries of Scotland.
Tropical Vegetation (Martinique), 1887.
The Vision after the Sermon (*Jacob Wrestling with the Angel*), 1888.
Three Tahitians or *Conversation*, 1899.
LONDON, Courtauld Institute Galleries.
Harvest in Brittany, 1889.
Te rerioa (*The Dream*), 1897.
Nevermore, 1897.
National Gallery
Still-life with Red Flowers, 1896.

Tate Gallery
Faa Iheihe (*Tahitian Pastoral*), 1898.
MANCHESTER, City Art Gallery.
The Port, Dieppe, 1885.
NEWCASTLE UPON TYNE, Laing Art Gallery.
The Breton Shepherdess, 1886.
NORTHAMPTON, Smith College Museum of Art.
Market Gardens in Vaugirard, 1879.

ITALY

MILAN, Civica Galleria d'Arte Moderna.
Cows at the Watering-place, 1885.

NORWAY

OSLO, Nasjonalgalleriet.
Flowers, Still-life or *The Painter's Home, Rue Carcel*, 1881.
Mette Gauguin in Evening Dress, 1884.
The Willow Trees, 1889.
On the Beach in Brittany, 1889.
The Square Basket, 1889.

SPAIN

BILBAO, Museo de Bellas Artes.
The Laundresses (Arles), 1888.

SWEDEN

GÖTEBORG, Kontsmuseum.
Effet de neige, 1888.
STOCKHOLM, Nationalmuseum.
Les Mas d'Arles, 1888.
Fields by the Sea, 1889.

SWITZERLAND

BASEL, Kunstmuseum.
Portrait of Achille Granchi-Taylor, 1885.
Entre les legs, 1889.
Nafea faaipoipo (*When Will You Marry?*) (Tahiti), 1892.
Ta Matete (*The Marketplace*), 1892.
Self-portrait (Hivaoa), 1903?
ZURICH, Bührle Collection.
Mette Sewing, 1878?
Tahitian Idyll, 1901.
Still-life with Sunflowers on an Armchair (I) (Hivaoa), 1901.
Still-life with Knife (Hivaoa), 1901.
The Offering (Hivaoa), 1902.
Kunsthaus.
Quarry in the Vincinity of Pontoise, 1882.
Early Flowers in Brittany, 1888.

THE NETHERLANDS

AMSTERDAM, Vincent Van Gogh Foundation, Rijkmuseum Vincent Van Gogh
By the Pond (Martinique), 1887.
Under the Mango Trees (Martinique), 1887.
Self-portrait, 'Les Misérables', 1888.
Vincent Van Gogh Painting Sunflowers, 1888.
Women by the River (Tahiti), 1892.
Paris in the Snow, 1894.
OTTERLÖ, Rijksmuseum Kröller-Müller.
The Edge of the Forest, 1885.
Atiti (Tahiti), 1892.
ROTTERDAM, Boymans Museum.
Cows Resting, 1885.

WEST GERMANY

BERLIN, Stadtgemälde.
Girl Tending Pigs, 1889.
COLOGNE, Wallraf-Richartz-Museum.
Nude Breton Boy, 1889.
ESSEN, Folkwang Museum.
The Seaweed Gatherers, 1889.
Woman with a Fan (Hivaoa), 1902.
Riders on the Beach (Hivaoa), 1902.
Primitive Tales (Hivaoa), 1902.
HAMBURG, Kunsthalle.
Young Bretons Bathing, 1888.
MUNICH, Neue Pinakothek, Bayerische Staatsgemälesammlungen.
Four Breton Women, 1886.
The Pond (Martinique), 1887.
Te tamari no Atua (*The Child of God*), 1896.
STUTTGART, Staatsgalerie.
Portrait of the Artist's Mother, 1890.
E Haere se i hia (*Where Are You Going?*) 1892.

EASTERN EUROPE

CZECHOSLOVAKIA

PRAGUE, Národní Gallery.
Bonjour Monsieur Gauguin, 1889.
The Lovers (Hivaoa), 1902.
Group with an Angel (Hivaoa), 1902.

EAST GERMANY

DRESDEN, Modern Art Gallery.
Parau api (*What News?*), 1892.

HUNGARY

BUDAPEST, Museum of Fine Arts.
Garden in the Snow, 1879.
The Little Black Pigs, 1891.

THE SOVIET UNION

LENINGRAD, State Hermitage Museum.
Les parau parau (*Words, Words*) (Tahiti), 1891.
Fatata te Mouà (*Against the Mountain*), 1892.
Matamoe or *Landscape with Peacocks*, 1892.
Tahitian Pastorals, 1892-1893.
En *Haere la se* (*Where Are You Going?*), 1893.
Nave nave moe (*The Joy of Repose*), 1894.
Eiaha Ohipa (*Do Not Toil*), 1896.
Bé Bé (*Baby*), 1896.
Te arii Vahine (*The Noble Woman* or *Woman with Mangoes*), 1896.
Te Vaa (*The Canoe*), 1896.
Landscape with Two Goats, 1897.
Rave te hiti ramu (*The Idol*), 1898.
Women at the Seaside, 1899.
Women at the Seaside Against a Yellow Background, 1899.
Rupe Rupe (*Luxury*), 1899.
The Month of Mary, 1899.
Still-life with Sunflowers on an Armchair (II) (Hivaoa), 1901.
MOSCOW, Pushkin State Museum of Fine Arts.
Still Life with Fruit, 1888.
Madame Ginoux at the Café, 1888.
Self-portrait, 1889-1890.

Te tiare Farani (*The Flowers of France*), 1891.
Vairumati tei oa (*The Name is Vairumati*),
1892.
Aha oe feii? (*What! Are You Jealous?*), 1892.

Horse on a Path, 1899.
The Great Buddha, 1899.
Riders (Hivaoa), 1901.
Still-life with Exotic Birds, 1902.

NORTH AND SOUTH AMERICA

ARGENTINA

BUENOS AIRES, Museo Nacional de Bellas
Artes.
Two Girls Bathing, 1887.
Vahine no te miti (*Woman at the Sea*), 1892.

BRAZIL

SÃO PAOLO, Museu de Arte Moderna.
Self-portrait near Golgotha, 1896.
The Poor Fisherman, 1896.

UNITED STATES

BALTIMORE, Museum of Art.
Vahine no te vi (*Woman with a Mango*), 1892.
Upaupa Schneklud (*The Player Schneklud*),
1894.
BOSTON, Museum of Fine Arts.
Breton Landscape, 1889.
Still-life with Flowers and Fruit, 1890.
Where Do We Come From? What Are We?
Where Are We Going?, 1897.
Women and White Horse (Hivaoa), 1903.
BUFFALO, Albright-Knox Art Gallery.
Yellow Christ, 1889.
Manao tupapau (*The Spectre Watches Over
Her*), 1892.
CAMBRIDGE, MASS., Fogg Art Museum.
Poèmes barbares, 1896.
CHICAGO, Art Institute.
Old Women at Arles, 1888.
*Portrait of a Woman, with Still Life by
Cézanne*, 1890.
Te raau rahi or *The Big Tree* (I), 1891.
Te Burao (The Big Tree), 1892.
Merahi metua no Tehamana (*Tehamana Has
Many Parents*), 1893.
Mahana no Atua (*Day of the God*), 1894.
No te aha oe riri (*Why Are You Angry?*), 1896.
Woman with Two Children, 1901.
The Incantation (Hivaoa), 1902.
CLEVELAND, The Museum of Art.
In the Waves (*Ondine*), 1889.

Te raau rahi or *The Big Tree* (II), 1891.
The Call (Hivaoa), 1902.
DALLAS, Museum of Art.
Farm at Le Pouldu, 1890.
I raro te oviri (*Under the Pandanus*), 1891.
HAWAII, Honolulu Academy of Arts.
Two Tahitian Women On the Beach, 1892.
INDIANAPOLIS, Museum of Art.
Farm at Arles, 1888.
KANSAS CITY, The Nelson Gallery
Foundation.
Faaturuma (*Reverie*) or *Woman in a Red Dress*
(Tahiti), 1891.
LOS ANGELES, County Museum.
Still-life with Bowl of Fruit on a Garden Chair,
1890.
MALIBU, The Getty Museum.
Breton Boy with a Goose, 1890.
MERION, The Barnes Foundation.
A Monsieur Loulou, 1890.
Morning Toilette (Tahiti), 1892.
MINNEAPOLIS, Institute of Art.
I raro te oviri (*Under the Pandanus*), 1891.
Mountains in Tahiti (I), 1892.
NEW HAVEN, Yale University Art Gallery.
Parau Parau (*Gossip*), 1892.
NEW YORK, Metropolitan Museum of Art.
Horse in a Pasture, 1891.
Ia orana Maria (*Hail Mary*), 1891.
Tahitian Women Bathing, 1892.
Farm in Brittany, 1894.
Two Tahitian Women or *Les Seins aux fleurs
rouges*, 1899.
Museum of Modern Art.
Still-life with Three Puppies, 1888.
Hina tefatou (*The Moon and Earth*), 1893.
NORFOLK, VIRGINIA, Chrysler Art Museum.
The Loss of Virginity, 1891.
PASADENA, Norton Simon Museum.
Portrait of a Woman and a Young Man, 1899.
PHILADELPHIA, Museum of Art.
Parahi te marae (*There Stands the Shrine*),
1892.
PITTSBURGH, Carnegie Institute.
Near the Huts, 1901.
SAINT LOUIS, Art Museum.
Madame Roulin (Arles), 1888.

SAN ANTONIO, Marion Koogler MacNay
Art Museum.
The Sister of Charity, 1902.
TOLEDO, Museum of Art.
Street in Tahiti, 1891.
Mountains in Tahiti (II), 1892.
WASHINGTON, National Gallery of Art.
Self-portrait for Carrière, 1886-1890.
Madame Alexandre Kohler, 1887-1888.
Breton Girls Dancing, Pont-Aven, 1888.
Self-portrait with Halo, 1889.
The Haystacks or *The Potato Field*, 1890.
Landscape at Le Pouldu, 1890.
Parau na te Varua ino (*Words of the Devil*),
1892.

Fatata te Miti (*Near the Sea*), 1892.
Bathers, 1898.
Te pape nave nave (*Delightful Water*), 1898.
The Phillips Collection.
The Ham, 1889.
WEST PALM BEACH, Norton Gallery and
School of Art.
Christ in the Garden of Olives (Self-portrait),
1889.
WILLIAMSTOWN, MASS., Sterling and
Francine Clark Art Institute.
The Young Christian Girl or *Girl in Yellow*,
1894.
WORCESTER, Art Museum.
Te faaturuma (*Silence*), 1891.

NEAR EAST AND FAR EAST

EGYPT

CAIRO, Mahmoud Khalil Museum.
The Path of Father Jean, 1885.
Life and Death, 1889.

IRAN

TEHERAN, Museum of Modern Art.
Still-life with Japanese Print or *with Vase
in the Shape of a Head*, 1889.

ISRAEL

JERUSALEM, Museum of Art.
Upaupa (*Fires of Joy*), 1891.

JAPAN

KURASHIKI, Ohara Museum of Art.
Te nave nave fenua (*The Delightful Land*),
1892.
TOKYO, Bridgestone Gallery (Ishibashi
Collection).
Return from Haymaking, 1884.
L'Aven, 1888.
Haymaking, 1889.
National Museum of Western Art.
Women Bathing (Dieppe), 1885.
Hilly Landscape with Two Figures or
Breton Shepherd Boy, 1888.
Breton Girls by the Sea, 1889.
Portrait of the Painter Slewinski, 1894.

SELECT BIBLIOGRAPHY

We list here only the writings that have been used in the making of this book. For a more complete bibliography see the catalogue of the retrospective *Gauguin,* Washington-Chicago-Paris, 1988-1989.

CATALOGUES OF GAUGUIN'S WORK

M. GUÉRIN, *L'Œuvre gravé de Gauguin,* Paris, 1927, 2 vol.
C. GRAY, *Sculptures and Ceramics of Paul Gauguin,* Baltimore, The John Hopkins Press, 1963.
M. BODELSEN, *Gauguin's Ceramics, a study in the development of his art,* London, Faber and Faber, 1964.
G. WILDENSTEIN, *Paul Gauguin, I, Catalogue,* Paris, Les Beaux-Arts, 1964. See also the precisions by Merete Bodelsen in "The Wildenstein-Cogniat Gauguin Catalogue", *Burlington Magazine,* January 1966.
G.M. SUGANA, *Tout l'œuvre peint de Gauguin,* Paris, Flammarion, 1981.
R. FIELD, *Paul Gauguin monotypes catalogue raisonné,* Philadelphia, 1973.
E. KORNFELD, *Catalogue raisonné of his prints,* Zurich, E. Mongan, 1988.

MONOGRAPHS

J. de ROTONCHAMP (pseudonym for Brouillon), *Paul Gauguin,* Weimar, 1906; Paris, 1925.
Ch. MORICE, *Paul Gauguin,* Paris, 1920.
A. ALEXANDRE, *Paul Gauguin, sa vie et le sens de son œuvre,* Paris, 1920.
Pola GAUGUIN, *Paul Gauguin, mon père,* Paris, 1938.
R. GOLDWATER, *Paul Gauguin,* New York and London, 1957.
H. PERRUCHOT, *La Vie de Gauguin,* Paris, Hachette, 1961.
Ch. CHASSÉ, *Gauguin sans légendes,* Paris, Les Éditions du Temps, 1965, 169 pages.
J. RUSSEL, *Gauguin,* Paris, 1970.
W. ANDERSEN, *Gauguin's Paradise Lost,* New York, Viking Press, 1971.
B. DANIELSSON, *Gauguin à Tahiti et aux Marquises,* London, 1965; Papeete, éditions du Pacifique, 1975.
P. LEPROHON, *Gauguin,* Paris, Gründ, 1975.
R. HUYGHE, *Gauguin,* Paris, Flammarion, 1979.
Y. LE PICHON, *Sur les traces de Gauguin,* Paris, Laffont, 1987.
M. HOOG, *Gauguin,* London, Thames and Hudson, 1987.
M. MALINGUE, *La Vie prodigieuse de Gauguin,* Paris, Buchet-Chastel, 1987.

GENERAL WORKS ON GAUGUIN AND HIS TIMES

M. DENIS, *Théories 1890-1910. Du symbolisme et de Gauguin vers un nouvel ordre classique,* Paris, 1912.
J.-E. BLANCHE, *De Gauguin à la Revue nègre,* Paris, 1928. See also *Les Arts plastique sous la IIIᵉ République,* Paris, 1931.
H. FOCILLON, *La Peinture aux XIXᵉ et XXᵉ siècles,* Paris, 1928.
R. REY, *La Renaissance du sentiment classique dans la peinture française à la fin du XIXᵉ siècle,* Paris, 1931.
R.W. WILENSKI, *Modern French Painters,* London-New York, 1940. 2nd edition, 1945.
B. DORIVAL, *Les Étapes de la peinture française contemporaine,* Paris, 1943, vol. I.
G. MICHAUD, *Message poétique du symbolisme* (4 volumes), Paris, Nizet, 1947.
C. CHASSÉ, *Le Mouvement symboliste dans l'art du XIXᵉ siècle,* Paris, 1947.
F. NOVOTNY, *Die grossen französischen Impressionisten. Ihre Vorläufer und ihre Nachfolger,* Vienne, 1952.
J. REWALD, *The History of Impressionism,* New York, Museum of Modern Art, 1973.
C. CHASSÉ, *Gauguin et son temps,* Paris, 1955.
H. R. ROOKMAKER, *Synthetist Art Theories,* Amsterdam, 1959.

S. LOVGREN, *The Genesis of Modernism—Seurat, Gauguin, Van Gogh and French Symbolism in the 1880's,* Stockholm, Uppsala, 1959.
W. HOFFMANN, *Art in the Nineteenth Century,* London, 1961.
S.T. MADSEN, *Art Nouveau,* London, Weindenfeld and Nicholson, 1967.
J. REWALD, *Post-Impressionism—From Van Gogh to Gauguin,* New York, 1978.
M. ROSKILL, *Van Gogh, Gauguin, and the Impressionnist Circle,* Greenwich, 1970.
Bogomila WELSH-OVCHAROV, *Vincent Van Gogh and the Birth of Cloisonnism,* Toronto, 1981.

WORKS ON PARTICULAR ASPECTS OF GAUGUIN'S WORK

C. CHASSÉ, *Gauguin et le groupe de Pont-Aven,* Paris, 1921.
R. J. GOLDWATER, *Primitivism in Modern Painting,* New York, London, 1938.
B. DORIVAL, "Sources of the Art of Gauguin from Java, Egypt, and Ancient Greece", *Burlington Magazine,* April 1951.
Gauguin, sa vie, son œuvre, special issue of *La Gazette des Beaux-Arts,* January-April 1958 — U.F. MARKS VANDENBROUCKE, "Gauguin, ses origines et sa formation artistique"; H. ROSTRUP, "Gauguin et le Danemark"; G. WILDENSTEIN, "Gauguin en Bretagne"; Y. THIRION, "L'Influence de l'estampe japonaise dans l'œuvre de Gauguin"; JÉNOT, "Le Premier séjour de Gauguin à Tahiti (1891-1893); G. WILDENSTEIN, "L'Idéologie et l'esthétique dans deux tableaux clés de Gauguin"; L.J. BOUGE, "Traduction et Interprétation des titres en langue tahitienne inscrits sur les œuvres océaniennes de Paul Gauguin"; J. LOIZE, "Gauguin sauvé du feu"; G. LE BRONNEC, "Les dernières années".
M. BODELSEN, "Gauguin and the Marquesan God", *Gazette des Beaux-Arts,* March 1961.
—. *Gauguin's ceramics,* London, Faber and Faber, 1964.
B. DANIELSSON, "Les Titres tahitiens de Gauguin", *Bulletin de la Société des études océaniennes,* September 1967.
R. PICKVANCE, *Gauguin Drawings,* London, 1969.
W. JAWORSKA, *Paul Gauguin et l'école de Pont-Aven,* Paris, Ides and Calendes, 1971.
H.R. ROOKMAKER, *Gauguin and 19th Century Art Theory,* Amsterdam, 1972.
R.S. FIELD, *Paul Gauguin, the Paintings of the First Voyage to Tahiti,* New York, Garland, 1977.
K. POPE, *Gauguin and Martinique,* University of Texas, 1981.
H. DORRA, "Le texte wagner de Gauguin", *Bulletin de la Société de l'art français,* 1984, p. 281 ff.
A.B. FONSMARK, *Gauguin og Danmark,* Ny Carlsberg Glyptotek, 1985.
Z. AMISHAI-MAISELS, *Gauguin's Religious Themes,* New York, Garland, 1985.
K. VARNEDOE, "Gauguin", *Primitivism in Twentieth-Century Art,* New York, 1984.

CONTEMPORARY ACCOUNTS AND REVIEWS

G.A. AURIER, *Œuvres posthumes,* Paris, 1983.
M. DENIS, *Théories (1890-1910),* Paris, 1912, re-printed under the title *Du symbolisme au classicisme. Théories,* presented by O. Revault d'Allonnes, collection Miroirs de l'Art, Hermann, 1964.
R. MARX, *Maîtres d'hier et d'aujourd'hui,* Paris, 1914.
O. MIRBEAU, *Des artistes,* Paris, 1922.
J.-E. BLANCHE, *De Gauguin à la Revue nègre,* Paris, 1928.
T. NATANSON, *Peints à leur tour,* Paris, 1948.
V. SEGALEN, "Le Tombeau de Paul Gauguin"; preceding the *Lettres à Daniel de Monfreid),* Paris, 1950.
A. VOLLARD, *Souvenirs d'un marchand de tableaux,* Paris, Albin-Michel, 1959.
L. LETHÈVE, *Impressionnistes et Symbolistes devant la presse,* Paris, Éditions Kiosque, 1960.
Correspondance complète de Vincent Van Gogh (3 vol.), Gallimard-Grasset, Paris, 1960.
F. FÉNÉON, *Œuvres plus que complètes.* Edited by J. Halperin, Genève, Droz, 1970.
C. PISSARRO, *Lettres à son fils Lucien.* Edited by J. Rewald, Paris, 1950; *Correspondance de Camille Pissarro,* pt. II (1886-1890). Edited by J. Bailly-Hertzberg, Paris, 1986.

WRITINGS BY GAUGUIN

P. GAUGUIN, *Avant et Après,* facsimile; Leipzig, 1918; re-published Paris, 1923.
Noa Noa. Voyage de Tahiti, (facsimile edition of the manuscript illustrated by Gauguin, Gift of Daniel de Montfreid to the Louvre, 1925), Berlin, n.d. (1926). Reprint, Stockholm, 1947 (facsimile).
Lettres de Gauguin à sa femme et à ses amis, Paris, 1946. Collected by M. Malingue, 2nd revised edition. Paris, 1949.

Lettres de Gauguin à Daniel de Monfreid. Preface by Victor Segalen. New edition revised by A. Joly-Segalen, Paris, 1950.

P. GAUGUIN: *Racontars de rapin,* Paris, 1951.

Ancien Culte mahorie, Paris, La Palme, 1951. Postface by René Huyghe. Re-print, Hermann, 1967.

P. GAUGUIN, *Noa Noa.* Paris, 1954. Facsimile edition of Gauguin's first manuscript (c. 1893-1894), without illustrations or commentaries, offered to Charles Morice.

Lettres de Gauguin, Gide, Huysmans, Jammes, Mallarmé, Verhaeren... à Odilon Redon, edited by Arï Redon et Roseline Bacou, Paris, Corti, 1960.

P. GAUGUIN: *Cahier pour Aline,* facsimile edition of the original manuscript, edited by S. Damiron, Paris, Société des amis de la bibliothèque d'Art et d'Archéologie de l'Université de Paris, 1963.

P. GAUGUIN: *Carnet de croquis, 1884-1888,* including the *Notes synthétiques* published in facsimile and edited by J. Rewald and R. Cogniat, Paris, 1963.

Noa Noa par Paul Gauguin, Édition Jean Loize, Paris, 1986.

Oviri, écrits d'un sauvage, anthology edited by D. Guérin, Paris, Gallimard, 1974.

45 lettres de Gauguin à Vincent, Théo et Jo Van Gogh, edited by Douglas Cooper, Lausanne, La Bibliothèque des arts, 1983.

Correspondance de Paul Gauguin 1873-1888. Edited by V. Merlhès, Paris, 1984.

Noa Noa, Gauguin's Tahiti. Edited by N. Wadley, London, Phaidon, 1985.

LIST OF ILLUSTRATIONS

204. *Aha oe feii? (What! Are you Jealous?)*, 1892.
Oil on canvas, 68×92 cm.
Moscow, Pushkin State Museum.
Photo V.A.P. 188-189

207. *Aita tamari vahine Judith te parari (The Child-
woman Judith Is Not Yet Breached) or Annah
the Javanese*, 1894.
Oil on canvas, 166×81 cm.
London, Private Collection.
Photo A. C. Cooper. 192

17. *Album Briant.*
Sketch Inspired by Degas,
Paris, Musée du Louvre,
Department of Drawings.
Photo Musées Nationaux. 24

14. *Album Briant,*
list of the paintings Gauguin owned,
and of his own painting's admirers.
Page from the Paris, Musée du Louvre,
Department of Drawings.
Photo Musées Nationaux. 21

304. *Aline and Pola*, 1885.
Pastel on paper, 70.5×52 cm.
Mr and Mrs David Lloyd Kreeger Collection. 281

297. *Aline Gauguin* by Jules Laure.
Saint-Germain-en-Laye, Musée Départemental
du Prieuré,
Maurice Malingue Donation. 277

312. *Aline in a black shawl*, photographed by Julie
Lauberg c. 1895.
Saint-Germain-en-Laye, Musée Départemental
du Prieuré,
Maurice Malingue Donation. 286

78. *The Alyscamps*, 1888.
Oil on canvas, 92×73 cm.
Paris, Musée d'Orsay.
Photo Giraudon. 77

291. *A Monsieur Loulou*, 1890.
Oil on canvas, 55×46 cm.
Merion, Barnes Foundation. 272

179 *L'Ancien Culte Mahorie*, 1892.
to Pen and watercolour on paper.
186. Paris, Musée du Louvre,
Department of Drawings.
Photo Musées Nationaux. 172-173

224. *The Angelus*, 1894.
Monotype on cardboard, 26.5×30 cm.
Josefowitz Collection. 206

208. *Annah the Javanese* photographed by Mucha.
Danielsson Archives. 193

200. *Arii Matamoe (Royal End)*, 1892.
Oil on canvas, 45×75 cm.
Paris, Private Collection.
Photo National Gallery, Washington. 184-185

87. *L'Arlésienne (Madame Ginoux)*
(Vincent Van Gogh), 1888.
Oil on canvas, 93×74 cm.
Paris, Musée d'Orsay.
Photo Musées Nationaux. 82

5. Gustave Arosa, photographed by Nadar. 15

77. *The Artist's Grandmother* (Émile Bernard), 1887.
Amsterdam, Vincent Van Gogh Foundation,
National Museum Vincent Van Gogh. 75

64. *Assaults (Hokusai)*, detail, extract from Mangwa.
Paris, Bibliothèque Nationale,
Department of Prints. Photo B.N. 64

230. *Auti te pape (The Fresh Water is in Motion)*,
1898. Woodcut.
Paris, Bibliothèque d'Art et Archéologie.
Photo Friends of the Bibliothèque. 211

275. *Bathers*, 1902.
Oil on canvas, 73×92 cm.
Private Collection. 258

117. *Bathers in Brittany*, 1889.
Zincography.
Paris, Bibliothèque d'Art et d'Archéologie.
Photo Soc. Amis. Bibl. Art Arch. Paris. 110

140. *Be a Symbolist, Caricature
of Jean Moréas*, 1891.
D.R. 131

273. *Before the Race (Edgar Degas)*, detail.
Pastel, 50×63 cm.
Location unknown.
Photo Durand-Ruel. 256

133. *Be in Love and You Will Be Happy*, 1890.
Carved and painted lindenwood, 119×97 cm.
Boston, Museum of Fine Arts,
Arthur Tracy Cabot Fund. 125

115. *La Belle Angèle*, 1889.
Oil on canvas, 92×73 cm.
Paris, Musée d'Orsay.
Photo Musées Nationaux. 109

137. *Be Mysterious*, 1890.
Carved polychrome limewood, 73×95 cm.
Paris, Musée d'Orsay.
Photo Musées Nationaux. 129

20. *Blue Roofs (Rouen)*, 1884.
Oil on canvas, 74×60 cm.
Winterthur, Oskar Reinhart Collection. 26

94. *Blue Trees, November-December* 1888.
Oil on canvas, 92×73 cm.
Copenhagen, Ordrupgaard Collection.
Photo Ole Woldbye. 89

110. *Bonjour Monsieur Gauguin*, 1889.
Oil on canvas, 113×92 cm.
Prague, Národní Gallery.
Photo Vladimir Fyman. 105

192. Borobudur, frieze on a Javanese temple,
detail. 178

149. Borobudur, frieze on a Javanese temple,
detail; the photograph once belonged
to Gauguin.
Private Collection. 141

166. Borobudur, frieze on a Javanese temple,
detail; the photograph once belonged
to Gauguin.
Private Collection. 160

127. *Breton Girls by the Sea,* 1889.
Oil on canvas, 92×73 cm.
Tokyo, National Museum of Western Art. 121

60. *Breton Peasant with Pigs,* 1888.
Oil on canvas, 73×93 cm.
United States, Private Collection. 62

39. *The Breton Shepherdess,* 1886.
Oil on canvas, 60×73 cm.
Newcastle Upon Tyne, Laing Art Gallery. 43

62. *Breton Women in the Fields*
(Émile Bernard), 1888. Private Collection. 64

53. *By the Sea,* 1887.
Oil on canvas, 46×61 cm.
Paris, Private Collection. 53

191. *Cahier pour Aline,* Illustrated page.
Paris, Bibliothèque Doucet.
Photo Friends of the Bibliothèque. 177

6. *Cahier pour Aline,*
Reproduction of Corot's
Woman with a Mandolin, glued in by Gauguin.
Paris, Bibliothèque d'Art et d'Archéologie.
Photo Friends of the Bibliothèque. 16

295. *The Call,* 1902.
Oil on canvas, 130×90.
Cleveland Museum of Art. 274

76. *Captain Jacob,* 1888.
Oil on canvas, 31×43 cm.
Paris, Private Collection.
Photo Flammarion. 75

281. Card announcing Gauguin's death.
Private Collection. 265

107. *Caricature* (Émile Bernard).
Paris, Musée du Louvre,
Department of Drawings.
Photo Musées Nationaux. 100-101

47. Ceramic Vase decorated with a Breton Woman,
1886-1887.
Copenhagen, Museum of Decorative Art. 48

46. Ceramic Vase decorated with a Dancer by
Degas, 1886-1887.
Copenhagen, Museum of Decorative Art. 48

56. *Children Wrestling,* 1888.
Oil on canvas, 93×73 cm.
Josefowitz Collection.
Photo Flammarion. 56

122. *Christ in the Garden of Olives*
(Self-portrait), 1889. Oil on canvas, 73×92 cm.
West Palm Beach,
Norton Gallery and School of Art. 115

222. *Christmas Night,* 1894.
Oil on canvas, 72×83 cm.
Josefowitz Collection. 205

50. *Les Cigales et les fourmis,*
Memories of Martinique.
Zincography.
Paris, Bibliothèque d'Art et d'Archéologie.
Photo Friends of the Bibliothèque. 51

52. *Conversation in the Tropics,* 1887.
Oil on canvas, 61×76 cm. Private Collection.
Photo Christie's New York. 52

145. *Copy of Manet's Olympia,* 1891.
Oil on canvas, 89×130 cm.
London, Private Collection
(once owned by Edgar Degas).
Photo Prudence Cumming. 137

36. *Cows at the Watering-place,* 1885.
Oil on canvas, 81×65 cm.
Milan, Civica Galleria d'Arte Moderna,
Grassi Collection.
Photo Saporetti. 39

156. *Crouching Tahitian Woman,* 1891-1892.
Charcoal and pastel, 55.3×47.8 cm.
Chicago, Art Institute. 148

249. *The Dance of Life (Edvard Munch),* 1899.
Oil on canvas, 125.5×190.5 cm.
Oslo, Nasjonalgalleriet.
Photo J. Lathion. 230

90. *Death of Sardanapale* (Eugène Delacroix),
detail, 1827.
Oil on canvas, 392×496 cm.
Paris, Musée du Louvre.
Photo Musées Nationaux. 86

135. Decorated Cask, 1889-1890.
Carved and painted wood.
Private Collection. 126

24. Decorated Wooden Box, exterior, 1884. Length
52 cm.
Stockholm, Private Collection. 27

25. Decorated Wooden Box, interior, 1884.
Length 52 cm.
Stockholm, Private Collection. 27

289. *Les Demoiselles d'Avignon* (Pablo Picasso),
detail, 1907.
Oil on canvas, 245×235 cm.
New York, Museum of Modern Art,
purchased from the L.P. Bliss Collection, 1939.
Photo Giraudon. 271

242. *Diana Reclining (Lucas Cranach),* 1537.
Oil on wood, 48.5×74.2 cm.
Besançon, Musée des Beaux-Arts
et d'Archéologie.
Photo Lauros-Giraudon. 222

75. Drawing by Gauguin in a letter
to Schuffenecker, 9 October 1888.
Private Collection. Archives Tallandier. 74

101. *The Eiffel Tower* (Georges Seurat), 1888-1889.
Oil on canvas, 24×15 cm.
San Francisco, Fine Arts Museum. 95

250. *L'Esprit Moderne et le Catholicisme (cover),*
1897-1898.
Monotype, 31.8×19.2 cm.
Saint Louis, Art Museum.
Gift of Vincent Price, Beverly Hills,
in memory of his parents Marguerite and Vincent
L. Price. 231

251. *L'Esprit Moderne et le Catholicisme.*
Paradise Lost, engraving glued onto the cover.
Saint Louis, Art Museum. Gift of Vincent Price,
Beverly Hills, in memory of his parents
Marguerite and Vincent L. Price. 232

114. *Eve,* 1889.
Pastel and watercolour.
San Antonio, McNay Art Institute. 108

233. *Eve.* Woodcut.
Paris, Bibliothèque Nationale.
Photo B.N. 213

150. *Eve Exotique,* 1890.
Oil on cardboard, 43×25 cm.
Paris, Private Collection. 141

252. *Faa Iheihe (Tahitian Pastoral),* 1898.
Oil on canvas, 54×169 cm.
London, Tate Gallery. 232-233

161. *Faaturuma*
(Reverie or Woman in a Red Dress), 1891.
Oil on canvas, 94.6×68.6 cm.
Kansas City, Nelson Atkins Museum of Art. 154

32. *Fan with Landscape after Cézanne,* 1885.
Gouache, 28×57 cm.
Copenhagen, Ny Carlsberg Glyptotek. 35

79. *Farm at Arles,* 1888.
Oil on canvas, 91.4×71.7 cm.
Indianapolis, Museum of Art,
Gift in memory of Wm. Ray Adam. 77

124. *Farm at Le Pouldu,* 1890.
Oil on canvas, 71×88 cm.
Dallas, Museum of Art.
Wendy and Emery Reeves Collection. 117

196. *Fatata te Miti (Near the Sea),* 1892.
Oil on canvas, 68×92 cm.
Washington, National Gallery of Art. 180-181

136. *Fénéon at La Revue Blanche* (Félix Vallotton),
1896. Oil on cardboard, 52.5×65 cm.
Josefowitz Collection. 127

132. *The Follies of Love,* 1889.
Gouache on millboard, diameter 26.7 cm.
Westgrove, Private Collection. 124

40. *Four Breton Women,* 1886.
Oil on canvas, 72×91 cm.
Munich, Bayerische Staatgemäldesammlungen. 44

209. Paul Gauguin (photograph). 194

296. Gauguin (photograph), winter 1893-1894, taken in
front of his painting Te Faaturuma (Silence). 276

311. Gauguin, 13 February 1891 (photograph).
Saint-Germain-en-Laye, Musée Départemental
du Prieuré,
Maurice Malingue Donation. 285

298. Gauguin aged two, by Jules Laure.
Saint-Germain-en-Laye, Musée Départemental
du Prieuré,
Maurice Malingue Donation. 277

308. Gauguin between his son Émile and his
daughter Aline in Copenhagen in March 1891
(photograph). Maurice Malingue Collection. 283

83. *Gauguin's Chair* (Vincent Van Gogh), 1888.
Oil on canvas. Amsterdam,
Vincent Van Gogh Foundation,
National Museum Vincent Van Gogh. 81

305. Gauguin in an amateur snapshot
from Pont-Aven in 1888?
Maurice Malingue Collection. 282

300. Gauguin in 1873 (photograph).
Maurice Malingue Collection. 278

310. Gauguin in 1891, photographed by the
painter Boutet de Monvel in Paris.
Saint-Germain-en-Laye, Musée Départemental
du Prieuré,
Maurice Malingue Donation. 284

307. *Gauguin Playing the Accordion* (Paul Sérusier),
1893-1894. Drawing.
Paris, Musée du Louvre,
Department of Drawings.
Photo Musées Nationaux. 282

306. *Gauguin Rowing* (Paul Sérusier), detail, c. 1889?
Drawing.
Paris, Musée du Louvre,
Department of Drawings.
Photo Musées Nationaux. 282

285. *Gertrude Stein* (Pablo Picasso), 1906.
Oil on canvas, 100×81 cm.
New York, Metropolitan Museum of Art. 269

129. *Girl Tending Pigs,* 1889.
Oil on canvas, 73×92 cm.
New York, Private Collection.
Photo Artemis Group and E. C. Thaw and Co.,
Inc. 120-121

57. The Gloanec Inn in Pont-Aven in Gauguin's day
(photograph). 58

112. *The Green Christ,* 1889.
Oil on canvas, 92×73 cm.
Brussels, Musées Royaux d'Art et d'Histoire.
Photo A.C.L. 106

120. *The Ham,* 1889.
Oil on canvas, 50×58 cm.
Washington, Phillips Gallery. 113

125. *Harvest in Brittany,* 1889.
Oil on canvas, 92×73 cm.
London, Courtauld Institute Galleries. 118

130. *The Haystacks or The Potato Field,* 1890.
Oil on canvas, 74×93 cm.
Washington, National Gallery of Art.
Gift of the W. Averell Harriman Foundation
in memory of Marie N. Harriman. 122-123

286. *Head of a Breton Woman,* 1894.
Gouache on cardboard, 27×36 cm.
Private Collection (Ex-Paco Durrio Collection). 269

48. *Head of a Martinique Woman,* 1887.
Pastel, 36×27 cm.
Amsterdam, Vincent Van Gogh Foundation,
National Museum Vincent Van Gogh. 50

155. *Head of a Tahitian (with Profile*
of Second Head to His Right), 1891-1893.
Crayon and pastel, 35×37 cm.
Chicago, Art Institute. 148

153. *Head of a Tahitian Woman,* c. 1891.
Graphite on vellum, 30.5×24.5 cm.
Cleveland Museum of Art. 146

212. *Hina tefatou (The Moon and Earth),* 1893.
Oil on canvas, 112×62 cm.
New York, Museum of Modern Art. 197

51. *Hodogaya on the Road to Tokaido (Hokusai),*
1825-1832.
Print from the Thirty-six Views of Mount Fuji.
Paris, Huguette Berès Collection. 52

210. *Homage to Cézanne* (Maurice Denis), 1900.
Oil on canvas, 180×240 cm.
Paris, Musée d'Orsay.
Photo Musées Nationaux. 195

188. *Hope* (Pierre Puvis de Chavannes), 1877.
Oil on canvas, 70.5×82 cm.
Paris, Musée d'Orsay.
Photo Musées Nationaux. 174

84. *Human Misery or Grape Harvest* (Arles), 1888.
Oil on canvas, 73×92 cm.
Copenhagen, Ordrupgaard Collection.
Photo Ole Woldbye. 81

232. *Human Misery,* Memories of Brittany, c. 1895.
Woodcut. Paris, Bibliothèque Nationale.
Photo B.N. 212

263. *The Hut,* c. 1900.
Monotype enhanced with crayon, 58×44 cm.
Paris, Private Collection.
Photo Flammarion. 245

167. *Ia orana Maria (Hail Mary),* 1891.
Oil on canvas, 113.7×87.7 cm.
New York, Metropolitan Museum of Art.
Bequest of Sam A. Lewisohn, 1951. 161

194. *Idol with a Pearl,* 1891-1893.
Height 25 cm.
Paris, Musée d'Orsay.
Photo Musées Nationaux. 178

193. *Idol with a Shell,* 1893.
Height 27 cm.
Paris, Musée d'Orsay.
Photo Musées Nationaux. 178

247. Illustrated letter to Daniel de Monfreid,
February 1898.
Paris, Private Collection. Archives Tallandier. 228

254. Illustrated Menu, 1899.
Pen and watercolour.
Paris, Private Collection. 235

91. *In the Hay,* 1888.
Oil on canvas, 73×92 cm.
London, Private Collection.
Photo A. C. Cooper. 87

29. *In the Soup,* Drawing on Dillies & Co.
letterhead, detail, 1885.
Photo J. P. Leloir. 31

116. *In the Waves (Ondine),* 1889.
Oil on canvas, 92×71.5 cm.
Cleveland Museum of Art.
Gift of Mr and Mrs William Powell Jones. 110

172. *I raro te oviri (Under the Pandanus),* 1891.
Oil on canvas, 67×90 cm.
Dallas, Museum of Art,
Foundation for the Arts Collection,
Adèle R. Levy Fund. 165

71. *Japanese Proverbs*
from the Tatoye Zukuski series (Kuniyoshi).
Document belonging to Huguette Berès. 70

45. *Jardinière Decorated with Motifs*
from The Breton Shepherdess and The Toilette,
'The Toilette', 1886-1887.
Stoneware decorated with barbotine.
Paris, Private Collection.
Photo Musées Nationaux. 47

293. *La Joie de vivre* (Henri Matisse), 1905-1906.
Oil on canvas, 174×238 cm.
Merion, Barnes Foundation. 273

237. *Joseph and Potiphar's Wife,*
Oil on canvas, 88.3×117.5 cm.
United States, Private Collection. 218

134. *Jug in the Form of a Head,* Self-portrait, 1889.
Glazed stoneware, height 19.3 cm.
Copenhagen, Kunstindustrimuseet.
Photo Ole Woldbye. 126

82. *The Laundresses* (Arles), 1888.
Oil on canvas, 73×92 cm.
Bilbao, Museo de Bellas Artes.
Photo Flammarion. 80

121. **Letter from Gauguin to Van Gogh,** November
1889.
Amsterdam, Vincent Van Gogh Foundation, Na-
tional Museum Vincent Van Gogh. 114

287. *Life* (Pablo Picasso), 1903.
Oil on canvas, 197×127.5 cm.
Cleveland Museum of Art. 270

283. *Life* (Pablo Picasso), detail, 1903.
Oil on canvas, 197×127.5 cm.
Cleveland Museum of Art. 268

118. *Life and Death,* 1889.
Oil on canvas, 92×73 cm.
Cairo, Mahmoud Khalil Museum. 111

278. **Lintels from 'The House of Pleasure',** 1902.
Carved and painted redwood
(five lintels/jambs: L: 2.44 m;
vertical jambs: L: 2m and 1.60 m; bases: L: 2m).
Paris, Musée d'Orsay. 260-261

143. *The Loss of Virginity,* 1891.
Oil on canvas, 90×130 cm.
Norfolk, Virginia, Chrysler Art Museum. 36

142. *Madame Death,* 1891.
Paris, Musée du Louvre,
Department of Drawings. Photo Giraudon. 134

88. *Madame Ginoux at the Café,* 1888.
Oil on canvas, 73×92 cm.
Moscow, Pushkin State Museum of Fine Arts.
Photo A.P.N. 83

10. *Madame Pissarro Sewing*
(Camille Pissarro), 1878.
Oil on canvas, 16×11 cm.
Oxford, Ashmolean Museum. 18

85. *Madame Roulin* (Arles), 1888.
Oil on canvas, 49×62 cm.
Saint Louis, Art Museum. 82

86. *Madame Roulin* (Vincent Van Gogh), 1888.
Oil on canvas, 54×65 cm.
Winterthur, Oskar Reinhart Collection. 82

144. *Madeleine in the Bois d'Amour*
(Émile Bernard), 1888.
Oil on canvas, Paris, Musée d'Orsay.
Photo Musées Nationaux. 136

215. *Mahana no Atua (Day of the God),* 1894.
Oil on canvas, 68.3×91.5 cm.
Chicago, Art Institute. 200

170. *The Man with an Axe,* 1891.
Oil on canvas, 92×69 cm.
Basel, Private Collection. 164

190. *Manao tupapau*
(The Spectre Watches over Her), 1892.
Oil on canvas, 73×92 cm.
Buffalo, Albright-Knox Art Gallery, A. Conger
Goodyear Collection, 1965. 176

231. *Manao tupapau*
(The Spectre Watches Over Her), Woodcut.
Paris, Musée des Arts Africains et Océaniens.
Photo Musées Nationaux. 211

292. *Marguerite* (Henri Matisse), 1906-1907.
Oil on canvas, 65×54 cm.
Paris, Musée Picasso.
Photo Musées Nationaux. 272

8. *Market Gardens in Vaugirard,* 1879.
Oil on canvas, 65×100 cm.
Northampton, Smith College Museum of Art. 17

163. *The Meal or The Bananas,* 1891.
Oil on paper mounted on canvas, 73×92 cm.
Paris, Musée d'Orsay.
Photo Musées Nationaux. 156-157

206. *Merahi metua no Tehamana
(Tehamana Has Many Parents),* 1893.
Oil on canvas, 76×54 cm.
Chicago, Art Institute. 191

22. *Mette Gauguin,* 1879.
Marble.
Paris, Musée d'Orsay. 26

309. Mette Gauguin and her five children in Copen-
hagen in 1888 (photograph). 283

299. Mette Gauguin in Copenhagen (photograph).
Maurice Malingue Collection. 278

21. *Mette Gauguin in Evening Dress,* 1884.
Oil on canvas, 65×54 cm.
Oslo, Nasjonalgalleriet.
Photo Jacques Lathion. 26

11. *Mette Sewing,* 1878?
Oil on canvas, 116×81 cm.
Zurich, Bührle Collection.
Photo W. Dräyer. 19

109. *Meyer de Haan,* 1889.
Oil on wood, 79.6×51.7 cm.
New York, Private Collection. 104

147. *Octave Mirbeau* (engraved portrait).
Paris, Bibliothèque Nationale.
Photo B.N. 138

139. Jean Moréas, photograph.
Paris, Bibliothèque Nationale. 130

31. *Mountains, L'Estaque* (Paul Cézanne),
c. 1883-1885.
Cardiff, National Museum of Wales. 34

205. *Mountains in Tahiti,* 1891.
Oil on canvas, 67.8×92.4 cm.
Minneapolis, Institute of Art. 190

176. *Mural from a Theban tomb,*
c. 1500-1400 B.C.
London, British Museum. 168

262. *Nativity.*
Monotype.
Paris, Private Collection.
Photo Flammarion. 244

238. *Nave nave mahana (Delightful Day),* 1896.
Oil on canvas, 95×130 cm.
Lyons, Musée des Beaux-Arts.
Photo Bernard Lontin. 218-219

240. *Nevermore,* 1897.
Oil on canvas, 60×161 cm.
London, Courtauld Institute Galleries.
Photo the Bridgeman Library. 220-221

123. *'Nirvana',* Portrait of Jacob Meyer de Haan, c.
1890.
Essence on silk, 20×29.2 cm.
Hartford, Wadsworth Atheneum.
Photo Joseph Szaszfai. 116

Noa Noa. Manuscript written and illustrated
by Gauguin with additional woodcuts and
photographs. Paris, Musée du Louvre,
Department of Drawings.
93. **Drawing by Van Gogh glued in by Gauguin.** 88

216. *'The Narrator Speaks'.* 201
217. Page 55, *Hina and Fatu,* watercolour; glued-in
photograph. 202
218- Pages 57 and 75. 202
219.
220. *Maruru,* 1894-1895.
Enhanced woodcut glued onto page 59. 203

128. *Nude Breton Boy,* 1889.
Oil on canvas, 93×74 cm.
Cologne, Wallraf-Richartz-Museum.
Photo Rheinisches Bildarchiv. 121

80. *Old Women at Arles,* 1888.
Oil on canvas, 73×92 cm.
Chicago, Art Institute. Mr and Mrs Lewis
Larned Coburn Memorial Collection. 78-79

199. *Otahi* (Alone), 1893.
Oil on canvas, 50×73 cm.
Paris, Private Collection. 183

228. *Oviri,* 1894.
Partially glazed stoneware, height 75 cm.
Paris, Musée d'Orsay.
Photo Musées Nationaux. 209

229. *Oviri,* 1895.
Woodcut. Paris, Musée des Arts Africains
et Océaniens.
Photo Musées Nationaux. 209

290. *Oviri* (Savage).
Monotype, 29×20 cm. 271

226. *Oviri* (Savage) (Self-portrait), 1894.
Patinated plaster. Private Collection.
Photo Vizzavona. 208

19. *The Painter's Family in the Garden,
Rue Carcel,* 1882.
Copenhagen, Ny Carlsberg Glyptotek. 25

202. *Pape Moe (Mysterious Water),* 1893.
Oil on canvas, 99×75 cm.
Switzerland, Private Collection. 188

174. *Parahi te marae (There Stands the Shrine),*
1892.
Oil on canvas, 68×91 cm.
Philadelphia, Museum of Art. 166-167

63. *The 'Pardon'* (Pascal Dagnan-Bouveret), 1887.
Oil on canvas, 125×141 cm.
Lisbon, Caloustian Gulbenkian Foundation. 64

171. The Parthenon, detail of a frieze, photograph
published by Gustave Arosa;
belonged to Gauguin. 164

258. The Parthenon, relief from the west frieze.
Reproduced in Frises du Parthénon, a book
illustrated with Gustave Arosa's photographs. 238

302. Paul and Mette Gauguin at the time of their
marriage in 1873.
Maurice Malingue Collection. 281

35. *Peasant Girls Bathing* (Edgar Degas), 1875-1876.
Oil on canvas, 65×81 cm.
Private Collection.
Photo Prudence Cumming. 38

13. Camille Pissarro (photograph). 21

138. Portrait of Albert Aurier in the frontispiece
of his Œuvres Posthumes.
Paris, Bibliothèque Nationale. 130

211. *Portrait of Ambroise Vollard* (Paul Cézanne),
1899.
Oil on canvas, 100×81 cm.
Paris, Musée du Petit Palais. Photo Bulloz. 195

148. *Portrait of the Artist's Mother,* 1890.
Oil on canvas, 41×33 cm.
Stuttgart, Staatsgalerie. 140

23. *Portrait of Gauguin Sculpting
'Woman on a Stroll or The Little Parisienne'*
(Camille Pissarro). Charcoal, 29.5×23 cm.
Stockholm, Statens Kontsmuseer. 27

59. *Portrait of Madeleine Bernard,* 1888.
Oil on canvas, 72×58 cm.
Grenoble, Musée de Peinture et de Sculpture.
Photo André Morin. 61

141. *Portrait of Stéphane Mallarmé*
(Dedicated by the artist), 1891.
Etching on vellum, 18×14 cm.
Paris, Private Collection. Photo Flammarion. 132

160. *Portrait of Suzanne Bambridge,* 1891.
Oil on canvas, 70×50 cm.
Brussels, Musées Royaux des Beaux-Arts
de Belgique. Photo A.C.L. 152

104. *Portrait of Two Children,* 1890.
Oil on canvas, 46×61 cm.
Copenhagen, Ny Carlsberg Glyptotek. 98

234. *Portrait of Vaïté* (Jeanne) Goupil, 1896.
Oil on canvas, 75×64 cm.
Copenhagen, Ordrupgaard Collection. 214

131. *Portrait of a Woman,* with Still-life by Cézanne,
1890.
Oil on canvas, 65×55 cm.
Chicago, Art Institute. 123

256. *Portrait of a Woman and a Young Man,* 1899.
Oil on canvas, 95×61 cm.
Pasadena, Norton Simon Museum.
Photo A. E. Dolinski. 237

12. *Portraits: Gauguin by Pissarro and Pissarro
by Gauguin,* 1883.
Paris, Musée du Louvre, Department of Drawings.
Photo Musées Nationaux. 20

269. *Portraits of Women,* 1901-1902?
Oil on canvas, 73×92 cm.
Palm Springs, Private Collection. 252-253

169. *The Little Black Pigs,* 1891.
Oil on canvas, 91×72 cm.
Budapest, Museum of Fine Arts. 163

265. *Primitive Tales,* 1902.
Oil on canvas, 130×89 cm.
Essen, Folkwang Museum. 249

227. *Rave te hiti ramu* (The Idol), 1898.
Oil on canvas, 73×92 cm.
Leningrad, Hermitage Museum.
Photo Pic. Ed. Cercle d'Art. 208

270. *Rider.*
Monotype, 50×44 cm.
Paris, Musée des Arts Africains et Océaniens.
Photo Musées Nationaux. 254

271. *Riders,* 1901.
Oil on canvas, 73×92 cm.
Moscow, Pushkin State Museum.
Photo A.P.N. 254-255

272. *Riders on the Beach,* 1902.
Oil on canvas, 66×76 cm.
Essen, Folkwang Museum.
Photo Giraudon. 256

274. *Riders on the Beach,* 1902.
Oil on canvas, 73×92 cm.
London, Private Collection. 256-257

246. **The Sacred Wood**
(Pierre Puvis de Chavannes), 1885.
Lyons, Musée des Beaux-Arts.
Photo Bulloz. 227

96. **The Schuffenecker family**
(photograph). 92

97. *Schuffenecker's Family,* 1889.
Oil on canvas, 73×92 cm.
Paris, Musée d'Orsay.
Photo Musées Nationaux. 93

18. *The Sculptor Aubé and his Son,* 1882.
Pastel on wove paper, 53×72 cm.
Paris, Musée du Petit Palais.
Photo Giraudon. 25

69. *Seascape with Cow on the Edge of a Cliff,* 1888.
Oil on canvas, 73×60 cm.
Paris, Musée des Arts Décoratifs.
Photo L. Sully-Jaulmes. 69

38. *Seated Breton Woman,* 1886.
Charcoal and pastel.
Chicago, Art Institute. 42

126. *The Seaweed Gatherers,* 1889.
Oil on canvas, 87×123 cm.
Essen, Folkwang Museum. 118-119

7. *The Seine at Iena Bridge,* 1875.
Oil on canvas, 65×92 cm.
Paris, Musée d'Orsay.
Photo Musées Nationaux. 17

282. *Self-portrait.*
Drawing.
Private Collection. 266

279. *Self-portrait,* 1903?
Oil on canvas mounted on wood, 42×45 cm.
Basel, Kunstmuseum.
Photo Photocolor Hinz. 263

301. *Self-portrait,* 1885.
Oil on canvas, 65×54 cm.
Berne, Private Collection. 280

1. *Self-portrait,* 1889-1890.
Oil on canvas, 46×38 cm.
Moscow, Pushkin State Museum of Fine Arts.
Photo V.A.P. 8

73. *Self-portrait* (Émile Bernard), 1888.
Amsterdam, Vincent Van Gogh Foundation,
National Museum Vincent Van Gogh. 73

303. *Self-portrait for Carrière,* 1886-1890.
Oil on canvas, 41×33 cm.
Washington, National Gallery of Art.
Photo collection Viollet. 281

313. *Self-portrait for His Friend Daniel,* 1897.
Oil on canvas, 39×35 cm.
Paris, Musée d'Orsay.
Photo Harlingue-Viollet. 287

106. *Self-portrait* (Maurice Denis), 1889.
Oil on canvas. Private Collection.
Photo Giraudon. 99

72. *Self-portrait, 'Les Misérables'*, 1888.
Oil on canvas, 45×55 cm.
Amsterdam, Vincent Van Gogh Foundation,
National Museum Vincent Van Gogh. 72

235. *Self-portrait Near Golgotha*, 1896.
Oil on canvas, 76×64 cm.
São Paolo, Museu de Arte Moderna.
Photo Luiz Hossaka. 216

108. *Self-portrait with Halo*, 1889.
Oil on wood, 80×52 cm.
Washington, National Gallery of Art. 102

213. *Self-portrait with Hat*, 1894.
Oil on canvas, 46×38 cm.
Paris, Musée d'Orsay.
Photo Musées Nationaux. 198

214. *Self-portrait with Palette*, c. 1894.
Oil on canvas, 92×73 cm.
New York, Private Collection. 199

54. *Self-portrait 'for Vincent'* (Charles Laval), 1888.
Amsterdam, Vincent Van Gogh Foundation,
National Museum Vincent Van Gogh. 54

74. *Self-portrait* (Vincent Van Gogh), 1888.
Oil on canvas, 60.5×49.4 cm.
Cambridge (Mass.), Fogg Art Museum.
Bequest of Maurice Wertheim, 1906. 73

113. *Self-portrait with Yellow Christ*, 1889-1890.
Oil on canvas, 38×46 cm.
France, Private Collection.
Photo Flammarion. 106-107

164. *The Siesta*, 1892?
Oil on canvas, 87×116 cm.
Palm Springs,
Mr and Mrs Walter H. Annenberg Collection.
Photo Wildenstein. 158-159

28. *The Singer, Medallion, or Portrait
of Valérie Roumi*, 1880.
Mahogany with details added in plaster
and touches of polychrome, diameter 54 cm.
Copenhagen, Ny Carlsberg Glyptotek. 31

277. *Sketch of Gauguin's Hut* done by Le Bronnec
after a drawing by Tioka's nephew, who often
visited
Gauguin (published by *the Gazette des
Beaux-Arts*
in 1956). 260

26. *Sleeping Child*, 1884.
Oil on canvas, 46×55.5 cm.
Josefowitz Collection. 28-29

15. *Sleeping Child (The Little Dreamer, Study)*,
1881.
Oil on canvas, 54×73 cm.
Copenhagen, Ordrupgaard Collection.
Photo Ole Woldbye. 22

2. *Snow Scene, Rue Carcel*, winter 1882-1883.
Oil on canvas, 60×50 cm.
Copenhagen, Ny Carslberg Glyptotek. 12

198. *La Source* (Gustave Courbet), 1868.
Oil on canvas, 120×74.3 cm.
New York, Metropolitan Museum of Art,
Bequest of H. O. Havemeyer,
collection H. O. Havemeyer. 182

253. *Le Sourire, journal sérieux.*
Illustrated manuscript.
Paris, Musée du Louvre,
Department of Drawings.
Photo Musées Nationaux. 234

264. *Still-life with Bouquet of Flowers*, c. 1900-1901.
Oil on canvas, 95×62 cm.
London, Private Collection. D.R. 246

68. *Still-life: Fête Gloanec*, 1889.
Oil on canvas, 38×53 cm.
Orléans, Musée des Beaux-Arts.
Photo Patrice Delatouche. 68

16. *Still-life: Flowers, or The Painter's Home,
Rue Carcel*, 1881.
Oil on canvas, 130×162 cm.
Oslo, Nasjonalgalleriet.
Photo Jacques Lathion. 23

151. *Still-life with Flowers and Fruit*, 1890.
Oil on canvas, 43×63 cm.
Boston, Museum of Fine Arts. 142-143

276. *Still-life with Apples and Flowers*, 1901-1902.
Oil on canvas, 66×76 cm.
Lausanne, Private Collection. 259

260. *Still-life with 'Hope'*, 1901.
Oil on canvas, 65×77 cm.
New York, Private Collection.
Photo Giraudon. 241

27. *Still-life in an Interior*, 1885.
Oil on canvas, 60×74 cm.
Switzerland, Private Collection.
Photo Prociné Colorlabor. 30

119. *Still-life with Japanese Print, or
Still-life with Vase in the Shape of a Head,*
1889.
Oil on canvas, 73×92 cm.
Teheran, Museum of Modern Art.
Photo Lauros-Giraudon. 112

41. *Still-life with Profile of Laval*, 1886.
Oil on canvas, 46×38 cm.
Josefowitz Collection. 45

70. *Still-life with Three Puppies*, 1888.
Oil on wood, 92×62.6 cm.
New York, Museum of Modern Art. 70

261. *Still-life with Sunflowers and Mangoes*, 1901.
Oil on canvas, 93×73 cm.
Lausanne, Private Collection. 243

30. *Still-life with Vase of Japanese Peonies
and Mandolin*, 1885.
Oil on canvas, 64×53 cm.
Paris, Musée d'Orsay.
Photo Musées Nationaux. 32

37. *A Sunday Afternoon at La Grande Jatte*
(Georges Seurat), detail, 1886.
Oil on canvas, 205.7×305.8 cm.
Chicago, Art Institute. 40

9. *Suzanne Sewing or Nude Study*, 1880.
Oil on canvas, 115×80 cm.
Copenhagen, Ny Carlsberg Glyptotek. 18

105. *La Tache rouge* (Maurice Denis).
Oil on cardboard, 20×20 cm.
Paris, Musée d'Orsay.
Photo Musées Nationaux. 99

203. *A Tahitian man drinking at a spring*
(photograph). From Gauguin in the South Seas
by Bengt Danielsson. 188

201. *Tahitian Pastorals*, 1892-1893.
Oil on canvas, 86×113 cm.
Leningrad, Hermitage Museum.
Photo A.P.N. 186-187

154. *Tahitian Woman*.
Crayon and pastel, 39×30 cm.
New York, Metropolitan Museum of Art,
Bequest of Miss Adelaïde Milton de Groot,
1967. 147

197. *Tahitian Women Bathing*, 1892.
Oil on canvas, 112×89 cm.
New York, Metropolitan Museum of Art. 182

165. *Tahitian Women or On the Beach*, 1891.
Oil on canvas, 69×91 cm.
Paris, Musée d'Orsay.
Photo Musées Nationaux. 160

103. *The Talisman* (Paul Sérusier), 1888.
Oil on wood, 27×22 cm.
Paris, Musée d'Orsay. 96

175. *Ta Matete (The Marketplace)*, 1892.
Oil on canvas, 73×91.5 cm.
Basel, Kunstmuseum. 168

189. *Te aa no Areois
(The Seed of the Ariois)*, 1892.
Oil on canvas, 92×78 cm.
New York, Mrs William S. Paley Collection. 175

243. *Te arii Vahine, Letter illustrated with*, 1896.
Pen and watercolour on paper.
Paris, Private Collection.
Photo Flammarion. 223

241. *Te arii Vahine (The Noble Woman or
Woman with Mangoes)*, 1896.
Oil on canvas, 97×130 cm.
Moscow, Pushkin State Museum of Fine Arts.
Photo V.A.P. 222

159. *Te faaturuma (Silence)*, 1891.
Oil on canvas, 91×68 cm.
Worcester, United States, Art Museum. 151

168. *Te fare (The House)*, 1892.
Oil on canvas, 73×92 cm.
Paris, Private Collection. 162-163

195. *Tehamana*.
Carving in polychromed Pua wood,
height 25 cm.
Paris, Musée d'Orsay.
Photo Musées Nationaux. 179

178. *Te nave nave fenua
(The Delightful Land)*, 1892.
Gouache on wove paper, 40×32 cm.
Grenoble, Musée de Peinture et de Sculpture. 171

177. *Te nave nave fenua
(The Delightful Land)*, 1892.
Oil on canvas, 91×72 cm.
Kurashiki, Ohara Museum of Art. 170

239. *Te rerioa (The Dream)*, 1897.
Oil on canvas, 95×132 cm.
London, Courtauld Institute Galleries. 220

236. *Te tamari no Atua (The Child of God)*, 1896.
Oil on canvas, 96×129 cm.
Munich, Neue Pinakothek. 217

162. *Te tiare Farani (The Flowers of France)*, 1891.
Oil on canvas, 72×92 cm.
Moscow, Pushkin State Museum of Fine Arts. 155

255. *Three Tahitians or Conversation*, 1899.
Oil on canvas, 73×93 cm.
Edinburgh, National Galleries of Scotland. 236-237

4. *Flora Tristan*, engraving by Gerinler, 1847.
Paris, Bibliothèque Nationale,
Department of Prints. 15

55. *Tropical Vegetation*, 1887.
Oil on canvas, 116×89 cm.
Edinburgh, National Galleries of Scotland. 55

223. *Two Breton Women on a Road*, 1894.
Oil on canvas, 66×92 cm.
Paris, Musée d'Orsay.
Photo Musées Nationaux. 206

33. *Two Girls Bathing*, 1887.
Oil on canvas, 92×72 cm.
Buenos Aires, Museo Nacional de Bellas Artes. 37

173. *Two Marquesan Women and Design
of an Ear Ornament*, detail.
Pen and graphite.
Chicago, Art Institute. 166

259. *Two Tahitian Women*, 1899.
Oil on canvas, 94×72.4 cm.
New York, Metropolitan Museum of Art. 240

152. *Two Tahitian Women on the Beach*, 1892.
Oil on canvas, 91×64 cm.
Hawaii, Honolulu Academy of Arts. 144

268. Two Women.
Photograph. B. Danielsson Archives. 252

49. *Two Women from Martinique*, 1887.
Drawing,
Paris, Musée des Arts Africains et Océaniens.
Photo Musées Nationaux. 51

100. Universal Exposition, Paris 1889.
The Eiffel Tower. Photograph. 95

99. Universal Exposition, Paris 1889.
Entrance to the Javanese Kampong.
Published in L'Illustration, 1889. 94

102. Universal Exposition, Paris 1889.
The Hall of Machines. Photograph. 95

98. Universal Exposition Poster for the
exhibition at the Café Volpini, 1889. 93

158. *Vahine no te Tiare (Girl with a Flower)*, 1891.
Oil on canvas, 70×46 cm.
Copenhagen, Ny Carlsberg Glyptotek. 150

244. *Vairumati*, 1897.
Oil on canvas, 73×94 cm.
Paris, Musée d'Orsay. 224-225

187. *Vairumati tei oa
(The Name is Vairumati)*, 1892.
Oil on canvas, 91×60 cm.
Moscow, Pushkin State Museum.
Photo V.A.P. 174

146. *Van Gogh's Funeral* (Émile Bernard), 1891.
Location unknown.
Photo Hubert Angot. 138

42. *Vase Decorated With Breton Scenes*, by Chaplet
43. and Gauguin, 1887-1888.
44. Glazed stoneware, Brussels, Musées Royaux d'Art
et d'Histoire.
Photo A.C.L. 46

95. *Vase in the Form of a Woman's Head, Madame Schuffenecker*, 1889.
Glazed stoneware with gold highlights,
24.2×16.8×17.8 cm.
Dallas, Museum of Art. 90

221. *Village in the Snow (Brittany)*, 1894.
Oil on canvas, 62×87 cm.
Paris, Musée d'Orsay. 204

89. *Vincent Van Gogh Painting Sunflowers*, 1888.
Oil on canvas, 73×92 cm.
Amsterdam, Vincent Van Gogh Foundation,
National Museum Vincent Van Gogh. 84-85

65. *The Vision after the Sermon
(Jacob Wrestling with the Angel)*, 1888.
Oil on canvas, 73×92 cm.
Edinburgh, National Galleries of Scotland. 64-65

67. *The Wave*, 1888.
Oil on canvas, 49×58 cm.
New York, Private Collection. 67

245. *Where Do We Come From?
What Are We?
Where Are We Going?*, 1897.
Oil on canvas, 139×374.5 cm.
Boston, Museum of Fine Arts, Tompkins
Collection, A. G. Tompkins purchase. 226-227
248, 284, 294, details of fig. 245. 229, 268, 273

66. *The Whirlpool (Hiroshige)*, detail, 1857.
Document belonging to Huguette Berès. 66

257. *The White Horse*, 1898.
Oil on canvas, 141×91 cm.
Paris, Musée d'Orsay.
Photo Musées Nationaux. 238

266. *Woman with a Fan*, 1902.
Oil on canvas, 92×73 cm.
Essen, Folkwang Museum.
Photo Collection Viollet. 250

267. Woman with a Fan:
Gauguin's model posing. Photograph. 251

61. *Woman with a Pitcher or
Landscape at Pont-Aven*, 1888.
Oil on canvas, 92×72 cm.
London, Private Collection.
Photo A. C. Cooper. 63

81. *Women of Arles* (Vincent Van Gogh), 1888.
Oil on canvas, 73.5×92.5 cm.
Leningrad, Hermitage Museum. D.R. 79

34. *Women Bathing (Dieppe)*, 1885.
Oil on canvas, 38×46 cm.
Tokyo, National Museum of Western Art. 38

288. *Women at the Seaside*, 1899.
Oil on canvas, 94×72 cm.
Leningrad, Hermitage Museum.
Photo Giraudon. 270

280. *Women and White Horse*, 1903.
Oil on canvas, 73×92 cm.
Boston, Museum of Fine Arts. 264-265

3. *Woodland Scene*, 1873?
Oil on canvas, 45×31 cm.
United States, Private Collection.
Document Wildenstein. 14

111. *Yellow Christ*, 1889.
Oil on canvas, 92×73 cm.
Buffalo, Albright-Knox Art Gallery. 106

92. The 'Yellow House' in Arles, c. 1938
(photograph). 88

58. *Young Bretons Bathing*, 1888.
Oil on canvas, 92×73 cm.
Hamburg, Kunsthalle.
Photo Ralph Kleinhempel. 59

225. *The Young Christian Girl or
Little Girl in Yellow*, 1894.
Oil on canvas, 65×46 cm.
Williamstown, Sterling and Francine Clark
Institute. 207

157. *Young Man with Flower*, 1891?
Oil on canvas, 46×33 cm.
United States, Private Collection.
Photo Christie's. 149

INDEX

Angelico, Fra 128
Angrand, Charles 39
Annah la Javanaise 193, 196, 204
Anne of Brittany 108, 124
Anquetin, Louis 34, 49, 60, 62, 66, 97,
 139, 195
Arosa, Gustave 14, 15, 16, 19, 20, 46,
 180, 218, 233
Aubé, Jean-Paul 22
Aurier, Albert 64, 66, 92, 112, 127, 128,
 129, 135, 196, 198, 262

Balzac, Honoré de 77, 97, 230
Bambridge, Suzanne,
 known as Tutana 153, 215
Barrès, Maurice 42, 131
Baudelaire, Charles 35, 36, 67, 98, 99,
 100, 101, 116, 128, 130, 172, 206,
 239
Becque, Henry 26
Bergson, Henri 92
Bernard, Émile 34, 49, 54, 58, 60, 62,
 63, 66, 71, 73, 74, 75, 79, 80, 94,
 97, 98, 99, 100, 113, 124, 127, 128,
 130, 135, 136, 137, 138, 139, 155,
 163, 195, 205, 212, 234
Bernard, Madeleine 107, 135, 136
Bernheim Jeune 212
Besnard, Albert 39
Bindesbøll 46
Blake, William 217
Blanche, Jacques-Émile 39, 49
Bodelsen, Merete 110
Bœcklin Arnold 220
Bonnard, Pierre 22, 44, 54, 71, 74, 75,
 96, 97, 108, 117, 118, 138, 143, 154,
 163, 167, 195, 212, 263, 278
Botticelli, Sandro 160, 219
Bouguereau, Adolphe William 234
Bourget, Paul 142
Bracquemond, Félix 46, 47, 49
Braque, Georges 10, 101
Breton, André 129
Brouillet, Pierre 27
Buffalo Bill 92

Caillebotte, Gustave 22
Caravaggio 127
Carlyle, Thomas 103, 108, 230
Carrière, Eugène 28, 217
Cassatt, Mary 21, 39
Cézanne, Paul 10, 11, 21, 28, 34, 35,
 36, 39, 44, 60, 76, 77, 97, 108, 123,
 128, 131, 153, 155, 156, 192, 195,
 196, 210, 212, 220, 230, 258, 268,
 275
Chamaillard, Ernest Ponthier de 75
Chaplet, Ernest 24, 33, 44, 46, 47, 58,
 126
Chardin, Jean-Baptiste Siméon 263
Charlopin 134
Chassé, Charles 108
Chazal, Antoine 15
Chazal, Aline (see Gauguin, Aline,
 Gauguin's mother)
Chirico, Giorgio de 155
Corot, Jean-Baptiste Camille 14, 16, 20,
 100, 128
Cottet, Charles 42
Courbet, Gustave 14, 84, 127, 197, 233
Cranach, Lucas 222
Cross, Henri Edmond Delacroix,
 known as 220

Danielsson, Bengt 153, 215, 236
Daudet, Alphonse 134

Daumier, Honoré 21, 77, 79
Debussy, Claude 212
Decamps, Alexandre 139
Degas, Edgar 10, 11, 19, 21, 22, 23, 31,
 35, 39, 46, 49, 57, 60, 71, 76, 77,
 128, 137, 138, 150, 156, 163, 183,
 196, 197, 210, 239, 254, 256, 272
Delacroix, Eugène 10, 14, 35, 36, 64,
 67, 84, 101, 128, 137, 139, 206, 234,
 258
Demnish, A. 46
Denis, Maurice 54, 68, 75, 79, 88, 96,
 97, 107, 117, 138, 167, 212, 236,
 239
Derain, André 262
Dolent, Jean 23, 84
Dostoevsky, Feodor 77
Dubois-Pillet, Albert 39, 40
Du Camp, Maxime 42
Dujardin, Edouard 62
Durand-Ruel 167, 194, 196, 197, 198
Dürer, Albrecht 256
Durio, Paco 269

Enfantin, Prosper Barthélemy, known
 as Père 15

Faure, Elie 268
Fénéon, Félix 28, 35, 36, 39, 40, 68, 97,
 127, 128, 177, 195
Filiger, Charles 128, 133
Flaubert, Gustave 42
Focillon, Henri 219
Fontainas 133, 234, 254
Freinhofer 11, 97

Gaudi, Antonio 49, 92
Gauguin, Aline (Gauguin's
 daughter) 22, 28, 174, 224
Gauguin, Aline (Gauguin's mother) 14,
 15, 16, 141, 269
Gauguin, Clovis (Gauguin's father) 15,
 16
Gauguin, Clovis (Gauguin's son) 28, 39,
 42
Gauguin, Jean-René 28
Gauguin, Mette 18, 19, 23, 26, 27, 30,
 31, 51, 54, 58, 60, 92, 139, 150, 174,
 183
Geffroy, Gustave 210
Gide, André 212
Ginoux, Mme 81
Giotto 128
Gloanec, Marie-Jeanne 68
Goupil, Auguste 215
Goupil, Jeanne 215
Granchi-Taylor, Achille 26, 44
Guillaumin, Armand 21, 33, 94
Guimard, Hector 49, 94
Guys, Constantin 99

Haan, Meyer de 98, 103, 108, 112, 115,
 117, 130, 188, 230, 248
Halévy, Ludovic 163
Hansen, W. 215
Helleu, Paul César 39
Henry, Charles 35, 41
Henry, Marie 98, 103, 123
Hiroshige 52, 66, 108
Hodler, Ferdinand 220
Hokusai 57, 64, 66, 108
Homer 169
Horta, Victor 92

Huet, Juliette 135, 136
Huyghe, René 172
Huysmans, Joris-Karl 16, 26, 31

Ibels, Henri-Gabriel 75, 96
Ingres, Jean Auguste Dominique 77,
 137, 197, 221, 244

Jacob, Captain 74
Jarry, Alfred 160
Jongkind, Johan Barthold 14, 16, 20,
 21, 39
Joyant, Maurice 196

Kahn, Gustave 35, 41
Kandinsky, Wassily 11, 268
Kock, Paul de 239
Krohn, Pietro 35
Kuniyoshi 71
Ky Dong 263

Laurent, Méry 138
Laval, Charles 44, 54, 58, 60, 73, 75
Lawrence, David Herbert 137
Le Barc de Bouteville 195
Leonardo da Vinci 128
Loti, Pierre, Julien Viaud known as 51,
 74, 80, 84, 128, 135, 142, 153, 171,
 242, 262

Maillol, Aristide 28, 54, 96, 97, 183,
 195
Mallarmé, Stéphane 10, 127, 133, 138,
 185, 196, 210, 217, 221
Manet, Edouard 16, 21, 24, 39, 135,
 136, 137, 156, 222
Mani 41
Mantegna, Andrea 128
Marquet, Albert 200
Marx, Roger 94
Matisse, Henri 10, 71, 100, 101, 143,
 148, 155, 158, 183, 200, 220, 242,
 268, 269, 272
Memling, Hans 275
Michaelangelo 139
Milton, John 103
Mirbeau, Octave 26, 138, 194, 198,
 210
Modigliani, Amedeo 123, 272
Moerenhout, J. A. 169, 185, 215
Monet, Claude 10, 18, 22, 34, 41, 76,
 94, 137, 194, 210
Monfreid, Daniel de 81, 92, 133, 138,
 145, 165, 186, 208, 212, 222, 224,
 242, 248, 254, 263
Monticelli, Adolph 77
Moréas, Jean 130, 134, 212
Moreau, Gustave 10, 129, 146
Morice, Charles 92, 97, 127, 129, 130,
 131, 133, 134, 137, 138, 160, 196,
 198, 200, 208, 212, 262
Morisot, Berthe 18
Morris, William 28, 47, 135
Mucha, Alphonse 193
Munch, Edvard 230

Nadar, Félix 20
Natanson Brothers 138

O'Connor, Roderick 145, 212

Péladan, Joséphin 128, 217
Petrarch 76
Phidias 236
Philipsen 46
Picasso, Pablo 10, 101, 208, 244, 254,
 262, 268, 269, 272, 275
Pissarro, Camille 10, 11, 13, 14, 18, 19,
 20, 21, 22, 23, 26, 28, 30, 33, 34,
 35, 38, 39, 40, 41, 44, 46, 47, 63,
 64, 67, 68, 77, 80, 94, 101, 127,
 128, 130, 194, 195, 196, 275, 277
Pissarro, Lucien 22, 196
Poe, Edgar Allen 133, 148, 221
Pomare V 153
Portier 58
Poussin, Nicolas 97
Proudhon, Pierre Joseph 15
Proust, Marcel 39
Prud'hon, Pierre, known as Pierre-
Paul 15, ,218
Puvis de Chavannes, Pierre Cécil 77,
 79, 116, 128, 146, 172, 180, 185,
 212, 218, 224, 230, 239, 254

Rachilde 134
Ranson, Paul 75, 96, 117, 138
Raphael 97, 139, 219, 236
Redon, Odilon 10, 28, 134, 139, 142,
 146, 165, 171, 185, 239, 242, 258
Rembrandt 194, 198
Renan, Ernest 42, 230
Renard, Jules 134, 138
Renoir, Auguste 21, 23, 34, 35, 39, 94,
 130, 194, 196, 206, 220
Rey, Robert 236
Rimbaud, Arthur 112, 142, 194, 275
Rodin, Auguste 49, 210
Rops, Félicien 31
Rosso, Medardo 49
Rotonchamp 194
Rouart, Alexis 156
Rousseau, Henri, known as
 Le Douanier 10,201
Roussel, Ker Xavier 75, 96
Rubens, Peter Paul 206
Ruskin, John 28, 262

Sand, George 15
Satre, Angèle 108
Schmidt 212
Schopenhauer, Arthur 135, 137
Schuffenecker, Émile 26, 30, 34, 36, 38,
 41, 49, 52, 54, 57, 58, 60, 63, 66,
 71, 76, 84, 92, 94, 113, 127, 130,
 135, 137, 138, 167
Schuré, Edouard 92
Segalen, Victor 13, 137, 204, 210, 260
Seguin, Armand 123, 204, 206, 212
Sérusier, Paul 74, 75, 76, 96, 98, 117,
 196, 239
Seurat, Georges 10, 11, 34, 35, 36, 39,
 40, 41, 49, 60, 92, 94, 97, 98, 100,
 101, 127, 193, 194, 206, 210, 224

Signac, Paul 36, 39, 40, 41, 49, 60, 94,
 116, 206, 220
Sisley, Alfred 13, 21, 22, 23, 194
Skovgaard 46
Spengler, Oswald 137
Steinlen, Théophile Alexandre 269
Stevenson, Robert Louis 153, 169
Strindberg, August 24, 210, 230
Swedenborg, Emmanuel 217

Taaroa 153
Taine, Hippolyte 278
Tamerlan 41
Tanguy, Père 156, 195
Tardieu 189
Tassaert 14, 218
Tehamana, also known as Tehura 153.
 169, 172, 181, 190, 201, 206, 218
Titi 153
Titian 135
Toulouse-Lautrec, Henri de 10, 11, 22,
 46, 62, 92, 96, 195, 196, 269
Tristan, Flora 15
Tristan y Moscoso, Don Pio 15

Uribe, Juan 49

Vairumati 172
Valéry, Paul 212
Vallette 134
Vallotton, Félix 96, 108
Van Eyck, Jan 186
Van Gogh, Theo 51, 58, 66, 71, 73, 74,
 75, 76, 79, 84, 88, 94, 108, 128
Van Gogh, Vincent 10, 22, 36, 49, 51,
 54, 58, 60, 62, 64, 66, 71, 73, 74,
 75, 76, 77, 79, 80, 81, 84, 88, 92,
 94, 99, 107, 108, 117, 121, 126, 127,
 128, 134, 135, 137, 188, 195, 234,
 242
Vanor, Georges 92
Verkade, Jan 117
Verlaine, Paul 112
Viollet-le-Duc, Eugène Emmanuel 92
Vollard, Ambroise 193, 195, 212, 237,
 247, 272
Vuillard, Edouard Jean 54, 75, 96, 117,
 118, 138, 154, 167, 195, 212

Wagner, Richard 92, 116, 205, 212,
 217, 275
Whistler, James Abbott Mac Neill 153
Wilde, Oscar 275
Willy, Henri Gauthier-Villars,
 known as 239

Ziem, Félix 77
Zola, Émile 16
Zumbul-Zadé 41